Electric Ladyland

Electric Ladyland

Women and Rock Culture

Lisa L. Rhodes

PENN

University of Pennsylvania Press
Philadelphia

10 9 8 7 6 5 4 3 2 1

Published by
University of Pennsylvania Press
Philadelphia, Pennsylvania 19104-4011

Library of Congress Cataloging-in-Publication Data

Rhodes, Lisa L.
 Electric ladyland : women and rock culture / Lisa L. Rhodes.
 p. cm.
 Includes bibliographical references and index.
 ISBN 0-8122-3840-0 (cloth : alk. paper)
 ISBN 0-8122-1899-X (pbk. : alk. paper)
 1. Feminism and music. 2. Women rock musicians. 3. Rock music—Social aspects. I. Title.

ML82 .R54 2005
781.66′082 22 2004043094

For Trisha Ryan

Contents

Preface

The Gaslamp Theater, Austin, Texas, 1980. It's close to 2 A.M. The event is a benefit to save rhesus monkeys no longer needed for lab experiments from certain death. Several bands, of varying quality, have already played. There are only two more to go, the Big Boys who are the headliners and a new all-girls band called the Sirens. That's where I come in. I am the singer and a guitar player for the Sirens. At nineteen and a freshman in college at the University of Texas, I live to play music.

The Sirens are a wild assortment of folks, mostly students, who come to music from many different avenues. The keyboard player is a twenty-year-old classical piano major who graduated from Interlochen. In this band she plays a Farfisa organ. The drummer, also twenty, is a film major from the Jersey shore who loves British punk music and plays a vintage set of red Slingerland drums. The bass player, twenty-one, is my big sister in the social sorority I have unwisely joined. She plays a giant Brian Wilson Telecaster bass through a blue tuck and roll sparkle Kustom bass amp, both of which I have appropriated from my real big brother, Fred. The other guitar player is the sister of a girl who lives in my dorm and is a state employee studying jazz guitar. The latter fact accounts for her choice of instrument, a very nonrock Gibson ES-335. I play a cherrywood-colored Gibson SG through a Peavey Deuce.

Our set list is as varied as the personnel and the instrumentation. We play old sixties covers by Paul Revere and the Raiders and Johnny Rivers. We also play newly released songs by the Buzzcocks (the drummer's suggestion). Whatever we play is pretty much by accident, as is our inclusion in this show. I don't remember how we got the gig but as it is a benefit, we probably just answered an ad for "Bands Wanted to Play for Free." I have never played anywhere but frat parties, high-school dances, and teen nights. I have only played for friends. This will be the first real-live gig for me and I have no idea what to expect.

After we finish setting up and tell the MC we are ready, the lights go down. Suddenly, my knees are knocking together so badly I can hardly stand still. This is completely unexpected. I have never been nervous in front of people before. Then I hear, "Ladies and gentlemen, the Sirens," and the lights go up. I have a quick choice, either stand still and let the whole place see me literally quaking in my shoes, or do something. As if someone else is controlling

my body, I find myself jumping up and down as I play the intro to "Secret Agent Man." I do not remember a thing about the rest of the show, except that the Big Boys made me laugh by opening up with the theme from the Monkees' TV show and we got a boatload of gig offers the next day.

Like a lot of young girls in the late 1970s and early 1980s, I joined together with others like me who wanted to play rock and roll. Grouped loosely under the rubrics of new wave and punk, we emulated our heroes du jour and played music. Some girls looked to Siouxsie Sioux and some to Chrissie Hynde and others to the Go-Gos, but the important point is that there were women in the industry to tell us that playing music was ok. For those of us who had started playing in the early to mid-1970s, this was a real sea change. In those days, there were hardly any women who played instruments. When I first started playing electric guitar, in 1972 at the age of twelve, my personal rock god was Suzi Quatro, an ex-pat American who played bass in her own glitter band in London in the early 1970s. Her Mickey Most–inspired persona was 1970s butch, complete with leather jumpsuits and platform soles. I learned how to play all her songs and thought she was wonderful. Then she joined the cast of *Happy Days* as Leather Tuscadero and lost much of her coolness for me.

I also liked Fanny but their records were hard to find and they sputtered out before I could really tell what they were all about. The Wilson sisters of Heart were another inspiration for many of the women that I would meet who played music during that era. Others took their cues from Bonnie Raitt, who then, as now, was the baddest slide player alive. The more punk, and Eastern seaboard, oriented players looked to Patti Smith, although I couldn't make head or tails of her album *Easter* when I bought it at my local record store. Her singing just sounded so awful to my fourteen-year-old ears, used to as they were to AM pop and 1970s album rock. Some of the more folk-influenced players spoke of liking Carly Simon and Judy Collins. Everybody loved Joni Mitchell, even if her songs, with their variant tunings and layers of vocals, were too hard for most of us to play.

We would sit, hunched over our turntables, and painstakingly pick out the chords or the notes or the drum riffs to these women's songs and dream of being up in the lights, someday, just like they were. We formed garage bands, mostly with guys because they were the ones who usually played. When we got to college, or our twenties, many of us formed all-girls bands or found other kindred spirits to make music with. The new wave and punk movements of the late 1970s and the early 1980s represented the first time that young women joined, or started, local rock-and-roll bands in large numbers.

Although our mass inclusion in rock music, and our numbers, were new,

make no mistake, women in rock was not. Without those earlier women to inspire us and act as role models, many of us would never have played at all. Or if we had played, it sure would have been a lot less acceptable to the people who watched, or played with, us. It would have seemed a lot less acceptable to us, too. The teenage years are not usually the ones that bring out the innovator in people, especially if they are women. These women made it ok to play in a way that brooked less argument. Success has a way of doing that.

Other women on the scene who did not want to play but loved the music turned to writing. Those who did so also had women to emulate and learn from. Female rock writers were nothing new, even if (like the musicians) their numbers were small. Despite that fact that it took me until I arrived in graduate school to discover many of them for myself, other more plugged-in women had been reading writers like Lillian Roxon, Lisa Robinson, Roberta Cruger, and Ellen Willis for years, as well as being stunned by Annie Leibovitz's poetic genius with a camera. Much like the female musicians, there were female journalists there to guide and inspire those women and girls who wanted to write about music culture or capture it on film.

This work, in many ways, is a labor of love. I really love the music made by the women in rock who came before me. Some of the personas and stage images that they created opened up new possibilities for women, players or not. As a former musician from a little bit later in time, I am still stunned that so many of these women were able to buck tradition, endure the loneliness and abuse that comes with being among the first in a field, and be so incredibly successful. For the indisputable fact is that they were successes, not only as musicians and artists, but also as women. They were our heroes. Many still play today and continue to delight and inspire us, and new generations of girls, with their work and their passion.

The women who were musicians, music writers, and groupies between 1965 and 1975 had two things in common: the double standard and a love of music. All of these women, solely because of their sex, faced obstacles that men in the same endeavors did not. Yet they were still influential participants in the music scene during that era. For the musicians, a partial list during this era should suffice: Janis Joplin, Aretha Franklin, Laura Nyro, Joni Mitchell, Tina Turner, Grace Slick, Cass Elliot, Carole King, Carly Simon, Bonnie Raitt, Linda Ronstadt, Patti Smith, Chaka Khan, Gladys Knight, Patti LaBelle, Karen Carpenter, Cher, and Diana Ross. And though the work of the women writers of this era has received far less attention than that of their male counterparts, their work still stands as a benchmark for rock journalism of the period. One only has to read Ellen Willis's articles for *New Yorker* or Lillian Roxon's *Rock Encyclopedia* or

Ellen Sander's work for *Saturday Review* to realize the quality of their work. As for the groupies, the term's continued usage, indeed its expanded usage in the case of the hip hop subculture, illustrates that it has caught hold in our collective imaginations. The film *Almost Famous* (2000) and other projects demonstrate that we still find that subculture alluring and that it remains a viable part of American popular culture.

There are other important reasons to consider the women in the rock community during this era. Some of the female journalists that I quote in this work also believed that women were what gave rock its sex appeal. Without women in the audience, or waiting backstage, all the posturing of male rock stars on stage would seem a little pointless, at least for those who were heterosexual.

Another reason to study rock women stems from the fact that between 1965 and 1975 gender roles were in flux in America and these women were on the front lines of the gender wars of the late 1960s and early 1970s. For example, by redefining what it meant to be a female musician or writer, these women were helping to change perceptions about women in general. The groupies, with their freewheeling sexuality, were also helping to reinterpret what it meant to be a sexually active woman in the music scene, as well as the roles of girlfriend, lover, wife, and whore. The activities of all of these women helped to establish gender roles as they exist in America today. It is imperative that what was said both by and about them during these years be addressed, especially in an academic format. Frankly, this perspective on women in rock will only be explored if a woman (or a feminist man) does the researching. As I shall explain further below, this matter of perspective is an integral one when approaching the study of American popular culture in the late 1960s and early 1970s.

This project also seeks to give a voice to a segment of the baby boom generation that has yet to be heard from. For too long, those of us who comprise the late baby boomer generation, roughly those born between 1958 and 1964, have allowed our generational "older brothers and sisters" to tell us what this era was all about. It is time for new perspectives on this time period based on archival research and textual analysis. More important, it is time for work from those whose analyses will not be clouded by personal involvement and the vicious partisan politics that characterized the era. For many of these people, the sixties are not over. I have no quarrel with this approach, but I find it beside the point as a scholar. I, along with most others in their late thirties and early forties, was too young to be on the barricades. This work is written from the point of view of people who remember the 1960s and 1970s but are not old enough to remember where they were when Kennedy was shot. We

were there, but like the proverbial "kid sister," have not yet been invited into conversations on the subject.

We of the late baby boom, however, were not the only ones excluded from many discussions on the popular culture of this era and its meanings. Before I began this project, it had always seemed to me that a rather dichotomous methodology was usually employed in discussions and analyses of the late 1960s and early 1970s. To those of the older generation and the political right, the actions of many during this era were an attempt by the forces of anarchy, immorality, atheism, and the artistic and intellectual elites to undermine and then destroy "traditional" values and lifestyles. To those of the younger generation and the political left, this era was an attempt to alter the consciousness of the nation (through means intellectual, artistic, and chemical) and promote a freer, more peaceful and communal society through the advocation of a profound change in the values of the nation. The more study I do on this era, the more I begin to question this analysis.

For one thing, the list of players narrows considerably when you begin to do archival or materials culture research on this era. For example, *Rolling Stone* has always been held up as one of the flagship of a new style of music journalism, the end result of which was supposedly a much more open and varied discussion of music and those who make it. I had never heard that the magazine treated women with any sort of enmity. Due to the fact that *Rolling Stone* is a youth music magazine from the late 1960s and 1970s, I expected to find some fairly unenlightened, pre-second wave feminism attitudes. But the level of misogyny toward women that I encountered in the magazine was a real surprise. This rather unpleasant picture is all we would be left with if not for two things: the existence of the artistic and cultural contributions that women rockers and journalists made during this era and the existence of the magazines themselves as cultural artifacts.

That *Rolling Stone* did make contributions to the journalistic branch of American popular culture is undeniable. But also undeniable is the fact that many of the writers and editors systematically belittled or ignored the contributions made by women musicians in the realm of popular music and culture during this era. Equally important are the methods they used to accomplish it. By relying on timeworn weapons from the sexist's arsenal, these men mounted a systematic assault on the women of this era. Far from expanding the dialogue and creating a new kind of journalism that was inclusive and progressive, the male writers at *Rolling Stone* wrote about women musicians much as their older generation, ideological "enemies" at the "mainstream" magazines did. Misogyny does indeed make strange bedfellows.

In light of all of the misogyny I encountered in the course of doing this

work, a good question to ask might be, Why study rock music, and especially women in the rock culture? I chose rock music because it conveys power, and being a woman in our society offers us precious little of that commodity. I wanted to do a study of powerful, talented, and artistic women who were influential in the American popular culture of the late 1960s and early 1970s.

How is rock music powerful? I can answer that in one word: volume. I can best illustrate this point through the employment of an object lesson. You walk into a club that has live music. Onstage is a female guitarist playing an acoustic instrument that is amplified only by the house sound system. She is good or maybe not so good. You might clap politely and be interested while the patrons at the table next to you may talk through her performance. Perhaps the whole club (including you) might talk over her performance. Whether she will be louder or softer is completely out of her hands as it is the soundperson who controls the volume level of her show. She has all the power and presence of a Rock-ola at moderate volume without the quarter slot.

Now you walk into another club. Onstage are some female performers playing electrified instruments and a full drum kit. The volume level is such that you cannot only hear the music, you can actually feel it pushing against you in the air. The sound is so loud it seems to have a physical presence rather than just an aural one. Patrons may (vainly) try to talk over the volume but end up shouting half-heard words in one another's ears. The performers control the volume level using their amplifiers and sticks. The patrons may show their displeasure with the performance only through the act of leaving the club, booing or withholding applause in between songs. The audience may dislike the performers owing to their volume level (or their usurpation of the traditionally male role of rock musician) but they may not ignore them or treat them like a jukebox with a pulse.

Performing music at a loud volume means different things to women than it does to men. As women we are (usually) told all our lives in subtle and not so subtle ways to be quiet in public, or at least more quiet than the men around us. For women to take center stage, literally, and draw attention to themselves through the employment of loud volume is thus a truly liberating act. As women, we are also warned, again subtly or not-so-subtly, against drawing attention to ourselves in public for reasons of personal safety. For us, as women, to "flaunt" ourselves on a stage in front of the public is often to open ourselves to the possibility of great personal risk. Volume, and the power it can seem to bestow upon those who wield it, can serve as a shield to deter those considering assaults on us as women who have forgotten our "place."

Another facet of volume is that which makes it possible, namely technology. Traditionally, women in our society are taught to fear technology or at the

very least to feel as if they have some physiologically based inability to harness and understand things technical. Technology is as traditionally a male preserve as is rock and roll. It is not surprising then that when the two are joined, women would be excluded from them. For a woman to decide to harness technology in the pursuit of artistic expression is as subversive as if she were to paste on a beard and dress in drag. Both acts seem to have much the same effect on male performers and audience members of both sexes. Many become angry or surprised; seldom do audiences react as if this behavior is "normal." Although thankfully this state of affairs is changing, it was a hard battle and the first women to play and sing rock were some of the first to challenge the music status quo. By challenging the patriarchal power structure in the music world, these women were also challenging it in the larger world.

At the end of this project I am left with one overwhelming impression of the women who were part of the rock subculture during these years: they were dynamite. They literally blew apart the world as they had found it, exploded it using music and words and sex. Every time their music makes me want to dance, or their words strike a responsive chord in my soul, I know that they are still dynamite and they make me proud of all women, and proud of myself for being one too. That is the source of both their power and our own.

Chapter 1
The Tenor of the Times

Starting in the mid-1960s, women rock musicians began to assert themselves like never before. Consider the year 1967, for example, a watershed year for American women in popular music. Grace Slick, backed by the Jefferson Airplane, had hits with "Somebody to Love" and "White Rabbit." Aretha Franklin began a remarkable string of successful records with her version of Otis Redding's "Respect." Country singer Bobbie Gentry had a surprising crossover smash with her mysterious ballad "Ode to Billy Joe." Singer Spanky McFarlane, backed by her band Our Gang, reached number one on the pop charts with "Sunday Will Never Be the Same." At the Monterey Pop Festival, Janis Joplin rewrote the rulebook for female singers with her rendition of "Ball and Chain" and scored a lucrative deal with Columbia Records in the process.

Not all of the women who experienced success that year were newcomers to the field. Dionne Warwick continued as the vocal interpreter for the songwriting team of Burt Bachrach and Hal David with "I Say a Little Prayer." Cher, with her husband Sonny Bono, scored big with "The Beat Goes On," and Nancy Sinatra, in a duet with her father, Frank, assured us that she was saying "Something Stupid." The Supremes had their tenth number-one song, the most by any female group up to that point, with "The Happening," the title song from the movie of the same name. Never in the history of popular music had so many women in so many different musical genres been so successful.

The timing of these women's success was not accidental. Powerful forces in the United States were radically transforming America, both ideologically and socially, in the decade between 1965 and 1975. Indeed, the America of 1965 bore scant resemblance to that of 1975. Due to this extreme cultural shift, I approach the history of the larger society in which the women addressed in this work lived as if it were in actuality two different cultures with almost entirely different rules and standards. Therefore, before any meaningful discussion of the female musicians, music critics, and fans can take place, a series of interconnected events in American cultural history that took place during these years must be understood.

Three topics most relevant to the earlier part of this book help to provide

a backdrop for the more specific rock music events that occurred during these years. These events are: the "sexual revolution" of the 1960s; the rise of second wave feminism; and the hippie counterculture. An understanding of these three subjects also helps to explain the rise of *Rolling Stone*, its approach to rock journalism, and the treatment of women within its pages.

The three topics most relevant to the later years of this work also provide a backdrop but, more important, they also exemplify the cultural changes that occurred during these years. These events are the Stonewall Riot, gay liberation in New York and its influence on new genres of popular music, especially disco, as well as its impact on gender roles in the rock subculture; the rise of disco music and its subculture, and the consequences for rock music; and changes in the drugs of choice favored by the counterculture and their effect on the music subculture.

Although I spend a great deal of time in this chapter describing aspects of the milieu that surrounded the women during these years, the focus of the majority of this work is, however, the women rockers, critics, and fans. Through their innovation, talent, and sheer guts, they transformed forever the roles of women, both in music and in America. Although they were forerunners and leaders, the women rockers were also being led by powerful forces that were changing the landscape of social relations in the United States. Much like a rip current, they pulled everything and everybody along, and sometimes under, in their wake.

* * *

Most people are familiar with the idea of the sexual revolution of the 1960s. The salient features of this revolution are a lessening of the sexual reticence that characterized America in the 1950s, a redefining of the sex roles of the two dominant genders, and an emphasis on the pleasurable aspects of sex, especially of the nonmonogamous variety. However, many scholars argue, especially feminists, that the sexual revolution of the 1960s produced mixed results for women in American society. As feminist theorist Lillian Robinson has often said, "The sexual revolution was neither." A sexual revolution may have occurred, but it barely put a dent in the double standard that prevailed in the sexual arena and hardly resulted in revolutionary changes in relations between the sexes. Even without these modest changes, women's entry into rock music in the mid- to late 1960s would have been different if it had occurred at all.

From the vantage point of the early twenty-first century, the sexual revolution appears to have been primarily concerned with boundaries. Many people during this era appeared especially concerned with prohibitions as they

related to expressions of sexuality, both public and private. I will focus almost exclusively on the public facets of these changes. Once most of the legal obstacles to the production and sale of explicitly sexual paraphernalia were lifted in the late 1960s, it was as if a floodgate had been opened. Many people, especially those in the arts or the political left, began to push the limits of the dialogue on sexual matters by exploring and discussing sexuality in public.

It should not be construed from the previous statement that only artists or political radicals engaged in an exploration of sexual boundaries. The sales figures for many books on human sexuality during these years, both "scientific" and those with fewer pretensions of didacticism, belie that. It should be remembered the same country that made best-sellers of Masters and Johnson's *Human Sexuality* and Jacqueline Susann's *Valley of the Dolls* also elevated Richard Nixon to the office of president of the United States in 1968.

As with many cultural revolutions, no clear consensus exists on what events mark the beginning of the sexual revolution of the 1960s. A precipitating factor was certainly the publication of Alfred Kinsey's groundbreaking studies on human sexuality—*Sexual Behavior in the Human Male*, which was published in 1948, and its companion study of female sexuality, *Sexual Behavior in the Human Female*, followed in 1953.[1] That these rather dryly written scientific treatises on the sexual behavior of more than eighteen thousand men and women became unanticipated best-sellers foreshadows the revolution in sexually explicit printed materials of the late 1960s. Almost a quarter of a million copies of *Sexual Behavior in the Human Male* were sold, and the book spent more than six months on the *New York Times* best-seller list. In 1953, when the companion volume on female sexuality was published, it too caused much furor in the publishing world.[2]

The major influence that these books had on the development of the sexual revolution of the 1960s was their encouragement of dialogue, both public and private, about the sexual activities of men and women. They provided the general public with data about sex that had been gathered in a scientific manner, and more important, this data established in a manner unassailable by moral crusaders that a lot more people than anyone suspected were "doing it" and in exotic ways. Kinsey's work made it plain that an enormous difference existed between socially acceptable sexual behavior and actual behavior.

Kinsey's prose was so scientific, and devoid of both prurience and moralizing, that it was difficult for conservative "watchdogs" to assail his work on the grounds that it was immoral. In his work he intimated that the social norms governing sexual behavior in America were in need of a revision. This reassessment was necessary if society's stated values were to reflect the actual sexual behavior of Americans, something structural-functional sociologists believed

was important for a proper social environment.[3] After Kinsey, it became not only more acceptable to talk about sexual activity in America, but those discussions had the weight of science behind them.

Another important factor influencing the sexual revolution of the 1960s was born in late 1953 with the publication of the first issue of Hugh Hefner's *Playboy* magazine. Unlike the Kinsey reports, this magazine was designed for and targeted at men alone. Its primary ethos, as the name *Playboy* implies, was sexual pleasure for men; its pages were filled with photographs of naked women so idealized that even their pubic hair was airbrushed out. The *Playboy* philosophy urged its male readers to avoid marriage and "enjoy the pleasures the female has to offer without becoming emotionally involved."[4] Hefner viewed marriage as a financial snare for men and urged all the aspiring "playboys" in America to spend their money on themselves instead of on marriage and children. This ethos made the magazine hugely popular not only with men, but also with the advertisers who wanted men's discretionary income.[5] By 1967, *Playboy's* subscription numbers approached 5 million, making it second only to *Reader's Digest* in the American mass market magazine business.[6]

In 1962, Helen Gurley Brown, in *Sex and the Single Girl*, urged women to explore the pleasurable aspects of sex. In this best-selling book Brown advised women to eschew marriage as long as possible, to concentrate on their careers, and to have sex with whatever men they chose.[7] Most important to women's efforts to claim sexual pleasure as privilege, Brown urged women to stop regarding sex before marriage as "shameful" or "dirty."[8] She parlayed her writing success into a movie deal and the editorship of the ailing Hearst magazine *Cosmopolitan*. After assuming its helm in 1965, Brown transformed *Cosmo* into a forum for discussions on women's sexuality, with lots of beauty and fashion advice as an enticement to advertising dollars.[9]

Another contributing factor to the 1960s sexual revolution, and what made Hefner's and Brown's messages both welcome and practical, was the development and marketing of the birth-control pill. The oral female contraceptive received FDA approval in 1960;[10] in heterosexual circles it was a watershed event. Two years later it was estimated that 1,187,000 women were using it.[11] The pill, like the diaphragm, however, allowed women control over their reproductive systems. Unlike the diaphragm, the pill allowed couples to remain spontaneous in their sexual passion.[12] It was also cheap, fairly effective, and not difficult to use.[13]

The pill was also a blow against the sexual double standard that mandated different approaches to sexuality for men and women based on reproductive repercussions. No longer did women need to avoid sex until marriage for fear of pregnancy. Instead, they could explore their sexuality and engage in intercourse

because it was pleasurable for them. This is not to say that power relations between the sexes in the area of sexuality were equalized; the double standard was still alive and well in most quarters. However, the consequences of having sex, both marital and nonmarital, had been lessened considerably for women with the creation of a birth-control method that was easily available and not dependent on the negotiation of its use with their partners.

Though these earlier events began the sexual paradigm shift in America, the pace of the sexual revolution quickened considerably between 1966 and 1969. Several events occurred in 1966 that exemplified this faster pace. One of the most influential was the publication on April 26, 1966, of *Human Sexual Response*, an in-depth study of the biology of human sexual response by William H. Masters and Virginia Johnson, better known as Masters and Johnson.[14] Originally associated with Washington University in St. Louis, by 1966 the researchers had established the Reproductive Biology Research Foundation to study sexuality.[15] With prose reminiscent of *The Kinsey Report, Human Sexual Response* was another unlikely best-seller, with the first printing selling out in a week, and eventually selling more than 300,000 copies.[16] The extent of American's desire to read about sex, even in hard-to-follow scientific language, was evidenced by the book's sales and the fame of the sexologists who wrote it.[17]

Another event that triggered the acceleration of the pace of the sexual revolution, especially in print media, was the 1966 legal appeal surrounding the publication of *Naked Lunch* in America. Written by William Burroughs, *Naked Lunch* is a dark, graphically sexual novel that included descriptions of necrophilia, homosexuality, and adultery.[18] A lower court in Massachusetts had ruled in 1965 that the book was obscene. Grove, its publisher, appealed the ruling, and the case progressed to the supreme court of Massachusetts. If precedence was any indicator, the publisher should not have expected to win this decision, since that same court had declared *Fanny Hill* obscene in 1965.[19] Yet on July 7, 1966, the justices ruled in a surprising decision that the book was not obscene, and American publishers no longer had to fear that "banned in Boston" would decide their ability to print whatever they wanted.[20]

The *Naked Lunch* decision signaled that the status quo in police-sponsored censorship of written materials was at an end for the foreseeable future. The effects of this decision were both immediate and profound. It was as if many Americans had been waiting for legal or official permission to read, write, and discuss printed works about sex. Some of these works represent artistic and intellectual experimentation in the field, while others are more correctly identified as masturbatory "one-handed reading," or titillating escapist fare.

One of the most successful of the latter books published in the aftermath of this ruling was Jacqueline Susann's *Valley of the Dolls* (1966), a fictionalized

account of the off-camera lives of several Hollywood stars.[21] It deals in a sexually explicit manner with lesbianism, anal sex, and adultery. One of the most successful books of the year, *Valley of the Dolls* again illustrated that Americans were ready to spend their money on sexually explicit books. *Valley of the Dolls* was brought to the screen as a major motion picture by Twentieth Century Fox in 1967—albeit in a much cleaner version.

One of the most popular of the more "highbrow" novels from this era was Robert Rimmer's *The Harrad Experiment.*[22] Published by mainstream Bantam Books in 1967, it was basically a work of sexual utopian literature, a fictionalized account of a sociology experiment at an eastern college that sought to inject more reason into humanity's sexual attitudes. However, this book was no *Walden Two*; its descriptions of the students' sexual experimentation are graphic and erotic. At the end of the novel, the students have liberated themselves from sexual repression and they move happily into successful group marriages, full of deep spiritual meaning and lots of group sex. Its strong sales made it one of the most popular novels of the late 1960s and early 1970s.[23] In the eighteen months following its publication, more than 2.5 million copies were sold.[24]

At times it must have seemed to Americans of this era that they were being buried under an avalanche of sexually explicit printed material. As the four works above demonstrate, the approach and the quality of the material varied greatly. However, by 1969 Americans were even ready to read about subjects considered taboo only a year or two before. This is evidenced by the success that year of Philip Roth's frank novel about male masturbation, *Portnoy's Complaint*, which reached the best-seller list by selling 418,000 copies in hardback; it stayed on the paperback best-seller list for five months.[25] In the novel, Alexander Portnoy recounts in great detail his masturbatory experiences to his psychoanalyst. Employing the literary technique of the first-person narrative, the novel's style made it seem as if it were autobiographical rather than fictional. With the popularity of this book, it appeared that Americans were ready to jettison even the old taboo of admitting that they engaged in erotic self-stimulation, or they were at least interested in reading about the practice.

This acceptance of greater frankness in the media was also evident in the soft-core pornography industry. *Playboy* had been the unchallenged "king" of this type of magazine in America since its inception in 1953. After conquering the publishing world, Hefner had set out to "pseudo-sexualize" the restaurant and nightclub business. In 1960, he opened the first of the Playboy Clubs, complete with their now infamous bunnies.[26] This members-only club signed up 50,000 would-be "playboys" by the end of 1961.[27] By 1964 five more clubs in America boasted a membership of 250,000.[28] By 1967 that number had risen to 450,000 and included clubs in London and Jamaica as well.[29] Like the magazine

Playboy, these were upscale venues that catered to well-heeled businessmen. With a "look-but-don't-touch" policy, the bunnies were not sex-workers in the legal sense of the word and perfectly matched *Playboy*'s sanitized approach to visual, soft-core porn.

By 1968 and 1969, not everyone was content with this reticence in explicit visual pornography. Among the dissatisfied were a New Yorker named Al Goldstein and an American expatriate living in London named Bob Guccione, who both launched sexually explicit magazines that had a enormous influence on the print media porn business. On November 3, 1968, Goldstein and partner Jim Buckley began publishing an X-rated newspaper they called *Screw*.[30] The language and pictures in *Screw* were very graphic and often deliberately provocative, a departure from the approach of *Playboy*. It called sexual intercourse fucking, for example, and printed pictures of people actually engaged in coitus. Additionally, Goldstein reviewed pornographic films using a scale called "The Peter Meter," rating porn films based on how large and how long (in duration) an erection he had while viewing them. Needless to say, *Playboy* it was not.

Guccione's approach was smoother than Goldstein's, and with it he aimed to topple Hefner from his position as king of soft-core porn in America. In 1965, while living in England, he had launched a soft-core porn magazine called *Penthouse*, aimed at male readers.[31] With its first issue *Penthouse* overtook *Playboy* as the leading soft-core porn magazine in Great Britain.[32] Guccione created wildly popular "innovations" within the industry as well, such as *Penthouse*'s "Forum." In this section, readers wrote into the magazine and shared their sexual escapades, fantasies, and problems with other readers. By 1969, Guccione took on Hefner in his own backyard by launching an American edition of *Penthouse*.[33] In April 1970, Guccione introduced another innovation to commercial soft-core pornographic photography by showing a woman's pubic hair.[34] The success of this move was evident in December when *Playboy* too began showing women's pubic hair in its photo layouts.[35] By 1978, *Penthouse* not only outsold *Playboy*, but had also become the third most profitable magazine in history.[36]

However, by the late 1960s, soft-core pornography was not the only variety available to Americans. The Danish government decriminalized hard-core pornography in 1969, causing tremendous changes in the availability of the hard-core pornography in the United States.[37] In the same year, the Swedish adult film "I Am Curious (Yellow)" began playing in America. Though initially seized by customs officials, this film played to large crowds in many mainstream American theaters in 1969.[38] Apparently not all Americans were pleased by this turn of events, as is evidenced by the fact that one theater showing it in Houston, Texas, was the victim of arson on June 6, 1969.[39]

The Danes were not the only government to alter its laws to allow its citizens access to pornography. In 1969, the United States Supreme Court handed down a landmark ruling in the case *Stanley v. Georgia*. During a raid, Atlanta police had seized some rolls of 8mm film, which upon viewing were found to be hard-core pornography. Subsequently, Robert Stanley was tried and received a year in jail. In his majority opinion, Justice Thurgood Marshall stated that US citizens had the right to possess materials of a sexual nature in their own homes and that the police had no business seizing Stanley's property. This ruling struck a strong blow for civil liberties in America, and it also gave legal protection to professional pornographers who were soon thriving financially.[40]

Various groups alternately hailed and decried all these rapid changes in the public expression and discussion of sex in America. One *Newsweek* author captured the controversy in his introduction to a 1967 article on the new sexual mores:

The old taboos are dead and dying. A new more permissive society is taking shape. Its outlines are etched most prominently in the arts—in the increasing nudity and frankness of today's films, in blunt, often obscene language seemingly endemic in American novels and plays, in the candid lyrics of pop songs and the undress of the avant-garde ballet, in erotic art and television talk show, in freer fashions and franker advertising. And, behind this expanding permissiveness in the arts stands a society that has lost its consensus on such critical issues as premarital sex and clerical celibacy, marriage, birth control and sex education; a society that cannot agree on standards of conduct, language and manners, on what can be seen and heard.[41]

Though many lamented the loss of a "center" in American culture, many others, especially among the young, were celebrating these events. Paramount among those celebrants were the radical feminists.

Much like women musicians, feminists were also trying to alter women's roles in American society during this era. As one historian had described it, social pressure on women to marry in the early 1960s was "relentless."[42] That this pressure was largely successful is borne out in the statistics on marriage from those years: twenty was the average age for matrimony, the lowest since the nineteenth century, and almost three-quarters of women were married before age twenty-four.[43] For women who worked outside the home the situation was bleak. For example, in 1960, women employed full-time and year-round earned sixty percent of what men earned, and women college graduates were paid less than men who had only completed high school. What is worse, the pay gap between men and women had widened since 1945. The need for a pressure group to address the situation of women in America was both real and growing.

Rather than presenting a single front against such social pressures, second

wave feminism during the late 1960s and early 1970s contained at least two separate feminist movements, liberal or cultural feminism and radical feminism.[44] Chronologically, liberal feminism came first. A benchmark of the beginning of Second Wave feminism is the publication of Betty Friedan's *The Feminine Mystique* in 1963.[45] Friedan described the effects of a life of compulsory marriage and motherhood on middle-class white women in America during the 1950s and early 1960s. She also discussed the dissatisfaction that many women felt in those roles and indicated that this dissatisfaction was not discussed in any forum or in any meaningful way: "the problem that has no name." Freidan's book not only highlighted the problem but also alleviated the guilt that many women felt about their unhappiness with their lives. Many women responded enthusiastically, the book became a best seller, and Friedan's name became well known in America.

In 1964, women's issues also received some help from the federal government as a result of the passage of the Civil Rights Bill. With this bill, Congress prohibited sex discrimination by employers and created the Equal Employment Opportunity Commission (EEOC) to oversee violations of the law.[46] Women of this era could base their claims for the right to wage-equity protection on Title VII of this bill.[47] However, Davis makes a compelling case that the commissioners assigned to address violations of Title VII were less than responsive to women's complaints and that their actions appeared to be only "lip service."[48]

In 1966, Friedan and several politically savvy women involved in politics in Washington, DC, formed the National Organization for Women (NOW). A short list of some of NOW's early members reveals that this was no grass roots organization of amateurs unfamiliar with politics and business. In addition to Friedan, the membership included Marguerite Rawalt, an attorney and former member of John F. Kennedy's Presidential Commission on the Status of Women; Kathryn Clarenbach, an academic who had chaired the Wisconsin Status-of-Women Commission; Caroline Davis, director of the Women's Department of the United Auto Workers; and Richard Graham and Aileen Hernandez, both former EEOC commissioners.[49]

NOW's Statement of Purpose, emphatically declared that the organization would attempt to reform the political order on behalf of women by working from within the system. Its language, replete with calls for "true equality" and "equal partnership of the sexes," indicated that NOW wanted to integrate women into the political and economic systems as they existed.[50] NOW did not seek to assign blame for the status quo. NOW's Statement of Purpose promised that its members would seek equality and freedom for women without "enmity toward men, who are also victims of the current half-equality between the sexes."

The women and men of NOW were not the only people in America inter-
ested in improving the lot of women. Others, especially those on the left and
the young, and many from the ranks of the civil rights movement and the New
Left, were dissatisfied with the state of women's lives in America.[51] Idealistic
young women became involved in the civil rights movement only to find them-
selves "ghettoized" within those organizations into jobs that were traditionally
female. One of the earliest articulations of women's dissatisfaction with the
status quo vis-à-vis women in the civil rights movement was "A Kind of Memo
from Casey Hayden and Mary King to a Number of Other Women in the Peace
and Freedom Movements."[52] The two authors were part of a group of white
activists who had gone to the South to work for civil rights. In the memo they
described women as belonging to a "sex-caste," outlining their oppression as
well as comparing women's lot to that of African Americans. This discussion
was effectively ended by the rise of the Black Power movement in 1966, which
curtailed the involvement of white youth in the civil rights movement.

Young women involved in New Left organizations also found their con-
tributions minimized by male sexism. After 1966, a combination of the forced
retreat of white activists from the civil rights movement and the escalation of
the Vietnam War pushed antiwar activities to the top of many agendas of New
Left organizations.[53] The status of women in New Left organizations had never
been on an equal footing with that of men, and the emphasis on antiwar activ-
ities by many of these groups further marginalized women. Women could not
resist the draft nor burn their draft cards; they were reduced to being Leftist
pseudo-cheerleaders for the men's direct action events. Or worse, they could
act as sexual helpmeets for the men in the movement: an antiwar poster pop-
ular at the time stated, "Girls Say Yes to Guys Who Say No."[54]

The situation of women in Students for a Democratic Society (SDS) offers
a good example of their condition in other New Left groups.[55] Though the prob-
lem was discussed by the Leftist groups popular with young, white, middle-
class people in America during the period, by 1967 the status of women in the
SDS was deteriorating. Sara Evans attributes some of this erosion to the pene-
tration of the idea of "free love," popular in the counterculture, into the move-
ment.[56] Despite this, female members of SDS did not initially give up on the
organization, choosing instead, much like the women of NOW, to work within
its organizational structure to improve their lot.[57] After having their efforts
rebuffed time and again by the male SDS leadership, several women members
led by Shulamith Firestone drafted a resolution on the need for women's liber-
ation to be read at the 1967 annual conference. William Pepper, the chair, re-
fused to read it to the assembled membership.

However, it was Pepper's extemporaneous remarks that galvanized the

women's resolve to organize. After refusing to read the resolution, Pepper reportedly patted Firestone on the head and said, "Move along, little girl; we have more important issues to talk about here than women's liberation."[58] The SDS women who had written and sponsored the resolution met the next week in Chicago and formed the first radical feminist group in America. Later that year, the group published a manifesto, "To the Women in the Left," in which they described an organizational approach for a women's liberation movement modeled after that of the Black Power movement.[59]

Firestone remained a central figure in radical feminism in America for the next five years. Born in Ottawa, Canada, during World War II, she grew up in the Midwest and attended Yavneh Telshe Yeshiva, Washington University, and the Art Institute of Chicago, from which she received a B.F.A. in painting.[60] In late 1967 Firestone moved to New York City and helped to found the first radical feminist group in that city, New York Radical Women.[61] After its demise in early 1969, members of this group went on to found several other influential radical feminist groups, mostly in the New York City area. In 1970, Firestone published one of the most influential books in radical feminist history, *The Dialectic of Sex: The Case for a Feminist Revolution*.[62] A work of theoretical complexity, it exhibits her fluency in theories as diverse as those of Marx, Freud, and de Beauvoir. Kate Millett's *Sexual Politics*, also published in 1970, and *The Dialectic of Sex* demonstrated that the radical branch of feminism could count theoreticians of considerable depth among its members. Second wave feminism's philosophical underpinnings were derived largely from the ranks of the radical feminists.

After they joined their own feminist groups, many of the radicals began to distance themselves from the mainstream organizations of the New Left. Events at a direct action in Washington, D.C., in January 1969 considerably hastened the complete break. Dubbing it the Counter Inaugural Protest, a coalition of Leftist and antiwar groups sponsored the action to protest the Vietnam War and President Nixon's inauguration. Characterized by Echols as "traumatic" for almost all the radical feminists involved, the women found virtually no allies for their cause at the protest.[63] As part of the larger protest rally, the radical feminists planned to "give back the vote" in order to draw attention to the fact that giving women the franchise had not erased inequalities between men and women. The radical feminists also wanted to demonstrate that first wave-style "suffragism" was over and that the real feminist revolution was only beginning. Radical feminist groups from New York, Boston, Chicago, and Washington, D.C., had agreed to take part in the action.

Even though the largely male Leftist organizers' treatment of the feminists was problematic, the organizers believed it politic to at least pay lip service to

the cause of women's liberation. The crowd, however, was openly hostile. The women had planned to gather onstage at the rally and deliver a speech declaring their intentions. When the first speaker began to talk, some men in the crowd began to chant "Take it off" and "Take her off the stage and fuck her." This sort of hostility from men who were supposedly among the most progressive in America shocked and traumatized the women who had staged the action. About their reaction Echols quoted radical feminist Ellen Willis as saying, "If radical men can be so easily provoked into acting like rednecks, what can we expect from others?"[64]

Firestone's and Willis's actions after they returned to New York City made it clear that they were not giving up and that the ordeal had only intensified their commitment to women's liberation. In February 1969, Willis wrote an article, "Women and the Left," published that month in the *Guardian*, which established definitively that the radical feminist movement must operate independently of the Left. "We have come to see women's liberation as an independent revolutionary movement, potentially representing half the population. We intend to make our own analysis of the system and put our interests first, whether or not it is convenient for the (male-dominated) Left."[65] The rhetoric of the article was equally straightforward in its assessment of the position of women in America with respect to men: "Women are the only oppressed people whose biological, emotional and social life is totally bound to that of the oppressors."

The strategies that the article put forward to rectify these inequalities were, not unexpectedly, radical toward men and conciliatory toward women. In discussing the role that violence should play in the movement to liberate women, Willis admitted that women were at a disadvantage to men in this area due to sexual dimorphism and social conditioning. However, she ended her discussion of the use of violence by women in the liberation movement by stating that, "On the other hand, we must realize that one reason men don't take us seriously is that they are not physically afraid of us."

Willis's tone was conciliatory toward women, and perhaps reflected the radical feminists' desire for a larger pool from which to draw their membership. I believe that it also reflects the fact that Willis was not drawn from the ranks of the radical left. "But we should have the humility to realize that women who have never been committed to a male-oriented radical analysis may have clearer perspectives than we."

Despite her criticism of men, Willis did not name them as the real "enemies" of women; instead, she identified structural elements of society as the main source of the oppression of women. "Our demand for freedom involves not only the overthrow of capitalism but the destruction of the patriarchal

family." However, male supremacy perpetuated both of these systems. Thus, though radical feminists had equated the personal and the political, only a revolutionary change in the framework of society, on both the macro and the micro levels, could effect real change.

That same month Firestone and Willis founded Redstockings. Echols asserted that the group left its mark on the radical feminist movement by popularizing consciousness-raising, inventing the speak-out, and radicalizing thousands of women through the free distribution of movement literature.[66] Along with organizations like Boston's Cell 16, New York's the Feminists and the New York Radical Feminists, Redstockings was a breeding ground for radical feminist thought and action in America in the late 1960s and early 1970s. Unlike their more moderate sisters in organizations like NOW and the Women's Equity Action League (WEAL), the radical feminists sought a complete restructuring of American society to facilitate more equitable relations between the sexes. While liberal feminists sought equality for women in the system as it existed, radical feminists sought equality in a just world. The proposed scope of the radical feminists' efforts was truly breathtaking. Redstockings continued to function as an organization until the fall of 1970, when internal battles over such issues as separatism, the role of consciousness-raising, elitism, and expansion finally dispirited its members.[67]

One weapon that radical feminists used in their attempts to dismantle "the master's house" was female sexuality, capitalizing on the study of human sexuality by Kinsey and Masters and Johnson. The latter had established that the clitoris is the female organ responsible for orgasm. Radical feminists took this scientific knowledge and applied it to their analyses of relations between the sexes, resulting in several articles on the primacy of the clitoris in female sexuality.[68] These articles were not only concerned with sexual pleasure for women, but they also attempted to use this knowledge to radically alter the sexual habits of humans.

Paramount among these articles was Anne Koedt's "The Myth of the Vaginal Orgasm," originally printed in the radical feminist magazine *Notes from the Second Year*, which attacked the mythical vaginal orgasm and explained how it functioned in support of the patriarchy. Koedt successfully connected the then ubiquitous concept of female frigidity to the construction of the vaginal orgasm by the largely male medical establishment. Focusing on Sigmund Freud, Koedt explained that male doctors had created this mythical type of orgasm without any scientific evidence to support their claims. This fallacy was to serve as a basis for their assertions that women were sexually and psychologically dysfunctional.

Koedt also explained how vaginal sex is pleasurable for men, without taking

into consideration any concern for the female partner's orgasm. She commented on the fact that the "missionary" position, commonly described as standard, did not usually result in female orgasm due to a lack of stimulation of the clitoris, and called for a re-evaluation of the idea of "standard" sexual practices. Koedt stated that this lack of concern for women's sexual pleasure and needs was a reflection of the fact that men did not view women as individuals with their own desires and identities in any area of their lives. Thus, she believed that a reformation of ideas of female sexuality, indeed human sexuality, must be accompanied by analogous changes in society as a whole.

Unlike the liberal feminists who balanced their calls for equal rights for women with the clear message that men were not to blame for the status quo, Koedt and the radical feminists stated that the purpose of the myth of the vaginal orgasm in particular, and sexism in general, was to oppress women: "The essence of male chauvinism is not the practical, economic services women supply. It is the psychological superiority. This kind of negative definition of self, rather than positive definitions based upon one's own achievements and developments, has of course chained the victim and the oppressor both. But by far the most brutalized of the two is the victim."[69] This conclusion, along with the fact that coitus is not essential to female orgasm, led Koedt to describe men as "sexually expendable" and attributed women's decision to have exclusively male sexual partners to "primarily psychological reasons." "Lesbian sexuality could make an excellent case, based upon anatomical data, for the extinction of the male organ. Albert Ellis [author of the sex manual *Sex Without Guilt*] says something to the effect that a man without a penis can make a woman an excellent lover." She went on to state that the establishment of the primacy of the clitoral orgasm "as fact would threaten the heterosexual *institution*" (italics in the original).

Thus, Koedt not only asserted that sexual relations affected power relations between the sexes generally, but also reflected other uses to which the patriarchy had harnessed female sexuality. One of the most damaging of these was the widely held idea, supported by both church and state, that nonreproductive female sex must be punished, or at the very least discouraged. This idea was reflected in the difficulty that women had securing safe, legal abortions, the problems unmarried women in some areas had in finding birth control, and the sexual double standard itself.[70]

Until the adaptation of the clitoris as the cornerstone of radical feminist sexual politics, the subject of female homosexuality was conspicuous in its absence in the women's liberation movement. Firestone and Millett both discussed lesbianism, if in a rather abstract and oblique way, in their books. According to Echols, some feminists, including the members of the radical

feminist group Cell 16, argued that celibacy was the only way for women to end their oppression, while other groups saw lesbianism as primarily a sexual, as opposed to a political, movement and thus superfluous to the concerns of women's liberation. Indeed some radical feminists were prejudiced against the butch-femme role-playing that was common in the lesbian community, especially among working-class women.[71] However, as the radical feminist movement's analysis of sex progressed in early 1970, many women began to view lesbianism as a viable choice for themselves personally and the radical feminist movement in general. Yet, the movement as a whole remained divided on the subject.

Liberal feminists were completely opposed to lesbianism and any discussion of it in the women's movement. Friedan referred to it as a "lavender menace." In 1969 the NOW leadership even left out the lesbian pressure group the Daughters of Bilitis (DOB) from a press release naming the institutional sponsors of the Congress to Unite Women, sponsored by the New York NOW chapter.[72] NOW may have had no place for lesbians, but quite unknowingly they had nursed a "viper" to their collective "breasts" in the form of Rita Mae Brown, who had been editor of the New York NOW Chapter's newsletter. Shortly after the DOB slight, Brown was unaccountably fired from that position. She was furious, resigned from NOW, and took two other lesbians with her. Brown soon began networking with other lesbian feminists and traveled to various feminist meetings over the next few months where she raised the issue of the role of lesbianism in the Women's Liberation Movement. On May 1, 1970, Brown and several other lesbians disrupted the second Congress to Unite Women with a direct action protest they dubbed "the Lavender Menace."[73]

The schisms over issues like separatism, lesbianism, elitism, and soon racism and classism tore the radical feminist movement apart by the early 1970s. Many of the movement's original leadership were "decapitated" during the struggles over these issues and some of its founders withdrew from the movement when feminism was equated with lesbianism.[74] The women who flooded into the radical feminist organizations saw the groups more as vehicles for self-improvement as opposed to radical social reconstruction. It appeared that radical feminism was halted, at least in some measure, by its own conceptual shortcomings. That they were unable to rebuild the world order in such a short period of time with such meager resources is not surprising. That they were able to alter the ideas about the relationship between men and women in American society in such profound ways, however, is.

Second wave feminism in all its manifestations also began to make its mark on the wider popular culture in the early 1970s, especially with the founding of *Ms.* magazine. Yet differences between the first two founding

editors of the magazine demonstrate two schools of thought behind its creation. Pat Carbin came from the world of high-powered publishing and was an editor from *McCall's*, while Gloria Steinem was a journalist and professional public speaker who was deeply involved in the liberal feminist movement in New York. First issued as an insert in *New York* magazine in December 1971, *Ms.* published its first stand-alone issue in July 1972.[75] The magazine not only gave feminists a national forum for their writings and ideas, but also gave them positive visibility and empowerment. Its influence on the American liberal feminist movement of the 1970s was incalculably great.

Through efforts as disparate as the lobbying of elected officials and the formation of neighborhood consciousness-raising groups to the publication of *Ms.* magazine, feminists of all stripes caused women's issues to loom large in American society during the late 1960s and early 1970s. Though they had different approaches and ideologies, all sought to expand the possibilities available to women in this country. That Ellen Willis, the most cogently inclusive voice in American rock journalism of the 1960s and early 1970s, came from their ranks is further evidence of the success of their movement.

However, the radical feminists were not alone in their disillusionment with the American approach to life and love. Other Americans also rejected traditional values as well as the new "swinging singles" approach to life typified by *Playboy* and *Cosmopolitan*. Known as hippies, these members of the counterculture were mostly young people who had no interest in taking part in the consumer society their parents offered them, a society built around ideas of hard work, deferred gratification, and conformity. Drawn largely from the ranks of the white middle class, the hippies so totally rejected American society that they were referred to in one *Time* article as "expatriates living on our shores but beyond our society" and as "internal emigres."[76] Although their ranks were not homogenous, some merely adopted the trappings of the movement without assuming its philosophical underpinnings. Most of the early hippies, however, were true believers who were trying to overthrow "the system" through love, peace, and an expansion of human consciousness.

Regardless of whether they were hustlers or true believers, the hippies had a profound effect on the more conservative American society they were trying to escape. A *Time* writer commented in 1967: "Perhaps the most striking thing about the hippie phenomenon is the way it has touched the imagination of the 'straight' society that gave it birth. Hippie slang has already entered common usage and spiced American humor. Department stores and boutiques have blossomed out in 'psychedelic' colors and designs that resemble animated art nouveau. Uptown discotheques feature hippie bands. From jukeboxes and transistors across the nation pulses the turned on sound of acid-rock groups."[77]

Some people at the time saw the movement as far more influential than merely fodder for the fashion industry. In the article quoted above, one theologian saw the hippies as profound social critics: "'They reveal,' says University of Chicago Theologian Dr. Martin E. Marty, 'the exhaustion of a tradition: Western, production-directed, problem-solving, goal-oriented and compulsive in its way of thinking.' Marty refuses to put the hippies down as just another wave of 'creative misfits,' [and] sees them rather as spiritually motivated crusaders striking at the values of straight society where it is most vulnerable: its lack of soul."[78]

Regardless of what one thought about the hippies and their culture, the Haight-Ashbury neighborhood of San Francisco was depicted as the epicenter of the hippie counter cultural movement. Alice Echols, in her biography of Janis Joplin, *Scars of Sweet Paradise*, describes the conditions that led to that neighborhood's development as "hippie central": "Many factors converged to create the Haight and the hippie counter-culture, not the least of them drugs and rock 'n' roll, but the shift couldn't have happened on the scale it did had white America not been at that moment extraordinarily affluent. While white sixties rebels were rejecting what the playwright Arthur Miller called 'a system pouring its junk over everybody maroon[ing] each individual on his little island of commodities,' their revolt was subsidized and underwritten by America's unprecedented prosperity. In the Haight virtually everything, including the space, was surplus."[79] This extra space also allowed young entrepreneurs who wanted to cater to the hippie community in the Haight to afford the rental fees on large theaters and ballrooms where they began to hold rock-and-roll shows. The Avalon Ballroom and the Fillmore West, prototypes for the hippie rock-and-roll ballroom venue, were both located there.

Underlying all of this affluence were the sheer numbers of young people in America during the 1960s and 1970s. The baby boomers were the largest cohort of people in American history. By the mid-1960s, between 22 and 30 million people in America were between the ages of sixteen and twenty-two, with an estimated spending of $12 billion to $15 billion a year.[80] Not all, but many of these young people embraced the message of the counterculture.

In retrospect, the entrepreneurs in the counterculture were the wave of the future for the hippie movement. Few people could, or wanted to be, real hippies. Many of the hippies' philosophical underpinnings were based on a renouncing of possessions and the desire for them, mixed with large doses of Eastern-style meditation, while the white middle-class baby boomers who populated the movement had been raised to be good consumers and old habits die hard. Most people in the counterculture liked the clothes, the sex, the drugs and the music much more than the philosophy. For every real hippie, countless

more were weekend or summer hippies. These part-time hippies had money to spend on hippie paraphernalia, concert tickets, and albums. Hippie music became big business. In 1967, bands like the Jefferson Airplane put songs in the top ten by playing San Francisco-style rock music. As Robert Draper says in his history of *Rolling Stone*, "Local poster artists were now designing album covers; new clubs recruited light-show masters. Doing what they did best, some hippies were getting rich."[81]

The pivotal event that brought the San Francisco hippie rock music movement to national attention was the Monterey Pop Festival. *Time* estimated that this festival, which was held in June 1967 in Monterey, California, had an attendance of more than 50,000.[82] According to *Newsweek*, more than thirty acts, which included almost all the big names in rock music in both America and Britain, played the concert without payment.[83] Although many were well known, like the Mamas and the Papas, Simon and Garfunkel, and Jefferson Airplane, others were receiving wide exposure for the first time. These acts included Big Brother and the Holding Company, which featured Janis Joplin (who by all accounts stole the show), the Who, the Jimi Hendrix Experience, and Otis Redding backed by Booker T and the MG's.

The profits from the festival, which totaled more than $430,000 from ticket sales and the sale of television rights, made the music establishment and the younger "hip" entrepreneurs sit up and take notice of Monterey.[84] Additionally, the major record labels eager to add new blood to their stable of artists courted the new artists who had received exposure at Monterey. Columbia Records President Clive Davis had flown in from New York to attend the concert, and Davis signed Big Brother and the Holding Company to a record deal after seeing them perform.[85]

However, as rock historians Steve Chapple and Reebee Garofalo point out in their book *Rock'n'Roll Is Here to Pay*, the major labels all had different approaches to this new style of music called rock. Many record companies were unable to recognize which groups were worth signing; for this reason most would sign a few bands while agreeing with independent producers to supply them with other artists. Warner Brothers purposefully cultivated a reputation as "an artist's label" by allowing their artists more time to develop than did most other labels. Columbia used its deep pockets and large organization to acquire some of the best of the new artists: Joplin, Bob Dylan, Simon and Garfunkel, the Byrds, and Santana. RCA had the Jefferson Airplane and a successful track record with "bubble-gum" bands like the Monkees and the Archies. Capitol, with both the Beatles and the Beach Boys, could easily afford not to sign many other bands. MGM adopted a puzzling approach to the marketing and treatment of its artists, which included some very progressive acts

like Laura Nyro, the Velvet Underground, and the Mothers of Invention. MGM's approach was to sign the bands and then alienate them.[86]

The rise of the genre of counter cultural rock was not simply a case of new faces doing business the same old way. This change is evident in the fact that even the primary products being sold by these companies, formerly single 45-rpm records backed by a throwaway B-side (which were also the backbone of music radio) were instead albums during these years. This change was due largely to the fact that the creative bent inherent in rock music caused the artists to shift from making singles as their primary product to making albums, causing a ripple effect throughout the music business. According to Chapple and Garofalo, several reasons accounted for the preeminence of the album at this point in time. The era's affluence contributed to the development, as did a change in the method of doing business by the men who supplied albums to stores. Their decision was based on the bottom line. The margin of profit was greater with albums; they were also less fragile and were only slightly more expensive to distribute. As such, 80 percent of all record-sales dollars would be from albums by 1969.[87]

Though these record labels had signed contracts with the bands of the counter cultural rock movement, most times they had no idea what to do with them. The record company employees, especially the staff producers, had no clue how to record these artists' music to its best advantage, which led to the rise of the independent producer. Before the advent of rock music, most popular artists had not written their own material and relied heavily on either the staff producer or an artists and repertoire (A&R) person to connect them with a publisher who would then provide them with material.[88] However, most of these new rock groups wrote their own material and often stipulated in their contracts with which producers they wanted to work. This arrangement became industry standard by the end of the 1960s, when independent producers were producing 80 percent of all records being made.[89]

The rise of rock music also profoundly changed radio, especially on the FM band. FM radio had been developed after AM and had not been as commercially exploited.[90] One of the people who changed this was programmer, record producer, and disc jockey Tom Donohue, who became convinced that Top 40 AM radio no longer reflected the music being produced.[91] His formula to effect this change and develop FM radio was simple. Hire people who like music, are plugged in to the same scene as the young listeners, and let them play whatever they wanted. He tried out his ideas at KMPX, a San Francisco radio station that became the prototype for the "underground" FM station of the late 1960s and early 1970s. His ideas were successful and this movement swept American FM radio in the late 1960s.[92]

Three major factors were responsible for the success of this radio revolution. First, FM sound quality was far superior to that of AM radio. Not only was FM's fidelity of sound higher for single signal transmission, but it could also broadcast two separate signals at the same time in a process called "multiplexing." This discovery eventually led to the stereo musical broadcast.[93] Rock music producers utilized cutting-edge recording technology and stereo records became industry standard by the end of the 1960s.

Second, rock music fans soon discovered the exhilarating effect created by listening to rock music on state-of-the-art stereo systems. This sensation was exaggerated for those listening while under the influence of marijuana or LSD. In fact many artists recorded with this type of "altered" audience in mind. These audiences also came to expect the same quality of reproduction from the radio stations that were broadcasting this music. FM, with its higher fidelity and lack of static, could deliver a broadcast of quality near to that of the actual record.

Third, FM was also a relatively cheap medium for investors compared with television or AM radio. The reasons for this difference were varied. In the late 1940s, the Federal Communications Commission and the major radio networks had actively discouraged investment in FM radio. FM radio receivers' parts also cost more than those of AM radio, and the more lucrative and well-established AM market was harder to break into. Some younger venture capitalists who were looking to make a business out of the counterculture during the late 1960s realized an opportunity and invested heavily in FM radio. Not unlike the young capitalists who were opening rock-and-roll ballrooms and starting underground newspapers, these men realized that FM radio was a way for them to make a lot of money in a hip and cool industry.[94]

Due to the changes I have discussed above, and countless lesser ones not addressed in this work, rock music rose to preeminence in the recording business in the late 1960s. Beginning in 1968, rock music became the most lucrative of all of all the music genres for record retailers. The statistics on the number of gold albums broken down by genre for the years 1968–1972 explains economically why rock music became the "favored son" of record retailers. A gold album signifies $1 million in sales, and in 1968 their numbers were spread out relatively even between contemporary, easy listening, and all other types of albums, at 36 percent, 33 percent, and 31 percent, respectively.[95] By 1972, those figures had changed radically, with contemporary records accounting for 76 percent of all gold records, while easy listening and all other types of records made up only 4 percent and 20 percent, respectively. By 1973, record and tape sales combined topped $2 billion, with rock recordings leading the way.[96]

The rise of rock music and the restructuring it caused in the music business

wrought significant changes in the entertainment industry as a whole. Traditional methods of creating recordings were discarded for many reasons, some based on aesthetic considerations, while others were caused by technological developments. However, as is usually the case in the American entertainment industry, business considerations headed the list of reasons that the powers that be in the record business encouraged rock music's development.

The late 1960s and early 1970s saw different kinds of cultural shifts than had occurred just a few years earlier. The identity politics that had been pioneered by the African American community in the civil rights movement spawned other efforts for self-determination and liberty. Elements of the Latino, Native American, and Asian communities advocated for more rights and privileges. The feminists were another such group, while others who had dissatisfactions with gender politics also surfaced. Paramount among this latter group was those who advocated for homosexual rights, which also included members from many racial and ethnic communities. Employing the lessons learned on other battlefields, many of their fights would be waged in the realm of cultural politics.

The gay liberation movement in America measures its beginnings from riot that happened in a New York City gay bar in 1969. The bar was the Stonewall Inn located at 57 Christopher Street and the date of the riot was June 27, 1969. From this beginning sprang a movement dedicated to securing human rights for homosexuals in America. Few at the time could have foreseen how profoundly these efforts, and the people who took part in them, would transform the American cultural landscape in the 1970s and beyond.

The raiding of urban gay bars was an old practice. However, the raid on the Stonewall Inn that night in June proved to be anything but routine. John D'Emilio, in his book *Sexual Politics, Sexual Communities: The Making of a Homosexual Minority in America, 1940–1970*, provides good account of the circumstances that led up to the raid that night:

On Friday, June 27, 1969, shortly before midnight, two detectives from Manhattan's Sixth Precinct set off with a few other officers to raid the Stonewall Inn, a gay bar on Christopher Street in the heart of Greenwich Village. They must have been expecting a routine raid. New York was in the midst of a mayoral campaign—always a bad time for the city's homosexuals—and John Lindsay, the incumbent who had recently lost his party's primary, had reason to agree to a police cleanup. Moreover, a few weeks earlier the Sixth Precinct had received a new commanding officer who marked his entry into the position by initiating a series of raids on gay bars. The Stonewall Inn was an especially inviting target. Operating without a liquor license, reputed to have ties with organized crime, and offering scantily clad go-go boys as entertainment, it brought an "unruly" element to Sheridan Square, a busy Village intersection. Patrons of the

Stonewall tended to be young and nonwhite. Many were drag queens, and many came from the burgeoning getto of runaways living across town in the East Village.[97]

According to an account in the *Village Voice*, at first all went routinely. The police entered the bar, confined the patrons inside, and then began releasing them one by one out onto the street. The atmosphere was one of street theater until the appearance of the paddy wagon, when the crowd's mood became uglier. The bar's employees and three transvestites in full drag were loaded into the police vehicle and taken away. The next patron who was taken out was a lesbian who put up a struggle. At the sight of this, the crowd began throwing things at the cops and succeeded in driving all the police into the bar. The objects became bigger, and included a parking meter and cobblestones, and the crowd succeeded in setting a small fire in the window of the bar. The police then turned a fire hose on the crowd and succeeded in driving them back. At that point police reinforcements arrived and cleared the street.[98]

The Stonewall riot marked the beginning of more forceful, and visible, protests for homosexual rights, a fact that is clear by the amount of press coverage the raid received.[99] However, Susan Stryker, director of the GLBT Historical Society, asserts that "the event might not be remembered in quite the same way had it not been for the commemorative march and rally organized a year later."[100] Stryker asserts that the younger militant homosexuals who had been involved in various human rights movements in the 1960s possessed "media savvy and organizing skills" and were able to turn the Stonewall riot into a symbol of liberation for homosexuals. Marches, which drew thousands of people, were held in 1970 in several cities on the anniversary of the police raid.[101]

One of the aims of these young militant homosexuals was to expand the possibility of gender and gender roles. To that end, many in the movement, and the homosexual community in general, adopted a more androgynous appearance. This was also a political statement as it allowed homosexual people to be more open about their sexual orientation and challenged the hegemony of heterosexual standards. For instance, in the early 1970s many young men experimented with the idea of "gender fucking," a practice that involved men combining elements of both men's and women's appearances to create a totally different set of standards. For example, men with beards would wear dresses. This activity was not designed to allow homosexuals to "pass" as heterosexuals, but its aim was rather to shake up the status quo and people's ideas about gender. Much of this fluidity of gender boundaries would also be reflected in the nascent glam and proto-punk movements of the early 1970s in New York and London.[102]

These same militants also organized pressure groups to effect change in

the lot of the homosexuals, including the Gay Liberation Front (GLF) founded in New York in 1969.[103] One of the activities that they sponsored was dances, beginning in the months following the Stonewall riots. This activity was more subversive than it may seem upon first glance, when one considers that men and women were being routinely arrested in some of America's largest cities for dancing together at this time.[104] Their choice of dancing as a method of protest would prove to have a great impact on American popular culture in the 1970s.

During this time, gay discos began opening up in New York City. The first gay disco in New York was the Sanctuary, located on West 43rd Street and housed in a building that had previously been a German Baptist church, though the club had started life as a straight disco for white celebrities.[105] It was soon transformed into an almost exclusively gay male dance club, which paradoxically conferred cachet on the straight people who went there to dance. As sites of illegal activity (i.e., men dancing together) the gay discos were rendered a little "dangerous" to heterosexual people who patronized them.

Another early gay disco was the Loft. Located in a club DJ's loft apartment on Broadway north of Bleecker Street, it was a private after-hours club. Membership was free, the cover charge was low, and punch, cookies, and the coat check were free. This club was most notable for its imaginative dance mixes and the sexual and racial mix that characterized its clientele. Straight and gay, men and women, white people and people of color all danced at the Loft. These clubs, and the DJs and patrons in them, began to popularize a new type of dance music called disco.[106]

Disco did not spring fully formed onto the American landscape of the 1970s. Its evolution took some time. Disco, as it existed at that time in America, was an amalgam of soul, R&B, Latin salsa, and rock dance grooves. Although all of these styles contributed to disco's creation, the factor most influential among its early practitioners was not style but rather geography.

R&B music that came out of Philadelphia in the 1970s was characterized by lush orchestration and danceable beats. The most successful of the early practitioners of this sound was MFSB, the twenty-eight-piece house band for Philadelphia International Records. Their 1974 single "Love Is the Message" became the theme for the African American dance show *Soul Train* and is touted as one of the earliest identifiable disco songs. The album of the same name went gold in 1974. Philadelphia bands, including the O'Jays, the Three Degrees, and Harold Melvin and the Blue Notes, were a few of the successful practitioners of this style of disco music.[107]

Latin- and African-flavored disco music was created in both New York and Miami. New York disco music was heavily influenced by Puerto Rican and

Cuban immigrants to the area. Known as "salsa," this music incorporated Afro-Caribbean rhythms and usually employed horns and lots of percussion. Fania Records was the first New York record company to promote this style of music in the early 1970s. The Miami version of this type of disco music was hugely influential on the direction that disco music would take in America in the 1970s. Also employing horns and Afro-Caribbean beats, the Miami sound prominently featured the rhythm guitar as well. This music scene would produce one of the most successful and well known of the disco bands: K.C. and the Sunshine Band.[108]

K.C. and the Sunshine Band's first single, "Blow Your Whistle," was a dance club smash in 1973. However, K.C., born Harry Wayne Casey, was also a songwriter and one of his first contributions to the effort to help mainstream disco music was in this capacity. In 1974, along with collaborator Rick Finch, Casey wrote a song for one of the back-up singers on "Blow Your Whistle," George McCrae. This song, "Rock Your Baby," was released in 1974 and is generally accepted as having helped to popularize disco among the general public. Casey and his band would themselves become famous in 1975 with their own number-one hit "That's the Way (I Like It)."[109]

That year would also see the rise of three important players in the disco field: Gloria Gaynor, Van McCoy, and Donna Summer. In 1975, Gaynor had a hit with her version of "Never Can Say Goodbye," which was also the first extended-play (EP) record created especially for the disco market. Gaynor was proclaimed "Queen of the Discos" and would win a Grammy for her number-one song "I Will Survive" in 1978. McCoy's instrumental "The Hustle" helped to reintroduce Americans to songs that had discrete dances created for them and won a Grammy in the process. Both Gaynor's and McCoy's efforts, although important, would take a backseat to the disco powerhouse that was emerging from Germany. Her name was Donna Summer and she, and her producer Giorgio Moroder, would completely reshape disco music from the bottom end up.[110]

Before Summer and Moroder, the beat, or the bottom end, of most disco songs was created by using conventional percussion instruments, usually kick and snare drums with a high hat on top. American by birth, Summer was living in Germany when she met Moroder, a producer from Munich. The pair combined heavy bass drum beats with electronic enhancements to create the "thump" on the bottom, known as "four on the floor," that has remained a characteristic of disco music ever since. When coupled with Summer's impressive vocals, the music the two created caused a sensation, especially in America. They had their first hit in 1975 with "Love to Love You Baby," and the album which contained it was their first gold record.[111]

Much like rock culture, one aspect of disco culture was its encouragement of the use of illegal drugs. Many patrons of the new discos, like their counterparts at rock concerts, equated the use of drugs with the music. Although they often had different choices of drugs, both cultures operated on the belief that drug consumption enhanced the musical experience.

An important part of the hippie counterculture of the 1960s and early 1970s was the use of drugs for recreation or potential expansion of consciousness. The drugs of choice of these early hippies were marijuana and LSD. Both relatively cheap drugs, they lend themselves well to communal use and their effects are typically benign on the user, excepting LSD's anomalous "bad trip" and the effects that can result from their overuse. Their role as a secular sacrament and subcultural marker were one of the linchpins of the hippie subculture and soon spread to the rock music subculture as well.

That the rock music subculture embraced drug use was visible in its music, art, and fashion, but especially in its concerts. Rock concerts became a favorite site for drug use by the music's fans, where passing joints or tripping on LSD became a standard practice. Partaking in these activities cemented not only one's cool, but also one's membership.

However, this practice was bemoaned by members of law enforcement and the older generation. Their credibility was further compromised by lumping marijuana in with other drugs, especially addictive or psychotropic ones. The employment of "scare tactics," although well meaning, caused many young people to believe nothing that they were told in school or by anyone else in authority, which created conditions where experimentation with more lethal or addictive drugs was not only understandable, but virtually inevitable.

Beginning in the early 1970s, the use of "downers" by those in the rock subculture became more widespread. Downers in pill form actually encompass three main groups of drugs; they are barbiturates, pre-benzodiazepine non-barbiturates, and benzodiazepines. The earliest of these groups was the barbiturates. First synthesized in 1864, it was not until 1903 that medical practitioners began using a form of this drug, Veronal. In 1912, a more familiar drug, phenobarbital, was introduced. Thousands more varieties followed. Classified as hypnotic/sedative drugs, they had a wide range of uses, including the treatment of insomnia and anxiety, and remained doctors' drugs of choice for the next fifty years.[112] Some of the more widely known of these drugs among members of the counterculture included reds (Seconal), yellows (Nembutal), and rainbows (Tuinal). All are highly addictive and lethal at high doses or in combination with other drugs or alcohol.

These drugs' medical hegemony was challenged in the 1950s with the introduction of the pre-benzodiazepine nonbarbiturates. The most widely used

of these drugs was Meprobamate, or Miltown, and Methaqualone, or Quaalude, and they were effective if highly addictive, sedatives.[113] Quaaludes became particularly embraced by young people and members of the rock subculture. Anecdotally, this is the drug that Karen Ann Quinlan combined with Jack Daniels to such devastating effect in 1975.

Although synthesized thirty years earlier, benzodiazepines were first prescribed to treat anxiety in the 1960s. The most commonly known and used of these drugs is Valium. Initially they were described as difficult to overdose on and nonaddictive, but these fallacies were soon tempered by the reality of Valium addiction and the lethal effects of combining benzodiazepines with other drugs and alcohol. This family of drugs is now the most frequently prescribed medications in the United States.[114]

The effects of all these drugs are, within limits, fairly similar. They include sedation, anxiety relief, and sleep inducement. Their use is also characterized by drowsiness, slurred speech, euphoria, uncoordinated movements, impaired thinking and motor and memory impairment and tolerance to them develops in a relatively short period of time. The sense of euphoria they induce was what made them particularly attractive to members of rock subculture. Their ubiquity, popularity, and toxicity among those in both the larger culture and the rock subculture are supported by the fact that in the early 1970s barbiturate poisoning was the leading type of poisoning death in the United States.[115] The effects of the use of these drugs, especially in combination with alcohol, changed the rock subculture, particularly its concert culture. Gone were the days of happy mellow crowds stoned on pot or tripping on acid that had been so prevalent in the 1960s. Also gone among these younger fans was the hippie's aversion to their parent's drug of choice, alcohol.

By the early 1970s, this change in the pattern of drug usage was cited as a reason for the closure of one of rock's most popular ballroom venues, the Fillmore East in New York City. Discussing the closing of the ballroom in 1971, *Village Voice* writer Lucian K. Truscott IV alluded to these drugs and their effects on the crowds who attended shows at this hall: "[It has been] six months since anyone at the Fillmore can remember much trouble with kids bad-tripping on acid. Now they're eating reds and putting a fuzzy, angry edge on things with cheap wine. Many of them pass out in their seats during the show. And maybe that, more than anything else, explains why Bill Graham announced last Thursday that on June 27, 1971, the Fillmore East will close, with its San Francisco counterpart close on its heels."[116]

Graham, in the announcement of his intention to close the Fillmore ballrooms published in the *Village Voice,* did not specifically mention the use of downers and alcohol. However, he stated that, "the scene has changed and, in

the long run, we are all to one degree or another at fault. All that I know is that what exists now is not what we started with, and what I see around me does not seem to be a logical, creative extension of that beginning."[117]

It is likely that changes in the infrastructure of the rock business were most responsible for Graham's decision to close his medium-sized venues. They were simply too small to turn a profit in the face of rising band prices (all of which Graham mentions in his announcement). However, changes in the crowds' behavior could certainly make the concert business a more unpleasant one in which to work. This unpleasantness was soon to pale in the wake of the rise in usage of the other drug that became virtually synonymous with 1970s culture: cocaine.

In the early part of the twentieth century, America had experienced widespread cocaine addiction among the general population.[118] The results had been grim and could be measured in the lives lost to and broken by cocaine addiction. However, historical and cultural amnesia, coupled with the younger generation's willingness to experiment with drugs and the lack of credibility that deservedly dogged most authority figures on the subject of drugs, created the perfect conditions for a new wave of addiction to cocaine. Like the previous epidemic earlier in the century, this one was fueled by misinformation and the highly addictive nature of the drug itself.

Jill Jonnes in her book *Hep-Cats, Narcs, and Pipe Dreams: A History of America's Romance with Illegal Drugs* comments on the glamorization and misinformation about cocaine perpetrated by both the popular press and those in authority, who really should have known better. She quotes *Newsweek*, in 1971, as characterizing cocaine as "the status symbol of the American middle-class pothead," and the deputy director of Chicago's Bureau of Narcotics as stating that "You get a good high with coke and you don't get hooked."

Jonnes cogently summarizes the attitudes of many in the media as well as the rock subculture in 1970s America:

The words and especially the images of the time promoted cocaine as a safe, classy, and purely pleasurable drug historically used by brilliant, creative, powerful people because it made you feel smart, energetic, and sexy. Still extremely expensive—an amount the size of a pea (enough for a few snorts) cost one hundred dollars—cocaine had become a major status symbol. True, some who used cocaine got into trouble, but the implicit message was that those who faltered were people who used untoward amounts of cocaine or went beyond the safety of snorting to shooting. In brief, a tiny minority of people who were not smart about their drug use.[119]

Unfortunately, their information and their attitudes were wrong about cocaine. Far from being a benign high with no addictive side effects, the reality of the drug has produced three devastating cycles of addiction in America in the twentieth century.[120]

Some of the most ardent supporters of this new drug were members of the rock subculture. Many musicians began referring to cocaine and its effects in their songs. However, some of the musicians were at least more aware of the effects of the drug, their knowledge having been gained from hard experience. It is instructive to note that the Grateful Dead's song "Casey Jones," which characterizes Jones as being "high on cocaine," is about a train wreck.

The effects of cocaine that are most relevant to this work are those it wrought on the backstage culture of rock music. Unlike pot and LSD, cocaine is expensive. Its highly addictive nature further encourages a sense of parsimony among its users. Overuse and addiction can also lead to bouts of paranoia, sleeplessness, sexual dysfunction, eating disorders, and delusions, not to mention poverty. These are hardly symptoms conducive to feelings of expansiveness and inclusivity.

<p style="text-align:center">* * *</p>

Like the rest of society, women musicians changed radically from 1965 to 1975. Some of these changes were stylistic. Other transformations were the results of shifts in the world around them and related to the changing music business, like the rise of the counterculture or the singer-songwriter. Finally, some of these differences can only be accounted for by the revolutionary nature of the women themselves and the music that they created.

Before I discuss the women musicians during 1965 to 1975, I believe it is useful to take a brief look at those who came before them. In the 1950s, women popular musicians were largely confined to the realms of pop and rhythm and blues, depending upon their race. The genres might have been different, as well as their experiences in a largely segregated society; however, the women's sartorial expressions were fundamentally the same. The dresses (and they were always dresses) that Connie Francis wore in the 1950s looked just like Ruth Brown's, for example. Much like their predecessors in the 1930s and 1940s, the solo singers (and they were always vocalists) were as much about looks as talent, and were so regarded by the industry. Singers like Francis, Brown, Patti Page, LaVern Baker, Kay Starr, Etta James, and Gogi Grant may have sung wildly divergent material in markedly different circumstance but they all basically subscribed to a similar template. They were women singers in popular formats who dressed up in typically feminine attire and sang other people's songs.[121]

The other model for women musicians during this era, the singing group, also had deep roots in popular music reaching back to the 1930s and 1940s. Like earlier all-women's acts such as the Andrews Sisters, the female singing groups of the 1950s capitalized on a format already familiar to the American listening

and viewing public.[122] Groups like the McGuire Sisters, the Chordettes, the Bobbettes, and the Chantels all experienced varying degrees of commercial success in the popular music industry in the 1950s. Visually, they looked like a group of the female solo singers in matching outfits, and they too sang other people's songs.[123]

The female rockabilly artists of this era followed a bit of a different trajectory than their pop and R&B counterparts. It is their approach that presages the changing roles of women in rock music during 1965 to 1975. Partially a reflection of the need not to stray too far from their working class and rural roots, which might alienate their fan base, and the fact that rock and roll was considered outlaw music by the powers that be, the women rockabilly artists often wore more daring outfits than the "ladies" of pop and R&B. A few, like Cordell Jackson and "Bonnie Guitar" (Bonnie Buckingham), both of whom played guitar, were also instrumentalists. Artists like Jean Chapel, Wanda Jackson, and Brenda Lee all scored hits in the genre during the late 1950s. With the exception of Lee, who would continue to have success in pop music into the early years of the 1960s with such songs as "I'm Sorry," "I Want to Be Wanted," "Fool #1," and "All Alone Am I," the women in rockabilly largely saw their careers fizzle out with the demise of genre in the late 1950s.[124]

The early 1960s witnessed the ascension of the girl group in the world of pop music. The Shirelles kicked off this resurgence in late summer 1960, with a song originally considered "too white" by the group.[125] "Will You Still Love Me Tomorrow?" was written by songwriting team Carole King and Gerry Goffin and signaled, at least for a while, the primacy of New York's Brill Building writers and producers in relation to the women singing groups.[126] These groups were comprised mainly of young, African American women who dressed in matching outfits and performed other people's material.

When discussing the girl groups of the early 1960s, three men must be mentioned: Phil Spector, George "Shadow" Morton, and Berry Gordy. Spector, also affiliated with the Brill Building, was the first of the three to achieve commercial success with female singing groups. As a songwriter and producer, Spector had already created big hits for other, mostly male, artists. These included co-writing "Spanish Harlem" (for Ben E. King); producing Ray Peterson's "Corinna, Corinna"; Gene Pitney's "Every Breath I Take"; Curtis Lee's "Pretty Little Angel Eyes"; and the Paris Sisters' "I Love How You Love Me."[127] In 1961, Spector formed his own label and began recording a female singing group, the Crystals. They had numerous hits in 1962, including "Uptown" and "He's a Rebel."

Largely utilizing the girl groups and female singers, Spector had twenty consecutive hits over the next three years. These included: with the Crystals

"Da Doo Ron Ron" and "Then He Kissed Me," and the Ronettes "Be My Baby," "Baby I Love You," and "Walking in the Rain." A heavy-handed producer, Spector's signature "wall of sound" approach to recording, in which he layered multiple instruments creating a unique sound montage, in some ways made the identity of the artists less important than the man behind the control panel. The failure in the United States of Ike and Tina Turner's 1966 release "River Deep, Mountain High" marked the end of Spector's unbroken string of successes, as well as a two-year retirement from the music business.

Morton was also associated with Spector and the Brill Building writers and producers.[128] He is most often remembered for his work with the all-white, female singing group the Shangri-Las. During 1964–1965, together they had a number of pop successes: "Remember (Walking in the Sand)," "Leader of the Pack," "Give Him a Great Big Kiss," and "I Can Never Go Home Anymore." Most of these songs were written by Morton or Morton in conjunction with another Brill Building team, Jeff Barry and Ellie Greenwich.[129] Morton also had hits with the Dixie Cups ("Chapel of Love") and the Jelly Beans ("I Wanna Love Him So Bad"). His style could best be described as teenage drama meets the pop song and incorporated large measures of angst and light pop. Morton's work with the Shangri-Las was the high water mark of his career, both professionally and artistically.[130]

The Shangri-Las were anomalies in the world of the girl groups. They were white; most of the other successful groups in the genre were black. Their signature look included slacks and high boots. The matching outfit aspect was still firmly in place; however, their look had a tough, street edge to it, as did some of their lyrics. Several of their songs portrayed them as possibly sexually experienced or as romantically involved with "juvenile delinquent" boyfriends. Clearly they were playing with the boundaries of proper female behavior, especially in the realm of public performance. Like the rockabilly women before them, in many ways the Shangri-Las were portents of what was to come in the world of women in rock.

Gordy, best known as the founder of Motown Records, was instrumental in the promotion of women performers of an earlier era and those of 1965 through 1975. Although he had successes with numerous female artists during the early 1960s, including Mary Wells, the Marvelettes, Doris Troy, and Tammi Terrell, he is most closely associated with the Supremes. Beginning in 1964 with "Where Did Our Love Go?" and ending with "Someday We'll Be Together" in 1969, the Supremes would eventually have a string of twelve number-one hits, a feat not equaled by any other female group or artist until Madonna in 2000.[131] Still singing other people's songs and utilizing the matching-outfits approach of the earlier all-female groups, the Supremes and their lead singer

Diana Ross nevertheless helped to modernized the image by incorporating "hip" fashions that paid a nod to those of the counterculture.

Beginning in 1965, parts of the counterculture began to seep into the world of pop music. Incorporating elements from the Pop Art, high fashion, and high culture arenas, as well as those from the worlds of West Coast hippie and folk music culture and fashions, women musicians' look began to change. Beginning in 1965–1966, women performers' fashions began to demonstrate the impact of the Pop Art movement. Stripes, miniskirts, day-glo flowers, and vinyl go-go boots made their way into the wardrobes of many of these new stars, especially Petula Clark and Nancy Sinatra.[132] Both of these artists had major hits during these years, the former with "Downtown," "I Know a Place," and "My Love," the latter with "These Boots Are Made for Walkin'," and "Sugar Town."

Another of the most successful of the early subscribers to this new trend was Cher. Starting in 1965, she and her then-husband Sonny Bono popularized a whimsical West Coast hippie look that incorporated fuzzy vests, bell bottoms, and long hair for both men and women. While utilizing this style, they had hits from 1965 to 1967 with songs like "I Got You Babe," "Baby Don't Go," and "The Beat Goes On."[133] It is also noteworthy that Cher's alto was one of the deepest female voices on the charts up to that point in time. Sonny and Cher's gender-bending was merely another salvo in the *kulturkampf* waged in America from 1965 to 1975.

Another successful band with female members to capitalize on the hippie/folkie look was the Mamas and the Papas. Beginning in 1966 with their Dunhill release "If You Can Believe Your Eyes and Ears," the group had a string of hits over the next three years. These included "California Dreamin'," "Monday, Monday," and "Words of Love." Singer Cass Elliot's contralto was also another example of the gender-bending approach adopted (at least vocally) by the female members of some of these groups. Like many of the women in the folk music genre, both Sonny and Cher and the Mamas and the Papas also performed music that they had largely written, although the lion's share of the songwriting was conducted by the male members of both groups.

For it was not only stylistic changes that were occurring among the women musicians during these years, there were also substantive changes in their approach to music and the entertainment business. Female artists were eschewing the prepackaged, matching outfit look as dated. Some of this change was also due to the influence of the hippie counterculture, which was striving to keep it "real." Reflecting the demise of the old A&R system and the rise of the independent producer as well as the influence of the Beatles and folk music, many of the newer artists were writing their own material. Some women were

even instrumentalists.[134] Although they were building upon the work and success of the women who had come before them, the women in the music business from 1965 to 1975 often utilized a completely different approach to performance and artistry. Some of this change was a reflection of the times; some of it was sheer innovation.

Starting in 1967, two developments radically changed the world of women in music. They were the rise of Aretha Franklin and the ascendancy of artists associated with the West Coast hippie counterculture. Beginning with her Atlantic release "I Never Loved a Man (the Way I Love You)" in February 1967, Franklin proceeded to climb to the top of the pop and R&B hierarchy, where she stayed until 1971. With songs like "Respect," "Baby I Love You," and "Chain of Fools," she firmly established her dominance in the field.

Franklin's approach, although innovative, also paid homage to and employed methods that had worked for other female artists in the past. She used Brill Building writers Goffin and King on "(You Make Me Feel Like) a Natural Woman" and even had Ellie Greenwich singing back-up on "Chain of Fools." She was also among the artists on Ahmet Ertegun's Atlantic Records label, long a supporter of African American music. Franklin's appearance began rather conservatively and consisted of processed hair-dos and typically feminine clothes. However, this gave way to dashikis and a natural afro as her career, and the era, progressed.

Franklin also employed some innovations in her work. She co-wrote some of her own material, like "Think," "Dr. Feelgood," and "Since You've Been Gone." She was also an accomplished pianist who played on both her recordings and at her concerts. Franklin was responsible for many of the arrangements for her songs as well. Clearly, she was a hybrid of the approaches that female performers, white and black, had used in past and those they were newly developing. That her approach was successful is also clear. Franklin was *Billboard*'s top female artist from 1968 to 1971.

The female artists who were closely associated with the West Coast counterculture were also breaking new ground during this period. Beginning in 1965–1966 with Cher, and the Mamas and the Papas, and continuing with Grace Slick's success in 1967, women artists associated with the hippie counterculture also became tremendously influential on the roles of women in the music business. Gone was any semblance of the matching outfits. These women sported variations on hippie thrift-shop chic and let their hair grow long. Many wrote their own songs; Slick was responsible for "White Rabbit," for example. Several were instrumentalists (Slick was a pianist with the Jefferson Airplane) and artists from the more folkie end of the spectrum, like Joni Mitchell, often played the acoustic guitar.

One of the most innovative artists to come out of this movement was Janis Joplin. Beginning with her conquest of the rock music business at the Monterey Pop Festival in 1967 and ending with her death in 1970, Joplin was influential musically and the most passionate performer of her generation. From her contributions to the popularization of the San Francisco sound, to her part in the blues revival of 1968, to her employment of elements of country music in her final album, Joplin was on the cutting edge creatively and stylistically. She also achieved monetary and business success. Her albums, both with Big Brother and the Holding Company and alone, sold extremely well. Several of her singles, including the posthumous number-one "Me and Bobby McGee," charted in the top twenty.

Joplin's sense of style was also hugely influential on many young women during this era.[135] Music critic Ellen Willis wrote that she stopped straightening her hair after seeing Joplin perform. Joplin's freewheeling approach to sexuality was also both a reflection of the times and an innovation on the theme. Her bisexuality places her more rightly among the sexually adventurous artists who would follow in the 1970s. While her death from a drug overdose served as a cautionary tale, she was the female avatar of the woman performer during her career, and remains so to many even today.

The early 1970s saw the rise of the singer-songwriter, and women artists were among some of the most notable participants in this genre. Some, like Brill Building alumna Carole King, were old hands in the business. Singing was merely a new riff on her songwriting career and a good move on her part. Her 1971 album *Tapestry* was the largest selling album of the seventies until 1976. Others, like Joni Mitchell, had also started out as songwriters for other artists, usually those in folk music. The early 1970s saw the development of an audience for her own performances. Artists like Roberta Flack, who had been bubbling under in the business for a while, finally broke through as instrumentalists, songwriters, and performers. She was *Billboard*'s top female artist of the year in 1972. Carly Simon was another luminary in the genre, with songs like "That's the Way I've Always Heard It Should Be," and the Grammy-winning "You're So Vain" in 1971 and 1972, respectively.

As the 1970s progressed, three significant trends emerged in popular music. These trends were the increased popularity of the adult-oriented format (AOR), the rise of disco,[136] and the punk and glam movements. AOR had always had some popularity in the music business. However, beginning in the early 1970s, several women performers took the format and ran with it. Artists like Gladys Knight, who experienced some success as a Motown artist in the 1960s, came into her own when she shifted record labels in the early 1970s. With songs like "Neither One of Us (Wants to Be the First to Say Goodbye),"

"Midnight Train to Georgia," and "I've Got to Use My Imagination" (with lyrics by Goffin), Knight finally experienced greater success in 1973–1974. In keeping with the AOR format, Knight and her Pips presented a very traditional appearance, wearing matching outfits and doing some of the best coordinated dancing in the industry.

After starting out with the Grammy-winning, feminist anthem "I Am Woman" in 1972, Helen Reddy headed back toward the middle of the road with her music. With songs like "Delta Dawn" and "Angie Baby" (both number one in 1973 and 1974, respectively), Reddy continued to experience professional success in the AOR format and was *Billboard's* top female artist of the year in 1973. Following Reddy in that position in 1974 was Olivia Newton-John, who had two number-one singles with "I Honestly Love You" in 1974 and "Have You Ever Been Mellow" in 1975. While Cher, both before and after her divorce from Sonny Bono, had number-one hits in the format with "Gypsies, Tramps and Thieves," "Half-Breed," and "Dark Lady" in 1971, 1973, and 1974, respectively. Linda Ronstadt's smash album *Heart Like a Wheel* in 1974 also signaled a return of the female vocalist who sang other people's songs and was easy on the eyes, even though she did favor lots of pseudo-youth culture denim in her wardrobe.

At the other end of the musical spectrum during the first half of the 1970s was glam and punk rock. Beginning primarily as a British movement, glam rock was characterized by lots of gender-bending, flashy outfits (hence the glam), and crunchy driving rock and roll. Two acts that were influential on the genre were also innovators of the first rank, and as such begin my discussion of the female artists of the 1970s who truly threw the rule book out the window. The first was American expatriate Suzi Quatro. Although born in Detroit and active in the music business in the United States in the late 1960s and early 1970s, she did not achieve break-out success until she relocated to England. A protégé of British hit-maker Mickie Most, Quatro was provided material written by the successful pop songwriting duo Nicky Chinn and Mike Chapman. She cracked the British top ten in 1973 and 1974. What was most innovative about Quatro was the fact that she played a nontraditional instrument (the electric bass), wore gender-bending outfits, and fronted her own band singing songs that were usually thought of as "guy songs." These included the Beatles' "I Wanna Be Your Man." She never managed to catch on commercially in America, although she did have a hit song in 1979 and a recurring role on the sitcom *Happy Days*. Her most important role was as one of the first female rock instrumentalists to play an electric stringed instrument while maintaining an androgynous appearance. Many women musicians who followed were inspired by her innovations, especially acts like the all-girl band the Runaways.

The other innovative glam musicians that I will discuss were so original that an entire category in the history of women musicians should be established just for them. They were the New York-based, African American, glam band LaBelle. Originally known in the 1960s as the all-woman singing group the Blue-Belles, they were fronted by vocal powerhouse Patti LaBelle. The group changed its name to LaBelle in the early 1970s after hooking up with manager Vicki Wickham, a veteran of the British music TV show *Ready, Steady, Go!*[137] Their stage persona, image, and material were unique. Their costumes resembled nothing so much as flashy space outfits, complete with dizzyingly high platform shoes. Initially, they covered songs by white rock bands like the Rolling Stones. Beginning in 1974, however, group member Nona Hendryx assumed writing duties for the band. The year 1975 marked their first large-scale chart success when a single off their album *Nightbirds*, "Lady Marmalade" (and penned by veteran New Orleans producer Allen Toussaint), reached number one in January. This was to be the acme of their career, however. Music historian Gillian Gaar attributed this fact to race. She wrote, "The stratification of black and white performers on radio playlists left LaBelle little room for maneuvering: white radio wouldn't play them because they were black, and black radio wouldn't play them because rock was white music."[138] As was the case for many who have tried new things visually and musically, the business aspects of the industry were incapable of accommodating their innovations.

While LaBelle was heading for outer space, another innovative New York artist was looking inward. Proto-punk rocker Patti Smith was another woman musician who created herself and broke the mold. Her songs' lyrics were deeply rooted in poetry, which she coupled with minimalist guitar rock and an unpolished vocal style. Smith's androgynous appearance and her ripped t-shirts and jeans would also have been jarring to audiences more used to the flash of glam or rock. Part of the Mercer Arts Center scene that had been ground central for glam rockers the New York Dolls, Smith released her first album, *Horses*, in late 1975 and continued to exert a powerful influence on women in the punk and rock music scenes throughout the remainder of the decade.

The impact of women musicians who played instruments (like Suzi Quatro), especially those not traditionally associated with female performers, truly ripped the door off the little boy's club that had been rock music in a completely new way. Drummer and vocalist Karen Carpenter, along with her brother Richard, climbed to the top of the charts in 1970 and stayed there throughout most of the decade. Unfortunately, she was advised to give up the drums to concentrate on her singing after a few years. It was a decision that was said to have caused her some unhappiness, if not professional damage.[139] Karen died from complications due to anorexia nervosa in 1983 at the age of thirty-two.

Karen's decision to play drums was an important one to me personally. I was nine years old when I saw her playing drums on *American Bandstand*. It was a revelation and completely realigned my thinking about music making. I had never seen a woman play anything except the piano or an acoustic guitar. To see her behind the drums was just mind-blowing and made me think that maybe I could play any instrument I wanted to. I'm sure I wasn't the only one.

Slide-guitar virtuoso Bonnie Raitt was another groundbreaking instrumentalist. The daughter of Broadway star John Raitt, Bonnie began as folk player. During her time at Radcliffe, she became acquainted with the work of blues legends like Fred McDowell and especially Sippie Wallace, whose tunes she covered. Bonnie released her first album in 1971 and is acknowledged as one of the foremost practitioners of the electric slide guitar in the world today. In 1975, she was the first woman I ever saw play an electric guitar. I had been playing the instrument for two years by that time. It was powerful reinforcement for a teenage girl trying to buck the system in small-town Texas.

The last two artists that I am going to discuss, Carol Kaye and June Millington, are in many ways, counterpoints to each other and form a bridge between the earlier part of the years of this study and the later ones. Kaye is one of the most respected electric bass players in the world and a fixture in the studio session musician community in Los Angeles in the 1960s and 1970s. A partial list of the songs she played on will suffice to establish her credentials: for the Beach Boys, "Good Vibrations," "California Girls," and the entire "Pet Sounds" LP; for Nancy Sinatra, "These Boots Are Made For Walking" and "Something Stupid"; for Stevie Wonder, "I Was Made to Love Her"; for Joe Cocker, "Feelin' Alright"; for Elvis Presley, "A Little Less Conversation" and "Suspicious Minds"; six of the Supremes' number-one records, including "Stop! In the Name of Love" and "Back in My Arms Again"; for the Doors, "Light My Fire"; for the Crystals, "Da Doo Ron Ron"; and my two personal favorites, "Bernadette" for the Four Tops and "Midnight Confessions" for the Grass Roots. The list of her credits is five times the size of that listed here.

Born in Everett, Washington, to musician parents, Kaye began as a professional jazz guitarist in 1949 and worked as a session musician in Los Angeles, beginning in 1957 when she played on some Sam Cooke sessions. She switched to the electric bass in 1963 when the bassist failed to show up for a session at Capitol Records. She quickly became the most requested electric bassist in Los Angeles session work. As the sessions above attest, her work is some of the most recognizable and well known in the world. It would be an amazing career for any musician. For a female musician of this era, it is simply astounding.

Very few other women instrumentalists existed in the industry at that point in time. Kaye related that only 1,000 of the 16,000 members of the Local 47

Musicians Union in Hollywood/Los Angeles were women, and they were largely string (violin, etc.) and harp players. When questioned about why there were so few women rhythm players and why she had been so successful, Kaye was characteristically down to earth in her answer: "You have to carry the danged things. There are many women in rhythm sections playing live down through the years but not in studio work during the years I was. I'm the first one who worked that steady in studio work (lucky I was a guitar player back then) and probably because the Fender [electric] Bass was such a new instrument and quickly became the anchor for commercial hits and I was the only one at that time who could invent good line."[140]

Studio work, which was more sedentary, allowed Kaye to be a professional musician and raise a family. This aspect was especially important in an era when the woman was supposed to take primary responsibility for the children in a family. She has three children and always worked even when she was pregnant. However, the need and desire to be near her children kept from accepting at least one job that she would have liked. "I was asked by George Shearing to go on the road with him and join his great jazz group, which I would have loved to do, but not then. I had kids I didn't want to be away from, plus you lose your place in studio work if you travel. So, sadly, I turned him down but I'd never leave my kids again."

Kaye found that being a musician also made it difficult to find and maintain a relationship: "You don't have time to devote to a real relationship, you marry on the fast time track, and with the music business drawing all kinds of creeps to you (a woman in the biz), you don't have time to psyche them all out to get a good one, limiting the possibility to find a good husband. Let alone figure out the dynamics of your own background/family to stop from marrying someone bad for you that you're attracted to. It's tough in the music biz, as is witnessed by the tragic stories, but there are some success stories too."

Kaye found less problems were caused professionally by the fact that she was a woman and that skill was more important there than sex: "You could always defend yourself with some good humor and feeding back to them what they said and get everyone to laugh at the perpetrator, but this was very rare, if you could really PLAY GREAT. The men appreciated the women totally, professionalism and skill always spoke the loudest—not like today where aggression is sooo acceptable. It's really tough for women now, as men feel freer to attack them for some reason, and vice-versa. It's a changed world, although there're more women musicians."

June Millington's experience was very different from Kaye's, partly because she was not a session musician and partly because her involvement in the business began later. Born in the Philippines in 1949, Millington was one of the

first female lead guitarists in rock music and one of the most successful. She and her sister Jean, an electric bassist, were two of the founding members of Fanny, the first all-woman band to have a song on the American Top Forty.

June's evolution and development as a rock lead guitar player was made more difficult by her sex. Although encouraged in her musicality both by the cultural attitudes in the Philippines and her parents, she had many struggles along the way. The Millington family came to America in 1961 and lived in Sacramento, California. Her desire to play the lead guitar in a rock band began in high school, when she attended a concert by the Grateful Dead and heard Jerry Garcia play. Her problem was that she had no idea how become a lead player.

The obstacles in June's way were both ideological and practical. The attitudes of many in society at this point about women playing electric instruments were both daunting and isolating. Often those closest to you were not encouraging:

The general feeling was that if you played an electric instrument you were setting yourself apart from the social mores, from the power structures. The people who seemed to be most threatened were boyfriends and the parents of other girls who wanted to play in the band with us. They got a lot of pressure not to do that because it took away from activities that were considered normal. There was a general perception that if you wanted to play in a band you were this loose, amoral woman. It was not thought of as a career. It just simply wasn't done. I mean you were making a big statement right there. You were a rebel, with all that comes along with that in people's minds.[141]

Another difficulty that June had was practical, but more harrowing. Like many rock players during this era, new players learned from other guitarists. Her sex problematized this approach: "It was pretty dangerous. I mean you had to go ask guys. You had to spend time with guys alone and just kind of trust that they'd not rape or kill you. A lot of guys just assumed just because you want to learn a chord that you're coming on to them, so you had to do that dance. This is a lot of energy spent on getting just one little tidbit of information for a lot of dancing. I just accepted it because that's the way it was. You did what you had to do. Women do what they have to do." June had never seen another female lead player when she decided to become one.

Unlike Kaye, who largely ceased touring when her children were born, June and Fanny did a lot of road work. It is difficult work for most musicians, but was made more so by their sex: "I don't think that it was so different then than it is now, to tell you the truth. What is different now is when you walk into a hall, there's just a little bit more perception that maybe I'm going to be standing up and playing the guitar or maybe I'm part of the band. Once when Fanny arrived at a show, the producer said 'Here's your room and here's the room for

the band.' And he had hired us. He just made the assumption that we had a backup band." However, travel also allowed the band exposure to crowds that were more accepting of women musicians. June found European audiences more open: "They're just much more sophisticated."

Traveling also allowed the band to seek out other women musicians. Fanny was big on trying to network with other women players. "We went out of our way to try to find every woman that we could. If we even heard of someone in another city, sometimes we would fly them to LA just to check them out." Some of this solidarity resulted from the fact that they were an all-woman band, not just women musicians.

The women musicians who became active during the earlier part of the years discussed here sprang from a different reality than those who entered the industry during its later years. Kaye and June Millington are good examples of this fact. Both are women who made their marks in the music business. Yet Millington's role as a member of an all-female rock band in the early 1970s differed greatly from Kaye's as a Los Angeles session player in the 1950s and 1960s.

Their stories form a part of the history of women in the industry and that of women artists in America. It is not a story that is well known or well researched. It is vital that more attention be paid to their, and other women musicians', stories. For they form an important part of the cultural history of America. Without their inclusion, the story will be incomplete and we will never be able to reconstruct the path of how we have come to where we are today. Their talent, innovation, and courage deserve no less.

All of the themes covered in this chapter, from the sexual revolution of the 1960s to the change in America's drug habits in the 1970s, form an interconnected whole that must be viewed as more than the sum of its disparate parts in order to understand its effect on the women musicians, critics, and fans of this era. Each strand added its unique contribution to the sensibilities and personalities that shaped the dialogue on these women. To exemplify this generalization one has only to try to imagine rock music without the countercultural influences of the hippies, or attempt to envision second wave feminism without the sexual revolution of the 1960s, or picture what disco music would look like without the homosexual community's contributions. To unravel each strand and then recombine them to their all-encompassing whole is the challenge for cultural historians who study topics from these years, and we must meet it in order to do any justice to the complexity of the period.

The 1960s and 1970s was a fecund period, culturally, for American society. It produced landmark changes and laughable excesses, moments of artistic

brilliance and crass commercialism. The one constant during the period appears to be that there was precious little middle ground during these years. Perhaps the insularity and affluence of the suburbs had rendered the mean unattractive to the young men and women who had grown up there. Maybe the rabid conformity of the 1950s had shown them with startling clarity how easy it is to drown in still waters. However, what is clear is that American society has never been the same since the social and cultural movements that occurred during this era.

Chapter 2

Women Rockers on the Printed Page

While it was disagreeable and unreasonable to have our wearing apparel described in the papers, it was inevitable in this stage of woman's progress, editors and reporters being much more able to judge of our clothes than they were our arguments.

—Olympia Brown, suffragist (1835–1926)

In 1968, Big Brother and the Holding Company, with Janis Joplin on lead vocals, released *Cheap Thrills*, one of the best-selling albums of the year. Later that year, Joplin had split from the band to become a solo artist.[1] Her first performance with her new band was set for the Stax-Volt Record Company's Christmas party in Memphis. Stax was not only successful commercially, but also on the cutting edge musically and in interracial relations. The label boasted one of the few successful musical groups with both white and black players, Booker T. and the MG's. Joplin's was the only act not on the Stax label invited to perform at the party. In addition, aside from the two white members of the MG's, Joplin was the only white performer on the bill and the only white woman. Her inclusion in this event was a big feather in her professional cap and a bold racial statement.

Except for the fact that Joplin was the only non-Stax artist included, none of these details are mentioned in Stanley Booth's *Rolling Stone* article, "The Memphis Debut of the Janis Joplin Review."[2] Instead, this very negative review of the poorly received show saves its most detailed descriptions for Joplin's physical appearance. Booth writes: "There was some fear that she [Joplin] might turn out to be blatantly unprofessional, as so many people are in contemporary popular music. It was a relief, then, backstage at the Yuletide Thing, to see that she was wearing makeup and a cerise jersey pants-suit with bursts of cerise feathers at the cuffs. She looked like a girl who was ready to go out and entertain the people."[3]

This quotation is typical of many descriptions of women musicians found in the popular periodical press of the era, creating yet another challenge that female musicians had to overcome. The sartorial detail demeaned not only the fact of Joplin's inclusion in such a prestigious show, but also her musical abilities that produced the invitation in the first place. According to Booth, donning makeup and a cerise pants suit was what any "girl" had to do to "entertain

the people." Rather than just writing that, "Joplin had on makeup and a matching pants suit," he described the outfit in detail and used language more appropriate to a magazine concerned with women's fashion than with rock-and-roll music. Certainly one would expect that a performer and innovator of Joplin's stature at a prestigious gig would have been accorded more serious treatment by the press, especially the counterculture press.

I begin with this example because it is typical of many that I encountered during my research into how women musicians were portrayed in the American periodical press. I wanted to see just how these extraordinary women were addressed by the largely male fourth estate. More specifically, since the years covered by my research were so pivotal in the development of female identity in American society, I wanted to see if I could detect any tensions or disconnects between the female musicians' careers and their treatment in the press. Was their work treated with the careful consideration that its quality, and sales, deserved? Were they the objects of press attention with the frequency that their positions entitled them? Were they and their careers addressed by writers of the first rank in the field? In short, how were they discussed in the periodical press?

In order to approach these questions, it was necessary for me to consider works on these women from three disparate, yet related sources. They are *Rolling Stone*, various other American periodicals (both mainstream and lesser known), and the *Village Voice*. While all of these sources did display some commonalities, distinct differences exist in the approaches employed by the writers at these magazines. For example, the writers at *Rolling Stone* tend to be much more likely to employ superfluous and stereotypical details and use double entendres, especially those of a sexual nature, while the mainstream magazine's articles are more concerned with the business aspects of these women's careers. *The Village Voice*, thanks in a large part to the work of Richard Goldstein and Robert Christgau, tended to write about these women in a much more even-handed way than did writers from the other two sources.

In order to better understand the portrayals of these women in the press during these years, it is necessary to have an understanding of the creation of rock journalism in America and the rise of *Rolling Stone* magazine. Much as it had in the music business and radio, the rise of rock music and the counterculture also radically changed journalism. Before the advent of rock, a group of magazines known collectively as "the trades" dominated music journalism, including *Cashbox*, the *Gavin Report*, *Billboard*, and other lesser known magazines of the same variety. The *Gavin Report* was basically a tip sheet for radio-station programmers that reported which radio stations were playing what records in which markets. *Cashbox*, in addition to charting records, also covered industry

events. *Billboard* was, and remains, the voice of the music business. It provided charts for different types of music (i.e., pop, gospel) based on record sales and, more important, the number of radio stations that had added the record to their play lists. *Billboard* also provided information on many different aspects of the music business; within its pages anyone could check up on the activities of executives in the entertainment industry, read about new technological developments that affected recording or production methods, or find in-depth reporting on specific musical genres like classical or gospel. These magazines were, and are, geared toward music business professionals, and were not intended for the general reader, nor did their coverage focus on rock, or even pop, music.

The affluence that underscored the rise of rock music, with its attendant changes to the music business, and the large numbers of teenagers and young adults who represented dollars to American business interests in a variety of fields were pivotal factors in the creation of rock journalism as a discrete genre. That many young rock fans began to write about the music and the culture that surrounded it encouraged other young fans to buy products. These writers took the rock movement seriously and wrote with the fervor of youthful true believers, and were the perfect, if unwitting, "pitchmen" for the genre. Experts assert that the rock press began in America in the mid-1960s with *Hit Parader*, a pulp magazine Jim Delahunt edited, which included the words to hit songs as well as articles about the recording artists.[4] With the advent of more sophisticated rock journals such as *Rolling Stone* in 1967, *Hit Parader*'s popularity declined, and it ceased publication in 1968. Although concerned with rock and pop music, *Hit Parader* had more in common with teen fanzines of the period than with the later rock magazines, but was an important bridge between the two.

Peer-group criticism, or rock journalism produced by writers the same age as the fans of rock music, began in 1966 when a twenty-year-old Columbia School of Journalism graduate, Richard Goldstein, started writing a regular rock column, "Pop Eye," for the *Village Voice*. His peers thought highly of his work, as is evidenced in an article on the history of rock journalists written by Ellen Sander, the rock-music critic for the *Saturday Review* from 1968 to 1972. She writes, "Richard Goldstein came to be recognized not only as the most astute rock critic of his times and one of the decade's most promising young writers, but as one of the most creative, colorful, and scholarly American journalists."[5] He left the field of rock writing in 1968, declaring rock dead, but returned in 1969 with *Us*, a "paperback magazine" described in detail below.

Less noticed, but certainly as important in the long run, was *Crawdaddy*, a magazine of rock criticism launched in spring 1966 by seventeen-year-old

Swarthmore freshman Paul Williams, who mimeographed 500 copies of issue number one on yellow paper.[6] The magazine was unprecedented in music journalism: *Crawdaddy* was not an industry trade paper or a fanzine like *Hit Parader*; instead, it strove to be a journal of quality articles written by young writers who "took rock seriously as a cultural phenomenon."[7] By 1967 the magazine had improved in quality and become a slicker, more lavishly illustrated magazine with a circulation of 20,000. Many influential commentators in the field started at *Crawdaddy*, including Sandy Pearlman, Richard Meltzer, Ed Ward, and particularly Jon Landau, who Chapple and Garofalo considered by the late 1970s to be "the longest running, most popular, most powerful critic in the country."[8] *Crawdaddy's* approach to rock music was intellectual, poetical, philosophical, and sociological; however, *Crawdaddy's* erudition was alienating to many fans.

In late 1966, David Harris and Greg Shaw joined forces in San Francisco to publish a different kind of magazine, the *Mojo-Navigator News*, which contained not only record reviews and discographies but also interviews, cartoons, and rock gossip.[9] Although it was described as a "lively rag" and an "exciting little tabloid," the lack of business acumen on the part of the editors doomed the magazine to failure and it folded in August 1967.[10]

Established publishing interests wanted to capitalize on this new type of journalism in order to tap the youth market's large discretionary income. *Esquire* magazine's *GQ Scene*, advertised as "The Magazine for Teen Men Only," begun in 1967, was one such silly attempt by journalists who should have known better.[11] Described by writer David Anson as a "pandering effort," the magazine's articles were a goofy collection of the same old *Gentleman's Quarterly* articles with a "hip" spin.[12] When *GQ Scene* folded in 1968, its loss, according to John Tebbel of the *Saturday Review*, was "unmourned except by [its] publisher."[13]

Cheetah and *Eye*, both launched in 1967, were of better quality. Leonard Mogel, former publisher of *Signature* and *Bravo*, both Diners Club publications, published *Cheetah*, which had a royalty arrangement with the popular nightclubs of the same name.[14] The editor was Jules Seigel, a thirty-two-year-old New York freelance writer whom *Newsweek* described as "long-haired."[15] Characterized by Draper as "an adolescent marriage between *Playboy* and *Ramparts*," this venture proved to be short-lived but was, nevertheless, influential on rock journalism. For example, *Cheetah* was an outlet for the work of critics like Robert Christgau, Ellen Willis, and others who would become the leading lights of the New York pop critic establishment.[16]

The other notable "establishment" entry into the youth magazine market in 1967 had very deep pockets indeed and impressive connections in the

publishing world. The magazine *Eye* was a part of the Hearst empire that began publishing in February 1968.[17] Hearst Magazines president Richard E. Deems promised that Hearst would spend $2 million to start the magazine, and experienced professionals headed the editorial and advisory staffs. The editor, twenty-seven-year-old Susan Szekely, had been the *New York Post*'s "Teen Talk" columnist, and the executive editor, thirty-year-old Howard Smith, was a *Village Voice* columnist.[18] Advising the *Eye* staff was *Cosmopolitan* editor Brown, who "urged large servings of sex" be included in the magazine.[19] By the end of 1968, *Eye*'s circulation stood at 500,000.[20]

The other influential and well-financed youth music and culture magazine launched during this era was a mixed media offering put out by Bantam Books called *Us*. Described as a "paperback magazine," it had an initial offering of 130,000 copies and was an outlet for the new young journalists. In a *Newsweek* article announcing the magazine's launch, Goldstein stated that "a lot of people were able to find jobs as writers on rock because there was no critical establishment for it as there was for theater and books. This magazine will let them write about their unwashed obsessions."[21] James Kunen, the twenty-year-old author of the best-selling account of the Columbia students' revolt, *The Strawberry Statement*, was described as "one of the few celebrities on the masthead."[22] It was a short-lived effort, ceasing publication later in 1969.

Though neither well financed nor strictly concerned with music journalism, underground newspapers also contributed many notable writers to the field of rock journalism. The San Francisco-based *Express Times* (later renamed *Good Times*) published both Greil Marcus and Langdon Winner before they moved on to write for *Rolling Stone*.[23] These few but competitive journals provided the general context in which *Rolling Stone* began.

In 1964, Jann Wenner was a Berkeley freshman and an eighteen-year-old "go-fer" for NBC radio in San Francisco. He performed tasks as varied as transporting tapes to and from the airport to fetching Chet Huntley's cigarettes during the Republican National Convention, and in a short time was promoted to reading traffic reports. In 1965, Wenner had his outlook altered by his first LSD trip, resulting in a life-long love affair with the counterculture and its music.[24]

The same year, Wenner met Ralph Gleason, whose career in music journalism was already both long and impressive. Born in New York City in 1917, Gleason had been a jazz aficionado since his days at Columbia University in the 1930s,[25] and was news editor of its paper, the *Spectator*.[26] In 1934 he was also one of the founding members of *Downbeat* magazine.[27] In 1939, along with Gene Williams, Gleason founded the first American jazz magazine, *Jazz Information*, which was a mimeographed four-page magazine and lasted until

1941.[28] The magazine ceased publication with the coming of World War II and Gleason served overseas with the Office of War Information.[29]

After World War II, Gleason headed west and began to work for the *San Francisco Chronicle* in 1950, for which he wrote what Anson characterizes as, at the time, the only regular music column in the country.[30] At that same time Gleason also wrote the first weekly jazz column, which was syndicated in the *New York Post* and other papers in Europe and the United States. In 1957 he founded *Jazz: A Quarterly of American Music*, which lasted two years.[31] During the 1960s Gleason also worked in radio as a jazz disc jockey for San Francisco's KHIP and KMPX and as a television producer. He produced a TV series called "Jazz Casual" for National Education Television, and a documentary on Duke Ellington that was nominated for two Emmy Awards.[32]

Gleason and Wenner formed a mentor-style friendship based on their mutual love of music. However, they were an unlikely pair. In 1965, Wenner was nineteen years old and gregarious, while Gleason was forty-eight years old, a less outgoing, avuncular type who was "tweedy, pipe-smoking, [and] graying at the temples."[33] In February 1966, Wenner began to write a music column closely mirroring Gleason's *Chronicle* column for the Berkeley campus newspaper, the *Daily Californian*, under the nom de plume Mr. Jones.[34] He enjoyed great success with the column, which mirrors the later gossipy style that he adopted later, especially in the "Random Notes" section of *Rolling Stone*. However, he soon tired of Berkeley and his column.

In search of something new, Wenner dropped out of college and followed two friends, Richard Black and Jonathan Cott (a future *Rolling Stone* luminary), to London in the summer of 1966. Gleason had put him in touch with the editor at a British music tabloid, *Melody Maker*, but Wenner could not persuade the journal to publish his articles about San Francisco music. He returned to the United States and lived with friends from his old prep school, Chadwick School, and college friends in White Plains, New York. There he tried, unsuccessfully, to write a novel. Wenner became depressed and unsure what to do with his life.[35]

After taking the civil-service exam in order to be hired as a postal carrier, Wenner returned to the idea of music journalism as a career. He initially approached Gleason with a plan for them to coauthor a "rock & roll encyclopedia," but the project didn't work out. When Chet Helms, the hippie manager of the Avalon Ballroom, heard about Wenner's situation, he invited him to join a project with which he was involved, a counterculture magazine to be called *Straight Arrow*. Wenner was soon dismayed by Helms's communal, hippie-style approach to the creation and organization of *Straight Arrow*; he was more enamored with the cult-of-personality style of editorship practiced by Warner

Hinckle, Henry Luce, and, most particularly, Hugh Hefner at *Playboy*.[36] He decided to create his own magazine, one that concentrated on music more than anything else. By this time Helms and his partners had chosen a name, *Straight Arrow*, held several meetings, and located a mailing list of prospective readers at a local AM radio station, KFRC.[37]

Wenner enlisted Gleason, who was immediately supportive for reasons of his own. Gleason had long wanted a journalistic channel that would enable him to speak directly to the young people who were members of the counterculture and liked its music. Gleason hoped that his age and experience would give some perspective to this new magazine specifically and the counter cultural music scene in general. He decided to write a regular column, "Perspectives."[38]

They then had to decide what to call their magazine. Wenner suggested *The Electric Newspaper*; Gleason suggested instead, *Rolling Stone*, a Muddy Waters's song title, originally lifted from a proverb. For their publishing company Wenner suggested Straight Arrow, the proposed name of Helms's new magazine.[39] He also appropriated Helms's mailing list: as it was the only copy of the list, *Straight Arrow* would be unable to publish. After discovering the betrayal, Helms was "stupefied." *Straight Arrow* was unable to begin without the subscriber list, and the magazine folded.[40]

Wenner began his venture with $7,500 borrowed from his mother, mother-in-law, sister-in-law, and Gleason. He also sold some of his wife's stock to obtain the money.[41] He convinced Michael Lydon, a well-known young *Newsweek* reporter, to be his managing editor, and hired a local photographer named Baron Wolman as his chief photographer.[42] *Rolling Stone*'s first office was located in free office space donated by the magazine's printer,[43] and Wenner recruited his wife, Jane Schindelheim, to work for the magazine.[44] He also approached Michael Lydon's wife, Susan, to help out, because he wanted her to help prepare the sample issue by typing address labels for it. When he suggested that this sort of a task was "woman's work," Lydon told him to "go fuck himself"[45]; she was a writer and wanted to write and edit copy.[46] Susan Lydon, at Wenner's insistence, was also *Rolling Stone*'s first receptionist because, as she related to Draper, he believed that "a feminine voice" should always answer the phone. After the first issue Wenner replaced her as receptionist with a self-identified groupie volunteer, Henri Napier, later featured in *Rolling Stone*'s groupie issue.[47] His approach is indicative of the way women would be treated at *Rolling Stone* for many years to come.

Forty thousand copies of *Rolling Stone*'s first issue hit the newsstands on November 11, 1967. Thirty-four thousand copies were returned unsold.[48] After reading *Rolling Stone*, Warren Hinckle pronounced the magazine "counterculture bullshit" and predicted that Wenner's future in the publishing business

would be short.[49] Remarkably, *Rolling Stone* kept on publishing month after month and even seemed to be thriving. The reasons for this are not entirely clear from a traditional business perspective: Wenner did not follow traditional approaches to publishing nor did he look to experts for advice. He had no formal business training, but rather had educated himself from a few used books he had bought on the subject.[50] However, one area of business that Wenner understood very well was the need for advertising revenue. *Rolling Stone*, unlike *Ramparts*, could not depend on its subscribers or wealthy benefactors to keep it afloat. From the very beginning, Wenner and his magazine depended heavily on advertising revenue from record companies. By early 1968, *Rolling Stone* could number almost every major record company among its advertising accounts, including Atlantic, Capitol, Columbia, Reprise, Elektra, A&M, Warner Brothers, and RCA.[51]

Certainly some of Wenner's early successes in this area can be attributed to Gleason's association with the magazine. He had been a music journalist for more than twenty years by the time of *Rolling Stone*'s founding and wielded no small influence in the music community, and his name on the masthead ensured advertising revenue from record companies trying to curry favor with the city's most influential journalist. Thanks to Gleason, musicians agreed to interviews and radio stations promoted the new magazine as well.[52]

However, it was not just Gleason's involvement with *Rolling Stone* that accounts for its success. The record companies recognized that *Rolling Stone* was something completely new and different in the world of youth music and culture magazines. Gleason remarked that the record companies saw *Rolling Stone* "not as a sales tool for their own product exclusively, but as a forum in which to discuss the music they sold in a publishing world which did not [previously] have such a forum."[53]

Though the magazine had financial problems in its first two years of business, its reputation among its young readers never wavered. Despite its initial success, however, *Rolling Stone* nearly went under several times during the first five years of business.[54] By November 1969, however, *Rolling Stone* had definitely turned a corner and reported a paid circulation of almost 60,000.[55] As discussed later, the coverage of groupies played no small role in the magazine's success and continued survival.

The magazine also had become influential in disseminating information on concerts and record releases to a demographic group that had previously been very difficult for advertisers to reach: young, hip, middle-class, white kids in their teens and twenties.[56] Few of *Rolling Stone*'s "faithful" read any other magazines, which gave its editors and writers an opportunity to shape its readers' opinions in a profound way.[57]

Rolling Stone became so influential in music journalism partly because many of its readers thought it was "incorruptible." Certainly the magazine accepted ads from record companies, but the readers believed the writers, and especially the editor, to be motivated by ethics that reflected the new ideology of the "younger generation." These ethics, loosely translated, held that some things were more important than money, rock music being one of them.

In retrospect, we know that Wenner's ethics were questionable. Consider, for example, his method of securing advertising from Warner Bros. Records. In early 1968 Wenner assigned Lydon to pan a Jimi Hendrix album that Capitol Records had just released. Hendrix had recently moved to the Warner Brothers' Reprise label, and Warner wanted *Rolling Stone* to criticize the Capitol album "as a favor" to his new label. Lydon told Draper that he had no trouble obliging as he honestly thought the album was bad, but he also "didn't think much of Jann's ingratiating tactics." The review was written and in the next issue Warner bought advertising in *Rolling Stone* for the first time.[58]

Wenner exerted totalitarian control of the editorial duties at *Rolling Stone*. According to Anson, responsibility for the copy was Wenner's alone, and nothing appeared in the magazine without his sanction. He also took his editorial duties very seriously and did not hesitate to alter copy to his liking. "There is no such thing as objectivity," Wenner has been quoted as saying. "It does not exist. Nobody's objective. It's patent bullshit." If any of the editors challenged his judgment, his stock answer was "It's my magazine." *Rolling Stone* did indeed reflect Wenner's philosophy.[59]

Even though *Rolling Stone* did not begin to publish until late in 1967, it became the benchmark by which other rock music journalism was measured. It is for this reason, and the fact that it became the most widely distributed of the music-oriented magazines, that I begin with I begin my discussion of the treatment of women musicians in the periodical press with *Rolling Stone*. I then address the articles found in the more mainstream magazines, most of which were weeklies. I conclude by addressing the articles on women musicians from the *Village Voice*. By "bookending" my analysis with periodicals from the West and East Coasts, respectively, I will also be able to discuss regional differences in the coverage of female musicians as manifested in these magazines.

To cognoscenti of the counterculture journalism of the 1960s and early 1970s, the words *Rolling Stone* conjure up some truly unforgettable achievements. Some may remember the "gonzo" journalism of Hunter S. Thompson or the prose of Greil Marcus. Others may wax poetic about the reviews of Ed Ward and Lester Bangs or the interviews of Ben Fong-Torres. Though the focal points of their memories may vary, to people who were younger than thirty

during this era and involved in music and the counterculture, *Rolling Stone* was a beacon in the wilderness. Two main reasons exist for its ubiquity in the memories of these people: it had a veritable monopoly on the youth music journalism, and it proclaimed itself the voice of the younger generation and made that pronouncement a reality.

It is not my intention to detract from the successes and achievements of *Rolling Stone*. Rather my project is to reveal the Achilles' heel of this music journalism "god" and those who created it. The men who were in charge of the creation and publication of *Rolling Stone* had one glaring area of journalistic sloppiness, inattention, and rancor: women. As I mentioned above, in many ways *Rolling Stone* was the benchmark against which all other music journalism of this time must be measured. How unfortunate, then, that the magazine's portrayal of women, to paraphrase Dorothy Parker, ran the gamut from A to B.[60]

Compare, for example, *Rolling Stone*'s treatment of the deaths of Joplin and Jimi Hendrix.[61] Tragically, their deaths were less than three weeks apart in 1970; the magazine's descriptions reflect a much wider gap. Hendrix overdosed at the apartment of a woman friend, Monika Danneman, whose inquest testimony *Rolling Stone* quoted: "He was sleeping normally. Just before I was about to go out I looked at him again and there was sick [vomit] on his nose and mouth. I tried to wake him up but couldn't." The unidentified author of the piece noted that "Miss Danneman checked Hendrix's pulse against her own and found no difference [i.e., it seemed normal to her]. Hendrix died in the ambulance on the way to the hospital."[62] There was no mention of how he was dressed or the position of the body.

This description is in sharp contrast to the treatment given Joplin, who died alone in a hotel room. *Rolling Stone* detailed the disposition of her body: "Janis was lying wedged between the bed and a nightstand, wearing a short nightgown. Her lips were bloody when they turned her over, and her nose was broken. She had $4.50 clutched in one hand."[63] Notice the detail in the description of Joplin's clothing. The writer not only mentioned what she was wearing, but emphasized it was a "short nightgown." She's not one of the world's most powerful rock stars who had met a bad end; she's a dead chick in a baby-doll nightgown.

It is also useful to compare *Rolling Stone*'s discussion of Joplin's and Hendrix's deaths to one that did not differentiate their treatment based upon gender. In an unattributed article from the *Christian Century* in November 1970, the author considered Joplin as a cultural symbol but did not concentrate on her gender. Commenting on the significance of the deaths of Joplin and Jimi Hendrix, the author remarked that Joplin's death occurred the same week that Congress had passed massive anticrime legislation. The reasons for this observation were subtle and thoughtful:

The juxtaposition of the two events is a symbolic reminder that the current struggle over the future of American society is deeply rooted in an age-old, classic conflict. On the one hand, "Apollo": order, stability, stasis. On the other, "Dionysus ": disorder, creative energy, kenesis [*sic*]. At their best, both forces meet real needs. Without order there can be neither society nor individual creativity; crimes do cause suffering, and individuals often need protection afforded by laws and police. At the same time, total order means banality or repression. A totally ordered society destroys vibrancy, creative life. Rollo May warns that order's issue may be apathy rather than stability. He acknowledges the *daimonic* as the power both of destructiveness and of creativity.[64]

The author made a direct connection between the idea of the *daimonic* and Joplin and asserted not only symbolic but actual linkages between the two: "And the deaths of Joplin and Hendrix can be seen as sacrifices to the *daimonic*. 'Maybe [my fans] can enjoy my music more if they think I'm destroying myself,' Janis Joplin had said. Her walk through the valley of chaos had permitted her followers to become intimate with the *daimonic* and to drink of its creative power without also sipping of its destruction. Janis Joplin and Jimi Hendrix taught their fans how to feel again, through them. For Janis and Jimi, there was no vicariousness to the experience; they gave themselves to it totally. Finally, it consumed them."[65] Thus, rather than using these two artist's deaths as object lessons on the dangers of drug abuse, as so many did, this author sought to explain larger cultural forces that both led to and reflect the reasons for Joplin's and Hendrix's deaths. Framing the deaths within a philosophical framework that transcended blame or ideas of retribution, the author ended the piece by praising the Aristotelian mean, with a little biblical imagery thrown in for good measure: "Neither [the Apollonian or the Dionysian] exists for long alone, and neither finds life through the destruction of the other. To cherish both, without repressing in the name of order or destroying in the name of disorder, is to quest after the most excellent way. It is for no little reason that the Old Testament portrays creation as both the forging of order out of chaos and the granting of life where there is no life."[66] This discussion of the musicians' deaths with all of its political and philosophical facets is a far cry from the *Rolling Stone*-inspired vision of Joplin dead in her nightie at a hotel bedside. It is not that *Rolling Stone* was not describing the situation as it literally existed. What is significant is the fact that they eschewed this approach in Hendrix's death and chose to employ it three weeks later when describing the death of the most powerful woman in rock music.

Consider also how Ben Fong-Torres described the members of the Mamas and the Papas in 1971.[67] In this article, the two men and the two women in the group were described differently; the women were described according to their perceived attractiveness. The physical descriptions of the two male members of

the group, John Phillips and Denny Doherty, were both less than one sentence long. Phillips was "the tall, tanned, wolf-king-haired leader," while Doherty "is pale and bearded these days, his hair as short as ever."[68]

But Fong-Torres rhapsodizes that Michelle Phillips "is still best described as *lovely* [t]hin but not frail; angelic but not soft." He continued: "Singing her parts, Michelle, in her red and amber checkered varsity sweater and jeans, hair tied back by a ribbon of white yarn, looks straight up at Denny [Doherty] across the table, as if his face were a stained glass window, and sings effortlessly. Singing behind John on 'Lady Genevieve,' she leaves her feet up on the table with her hands clasped, resting lightly between her legs."[69] This account is a far cry from the descriptions of John Phillips and Doherty. Not only was Michelle Phillips's clothing detailed (both style and color are included), but also her hairstyle, facial expression, degree of effort expended while singing, and the positions of both her hands and feet.

Cass Elliot, the other female member of the Mamas and the Papas, was an enormously talented singer who was also obese. In an earlier issue, the magazine had already reported on one of Elliot's very public, and unsuccessful, attempts to lose weight.[70] Fong-Torres alluded to this attempt and then described Elliot: "but she's still very big, very harmonic, and very funny."[71] Elliot was a woman but not one who was considered conventionally beautiful and, thus, not attractive to men. Therefore her physical description, unlike that of Michelle Phillips, was limited to only two words, "very big." As such, gender was not the only factor in the amount of physical description one received in *Rolling Stone*; attractiveness counted too.

According to these standards, in many cases the withholding of details was as devastating to women artists as its application. This fact is especially evident in an instance like the one above where one woman received a detailed description and another did not. That the amount of coverage given Michelle Phillips was based solely on her looks is obvious to those familiar with the music of the Mamas and the Papas, as Elliot was by far the more musically talented of the two. This discrimination seems odd to find in an interview of a musical group for a magazine primarily concerned with music. Yet it appears *Rolling Stone*'s decisions on how much coverage to give female musicians were based on women's appearance and not their musical talent. Thus, the amount of detail offered about women musicians became a tool in the arsenal of male journalists who were seeking to point out a woman's appearance in print while, at the same time, applying a double standard. But damaging comments were not limited to editorializing about a woman's physical beauty or lack of it.

Consider the question of race. One example of a writer who provided

unnecessary details came from a 1970 article about Aretha Franklin entitled "Aretha Cooks Up Some Pigs' Feet." The article started by describing Franklin's current recording sessions. The anonymous writer then reported that the recording sessions never began until late evening because the singer liked to cook soul food for her friends. "She was seen walking through the lobby of the plush Fontaine Bleau [sic] Hotel holding a bag of pigs' feet. The bag broke in the lobby, scattering pigs' feet under the noses of the sun-tanned, mink-clad vacationers, but Lady Soul kept right on walking."[72] This article, which at best could be described as damning with faint praise, was an example of using unnecessary detail that ends in racism. It was true that Franklin had thumbed her nose at the "sun-tanned, mink-clad vacationers" in the "plush" hotel, but she was also fulfilling a racist stereotype by doing it with pigs' feet. Moreover, the writer didn't call his piece "Aretha Cuts New Album in Miami" or "Lady Soul Snubs Rich Folks in Florida" but rather he situated her, in what could have been a nod to racist and sexist traditions, in the kitchen.

Unnecessary details were also used to indicate ethnic/religious prejudice. Writer Grover Lewis simultaneously drew attention to one artist's religious/ethnic heritage while he berated her appearance.[73] In his 1971 article "The Jeaning of Barbara Streisand," Lewis used detail that is anti-Semitic and implied that Streisand was overweight. "Distractedly, she [Streisand] traces a finger along the soft line of deli-food chubbiness that rings her fetching jaw."[74] Lewis connected Streisand's weight to her ethnicity, implying that as a Jewish person she ate at no other restaurants besides delis nor any other type of cuisine. As in the Franklin article, Lewis used these extra details to fit a woman artist into a stereotype, in this case one based upon her religion.

In addition to (and sometimes in tandem with) extra details, journalists at *Rolling Stone* often employed gender-based clichés in their descriptions of women. A combination of the two methods of trivialization is evident in "Laura's Got Them Writhing," a Ralph J. Gleason review of a 1970 performance by Laura Nyro. Gleason wrote: "Laura Nyro's stage image is curious. The songs are so anti-older generation, yet she looks like the girl down the block dressed up in a long white gown for her First Communion, her deep mahogany hair dramatically hanging down past her shoulders, and her pale cheeks heightened with, of all things, rouge."[75] The detail Gleason provides about Nyro's clothing and makeup, when coupled with the characterization of her as a little girl, minimizes the fact that she had given a concert that he also called in the same review "a triumph." The crowd was standing room only, and the theater was "as packed as Bob Dylan or anyone else had ever managed to make it." Yet Gleason used prose that instead diminished Nyro's accomplishments. As a result of this

rhetoric, Nyro becomes not an accomplished singer/songwriter/musician; she was "the girl down the block" in a white Communion dress who had been in Mommy's rouge, of all things.

In this same review, Gleason also referred to Nyro as "the dark-haired Manhattan Latin," "a cameo portrait of the Virginal Piano Student," and "this generation's Judy Garland." However, he referred to her as a singer and a songwriter only once each. By relying on gender-specific descriptions of Nyro, Gleason confined her to narrow, mostly gender-determined categories. These images ultimately diminished her accomplishments and marked her first as a female, and only second as a musician.

Stereotypical sexist clichés abounded in *Rolling Stone*'s descriptions of women from 1967 to 1975. In addition to those above, these stereotypes were a none-too-imaginative collection of the usual suspects: women as housewives, mothers, sisters, dolls, and whores. The use of one other term when describing women was ubiquitous in the magazine. The phrases "imperious whore" and "Babylonian whore" were used in descriptions of Joplin.[76] In a 1969 review of "Mother Earth Presents Tracy Nelson Country," Patrick Thomas combined three clichés into one sentence when he wrote that "Tracy is less whore than housewife-farmwife, actually."[77] Vince Aletti, who usually wrote much more sympathetically about women musicians, also achieved a three-for-one in his 1970 review of a Carnegie Hall concert by Nyro: "she looked like an Italian housewife-whore or real live lady madonna."[78]

Characterizing women artists as female family members was prevalent during this era at *Rolling Stone*. As part of his "Singles" reviews, Paul Gambaccini described Carole King as "everybody's sister" while reporting on the success of her 1971 single "It's Too Late."[79] The effect of this was to undercut King's achievements in the music business. As half of the Brill Building songwriting team of Goffin-King, she had already been responsible for some of pop music's biggest hits of the 1960s. "It's Too Late," which was climbing the charts with a bullet at the time of Gambaccini's review, eventually won a Grammy Award as Record of the Year in 1972.[80] This was hardly the achievement of "everybody's sister."

Wives, mothers, and dolls were also popular clichés for women. In a particularly flagrant example, Fong-Torres used all three of these in the same article: "Her big night. Opening night at the Westside Room of the Century Plaza Hotel but her husband's got it mistaken for some kind of velvet-wallpapered maternity ward."[81] Fong-Torres finally referred to Jackie DeShannon by name in the seventh paragraph of the article. Two paragraphs later he described her as "a coquettish kewpie doll." Subsequently, he mentioned several of her professional achievements, such as touring with the Beatles and writing songs for

the Byrds. However, his first characterization of her, indeed his depiction of her for the first seven paragraphs, was as a nameless, gender-based stereotype.

Rolling Stone writers also implied that women musicians should be held to different standards of conduct than their male counterparts. An article by Lester Bangs on Karen Carpenter is a case in point. Few women performers during this period participated in the music business in roles beyond the stereotypical one of female vocalist. One of the major exceptions was Karen Carpenter, who played the drums. Carpenter and her brother Richard made up one of the most successful pop duos of the early seventies. Between July 1970 and August 1972, the group had seven hits in the top five, one of which went to number one in 1970.[82] In addition to playing the drums in the group, Karen also sang lead, a feat few male drummers in this (or any other era) could match.

Bangs commented on Carpenter's drumming in "The Carpenters and the Creeps." This piece reviewed a San Diego, California, show on the Carpenter's 1971 tour. Far from encouraging her instrumental talents, *Rolling Stone*'s reviewer advised her to give up the drums. "The first thing is that Karen Carpenter not only sings lead but also plays drums—she's pretty damn good, too, seldom falters—but singing from behind that massive set she just doesn't give you much to look at, lovely and outgoing as she is. This band should invest in a drummer."[83] The reason Bangs wanted her to quit drumming was based on her gender and appearance: "she just doesn't give you much to look at." Try to imagine him suggesting to Dave Clark or Levon Helm, two male drummers of the period who also sang lead, that they give up drumming simply because the audience couldn't see them well enough. Instead of encouraging Carpenter's courageous attempt to break out of the rigid gender-based roles assigned to women, Bangs told her to hang up her sticks so the audience could have a better look at her body. Some people who knew Bangs observe that this type of treatment of women was not characteristic of his approach. However, this article remains a glaring example of an application of the double standard in rock based upon one's sex.

Race as well as gender was invoked to produce a double standard in rock music and rock music journalism. As with gender, however, writers could produce articles that shed light on the status quo of women in rock music, as the author of the following article does, thereby writing against the double standard. Though the piece is not from *Rolling Stone*, it demonstrates perfectly that one did not have to use double standards based upon sex and race, and that in fact the reportage is more complex and nuanced if one does *not* employ this type of language.

"Soul Kaleidoscope: Aretha at the Fillmore," written by Michael Lydon for *Ramparts* magazine in 1971, is primarily concerned with some live recording

dates by Franklin at the Fillmore West in San Francisco. Unlike many writers of the day, Lydon's experience included an understanding of the racism and sexism inherent in an industry that, by and large, had few female members in its higher echelons, much less women of color. Lydon was clearly aware of Franklin's position as an African American female artist in the music industry, and made it plain in his description of the possible ramifications of her Fillmore recordings:

The tension between Aretha as a Negro woman singer, a role allowed her by precedent, and Aretha as a newly adventurous artist in the popular music medium, was palpable. She was not making her record the way her white male contemporaries, Bob Dylan, John Lennon, the [Rolling] Stones, or Leon Russell make theirs—on their own with friends, delivered as tapes to submissive corporations. On the other hand she was far freer than in her days at Columbia or when she was Atlantic's brand new success in 1967. Here she was this weekend, the ranking black singer of the day, playing the Fillmore—in much the same position, four crucial years on, as Otis Redding had been at the Monterey Pop Festival in 1967. Where might Otis's music have gone after "Dock of the Bay," written on a Sausalito houseboat during a Fillmore engagement? The Fillmore audience had certainly changed B. B. King's music and career [his shows at the Fillmore are largely credited with introducing his music to white audiences and causing him greater commercial success]—how would it change hers? Might it help her break the invisible constrictions of race and sex that still webbed her in?[84]

Lydon's understanding of the effect that racism had on the music business during this era is much in evidence in this passage, as is his comprehension of Franklin's position and her attempts to change the lot of all African American women in popular music.

Often the sexism of *Rolling Stone*'s writers was not so explicit, as evidenced by the use of the double entendre. Like comedy, journalistic writing also has its arsenal of tried and true weaponry; the double entendre is to the sexist writer what the custard pie is to the comedian. It is difficult to defend against, it is hard for those to who are its targets not to look ridiculous, and such jokes are always good for a laugh at the victim's expense. Additionally, when confronted with their comments, writers can always say the double entendre was "all in fun." Most of the double entendres in *Rolling Stone* are puerile, not very imaginative plays on words about sex and women. But they still damage by degrading women's status as performers.

Take for example a piece by Stu Werbin from 1971, a largely laudatory review of an eponymous album by Fanny. In the last paragraph, Werbin wrote, "the truth is, and some publicity dude will no doubt realize it, that Fanny is the kind of group that makes you want to get behind them,"[85] thereby implying that the women in Fanny made its audience want to have sex with them. By ending his largely positive review with a comment that had the potential to

draw attention to the women in Fanny as sexual/physical beings, the author undermined both their musical prowess and his previous praise. It was as if he were saying, "Yeah, they can play, but I can still dominate them through my sexual innuendo." As is the case with all double entendres, it would have been impossible to pin Werbin down about this sentence's meaning. It is also note-worthy that a variation of this phrase was used by Fanny's own record com-pany in an advertisement for the band that ran in *Rolling Stone* a few months after this article appeared.[86]

During an interview with Millington, I discovered another instance of the application of a double entendre to Fanny. I had originally assumed that the band itself tried to capitalize on the physiological overtones inherent in their name. This assumption was further bolstered by the cover of their first album *Fanny*, which featured a full-body shot of the band standing together with their backs to the camera—that is, a picture of their "fannies." When I questioned Millington about the band's use of double entendre, she gave me a very differ-ent story. She stated that the record company, Reprise, was responsible for this "spin" on the name. Millington said even though the band was aware of the double entendre inherent in the name, they envisioned Fanny as a "great-aunt." The group wanted the album cover to be a picture of the band "rocking out" with great-aunt Fanny in a rocking chair knitting off to the side. Millington said that "the [company's] publicity machine never put out that side of it."[87]

Part of the reason for Reprise's approach can be found in the *Rolling Stone* review, namely that the connotation appealed to male reviewers, program directors, and booking agents. Werbin, in fact, called the album cover "quite funny." Reprise's marketing of the band, which *Rolling Stone*'s reviewer called "the first totally competent, all-female, four-piece electric rock band," relied on body-based stereotypes for its promotional materials. It is also clear that the publicity department of a major record label used a rather infantile double entendre in their publicity campaign for one of the first all-women's bands in American rock culture.

Despite the articles mentioned thus far, most of the male writers of the first rank rarely wrote about women musicians.[88] Indeed, with the exception of Bangs, Fong-Torres, Aletti, and Jon Landau, few of the more well-known writ-ers wrote much if anything about women musicians, thus damning them to a sort of journalistic invisibility. In the early days of the magazine, it appears that they often assigned new writers to cover these women and their work.

For example, take Booth sent to cover Joplin's Stax Christmas party show in Memphis that I discussed above. It is noteworthy that the Joplin assignment was his first for the magazine and that his second published piece was a review of Aretha Franklin's album *Soul '69*. To send someone like Booth, a writer with

no previous publications in the magazine, to such a potentially significant musical event as the Stax Christmas show speaks volumes about *Rolling Stone*'s regard for both women and musicians of color at this point in the magazine's history.[89] That *Rolling Stone* had such a profound impact on music journalism and popular culture makes it imperative that scholars re-examine this magazine from a gendered perspective. From the examples I have provided here, it is clear that it is not simply the case that women were included in its pages. We must discover how the male journalists at *Rolling Stone* included them and what the effect of this treatment was, not only on the women written about but on the women and men who read the magazine as well.

A key ingredient of *Rolling Stone*'s popularity with the youth of America was that unlike most mainstream magazines in the country, it took rock music seriously. The writers at the magazine also purported to speak more knowledgeably and frankly about both the music and the culture of the time. It would be impossible to decide if *Rolling Stone* delivered on these promises without examining some of the more mainstream magazines published during this period. As part of this work, I also wanted to examine articles about women musicians in a selection of mainstream magazines to see if they differed from those found in *Rolling Stone*.[90]

Because articles on women musicians in the mainstream press come from such disparate sources, it is more difficult to discern trends within them than in the articles on women in *Rolling Stone*. That said, four themes or approaches can be discerned in some of these articles: a privileging of the trained musician over the untrained; an attitude of condescension toward the musicians, their music, and their fans; the employment of excessive detail in the description of women musicians; and the use of sexist language, categorizations, or themes. Several themes—condescension, use of unnecessary detail, and the sexist language—were also evident in articles on, or that included, women in *Rolling Stone*. Not all of the four themes were present throughout the five years studied in this work. The trained versus untrained approach and much of the condescension disappeared from the most widely circulated magazines by 1968. However, I still consider them significant because this type of writing was circulating just preceding *Rolling Stone*'s inception and during its first year of publication when its editorial policies were beginning to gel.

Several articles contained comments that privileged formally trained musicians over untrained ones. Formally trained musicians have historically adopted this attitude toward their counterparts who play by ear, much in the manner that literate societies privilege the written work over the oral. Make no mistake, however; this type of characterization is not merely a benign exercise

in hierarchizing. The privileging of one thing over another is, ultimately, an expression of power.

When a writer adds gender or race to this trained-versus-untrained approach, the results are striking. In a 1968 article from the *Saturday Review*, Burt Korall discussed Aretha Franklin in just such terms. "The ABC's of Aretha" was a largely laudatory piece on the singer and her work. The years 1967 and 1968 were watershed ones for Franklin. In 1960, when Franklin was eighteen, John Hammond, a noted A&R representative, signed her to a record deal at Columbia Records.[91] The label disregarded his suggestion to let Franklin develop her own style, and instead endeavored to make her into a pop star who sang show tunes.[92] The results were seven years of lackluster sales.

In 1967, Jerry Wexler, an executive at Atlantic Records, brought her to that label, encouraged her to write her own songs, and coupled her with the Muscle Shoals rhythm section and the Memphis Horns from the Stax-Volt studio.[93] It was at these sessions that Franklin recorded the first of her many hits, including "I Never Loved a Man," "Baby, I Love You," and "Respect," each of which sold more than one million copies.[94] Franklin not only wrote much of her own material, but she also arranged and played piano on many of her songs. Though Korall mentioned much of this information in his article, the way that he characterized Franklin's music contains references to the stereotype that African American musicians are "naturally" talented: "Crucial to the strength of her Atlantic recordings is the fact that everything stems from her primitive art. Song interpretation, arranging conception, even rhythmic patterns are a product of her point of view. As a result, each package is a homogeneous study. That the music has been a gold mine for all involved remains a side issue; that it is lifting and as natural as the woman making it counts for more among those of us who open ourselves to music on a regular basis."[95]

Franklin had been a professional performer since the age of fourteen. She had played and worked with some of the greatest gospel and pop singers in the music business, including Mahalia Jackson, James Cleveland, Clara Ward, Lou Rawls, and Sam Cooke.[96] She had been under contract to a major record label for eight years and had just proven herself to be a hit songwriter. Despite all of this, Korall referred to her musical style as "primitive" and "natural," disregarding the many years of effort it took her to develop it. If she had spent those years at Julliard or on Broadway, it is doubtful that Korall would have described Franklin's style as having sprung fully grown from her "primitive," "natural" brow.

Indeed the use of the word "primitive" has racist overtones, reflecting longer discourses in the twentieth century that equate European music with technical complexity and African music with simplicity and sexuality. Such a

contrast is unjustified. Franklin's Atlantic recordings are musically complex and stylistically distinct. She mixed elements of gospel, rhythm and blues, blues, and jazz in a style known as soul music. It is difficult music to perform, and Franklin's work requires an almost virtuosic level of musicianship to reproduce credibly, much less to create. Her vocal performances during these years, it is commonly agreed based upon both sales and criticism, represent the apex of her vocal career. Many singers who are familiar with her music recognize that to attempt an Aretha Franklin song is to live dangerously, vocally speaking. Her power, pitch, and emotional intensity are almost impossible to match. This music justifies characterizations of Franklin as a tremendously talented and experienced musician at the top of her game. There is nothing "primitive" about it, unless one musical style is privileged over another. Franklin's music is self-aware and the end result of years of effort by an artist of subtle sensibilities and tremendous talent.

Another example of the privileging of the trained over the untrained comes from a 1969 article from the *New Yorker*. This unattributed piece, "Garden Gathering," was a review of a Joan Baez concert in Madison Square Garden. The writer's tone was one of praise, and he rarely had a bad word to say about either the singer or the concert. Yet, when describing Baez's singing, he lets his cultural underpinnings show: "[Baez] stood very still under four brilliant spotlights and sang with the kind of effortless control, intensity, purity of tone, and phrasing that one expects only of accomplished classical singers."[97] Here the wording intimates that audiences might experience a professional performance from pop music singers who have not been classically trained, but they should not expect it as a matter of course.

The attitude of condescension evident in the passages above goes a long way toward explaining *Rolling Stone*'s success. Although *Rolling Stone* wrote in remarkably sexist terms about women musicians, its writers still gave the music serious consideration. They were not critics who believed that classically trained musicians were somehow better than those who were not. In fact, most of its fans admired and were attracted to the apparent rawness of rock's sound and understood its underlying complexity. The music critics in the mainstream journals just did not like the new music very much or think it was as good as more formal genres like jazz and classical music.

The authors of the mainstream articles also exhibited attitudes of condescension toward the women musicians, their music, and their fans.[98] Although most of the writers reserved their disparaging remarks for the musicians' and fans' appearances, some also made negative comments about the music itself. One of the remarks reflected nothing more than a profound ignorance of rock

music and its culture while the others betrayed an attitude of malevolence toward it and the musicians, some of whom were women.

Such an article was "The Nitty-Gritty Sound" from *Newsweek* in 1966.[99] The writer referred to the bands' choices of names as "whimsical and irrelevant," and listed, among others, the Grateful Dead, Big Brother and the Holding Company, and the 13th Floor Elevators. I would perhaps grant the writer the "whimsical" description of these bands' names, but they were far from irrelevant. They reflected artistic interpretations of these bands' world views and articulated the ideology of the counterculture from which they sprang. "The Grateful Dead" came from a quotation in the Egyptian Book of the Dead, and is an example of the counterculture's infatuation with non-Judeo-Christian and Eastern systems of religious and philosophical thought.[100] "Big Brother and the Holding Company" is a combination of an allusion to George Orwell's *1984* and a drug reference (to "hold" is to possess drugs in counterculture parlance). While the name the 13th Floor Elevators was a wry comment on the fact that most buildings, due to superstition, do not have a thirteenth floor, much less an elevator by that designation.

Other articles revealed, at best, a dismissive attitude toward the musicians, their music, and their fans. At worst, the comments displayed an attitude of malevolence. In an unattributed article on Diana Ross from *Time* in 1970, the writer used hyperbole to ridicule her appearance and sarcasm to belittle her aspirations. He spent a great deal of time describing the costumes she wore during her new nightclub act. In all fairness, the writer included the fact that $60,000 of the $100,000 budget for the new show was spent on "elaborate clothes and new arrangements," although he did not break down expenses for each separately.[101] However, his use of hyperbole when describing one of Ross's costumes has no explanation, except that he was trying to make her look ridiculous. "She sports a frizzy Afro wig about the size of a boxwood hedge and a sequined sarong that looks as if it were cut from the Orion constellation."

Racial overtones exist in this comment as well. To call Ross's wig "a frizzy Afro" is redundant. By definition Afros are frizzy, which simply means tightly curled. In this instance, frizzy is invoked much the way earlier generations of racists used "nappy" to differentiate African American hair from Caucasian. In a racist society, to have characteristics of African Americans is to be second class, and in 1970, the writer should have known this. Ross's choice of an Afro also indicated a shift away from the Caucasian-like processed hairstyles and wigs that the Supremes had favored previously. Thus, in the era of the Black Power and Black Panther movements, for an African American to sport a natural hairstyle signified that they were making a political statement.

The *Time* writer also employed sarcasm to belittle Ross's aspirations. He described her future plans in the acting profession with biting sarcasm: "Her aim, naturally, is to be an actress. Doris Day advised her that it was not necessary to study acting, and Diana says, 'If Jim Brown [an African American former football star turned actor] can do it, I can do it—whatever he's doing.' She is especially eager to play the lead in a film biography of the late Billie Holiday, 'to sing about blues and sadness.' Accordingly, she has set herself to storing up bitter experiences that will help her in the role. Her biggest trauma so far came last year in New Jersey, when someone poisoned her pet dogs."[102] Such statements about an African American woman in a racist society were unnecessarily demeaning and, in fact, erroneous. Ross was not a middle-class child of privilege. She grew up in Detroit's black ghetto, living in a third-floor walkup. Later, her family sent Ross to live with her grandparents in the South when her mother contracted tuberculosis.[103] As the first African American to be employed by Hudson's, a large department store, in their cafeteria, it is likely that Ross experienced racial discrimination.[104]

In another example of condescension toward women in rock music, a *Saturday Review* writer combined dismissive comments about Joplin and Big Brother and the Holding Company's music with remarks about their appearance, all of which were designed to belittle their playing. Penned by jazz critic and radio announcer Willis Conover, the article described the 1967 Monterey Jazz and Blues Festival.[105] Immediately after his first mention of Big Brother and the Holding Company's name, Conover sarcastically questioned, "is there an act yet called Hairy Teen-Ager and the Conformist Rebellion?"[106] His description of the band's appearance and sound were equally uncomplimentary. "Three shoulder-length coiffures played amplified guitars, one beat on mercifully unamplified drums, and a young Texas girl named Janis Joplin sang and shouted and jerked." While reading this, one might reasonably ask, what hair length tells the reader about the band's playing. It is also notable that he did not describe the physical appearance of any other musicians who played at the festival, none of whom were from the counterculture.

Conover quoted a portion of a good review of Big Brother and the Holding Company written by Ralph Gleason. He stated his reasons for doing so: "I quote Mr. Gleason out of fairness to the group, because I thought it dreadful. For me, Miss Joplin was an uncured ham, self-confident to the point of bliss, and her associates were heavy and relentlessly unswinging, further proof that tomorrow's leaders are often turned on, or put on, by anything noisy."[107] To describe Big Brother and the Holding Company in terms of its ability to "swing" is like characterizing operatic music in based upon its danceability.

As I discussed above, the writers and editors of *Rolling Stone* treated

women musicians in a condescending manner in many of their articles, while still possessing a clear understanding of the culture that surrounded rock music. These men knew how to write about the bands and the music in terms relevant to the genre. Thus, though it would have been inconceivable to read articles that disparaged these women's music because it didn't "swing," for example, or because the names of the bands were "irrelevant," it was conceivable that a *Rolling Stone* writer would make made fun of a woman's appearance, and in this aspect, it reflected mainstream magazines well.

Most numerous by far were the articles that employed the use of unnecessary details in their descriptions of women. The approach of the writers varied depending on the magazine and the subject, but the practice was a near constant in articles on women, with the exception of those in the *New Yorker* which were largely written by Willis. *Time* and *Newsweek* were the most egregious offenders, with writers who seemed incapable of describing female musicians without resorting to such strategies.

Mainstream writers, however, used varying approaches when they supplied extra details. Several articles commented on the height and weight of the female musicians while others made use of an excessive number of superficial adjectives in their descriptions. Some of the latter were merely examples of authors who seemed to believe that any article on a female musician must contain some account of her appearance. Others were not so benign, and used details to objectify women musicians or to make them seem ridiculous. Finally, several descriptions of Joplin, mostly from *Newsweek*, are object lessons about how unnecessary details can be used to diminish women musicians and their work.[108]

Charles Michener used of this type of language in a 1972 *Newsweek* article, "The Pop and Op Sisters." This article compared the Simon sisters, Carly and Joanna, who were singers, Carly in pop music and Joanna in opera. The detail about Joanna's height was much in evidence in Michener's description of her: "She huddled her elegant, leggy, 5-foot 10-inch frame under a blanket."[109] Here the author not only drew the readers' attention to Simon's body but also let them know that she had long legs, further concentrating their attention on her body. Locating her under a blanket was just a sort of sexist lagniappe.

Another writer mentioned the female musician's weight as well her height. From a 1968 *Time* magazine profile of soul music, the remark concerned Franklin: "In all its power, lyricism and ecstatic anguish, soul is a chunky, 5-ft. 5-in. girl of 26 named Aretha Franklin singing from the stage of a packed Philharmonic Hall in Manhattan."[110] Here the author supplied Franklin's height, but also implied that she was heavier than she should be. Her talent was also related to her body size. This article was not the only one that implied

Franklin's weight was not ideal. Burt Korall in the *Saturday Review* opens his discussion of Franklin by describing her as "a husky, buxom young woman."[111] I am not disputing that Franklin may indeed have been "chunky" or "husky" or "buxom." However, in the case of a person as talented and successful as her, there were certainly subjects that had more bearing on Franklin and her music, which was the ostensible reason for the articles in the first place.

Compare this to Lydon's reportage on the same subject from the *Ramparts* article quoted above and notice how his language differed from that of the other two authors. Lydon's descriptions of Franklin's physical appearance showed great sensitivity and depth. For example, he did not supply details about her clothing as superfluous detail but rather included them as an integral part of the point he was making:

Aretha Franklin is short and round. Her clothes—high boots, short knit dresses, sunglasses, and costume jewelry—are stylish and expensive, but, while they suit *her*, they are not glamorous. She is a lovely black sister, not a willowy show biz figure like Diana Ross or Dionne Warwick, whose well-earned successes have in part depended on their stunning faces and figures. Aretha's beauty, while no less apparent than theirs, is more internal. At rehearsals her movements were restrained, her demeanor quiet and even shy. While the Sweethearts of Soul, her back-up singers with their curly wigs and patent leather bags, flirted and carried on like schoolgirls, Aretha stayed in the background when she wasn't singing. Her eyes took everything in but gave little back.[112]

Here Lydon describes an alternative to the "skin deep" beauty that typified most male periodical writer's approach to women during this era.

In contrast, women who were heavier than average often had their exact weights listed in mainstream articles. An example is a 1968 *Newsweek* profile of women singers. "Spanky McFarlane, nee Elaine, is one sizable ego, 5 feet 4 inches tall, weighing 140 pounds. 'After Cass Elliot, the world was waiting for another chunky chick, and here I am.'"[113] In the course of describing Elliot's failed attempt at a solo career, a 1971 *Newsweek* writer reported on her weight loss: "[Elliot] had dropped 120 of her 260 pounds and picked up mononucleosis."[114] By reporting the women's weights, writers emphasized the woman's physicality over her musicianship. Moreover, in the case of women who were larger than ideal, the focus on their exact weight had a destructive effect by implying that the woman failed to match a "normal" weight.

Women who were of slim build were also described in a manner that included extra detail. In a *Newsweek* article from 1970 on the singing duo Delaney and Bonnie, Hubert Saal commented on the female member's appearance. Intimating that Bonnie Bramlett's small build should have prevented her from singing powerfully, he writes: "When she's not singing, every muscle in her slender body is animated by the music. When she is singing it's hard to

believe. How can such a slightly built girl, in 'Hold Me' or 'That's What My Man Is For,' produce tones so sexy, abandoned and window-shattering?[115] Saal's logic in this statement is difficult to follow. The relationship between body dimension and ability to sing with abandon, in a sexy manner, or so as to shatter windows for that matter, is unclear. Voice projection is not necessarily related to size, as Brenda Lee has proven on most occasions.

Many of the authors who provided unnecessary details in their descriptions of women musicians did so through the use of an excess of adjectives. Sometimes they simply used many descriptive terms, that often had nothing to do with these women's work. A few of these instances were "value-neutral"; that is, they described but did not editorialize about whether the women's appearance was a good or a bad thing. Other times they merely fell back on the time-honored sexist idea that describing a woman as attractive is a necessity in order for people to like her music. Still other uses were instances of "death by extra detail." In these cases, they concentrated an inordinate amount of attention on the women's appearance.

An example of a value-neutral application of extra details is a 1967 piece in the *New Yorker*. This unattributed article, "The Non-Violent Soldier," reports on a Joan Baez concert held by at her Institute for the Study of Non-Violence in Carmel, California. The article is very complimentary of Baez and her work, but spends the better part of a paragraph describing her appearance: "[Ira Sandperl, Institute director] led us around a clump of chattering students toward the fireplace and a smaller group that included Miss Baez, who was wearing black pants and pullover sweater, and who struck us as startlingly more beautiful than any of her photographs suggest—features more delicately sculptured, expressions more luminously candid and humorous, hair only shoulder-length—and who, besides all that, was not behaving like a star whose concert was in imminent peril of being rained out."[116] Here the author made few value judgments on Baez's appearance. He did call her "beautiful" but only by way of comparing her looks to photographs of her.

At other times, the authors' providing unnecessary details about a woman musician's appearance was overly descriptive. In some instances this excess of description was merely that. In others it appeared to have a more salacious or titillating edge to it. Two articles that contained descriptions of Joni Mitchell, one from *Time* and one from *Newsweek*, illustrate this point. The merely overly descriptive example was in *Time* from 1969: "Joni is a blue-eyed, freckle-faced girl with straight, waist-long blonde hair who doesn't seem to care about her new wealth."[117] The author gives a great deal of information about her appearance, but his language is value neutral.

A less benign description of Mitchell was included in a 1969 *Newsweek*

article by Saal on several female folk and rock musicians. The title, "The Girls—Letting Go," gave a hint of the writer's approach. "'My mother was a romantic woman,' says the Canadian-born Joni [Mitchell], whose flaxen hair flows down to the small of her back."[118] Mitchell's hair was not simply long; it "flowed" and terminated in the "small of her back." This vivid description draws much attention to Mitchell's body and appearance. That its detail was superfluous is evidenced by its contrast to the previous quotation, the language of which had only a lascivious edge to it.

In another example, the writer's word choice seems clearly intended to provoke a salacious response. In a *Time* article from 1969 on the Fifth Dimension, the writer employs adjectives designed to titillate: "It was Lamonte [McLemore, member of the group] who met Marilyn McCoo, 25, lanky and curvaceous daughter of a Los Angeles doctor, while photographing the 1962 Miss Bronze California Pageant. Marilyn won the talent contest."[119] Here the author suggests that McCoo's lanky curvaceousness won it for her. Even if this was the case (and it likely was), the implications are that her career was founded on her body rather than her talent.

The final example of this extra detail was a real "poster child" for the method. It included not only the woman musician's height and a value judgment about her appearance, but it also intimated that she was overweight and buried the readers in descriptive hyperbole. The article, a 1972 piece by Charles Michener from *Time*, was about Bette Midler. Michener began the article with his description of Midler's physical appearance: "Next to the likes of Lainie Kazan, Lena Horne or Dionne Warwicke, Bette Midler is an ugly duckling. Her tiny, 5-foot frame seems absurdly inadequate for her ripe, oversize torso and her large oval face with its ski-jump nose, toothy mouth, and mop of curly red hair that is vaguely reminiscent of Rita Hayworth as Sadie Thompson."[120] When so many details are found in one spot, it is easier to see the effect it has when an author employs this approach. In Midler's case, Michener was implying that she looked ridiculous and was physically unattractive. In any case where a male author includes superfluous details in his description of a woman, it is an exercise of power. By concentrating a reader's attention on a woman's physical attributes, he objectifies her and distracts the reader from the reason for writing about her, namely her talent.

Finally, several descriptions of Joplin, mostly from *Newsweek*, illustrate how these extra details diminished this most influential and revolutionary of the women musicians in this era. The authors mostly used comments about Joplin's clothing to draw attention to her carnality. The effects of this approach were varied but all attempted to diminish Joplin and her accomplishments by describing her as "just another chick," when in fact she was the most innovative

performer in rock music at the time. She was also a very public example of a woman who embraced her sexuality and sought to dismantle the sexual double standard so prevalent during the years included in this work.

My first example was an unattributed 1967 *Newsweek* article on the Monterey Pop Festival. The author's use of detail is jarring because it is so at odds with the rest of this description of her: "But it was a onetime apprentice of Otis Redding's, Janis Joplin, who blew the minds of the listeners. A singer with Big Brother and the Holding Company, a group all but unknown outside of San Francisco, Janis jumped and sang like a demonic angel in her gold-knit pants suit. San Francisco Examiner [*sic*] Phil Elwood called her 'the best white woman blues singer I have ever heard.'"[121] Including the detail that her pants suit was "gold knit" seems unnecessary in relation to the degree of praise given Joplin. The author says she was "blowing people's minds," yet the clothing detail raises the question of how much her outfit played in the effort. Was it Joplin's jumping or her singing or her pant suit that "blew minds"?

To better understand the effects of the employment of extra details, it is useful to compare the passage above to an example of nonsexist writing that described the same event. This unattributed *Time* magazine review of the festival included a description of Joplin's performance as one of the "high points." "Janis Joplin, backed by a San Francisco group called Big Brother and the Holding Company, [was] belting out a biting alto and stamping her feet like a flamenco dancer."[122] That the author describes the artist and her performance without drawing attention to her clothing demonstrates that writing without this type of detail can be both effective and vividly descriptive. This piece focused on her singing and dancing, what made her performance at Monterey memorable, not what she was wearing.

The next instance of the use of gratuitous details was in a 1968 *Ramparts* article on Joplin. Written by Michael Thomas, "Janis Joplin: The Voodoo-Lady of Rock" described a party held by her road manager John Cooke when Big Brother and the Holding Company played in Boston. One of the descriptions is lengthy and full of detail while the other is shorter. Both were designed to titillate by portraying Joplin as a "bad" or an "easy" woman. At first glance, salacious descriptions of Joplin's public image from this era may seem to be in line with the public persona that she sought to create in the media, but I consider Joplin's actions the case of a woman attempting to expand the sexual possibilities for women.

An example of this portrayal is Thomas's description of Joplin's entrance into the party. "Janis Joplin came in, wearing a not-so-brand-new fur pillbox hat, with a fur handbag on her arm and bells jingling against the tight blue silk on her thighs, a quart of Southern Comfort under her arm and beads around

her ankle."[123] Thomas intimated that Joplin was haphazard about her groom-ing her hat is "not-so-brand-new." He not only described the material of her pants but drew attention to her body by writing that they were tight "on her thighs." The fact that Joplin came to the party with a quart of whiskey under her arm conjures up images of drunkenness or at least of being sexually vul-nerable or available. The next description focused on Joplin's face, hair and laugh: "Her face is pale, almost chalky, but looks as though she spends a lot of time outdoors; her forehead is furrowed and her cheeks are plump, her hair is raggedy—it's the kind of face to catch the eye of whoever it is draws Li'l Orphan Annie, except Janis' eyes roam too far and stare too hard. She looks like a beautiful barmaid with beads. She cackles when she laughs."[124] This pas-sage painted her as a pale, comic barmaid with a sense of humor, the stereo-typical "fallen girl" with a heart of gold.

Writers at *Rolling Stone* and the mainstream magazines were equally cul-pable in the utilization of superfluous details when describing women musi-cians. This similarity belied *Rolling Stone*'s claim that they were writing an entirely new type of music journalism and undercut its cultural posturing. Indeed they may have done so with male artists, but they certainly were not when it came to female artists. Although the mainstream magazines employed the practice primarily by describing the performers' bodies, both types of jour-nalism were using this type of detail for the same reason: to draw attention to women as women rather than as musicians, and by doing so they undermined the women's stature in a patriarchal system.

When describing women musicians in print, writers used other types of sexist rhetoric besides these extra details about their appearance. Sometimes they printed sexist remarks by other male and female musicians. They also fell back on the standard approaches of describing women using sexist stereotypes. Often this writing demeaned these women's work and lifestyle. Yet whatever the circumstance of these sexist writings, the results did not help women es-cape the roles that the patriarchy allowed them. In contrast, when authors allowed the women to speak for themselves in the articles, the results were truly insightful. These quotations also allow us to hear how the women musi-cians felt about their role as very visible examples of the way women's lives were changing during these years.

As one of the earliest and most visible of the women musicians, Joan Baez was featured frequently in these articles. Many writers treated her with much respect, possibly owing to her involvement with the civil rights movement, her antidrug stance, and her nonviolent Quaker beliefs, but occasionally they treated her in sexist ways. One example occurred in a 1967 *Time* article, the topic of which was a cartoon character by Al Capp, the author of "Li'l Abner."

The character in question, "Joanie Phoanie," was clearly intended as a parody of Baez. Capp, whose politics were notoriously to the right of center, was an ardent opponent of the counterculture and the antiwar movement of the 1960s.[125] Capp had created Joanie Phoanie as a way to both embarrass Baez and express his contempt for those opposed to the Vietnam War. The clearly partisan *Time* article "Which One Is the Phoanie?" discussed the cartoon character and Baez's request for an apology and the removal of the character from his strip: "Joanie Phoanie is a sight. She has a roller coaster of a nose, unraveled hair, and sandal straps that look as if they're devouring her legs. She douses herself with deodorant, wolfs down caviar in front of famished children. She sings of brotherhood to incite student riots. When one song triggers only three uprisings, she composes another she is sure will be a blockbuster: 'A Molotov cocktail or two/ Will blow up the boys in blue.' Could it be Joan Baez?"[126] Capp had denied that the character was Baez and refused to make any amends to the singer.

Baez complained that the cartoon misrepresented her beliefs. "'Either out of ignorance or malice,' she wailed, 'he [Capp] has made being for peace equal to being for Communism, the Viet Cong and narcotics.'" Although much of this article objected to Baez's politics, the author's use of the word "wail" is a word choice that has negative gender implications. It is highly unlikely the verb would be used for a male's complaints and trivializes Baez's position to a feminine display rather than a reasoned debate.

The final example of nonspecific sexist comments about Baez in these articles came from the *Christian Century*. Written by Charles E. Fager, this piece is a review of Baez's film, *Carry It On* (1971). The writer admitted to being prejudiced against Baez, and to having expressed those prejudices in earlier columns. Fager's opinions were based on her attitude, her politics, and her music. However, even his words of praise for Baez are insultingly sexist: "Such criticisms aside, the film gives us a Joan Baez who expresses herself with more calm and humility than I had earlier seen her display. And her singing seems to have gained new depth. It is tempting for a critic to draw self-serving conclusions from such observation [*sic*]—that she must have been learning some of the lessons of impending maternity, or coming to grips with the wearing nitty-gritty of a three-year separation from her husband [David Harris, an activist jailed for failure to comply with the draft laws] for which not even stardom can compensate, or even listening to some better music."[127] The writer was saying that if Baez's singing had gained "depth," it must have resulted from either her harnessing her ability to reproduce or because she could not rely on her husband. The possibility that her changes might have been a result of her life experiences as an individual rather than someone's mother or wife was not

suggested. Written far enough into the women's liberation struggle, the journalist should have known better.

The sexist idea that women are more simple and natural than men was expressed in "The Girls—Letting Go." Written by Hubert Saal in 1969, the article discussed women in rock music, focusing on several women including Joni Mitchell, Laura Nyro, and Melanie. Patriarchal sexist language often equates women with nature or beliefs that women are innately more "simple" than men due to their sex. Saal provided an example of this: "Each of these female troubadours is herself, distinct in style and subject. From Joni Mitchell's need for ruralizing greenery to Laura Nyro's ecstatic wonder, what they celebrate is the natural, preferring the simple joy to the complex, the artless to the artful and, rather than the holding back, the letting go."[128] The artless/artful contrast can be viewed as either a compliment or a sly dig. Artless can mean either "free from artifice" or "rudely or simply made," while artful can signify either "artificial or wily" or "dexterous or requiring skill to produce." Saal was either implying that these women's work was simple or required little skill to produce or that their work was without artifice or subterfuge. Yet anyone familiar with either Nyro's or Mitchell's work, even that produced prior to this article's publication date, would have realized how wrong it was to call their work artless in either sense of the word's meaning. Their work is some of the most complex and tightly crafted, both lyrically and musically, of any produced in the rock movement. Both were innovators of the first rank as well, a role which requires a clear understanding of the preceding work. This development is hardly a "natural" process but rather one that requires a great deal of thought as well as inspiration. Thus, while Saal may have intended to compliment the women, the effect is to misrepresent their work and potentially open them up to erroneous equations with the "essential" feminine.

In two instances, a male and a female musician were quoted as saying sexist things about their audience and their lifestyle, respectively. The male musician was Marty Balin, another of the lead singers for the Jefferson Airplane, and his remark appeared in *Time* in 1967. Concerned with the San Francisco sound and the bands who played it, the article ends with Balin's views. "'The stage is our bed,' exults Balin, 'and the audience is our broad. We're not entertaining, we're making love.'"[129] Had Balin used the word woman or lover rather than broad, the remark would be less sexist. However, "broad" as it was used here as slang for "a woman" implies promiscuity. Balin's comment spoke volumes about how he regarded women.

Male musicians were not the only members of the profession guilty of making remarks supportive of patriarchy to magazine journalists. At least one woman artist also did. Bonnie Bramlett was a member of the band Delaney

and Bonnie and Friends, a rock group that at times included Eric Clapton. She was also married to the Delaney of the band's name. Bramlett's quotation ended a 1970 *Newsweek* article about the band: "She's [Bramlett] been at it ten years and has two children and says, 'I never liked working as a single artist. A woman needs a man to take care of her. Delaney is my husband and my partner—and my friend.'"[130] Not all women felt as Bramlett did about working in the largely all-male business of rock music.

Indeed, one article from 1968 included extensive quotations from women musicians about being women working in rock music. Titled "The Queen Bees," this unattributed article from *Newsweek* briefly profiled several women musicians, including Joplin, Slick, McFarlane, Sandi Robison, Linda Ronstadt, Barbara Cowsill, Tracy Nelson, Mary Nance, and Tina Meltzer.[131] These women were part of a group of female musicians successfully entering the music business in 1967–68. Although these women had vastly different styles and vocal ranges, the author tried to lump them all together in several ways. For one thing, the author asserted that all of these female singers shared a vocal commonality: "Ever since that volcano of sound named Mama Cass Elliot erupted, an extraordinary collection of hot and cool contraltos has poured onto the rock stage until, now, the typical rock group resembles a beehive, three or four drones humming about a queen bee."[132] Elliot, Slick, and McFarland most definitely sang in the contralto range, which is between a tenor and a mezzo-soprano. However, Joplin, Robison, and Ronstadt were either altos or sopranos.[133]

Three possible explanations exist as to why the author would have printed these inaccuracies. The author may have been too unfamiliar with these women's music to know what their vocal ranges were, or he didn't care and he just wanted to make all the women in the article fit together. I also believe it is possible that the author was trying to intimate that women were finally entering rock music because they all sang in a range that closely approximated male singing. Such a view certainly would also be acceptable to other men looking for a reason why all of these women were entering the previously all-male world of rock music.

While researching the articles on women musicians in the mainstream magazines, the most noticeable thing was how few articles existed. The articles from *Rolling Stone* and the *Village Voice* take up the better part of half of a filing cabinet, while the articles from the mainstream magazines form a sad little pile about four inches high. Even though in their articles on women musicians the reportage in the *Rolling Stone* was often not very progressive and the focus of the writers in the *Village Voice* was often decidedly East Coast to the exclusion of other regions, these publications did write more frequently about women musicians and their work.

Comparing the writings about women musicians from *Rolling Stone* and the mainstream magazines to those in the *Village Voice* conjures up the proverbial apples-to-oranges cliché. The work from the former two sources was predominately article-driven (*Rolling Stone*'s "Random Notes" was an exception to this generalization), while the material from the *Village Voice* consisted mostly of information presented in column form. That, however, is not the only difference between these three sources. Most important, qualitative differences existed between these three sources in their writings on women musicians, with the *Village Voice* material generally exhibiting a much more nuanced and measured approach in its treatment of women.

For all intents and purposes, rock writing in the *Village Voice* began in 1966 with the advent of Richard Goldstein's column, "Pop Eye." However, Howard Smith's column "Scenes," which preceded Goldstein's, though not solely concerned with music gradually became a source of information on the women musicians as well. In 1968 another column, "Riffs," was added and was originally penned by Annie Fisher. In 1969, Robert Christgau's column "Rock and Roll" replaced Goldstein's when the latter ceased writing "Pop Eye." Finally, in 1971 and 1972, respectively, Carman Moore's column "new time" and Patrick Carr's column "cheap thrills" were added. It was rare for music topics to be addressed outside these columns during the ten years included in this work.

"Pop Eye" was arguably the first rock column produced by peer-group criticism in a major American newspaper or magazine.[134] It was an erudite, well-written source of commentary on the burgeoning rock-music field written by someone who, at the time, could only be characterized as a true believer. Goldstein's passion and engagement, as well as his formidable writing talents, were evident in his work on rock music produced for the *Village Voice*. I will compare his language, approach, and choice of subject matter to those found in *Rolling Stone* and the mainstream magazines.

Reading Goldstein's "Pop Eye" column is to glimpse the possibilities of the field of rock journalism before *Rolling Stone* laid its misogynist hands upon it. As one of the creators of peer-group rock journalism and definitely the most widely read of the early writers in the field, he was able to invent a new way of talking about rock music. Goldstein's writing was a thoughtful blend of media theory (Marshall McLuhan's name appeared in more than one column), tightly crafted journalism, politics, humor, and poetic language. Most important to this work, his articles on women musicians exhibit these tendencies as well.

The "Riffs" column was less coherent than "Pop Eye" and often consisted of concert or record reviews or announcements of impending shows, although in the beginning there were some article length pieces. Although begun by Fisher, "Riffs" evolved over time to include several other writers and later

became simply a place to post album and concert reviews. Carman Moore (who would eventually have his own column "new time"), Lucian Truscott IV, Don Heckman, Ira Mayer, Johanna Schier, Richard Nusser, Vince Aletti, and Frank Rose were some of its more frequent contributors. It is most valuable to this work due to its choice of subject matter and as an example of an East Coast alternative to *Rolling Stone*'s more San Francisco-centered approach to rock journalism.

Christgau's column "Rock and Roll" was one of the few examples at the time of a male rock critic writing with a feminist approach to women and gender in rock music. As such it is not only an anomaly but visible proof that the alternately dismissive and reductive approaches: typically employed by *Rolling Stone* and the mainstream magazines were just that, approaches. Christgau, much like Ellen Willis (with whom he lived during some of this period), presented a subtle picture of women musicians and their work and frequently addressed the subject of gender and women in rock music. Most well known for his series of album reviews entitled "Consumer Guide" and numbered sequentially, his writing demonstrated unequivocally that men could, and sometimes did, write about women in rock music during these years in an even-handed and measured way.

This approach also typified Goldstein's writing on women musicians in his column "Pop Eye." A few examples of his characterizations of women musicians serve to typify the body of his work. Consider two descriptions of Grace Slick's voice, both from 1968. Even in his less colorful prose, Goldstein was able to render the most quotidian task of reviewers, the album review, colorful and humorous. In a review of the Jefferson Airplane's *Crown of Creation*, he writes, "After this album you have to consider Grace Slick one of the finest stylists in rock. Her lyrics for 'Lather' are wistful and melancholic. And her singing on 'Triad' is strident without being Streisand."[135] Finally, in the column where he announced his choices for the best artists and material of the year, he writes, "As vocalist of the year, I chose Grace Slick of the Airplane, because she can sing as though her spine were made of eels, and then toughen up to hit a note as though it were a baseball."[136]

In an article on Aretha Franklin, Goldstein's prose was evocative and descriptive as well as being personal: "Then there is Aretha Franklin. She drops notes on me like a raincloud. Not always, but sometimes, I sit there listening to her bend sounds—tickling, coaxing them—as though she were sculpting, not singing. Even when I've heard 'Respect' 50 times, it picks me up at 5 A.M. when I'm washed out with a stubborn article, and watching the streetlights go out."[137] To read Goldstein's prose is to gain some sense of his passion and complete absorption in the music to which he was devoting so much time and effort.

However, Goldstein was not always laudatory to the women performers, or groups who had women members, about which he wrote. Often his criticism appears to have been meant to chide talented artists to live up to their potential. This is especially evident in a passage from 1967 that described music by the Mamas and the Papas: "The Mamas and the Papas do a thoroughly scurrilous rendition of the old Shirelles hit: 'Dedicated to the One I Love.' What was once a solid chunk of raunchiness is now cotton candy. But who wants limp revivals, especially from a group which used to specialize in socking harmonies and vocal pyrotechnics. 'Dedicated' needs an erection."[138] Here it appears that Goldstein truly liked the band's work and was merely disappointed with their current offering. More important, he focused his attention on their musical capabilities.

In his treatment of Bobbie Gentry, Goldstein alternately injected some wry comments as well as some political elements into his two columns in which he mentioned the singer, while not neglecting the musical aspects of her work. The first was written just as Gentry's song "Ode to Billy Joe" was beginning to gain some notice at the New York radio stations:

Her [Gentry's] yarn holds together well, and its power is enhanced by a sparse production. The strings stay secluded, brushing the voiceless pauses with grim cellos and squeaking violins. These tense musical touches become the mood of the narrator as she sits at the dinnertable hearing of her lover's suicide. And as the plot unravels, the conversation up front continues: eternal, irrelevant, ironic. But analyzing this song tends to falsify it. Ambiguity not withstanding, "Ode to Billy Joe" is no mighty tragedy, and Bobby Gentry no Sophocles. It's just another example of how important a strong narrative remains to folk and pop music. If it had been written 100 years ago Joan Baez would be warbling "Billy Joe" on acoustic guitar. Today, it's the WMCA [a large AM station in New York City] "long shot." Times change, but melodrama is ageless.[139]

In this short passage Goldstein discusses the song's musical merits and details, its narrative structure and historical importance, trends and traditions in folk and pop music, as well as contemporary and timely business considerations. Compare this to Goldstein's treatment of a press conference held for the singer:

You ask about the song's geography and she says it is all real, nothing more than a glance from her father's place. "Some station in Dallas is running a contest about what they threw into the water," she reveals, missing a wisecrack in the background about Tupelo, Mississippi being where they burn Nigras [*sic*]. "The winner gets to see the Talahachie Bridge." With the hottest topic of conversation in America this week being what to do about them Nigras [*sic*] and what in the hell went on at that bridge, the good people of Dallas will probably offer some intriguing possibilities. Even airline stewardesses on the upper East Side have an interpretation; they wink knowingly and mention one or another slang for fetus.[140]

This passage addresses even larger concerns than the previous one and injects some politics into the mix as well. The summer of 1967 was sometimes known as the time of "riots, Rap [Brown], and 'Retha." Many cities, especially Newark, New Jersey, experienced widespread rioting in their African American ghettoes and Goldstein's comments convey some of the anxiety felt by many white Americans at this time. While his references to the "Nigras" was a not-so-sly dig at those whose racial consciousness barely allowed them to refer to African Americans as anything but "Niggers," his final remark about the stewardesses and abortion drew attention to the battle being waged over this cause in the pre–*Roe v. Wade* America of 1967. These topics are heady stuff for a column on pop music, but indicative of the depth and quality that Goldstein brought to the field.

Goldstein's prose, even when he was criticizing women musicians and their work, never stooped to the juvenile, sexist rhetoric found in *Rolling Stone* and the more mainstream magazines. For example, Goldstein hated Joni Mitchell's performing: "No to Joni Mitchell! All they say about her is true. She is sensitive, all right. Oh that Tinkerbelle voice. How she sparkles fairy dust over essence and existence. Very soulful songs she writes, but very antiseptic too—no? Odor of Bactine over bleeding wounds of life. I come away feeling as though I've been served charlotte rousse in the name of steak. Very tasty, but one hell of an excuse for a meal. I guess what it comes down to is that Judy Collins thing again. I can't stand someone who comes on like beauty and leaves me feeling only pretty."[141] Although here he makes comments that are gendered, that is, referring to Mitchell as having a Tinkerbell voice, they are not sexist in the same way that the extra detail and double entendres found in the other magazines are. Goldstein was commenting on a quality found in both Mitchell's and Collins's work that he didn't like, not complaining because of, or drawing attention to, some essential quality they possessed related to their sex.

In his comments about women musicians, Goldstein never took the low road. In fact, even when ample opportunity existed for him to refer to these women in sexual terms, he often chose not to. An example is a comment about Janis Joplin's leaving Big Brother in 1968 and her efforts to find a replacement band: "Well, they are still auditioning musicians for Janis Joplin's new band. It's going to be a hard pull. Big Brother—whatever it lacked in virtuosity—was a compleat [sic] unit, as tight in its thrust as a confident cock. I don't particularly relish the thought of Janis against a studio back-up band; it would be like building a log cabin in the middle of Levittown."[142] It would have been very easy for Goldstein to have continued the sexual imagery that he had begun in the second and third sentences. That he chose not to illustrates that the precision and vividness of his language was more important than his employment of sexual innuendo as a strategy for degrading female musicians.

Also, consider another of Goldstein's descriptions of Joplin, this one of her 1967 performance at the Monterey Pop Festival: "A lot of it [the festival] was superb, with the most memorable performance provided by Big Brother and the Holding Company of San Francisco. Their major asset is a tiny capped [*sic*] crusader named Janis Joplin, whose voice sounds like a pitched battle between Aretha Franklin and Cass Elliot. It's a twitchy, raunchy, regal sound which turns you inside out with primal power. On a furious wailer called 'Ball and Chain,' she slinks like tar, scowls like sunburn, shrieks like war."[143] This is a far cry from *Newsweek*'s "gold-knit pants suit" description of that same performance.

Another head-to-head comparison between Goldstein's work and that of a writer at one of the other magazines, in this instance *Rolling Stone*, is also indicative of the differences inherent in their work. The subject matter on this occasion was the all-woman singing group the Shangri-Las. Separated temporally by almost two years, the difference between the style and quality of the two articles was much larger.

The article from *Rolling Stone* bemoaned the lack of sex appeal exhibited by the new generation of women rockers in comparison with their early 1960s counterparts, the all-girl bands. Titled "Da Doo Ron Ron," it was writer Richard Fannan's only contribution to the magazine. Factually suspect—he erroneously attributed "Da Doo Ron Ron" to the Ronettes when it was actually recorded by the Crystals—the article was a pseudo-porn collection of male fantasies centering on women rock musicians. For example, Fannan described the Ronettes as "Negro-Puerto Rican hooker types with long black hair and skin tight dresses revealing their well-shaped but not quite Tina Turner behinds." His characterization of the Shangri-Las was hardly more imaginative or perceptive: "The Shangri-las [sic], the white whore types with their high boots, when high boots were only worn by toughs and hustlers, and their skin-hugging blue jeans, faded and well-worn. And even more incredible were their songs. 'Leader of the Pack' about a motorcycle hood and she's his girl and you know he balls her every day then the tragic ending: he dies and she's left without a protector."[144] The overheated juvenile-style prose aside, it is clear from these descriptions that what was most important to Fannan (his describing their songs as "incredible" notwithstanding) was these women's sex and they way they looked, not their music. The female musicians here were described solely in terms of their sex appeal to men and boys.

This article was in sharp contrast to Goldstein's article on the same subject, titled "The Soul Sound From Sheepshead Bay," which was ostensibly an interview with the three women who made up the Shangri-Las. He too described the attire they wore in the early 1960s, "clinging blue jeans and leather

jackets, knee-high boots." However, he concentrated much more of his piece on the women's music and a description of the nature of soul in music. Compare a couple of descriptions of the band: "The Shangri-Las, three white girls from Queens, have soul. Their look and their sound is New York," or "Shangri-La epic tales supply a heady dose of fantasy to fill vague adolescent stirrings," or "Rebellious passion is the dominant subjects of Shangri-La ballads, but their material concerns itself with other love as well."[145] These characterizations are a far cry from Fannan's stark virgin-whore binary.

Even though he took the music seriously his writing, Goldstein's column was not all gravitas. His clever humor and his passion were always much in evidence. Despite the fact that he wrote during the pre-second wave feminism era, his work on women musicians showed very little deviation from this generalization based upon gender. He wrote about musicians, not sexes. Such a characterization would also be an apt one for his successor, Robert Christgau.

Christgau's column "Rock & Roll" was a fitting replacement for Goldstein's "Pop Eye" in many ways. Christgau was a perceptive and talented writer whose views on women were also very progressive. Beginning early in his career at the *Village Voice*, he structured many of his columns as "Consumer Guides" that were numbered sequentially. These columns were a series of album reviews based upon his, sometimes whimsical, criteria and included work by a more than healthy number of women musicians. The fact that Christgau was living with Ellen Willis during some of the time he was writing for the *Village Voice* also played an important part in his feminist sensibilities.

Christgau had a long but interrupted career with the *Voice*. His first column was published in March 1969, with his first "Consumer Guide" following in July 1969.[146] He then left the magazine in 1972 to publish in *Newsday* and *Creem* and returned to the *Voice* in September 1974. He continued to publish there until the end of the years covered in this study. By November 1974, he had published "Consumer Guide 50."

Unlike most other male music writers at the time, Christgau consistently brought a feminist sensibility to the world of rock journalism. This sensibility is clear even in his discussion of the groupies. In a column from July 1969, in which he discussed the MC5 and their then-manager John Sinclair, he mentioned the sexism inherent in a pronouncement made by their management. "John Sinclair claims that the groupies who come to Ann Arbor to fuck the [MC5] act as energy carriers disseminating the revolution and crabs from Lansing to Grosse Pointe. (Don't females have any revolutionary energy of their own?)"[147] His perceptive statement poked holes in that particular construction of female groupie sexuality as created by many male writers in the rock press.

Christgau's treatment of Laura Nyro was also novel in the rock press of this era. He had an acknowledged love of AM radio pop songs, which is another facet of his writing that separated him from the almost exclusively album oriented rock critics during this era. In another column from 1969, he discussed Nyro, his appreciation for good pop music, and his feminist sensibilities:

Driving to Washington in a Volkswagen with three women activists, "Wedding Bell Blues" comes on, another radio experience. I think Laura Nyro is a blowzy purveyor of bullshit sensuality, and am offended by the intelligent people who revere her. But as a composer of bullshit-meaningful songs for a great bullshit-meaningful group like the Fifth Dimension, she's great, and I have learned to enjoy "Wedding Bell Blues." Two women in the car argue with me on the grounds that "WBB" implicitly defines a woman in terms of her man. I will not bore you with the argument, but what it boils down to it [*sic*] this: the women were right but it doesn't matter to me. There is some rock and roll which can be understood as its creators intended it, more or less, but that's only half of it. What most excites is a richer phenomenon, the way that intention tends to fit into a much larger pattern of art and politics and pleasure.[148]

It is one thing to understand feminist sensibilities and choose to ignore them for aesthetic reasons. It is quite another matter to never acknowledge in print that women's sensibilities could, and often were, offended by sexism.

Christgau's sensibilities were subtle when it came to women musicians. It was as if he were attempting the difficult task in a patriarchal society of seeing them as both women and as people. A 1970 review of a Grace Slick performance amply exemplifies this trend. In his description of her he used superfluous detail. "Grace was wearing one of her bitch costumes—short black skirt, see-through top, black squares covering her breasts, black hair teased and splayed in a crown around her head—and looked like a cross between Jean Shrimpton and the Wicked Witch of the North [*sic*]. She was high on coke, apparently—and, as she explained later, menstruating."[149] However, in his description of a male heckler, Christgau exhibited remarkable understanding of feminist ideology and aims:

Grace asks for it, of course. She wants to be tougher than any man, but perhaps she's once again hoping in a vacuum that this can change, and out for herself until it does. Sing or fuck, the cretin was bellowing, and so were many other men in the audience. What little real hostility all of Grace's torments could stimulate was directed at Grace-the-woman, not Grace-the-class-enemy. And the justice of the radical feminist argument came so clear once again, for how are men who hate women so desperately going to change anything for the better? Grace knows: they don't even pretend to want to.[150]

Chrisgau's penetrating analysis vis-à-vis Slick, her stage persona, and her role as one of the first female rockers is in sharp contrast even to the other

reportage found in the *Voice*. Here he recognized not only the difficulty of her position but also her personal excesses and coping mechanisms, while framing the larger discussion of gender relations in terms of radical feminist thought. This type of reportage is truly anomalous in the largely male fraternity of rock writers of the 1960s and 1970s.

Another column from later in 1970 directly addresses the subject of women and rock music in great depth. In "Look at That Stupid Girl" Christgau describes how he had become more sensitive to sexism at the hands of an unnamed "militant feminist who is almost as fervent about rock music as I am," who is presumably Willis.[151] He also comments on the paucity of writing on women in rock (even by women writers). He writes that he was attempting this analysis of women in rock and that he felt "obliged to ignore the ridicule of the satisfied oppressors and the inevitable resentment of the conscious oppressed and try one myself."

In his analysis Christgau remarks on the fact that rock music had adopted "the classic pattern of man the pursuer and women the pursued," which he described as "sexist." He attributed some of the crudity of rock's treatment of women to a "sloughing off [of] all the genteel middle-class post-Victorian camouflage and getting back to basics." However, he reserved his most serious opprobrium for "the theater of rock, both in the media and in live performance." He mused that the lack of women instrumentalists might be due to "cultural deprivation" and stated his beliefs as to why there were so few women rock guitarists: "First, women cannot play rock guitar because men won't listen to them, and there's no need to belabor phallic analogies to explain why. Second (and the experience of several women I know supports me here), women cannot play rock because they cannot and/or do not want to create in blues-based male style."[152] True to his complicated approach to the subject, Christgau then posits that regardless of the sexism, aspects of the genre were "good" for women and that the next time music was "revitalized, it may be women doing the revitalizing."[153] It is notable that two female readers wrote in to congratulate Christgau on the article.[154]

Christgau was an unashamed booster of the female-fronted band Joy of Cooking and devoted a column to the band's work in 1971.[155] However, even though he believed it was "very important" that this was "a woman's band," he also stated that "I literally can't recall the last time a new record gave me as much, yes, pleasure as 'Joy of Cooking.'" During the course of his discussion of the band, he makes some interesting generalizations about women singers:

Basically, there are three kinds of female singer: the virgin, the sexpot, and her close relative the sufferer. Each of these stereotypes suggests a human being who does not act

upon the world, and the exceptions—little girl Melanie, for instance—usually play equally demeaning roles. Probably because the image seems closest to some metaphoric reality, I think most of the great women singers have been sufferers, but usually their defeat is so complete that even if they start out with a certain jaunty wit—like Billie Holiday—they end up hopelessly ravaged and their occasional assertions of strength—think of Janis or Aretha—have a desperate edge. I can think of only two sufferers who have managed to project a relatively sure and onsistent dignity: Bessie Smith and Tracy Nelson. Judy Collins and Joan Baez are dignified, of course, but at the cost not just of feeling but of corporeality.[156]

The complexity of this analysis and its eschewing of sexist rhetoric make the gap between it and many of the other writings on women in rock, especially in *Rolling Stone,* seem abysmal.

Christgau was no mindless supporter of all music female. In 1971, he panned Fanny's first album and praised their second. In his pan, in which he referred to the band as "Burbank's entry in the Ladies' Derby Day," he faulted the band for weak original material and gave them a C minus.[157] In his review of their second album, which he called "a vast improvement," he praised them for having more "presence" and better material and awarded them a B plus. He also commented on the freshness of "four women singing old-fashioned tight commercial rock," stating that for them it was a challenge due to its uniqueness.[158]

With his return to the *Village Voice* in 1974, Christgau demonstrated that he too was aware of the work of women in the new genres that were develop-ing in rock music, most notably glam and punk rock. This awareness was evi-dent in a wry comment with which he ended the first column after his return. He writes, "A well-fed woman in '50s décolletage, said to be sitting with friends of the new owner, during a recent Patti Smith set at Max's: 'I can't stand to see show business dragged down this way.'"[159] In his reviews of women musi-cians, Christgau also continued to demonstrate his eclecticism and the catholic nature of his taste, regardless of the sex of the performer. In "Consumer Guide (50)," he commented favorably on Suzi Quatro's album, which he awarded a B minus. However, during the course of another review in this same column, this one of a Maria Muldaur album, he had called her work clichéd. Of Quatro he writes, "Dumb, yes. Repetitive, too. Leiber-Stoller's 'Trouble' sounds silly—even in that chrome sweatsuit, Suzi can't convince me she's evil. But she's going somewhere she wants to go, and I rather hear Quatro shouting out 'Keep A Knockin' [*sic*], than a whole album of Maria Muldaur stylizations."[160]

Like Goldstein, Christgau's work (along with that of Aletti and Rose) con-sistently addressed the work of women musicians with the complexity and fre-quency it deserved. Christgau might not like the work of a woman performer,

but he never stooped to use hackneyed gender-based clichés when discussing it or them. In his writings he grappled with the difficult questions of gender politics, both in music and generally, which gives his work a universality lacking in much of the music reportage from other magazines, especially *Rolling Stone*. For this reason alone, his writings are fruitful objects of study for scholars seeking to understand the tensions that were present between the sexes at this time.

Even though Goldstein's and Christgau's work were some of the high-water marks of the music writing in the *Village Voice*, they were by no means the norm. Countless articles and reviews exhibited the same sort of misogyny and malice toward women as those in *Rolling Stone* and the more mainstream magazines. Most of these articles could be found in "Riffs."

As I mentioned above, "Riffs" began as one individual's column and then shifted to become a sort of catch-all area for the album and concert reviews of several writers, thereby making it much more difficult to characterize than the columns of Goldstein and Christgau. However, I found much of the writing here less encouraging of women musicians, and less artfully done, than that of the other two writers. Certainly there were exceptions, most notably the work of Vince Aletti and Frank Rose. However, many of the writers fell back on the sort of superfluous detail and less-than-progressive verbiage in their descriptions of women musicians and their work as found in *Rolling Stone*.

The first "Riffs" column appeared on May 16, 1968, and bore only Annie Fisher's name as the byline.[161] Although a woman, Fisher had no love for the work of Grace Slick and wrote about her in sexist and classist terms. In her description of the singer's behavior at a show held at the Whitney, she found fault with her stage appearance and comportment, and her class. These judgments seem to be based upon standards of behavior that Fisher believed should be adhered to based upon one's sex: "Someone who shall remain nameless here said later that she [Slick] should be told that she's a marshmallow and just come off it, baby. Grace Slick, stockbroker's daughter and Finch dropout, is not, in the farthest stretches of anyone's imagination except her own, funky. And funky and cheap are polarities. I would like to hear what she can do besides sing off-key. Off-color [Slick had cursed from the stage], she just don't make it, man."[162] Fisher's complaint with Slick appears to be that she acted "cheap" by cursing on stage and that her background was too rarified for her to be considered "funky." This analysis is given credence by a later statement in that same article. When describing cuts off Jefferson Airplane's album, *Crown of Creation*, sung by Slick, she writes, "Grace is quite right on something snotty like 'Greasy Heart,' or caustic like 'Lather,' but she'll never convince me singing a love lyric. Man, would I love to hear Marty Balin sing, with the conviction he

used to put into his own ballads, David Crosby's beautiful 'Triad,' which is a man's song anyway." The song "Triad" describes a ménage a trois in which the song's narrator has two lovers. By assuming that role, Fisher believed that Slick had somehow usurped the male role and sung a "man's song." It is instructive to compare this review to Goldstein's, which is mentioned above.

By 1969, other writers were contributing to "Riffs," and almost all of them were men. Much of this prose was not much better than that found in *Rolling Stone* or the mainstream magazines. Consider Lucian Truscott IV's 1969 description of Bonnie Bramlett: "She [Bramlett] has successfully overcome the two great obstacles before any girl singer today: Janis and Grace. She derives absolutely nothing from either of them, and her short blonde hair and unassuming dress were a pleasant departure from those of most chicks in the business these days."[163] Although Bramlett's voice was top-notch, her persona and her approach were nowhere near as progressive as those of Slick and Joplin, as is confirmed by her statements to a mainstream magazine article quoted above. Truscott appears to be applauding this fact rather than merely celebrating Bramlett for her abilities as a musician.

Some of the male "Riffs" writers also employed superfluous details in their descriptions of female rockers. One of these writers was Don Heckman, who applied this type of prose to his review of a Laura Nyro show at Carnegie Hall. He began his review with the following, "She is unexpectedly zahftig [*sic*]. Soft, plump white arms, tasty-looking boobs, and curly black hair tumbling down her back. Her dress is long, frilly, and white—the net effect vaguely like a cross between a first communion in El Barrio and a high school prom in Great Neck."[164] He then went on to mention her name in the second paragraph, relates that she "turns Miles Davis on," mentions that she wrote hit songs, and "makes Clive Davis look like a genius." Much like the Fong-Torres article on Jackie DeShannon cited above, Nyro remained a nameless collection of stereotypes until later in the review. Heckman's prose is also reminiscent of the Gleason description of a Nyro show quoted above, down to her "communion" dress.[165]

In another "Riffs" column, this one from 1972, writer Ira Mayer commented on a recent increase in the number of female musicians: "Whether trend or coincidence, there has been a tremendous rise in the number of solo female pop, folks and country singers over the last six months or so. I came up with over 20 names off the top of my head, some being more recent additions than others. But for a long time that field was pretty much limited to the three J's—Joan, Judy, and Joni. The plethora of female singers of the moment will surely dwindle with time—there are simple too many people doing the same thing—but it certainly seems worthwhile to examine at least some of them

here."[166] Mayer then went on to mention artists such as Bonnie Raitt, Linda Ronstadt, Rita Coolidge, Tracy Nelson, Mary Travers, Alix Dobkin, Melissa Manchester, Carole King, Rosalie Sorrels, Carly Simon, and Roberta Flack. While some of these artists did indeed have stylistic similarities, others differed widely from one another. Mayer's remark that there were too many women doing the same thing smacks of tokenism in his approach to women in pop music. His omission of Joplin and Slick from his early "history" of women in pop music is also puzzling. However, highlighting the difficulty of characterizing the work on women musicians by the writers who contributed to "Riffs," Mayer was a consistent supporter of the work of Bette Midler, largely it seems due to her abilities as a performer.[167]

The shift from folk rock into glam and punk rock was also reflected in the writings on women in the "Riffs" column. Women from these genres were generally more gender-bending and presented male reviewers with the difficult task of evaluating female performers who subscribed to an aesthetic in their appearance different from previous female musicians and were usually more aggressive in their performance style. Unable to fall back on the time-honored approaches used in rock journalism when discussing these female musicians, several of these writers rose to the occasion and recognized that this new style of music and performance style was something new and worth examining.

Two artists who fell into this category were Patti Smith and Suzi Quatro. Writer Frank Rose reviewed a Phil Ochs show at Max's Kansas City where Patti Smith was the opener. He immediately commented on the bizarreness of the pairing, stating that Smith "must have been picked for the slot by drawing." He then commented on her appearance: "She [Smith] looked like a scarecrow in a garden of chickpeas, standing there all skinny in the torn t-shirt that's become her trademark. In between she spit on the stage and whipped off a bunch of soiled one-liners couched in subliteracy." Rose ended the review by tying Smith's cultural references to the nascent punk genre: "Her [Smith's] poems are charged with an intense, fire-breathing rhythm, and her obsession with people like Rimbaud and Brian Jones and Edie Sedgwick reflect a passion for punkdom and a fascination with being out of control. 'Don't be afraid of me, I'm just a nice little girl,' she told the audience. Don't believe it. She's as tough as they come."[168] Punk and glam rock, with their emphasis on gender-bending alternating with a disdain for sex and traditional sex roles, respectively, were the perfect genres for women musicians who were trying to expand the possibilities for female rockers. Rose, and the next writer I will discuss below, were perceptive enough to see that this type of music and performance were indeed something completely different from that which had come before and did not hold these artists to standards that no longer applied to them.

In "As Bad as Any Boy," his review of Suzi Quatro's eponymously titled first album, writer Tom McCarthy also noted that these women rockers were a new breed.[169] Like Smith, Quatro wrote many of her own songs and she also played bass in her band, a rarity at the time. McCarthy commented on these facts and called her part of a rock-and-roll "renaissance." He also commented on the gender ramifications of Quatro performing songs traditionally done by men, including the Beatles "I Wanna Be Your Man." "By doing material usually associated with male performers, Quatro proves she can be as bad as any of the boys." He ended his review with a statement that acknowledged her innovation in the field: "Combining Motor City grease with English flash [Quatro was from Detroit and had moved to England], Suzi Quatro has emerged as the first female performer of punk rock."

Punk and glam rockers were not the only women to break barriers in performance style discussed in the "Riffs" column. Also noted were the efforts of pioneering funk/glam rockers Labelle. In a review of one of their shows at the Metropolitan Opera House, Vince Aletti demonstrated a clear knowledge of the innovative nature of Labelle's work as well as a subtle understanding of the racial politics in music. The writer commented on the fact that he could not understand why everyone was not as enamored with Labelle's music and stage show as he and then proceeded to discuss possible reasons for the lack of enthusiasm on the part of the unconverted. Aletti differentiated their stylized performance style from the equally studied approaches used by other African American bands: "It's not the usual high-gloss stylization of black singing groups—synchronized choreography; precise dramatic gestures; matching or at least coordinated outfits. We've all grown familiar, if not comfortable, with that. Labelle is off somewhere on its own. Mostly they look like African goddesses ready for some particularly erotic ceremony or queens from outer space (their 'futuristic' outfits suggesting both Dale Arden and Emperor Ming [characters from the Flash Gordon comics series]."[170] Here the writer is pointing out how innovation in popular music, when coupled with race, can become problematic to white audiences who were only barely comfortable with African American musical expression in the first place.

Aletti also commented on the double standard based upon race, as well as sex, that existed in the world of popular music. In the course of describing the band's evolution, he alluded to their initial role as interpreters of rock standards by artists such as the Rolling Stones and the Who. He then mentioned their shift to original material and the recent emergence of band member Nona Hendryx as the group's primary writer, following with this analysis: "The sound was a soul-rock fusion (arranged with the rich drama of voices in a gospel choir) at a time when no one knew just how to respond to such a hybrid.

(It was ok for a white group to sound 'black' but for a black group, especially a 'girl group,' to sound 'white,' well—it just wasn't done.) Even more of a problem: many of the songs were, and remain, aggressively 'relevant.' With political peace and power songs decidedly out of favor among whites."[171] His comments about Nyro in *Rolling Stone* quoted above notwithstanding, Aletti consistently wrote with much sensitivity about women and people of color in popular music.

The mentions of women musicians in "Riffs" varied widely depending upon who was writing the column and which artists were being discussed. Like the writers in *Rolling Stone*, the *Voice* writers had their favorites and their whipping "girls." However, these writers' employment of excessive details never approached the levels found in *Rolling Stone*. Nor did they use double entendres or sexist jokes with nearly the frequency of the San Francisco magazine. If I were to characterize the approach of the writers at the *Village Voice* in their writings on women musicians, the word "mature" immediately leaps to mind. Their writings, although often more prosaic and worker-like, stuck more to the facts of these women's work and editorialized less about them based upon their sex.

One good bellwether of how a magazine's writers treated women in this period was what they wrote about Janis Joplin. She was a trendsetter of the first rank and, as such, challenged people's preconceived notions of how a female musician should look and act. This fact sometimes strained some writer's abilities to transcend their own expectations and gender prejudices. The writers at the *Village Voice* tended to write about Joplin in ways that were substantively different than most of their counterparts at *Rolling Stone* and the mainstream magazines.

Unlike the writers at *Rolling Stone* and the mainstream magazines, those at the *Village Voice* tended to write about Joplin in spurts, usually coinciding with her performances in New York City or the release of her albums. In a "Scenes" column from February 1968 that followed quickly on the heels of her performance at the Anderson Theatre, Howard Smith commented on Joplin's anomalous role in rock music: "The girl gap is an easy term for a hard problem that's been facing the pop music industry. The plumage and the punch in last year's rock has remained the province of men. Outside of soul, no girl has emerged with the sexual pazazz [*sic*] of male singers like Jim Morrison and Jimi Hendrix. Now, with Janis, all this is over. She looks like the girl next door, but if you live on the Lower East Side. Although not beautiful in the usual sense, she sure projects. Janis is a sex symbol in an unlikely package."[172] Smith was perceptive enough to see the groundbreaking nature of Joplin's approach to beauty, typified by her refusal to straighten or tame her hair. He also recognizes

that she was stating that a woman's sex appeal did not necessarily depend upon her conforming to traditional norms of feminine beauty.

In one of his "Pop Eye" columns from 1968, Goldstein also wrote about Joplin's ability to help her audiences free themselves from their inhibitions through her musical performances: "It's always the same. She [Joplin] begs and coaxes her audiences until they begin to holler, first in clichés like 'do-it-to-it' and finally in wordless squeals. Suddenly, the room is filled with the agony in her voice. Kids surround the stage, shouting her name and spilling over with the joy of having been reached. Even the onlookers in neckties nod their heads and whisper 'Shit oh shit.' Because to hear Janis sing 'Ball and Chain' just once is to have been laid, lovingly and well."[173] Although he uses sexual imagery in his description of her show, it is clear that this imagery was appropriate to the type of experience that Joplin was creating for her audiences through her music. In a very short passage, Goldstein managed to capture the essence of Joplin's stage show and the innovation that she brought to the rock field in the form of audience participation. Girls may have screamed for the British Invasion bands, but everyone, according to Goldstein, screamed for Janis.

In that same issue, fashion writers Stephanie Harrington and Blair Sabol wrote about Joplin's wardrobe in their column "Outside Fashion." Articles such as this one were ridiculed in *Rolling Stone*, whose writers intimated that this type of coverage did not befit a rock musician, especially one from the counterculture. However, the fact was that women and girls during this time were looking for fashion leaders outside the realm of high fashion, with its high prices, impractical designs, and wafer-thin models. Joplin's thrift-shop chic and her more realistic figure were attractive to many female fans. Harrington and Sabol realized this and commented on it in their column. "There's no doubt about it that Janis is not in the same league with the clothes-horsey set of female pop singers, but then again she's not in the same costume set as the popular rock groups either. Yet somehow the word is out that San Franciscans, male and female, consider her look out of sight because she hasn't contrived it as other performers have theirs."[174] Far from ridiculing Joplin's fashion sense, the writers at the *Voice* celebrated it and congratulated her on her style. Some of this comes from the fact that the *Village Voice* was not solely a music magazine and thus had a fashion column in the first place. Some of it also stems from the fact that unlike *Rolling Stone*, they had women writers on their staff who could appreciate Joplin's liberating fashion innovations, like telling women and girls to get rid of their bras and girdles.

Fisher also wrote about Joplin in a highly perceptive way in her "Riffs" column. Much like Ellen Willis, Fisher was struck by the insatiability of Joplin's crowds and the singer's willingness to keep on giving regardless of the costs.

Of her 1968 performance at a Fillmore show, Fisher writes: "She [Joplin] lives more in one song than a lot of people do in one lifetime. I hope she doesn't kill herself doing it. [While the audience was calling for a second encore] I looked into the wings for her. It was a moment frozen in time. She stood back there pulling herself together for one more time, and her evident exhaustion was raw and frightening. I'd like to forget that look, but I won't for a long time."[175] Fisher was afraid that Joplin's intensity would lead to her death. Her obvious empathy with the singer and admiration for her sacrifice is in sharp contrast to the writings on Joplin in *Rolling Stone*.

Another subject that elicited much criticism of Joplin from the writers at *Rolling Stone* was her decision to leave Big Brother and the Holding Company. One writer at the *Village Voice* took issue with this disapproval in the wake of the release of Joplin's *Kozmic Blues* album. In a "Riffs" column from 1969, Johanna Schier commented that "There was a lot of skepticism about the split from Big Brother. The general feeling that she was getting too big for her britches was sent out by admirers of her original band. Lots of people seemed to hope that she'd fall flat on her face. That crisis has passed now and Janis's self-confidence seems fully regained. She was right in feeling that Big Brother was doing zilch behind her and, more importantly, blocking her growth."[176] This is a far cry from Ralph Gleason's advice to the singer to go back to Big Brother "if they'll have her." Though flawed in many ways as a band, the musicians who backed her *Kozmic Blues* were much more proficient and professional than Big Brother.

Christgau also dealt very evenhandedly with Joplin in his writing. His review of *Kozmic Blues*, which he awarded an A minus, addressed both the album's strengths and weaknesses: "Everyone who called Janis Joplin a great blues singer was wrong. She was, and is, a great rock singer. She needed Big Brother more than any of us knew, not just for image, but musically, and not as a complement but a parallel—their crudeness defined her own. Janis has been struggling to shake off that crudeness, and while this record doesn't quite do what she has in the past for most of us, it is a surprisingly strong try, with a lot of help from producer Gabriel Mekler. Anyone who has given up on Janis along the way ought to try again. She's coming on."[177] Though not as partisan in its support of the album as Schier, Christgau nevertheless recognized that Joplin was attempting to change musically. What he saw as growth, the writers at *Rolling Stone* labeled ego.

However, not all of the writers at the *Village Voice* wrote positively about Joplin. In a "Riffs" column from 1970, Heckman describes one of the singer's shows at Madison Square Garden as "Janis Joplin's wind-ding ego trip" and refers to her as "La Joplin" throughout the review.[178] Charles Wright, in a

review of her posthumous album *Pearl,* described her as alternately a "camp joke" and "a chubby, white Texas chick trying to go black." He also writes, "But we only saw, listened to the legend, while the poor bitch who just missed being a file clerk who drank a great deal, became frightened, desperate, saw the silent mushroom in the sky."[179]

The most glaring gap in the treatment of Joplin in the *Village Voice* came at her death. When Jimi Hendrix died three weeks before her, a special, three-page tribute section devoted to the guitarist's music and memory was published.[180] The writers who contributed to it included Carman Moore, Truscott IV, Heckman, Fisher, and Howard Blum. When Joplin died, only Smith commented on her death by running some excerpts from a recent phone interview he had conducted with the singer.[181]

That many of the women musicians during this period were groundbreaking innovators of the first rank is irrefutable. That they were often written about, especially by *Rolling Stone,* in a manner not befitting their talents, successes, or contributions to the field is also clear. If the amount of material that I was able to find on them is any indicator, they were often ignored by the periodical press. That some writers recognized and encouraged the changes that these women were bringing about is also clear. That they were few in number is unfortunate but also undeniable.

These examples from more than thirty years ago in rock journalism are merely another installment in the long and difficult struggle that women have had when they try to change their place in the world, when they attempt to open up new opportunities for themselves and others. They also point out the fact that that difficulty can be compounded if their efforts involve the media or they are carried out in public. That these women were even willing to try and that some men were willing to help them points to the possibility of a better future for us all.

Chapter 3
Rock Women Who Wrote

Freedom for women is defined solely as sexual freedom, which in practice means availability on men's terms. The rock community is a male monopoly, with women typically functioning as more or less invisible accessories; around male musicians I've often felt as out of place as a female sportswriter in a locker room.

—Ellen Willis, *"Rock, Etc.: But Now I'm Gonna Move," New Yorker, September 23, 1971*

In 1968, rock critic Ellen Willis raved over Franklin's new album *Aretha in Paris* in her "Rock, Etc." column for the *New Yorker*.[1] In the course of her review, she also commented in a novel way on the sensuality inherent in Franklin's recordings from this era: "I have never heard the gospel elements in Aretha's voice used to greater effect than in this particular rendition of 'Dr. Feelgood'—a song that also exploits to the fullest her warm, non-*femme-fatale* sexuality." In stark contrast to *Rolling Stone*, Willis argued in essence that active female sexuality was not necessarily threatening or dangerous or even necessarily prurient. In so doing, she and select other journalists like her set a different standard for the treatment of female musicians in rock journalism. Nevertheless, much of their work has been forgotten or left out of the canon of rock criticism.

The 1960s and 1970s were some of the most contentious years in American social and political history. The struggle waged over the representation of women musicians in the American periodical press is but one example of this fractiousness. As discussed in Chapter 1, gender and sex roles were undergoing tremendous change, as was the nature of rock music. Music journalists were at the vanguard of this "bargaining." Pop music stars like Bob Dylan and the Beatles were the heroes and the role models not only for many average people but also for the leaders of the various movements in the counterculture. Rock writers often acted as interpreters or analysts of these artists' work for everybody else. The fact that most of these journalists were men also influenced both the contents and the approach of those in the profession. However, there were also some women writers in rock journalism who performed these roles. Their work, directly and indirectly, not only expressed their views, but also served as an alternative to the professional endeavors of the members of the overwhelmingly male Fourth Estate.

This chapter examines the work of two writers in the mainstream periodical press who were among the most influential rock critics of their day: Ellen Willis and Lillian Roxon. These writers, along with a few other female and anomalous male writers, explored the complexities of rock music, especially its effects on gender and sexuality. This was especially true in their work on women musicians. Rather than trying to fit these anomalous women into existing stereotypes or diminish their impact by drawing attention to their physicality, these writers attempted to create a type of music journalism more befitting these women and their work.

Because their work has been so long overlooked, one of my main purposes in examining Willis and Roxon and their work is to offer the first detailed biographical essays of them.[2] In each case, discussion and analyses of the bodies of their work could easily fill a book. However, I wanted to provide an introduction to their work for those who were not around when it was first published and a solid basis for further research by scholars who want to delve into their considerable contributions to journalism and women's history.

Ellen Willis was born in 1941 in New York City, the daughter of a policeman and a housewife, Melvin H. and Miriam F. (Weinberger) Willis.[3] Until she was ten, her family lived in the Bronx in a Jewish neighborhood near Yankee Stadium. "I thought Catholics were a tiny minority and never even heard of Protestants till I met one in day camp." In 1952, the family moved to Bayside, Queens, to live in a development that provided single-family housing for police and firefighters. Willis described that neighborhood as "mainly lower-middle-class Irish Catholic" and "very suburban." Both of Willis's parents were former radicals and had been members of the Communist Party in New York in the 1930s. Of their influence on her approach to politics, Willis remarked that: "My parents never talked politics with me when I was a kid because this was the McCarthy period, and my father was really worried about being investigated. But I nonetheless picked up that their opinions were not the same as a lot of other people. From an early age being a political rebel was something that was in my world and not off the wall and I think that's very important. I didn't have to come to sort of some sudden conversion that maybe there was a reason to criticize the mainstream of society."[4]

Willis graduated from Barnard College in 1962 with an A.B. degree. She then studied for one year at the University of California at Berkeley. When questioned why she didn't finish graduate school, she replied, "Well I should never have gone to graduate school in the first place. I didn't have any conception. I really wanted to go to California and, I didn't have the nerve to just go without having some reason. San Francisco and the Bay Area still had a lot of

cachet from the Beats. So that's basically why I went. I certainly had no thought of, or interest in, becoming an academic. I guess I thought graduate school would kind of be like a fifth year of college but of course it wasn't anything like that. I found it really dreary." However, in one of her classes there she was to write a paper that hinted at her future profession and style. Her professor recognized and encouraged Willis's work:

I think the final thing was that I took a poetry course I really liked from Tom Parkinson, who was sort of a legendary teacher at Berkeley. He gave this wonderful seminar and I wrote a paper on Robert Frost, which in retrospect adumbrated a lot of my future interests in popular culture, because I was writing about the tension between his constructed public persona and his poetry and what that was all about. And Parkinson when I talked to him about the paper, said it was wonderful, he loved it. He loved the mind that he saw in it. But he couldn't for the life of him figure out where I might publish such a thing in the context of academia. So that was the last straw, I thought, "Forget this."[5]

Berkeley also exposed Willis for the first time to a culture that was profoundly different from that of New York with which she was so familiar:

I loved Berkeley. At that time West Coast culture was so different from East Coast culture. By now there's been much more of a convergence though there are still differences. I had the experience at Berkeley that most people have only when they go to a foreign country. That is, "Oh, I see. What I've grown up in is a culture, it's not reality. There are other ways." I found it a place that was much more open to the imagination than New York was at that time, or at least in the circles that I was in. It was, "What's your fantasy? Go out and do it." Whereas in New York it was more like, "What's your fantasy? Write about how it can't be done." [The Bay Area] was also far less work and career oriented. For the first time I saw people, as a way of life, getting jobs to pay the rent while their real life was somewhere else. So I was, I think, very influenced by Berkeley. Ultimately [I] didn't stay.

After leaving the university Willis worked in San Francisco for a textbook publisher writing promotion copy. She then headed back east.

Also contributing to Willis's decision both to go to Berkeley and to leave was her marriage a week after graduating from Barnard. She described the marriage as "a mistake and disaster long before it happened, some kind of kamikaze desire to prove my normality." She also commented that her decision to go to Berkeley was "unconsciously trying to break with this man, but he decided to come with me." When her husband took a job with the U.S. Information Agency's Foreign Service, Willis decided to go with him to his posting. During her husband's training Willis worked at various temporary clerical jobs and took an intensive French course. They were planning to go to Ethiopia at the end of his training. Her feelings changed, however: "I thought 'No, this is

an impossible thing to do. This is insane.' So I broke off with him and I came back to New York. There was definitely a question in my mind of would I stay in New York or would I go back to California but really, I was a writer and my work was really important then so New York was more my place. And of course being in New York in the [19]60s counterculture was much different from having been in New York at Barnard College." Upon her return to New York City, Willis began to join the community of writers.

Willis's writing career actually began before her trip to California. Her first publication came about as the result of her winning a writing contest. The article was written for *Mademoiselle* at a time when they were, as she described them, "really different and had literary pretensions." The contest winners were "guest editors" at the magazine and worked with an editor at the magazine for a month. Willis wrote about "how horrible it was to be a commuter student at Barnard College," and the magazine published the piece in 1960.

When she returned to New York City after splitting up with her husband, Willis began to carve out a career as a freelance writer. To that end she worked at Ralph Ginzburg's *Fact* magazine, though she did no writing there. Willis even contributed a piece on swimsuits to *Saturday Evening Post*, for which she was paid $1,500.[6]

During this same time, Willis became involved with the Free University of New York, a radical alternative school that was a place to think, learn, and commiserate with others who were interested in the more countercultural side of the arts and the life of the mind.[7] In January 1966, Willis became reacquainted with someone who was to have a huge effect on both her life and her writing, Robert Christgau.[8] They became romantically involved, but also influenced each other's work and worldviews.

Willis described both the school and its effects on her personal life: "It was this radical alternative school where virtually everybody who was involved in the Left or the counterculture seemed to have gravitated to in one capacity or another, which actually was a primary source of my sex life for the next 20 years or so. It was not only where I re-met Bob, but also where I first met the man I'm now with, plus there was also another lover I met there. It was a very fertile place in terms of ideas but also from a social point of view for me."[9]

Christgau and Willis's relationship was to shape both of their writing in significant ways. Willis described Christgau as "the person who introduced to me Pop Art and really got me started about thinking about rock and roll as a serious cultural issue, and was sort of instrumental in poking holes in my reflexive attitudes about these issues. Bob and I have very different sensibilities. I think I influenced him to be more political, much more political than he'd

been. And he influenced me to integrate a pop perspective into my politics. We read and edited each other's pieces."[10]

Of Willis's effect on his own writing, Christgau stated: "I can no longer remember who generated what. It seems to me that I was more the aesthetics guy and she was the politics person. I had, I think, something more of a passion for writing in New York in general than she did, and she because of her family background. She was always a much more committed Leftist than I was. I mean Ellen has a great mind and she really is one of the smartest people I ever met in my life."[11]

In 1966, Willis joined the staff of *Cheetah,* the ill-fated but highly regarded music and culture magazine (see Chapter 1). In 1967, she secured her first editorial job at the magazine and remained there until April 1968. Christgau described the operation as "seat of the pants and unprofessional. I mean, we had this stoned idea one day. You know we're called *Cheetah* we should do a zoo column, and Ellen did that zoo column [Laughs]. I mean, that couldn't happen anymore. Not at a slick, supposedly national magazine where somebody has a stoned idea for a goof [and] they'd put in a page about zoos every three months. Things were very loose."[12] Little of Willis's work there was specifically music journalism. She primarily wrote book reviews and general articles on subjects as varied science-fiction books and free speech movement activist Bettina Aptheker.[13] Nevertheless, a few of these articles contain passages that hinted at her future authorial stance and her keen grasp of culture, the media, and music.

One such article was a book review of a Ballantine series on the British mods. Willis's references exhibited an acute understanding of both British and American youth culture, particularly when describing 1950s American teen culture as having "a predatory competitive sexuality," and her pronouncement that in American youth culture "the common denominators were rock music, drugs, miniskirts for girls, long hair for boys, sybaritism, and *youth*" (italics in the original). She also thanked *Time* magazine for creating the concept of "Swinging London." That she did not neglect the political and economic aspects of American society was clear in her comments about the future of youth in America: "It may become academic: if the political situation gets much worse we may all be soldiers, revolutionaries, exiles or factory workers."[14]

Willis did write at least one piece about music for *Cheetah,* a review of a 1968 concert to benefit a group fighting Huntington's disease, the illness that had claimed Woody Guthrie's life the year before. She began the article with a description of the rise of the folk scene. She then followed it was a cogent analysis of why the movement's large-scale popularity among youth had ended:

"Then the folk thing died. Because Lyndon Johnson sang 'We Shall Overcome'; because Dylan went rock. And most of all because we were tired of apologizing for what we were—not oppressed workers, not Southern Negroes, but middle-class kids. When Dylan and the Beatles showed us how to accept our origins without joining the corporation or the country club, we went with them."[15] Willis also cast a sardonic glance at pop music and it purveyors. "Sure it [the concert] was sentimental. Sentimentality was one reason we deserted to pop. But pop has its own softness, and between that Indian Norman Vincent Peale [Maharishi Mahesh Yogi] snowing the Beatles and Pete Seeger glorifying just plain folks, I take the latter."

Though *Cheetah*'s run may have been brief—the magazine folded in 1968 —Willis's work there did not go unnoticed by journalists and editors at another, more august New York magazine. In 1967, Willis published her first music article, "Dylan," in *Commentary*. The piece was an erudite discussion of the musician-songwriter and his significance to music and culture. When the article was republished in *Cheetah* in 1968, it caught the eye of a *New Yorker* staff writer named Jacob Brackman, who showed it to William Shawn, who then asked her to write a music column for the magazine.[16] In the world of periodical writing, this was the equivalent of getting on an elevator to go to the second floor and instead being shot through the roof.

In 1968, Willis became the pop music critic for the *New Yorker* and published her first column, "Rock, Etc.," in April of that year. When asked if writing for such a well-known and high culture magazine affected her status among her fellow rock journalists, she replied, "I don't think that was important at all. What was important is that I was female, much more. So I was really marginal always to the male rock journalists' world, probably because many things about it repelled me. I also was not interested in hanging around with performers." Willis attributed this latter choice partly to her shyness and partly to the fact that she found most musicians "conceited and boring": "In any case I was most compellingly interested in issues of mass culture to which the audiences and its responses were central, records were as important as live performances if not more so, and performers' public images were more germane than whatever they might be like in private. As for my writing being affected, there are advantages and disadvantages either way, to being involved with the performers or not being involved with them. I just preferred to keep my distance."[17]

Willis held her job at the *New Yorker* until September 1975, during which time she published fifty-five columns of pop-music criticism for the magazine. When asked why she quit writing the column, Willis replied, "I got really interested in the proto-punk movement. So at a certain point [editor William]

Shawn complained I was writing too much about these people and he wanted me to cover more things. And I said 'I don't want to cover more things.' So I just stopped writing the column."[18] Her leaving this job also marked the end of her career as primarily a music journalist. When questioned about the reasons for this decision, and the fact that her work differed so markedly from most of her peers, she replied, "Well I never thought of being a rock critic as my central mission in life. This was one thing that I was doing and I got tired of it much earlier. It wasn't something that I wanted to do for the rest of my life."[19]

While writing for the *New Yorker*, Willis was also an associate editor at Richard Goldstein's short-lived magazine *Us* in 1969 and was a contributing editor for *Ms.* magazine from 1973 to 1975.[20] Willis made a "very public departure" from *Ms.* in the summer of 1975. Her reasons for leaving were varied and highlight both her involvement in radical feminism and her roots in rock music journalism. Willis decided that *Ms.* did not practice her "style" of journalism. She explained her reasons for leaving to Alice Echols in an interview. The approach to journalism that she described was very much that of rock journalists, many of whom were "true believers," and echoes the statements of Goldstein discussed in the previous chapter. Willis stated: "The best way to run a magazine is to get writers you really think are smart and let them write up their obsessions. And certainly not worry about whether you're being responsible to your audience, which I think is condescending. So I didn't think *Ms.* was ever as much of a contentious forum for different women's politics and voices as it could have been."[21] *Ms.* historian and co-founder Mary Thom put a slightly different spin on Willis's departure from the magazine. In her book *Inside Ms.*, Thom discussed the letter of resignation that Willis published, characterizing Willis's problems with the magazine as more editorial in nature. Thom also found her resignation letter "insulting." Willis's name was dropped from the *Ms.* masthead in September 1975.[22]

In August 1975, Willis's first article appeared in *Rolling Stone*.[23] In 1976, she assumed the post of a contributing editor. In August of that year, she began a regular column for *Rolling Stone* titled "Alternating Currents."[24] Only one of these articles was about a music topic, while the rest were more general cultural reporting. I discuss the substance of the articles that she wrote for the magazine in more detail in the conclusion of this work. Willis left *Rolling Stone* in early 1978.

In 1979, Willis became a staff writer at the *Village Voice*, where she eventually became a senior editor. She currently contributes to the *Nation*, *Dissent*, and *Salon*. In 1990, Willis began to teach cultural journalism classes at New York University, and in 1995, she formally launched the Cultural Reporting

program there. She is currently director of the Cultural Reporting and Criticism concentration in the graduate program in the department of journalism at New York University.[25]

When asked what influence her rock journalism had on her approach to cultural reporting, and the training of cultural reporters Willis replied:

Well I think total, because my fundamental motivation in starting this program is that I wanted to have courses and students that interested me. And when I came to the department there was one course in cultural reporting. Which luckily the person who was teaching it, who happened to be Margo Jefferson, who I love and whom I'm very friendly with, was at that point leaving, fortuitously. She was leaving to go back to journalism. So I asked to take over that course. My whole orientation toward that course and also toward creating the program was "what were all the things that I'd learned that had been most useful or central to me in doing the kind of work that I do? What did I read? What did I talk about? What are the important issues? Who are the people who influenced me?" That was basically the way in which I built the program. You know I feel like my own philosophy of what cultural journalism is, is a philosophy that I brought to the program.[26]

Willis's involvement with the feminist movement began just slightly later than her career in journalism and dates from the beginnings of the radical feminist movement in the United States. It is important to understand that she was not a part of the liberal or cultural feminist movement, represented by groups like NOW. From the very start of her activism in the women's movement, Willis was a radical feminist. However, unlike many women who were associated with the radical arm of the feminist movement, she had not previously belonged to any leftist organizations.[27] Historian of the radical feminist movement Alice Echols has stated that Willis had identified herself as a Leftist but had always felt excluded from the organizations that comprised that movement.

I asked Willis about how she came to be involved with the radical feminist movement. "In summer 1968 I was visiting a woman who had been in New York Radical Women before moving to San Francisco. She gave me *Notes from the First Year*, a collection of articles put together by the group and told me who to get in touch with in New York. I joined toward the end of that year."[28] Thus, her first formal association with the feminist movement came in December 1968 when she joined that seminal women's group New York Radical Women (NYRW).[29] After she became a part of the radical feminist movement, her ties to leftist causes became more formalized, and she became a part of the G.I. coffeehouse movement.

However, like several other members of NYRW, she believed that while individual women could work successfully for leftist causes, to attach the

women's liberation movement to the New Left would only make it subordinate to that group.[30] She joined NYRW before it completely dissolved and was an integral part of the group that helped stage the Counter-Inaugural Protest in Washington, D.C., in January 1969.[31] That traumatic protest led to many changes in the attitudes of almost all members of the budding radical feminist movement.

In February 1969, Willis and fellow NYRW member Shulamith Firestone reacted to the Counter-Inaugural Protest by organizing the Redstockings, "an action group based on militantly independent, radical feminist consciousness."[32] Women from New York who had been participants in the Counter-Inaugural Protest comprised the nucleus of this group. Redstockings ceased functioning as a group in the fall of 1970. However, several founding members (not including Willis) revived it in 1973.[33]

In the fall of 1969, Willis moved to Colorado to aid in the efforts there to start a G.I. coffeehouse, and while there decided to start a radical feminist movement in that area.[34] She found, however, that the organizing tactics that had been successful in New York City didn't work in Colorado Springs:

Another experience I remember is one of the organizing tactics we'd always had that had been very useful was that we'd go into department stores and places like that and put women's liberation leaflets up in the ladies room. You know we thought of the ladies room as kind of this liberated area. So I tried to do this in a Colorado department store and I was actually in a stall, I happened to be in a stall putting a leaflet up when a bunch of women walked in and looked at these pro-abortion leaflets and freaked out. "Who's doing this? This is terrible." I was standing in the stall waiting until they left.[35]

Willis left Colorado feeling, in her words, "very burnt out," and moved to Napanoch, a town near Ellenville (her mother's hometown) in the Hudson River Valley in upstate New York. When asked why she left and what had made her feel that way she replied, "intensive politics and drugs and the seeming collapse of everything" and stated that her decisions were "pretty ad-hoc at that point."[36] Her reasons for leaving were illustrative of problems inherent in trying to radically reshape one's worldview:

You know the freak-out of the left. Actually, I think much more than psychedelics it was—I write about this in another essay; it's in *No More Nice Girls*, called "Coming Down, Again,"—the way feminist consciousness-raising was appropriated at the end of the 1960s on the left as a project of trying to purge yourself of all your regressive, bourgeois attitudes and become a new person. It was a completely impossible thing, which drove a lot of people completely nuts. I bailed out of it before I went nuts and not because I understood what was wrong with it but just something in me was, uhh, there's

something wrong with this, goodbye. But I feel like it took me a long time to figure out what was going on. So I was living in upstate New York, and I wasn't writing very much. But I was still writing. I still kept writing for the *New Yorker*.[37]

Eventually, Willis returned to New York City where she became enamored with the proto-punk movement and ceased writing for the *New Yorker*.

In the fall of 1973, Willis also became a contributing editor for *Ms.* Her role at the magazine was basically "house radical" or "token radical," a role with which she was not entirely comfortable.[38] Willis's involvement with the radical feminist movement was inextricably bound to her writing and her sensibilities, a fact that is apparent when you read her *New Yorker* columns.

As is clear from her swift rise to relatively rarified levels in the world of periodicals, Willis and her writing are something special. Primarily an essayist (although she did write reviews of some rock concerts and albums), her work is intellectual, funny, insightful, and sui generis among rock writers. Willis was an accomplished and intellectual female rock writer in an era when there were precious few women in the profession at all. In many ways, her articles acted as a barometer of second wave feminism and reflected her involvement with the movement, though they never assumed the role of "party organ" for the feminist movement. The music always came first in her work. Although she often wrote from a feminist perspective, especially after 1971, Willis did not dwell on women in rock music. Indeed, she did not mention women artists at all in many of her articles. Nevertheless, she hardly ever overlooked gender in her writings.

The awakening of Willis's feminist sensibilities and the impact that this had on her work is evident in her articles in the *New Yorker*. All of the articles I discuss came from her column in the *New Yorker*, "Rock, Etc.," and begin with one of her 1968 essays. This essay, on the social aspects of rock music, also helps to demonstrate her evolution as a feminist since another article on the same subject, written three years later, shows a shift to a gendered, second wave feminist perspective.

In the first two paragraphs of this essay, Willis gives an erudite description of the evolution of rock music from the 1950s to 1968, no mean feat in that short space. At the end of this description, she commented on the rise of "the FM-L.P.-student-hippie-intellectual audience" described in Chapter 1. She believed that a "shift" occurred in music owing to these developments, through which technical virtuosity and musical complexity had become preeminent in the genre: "What all this adds up to is an increasing tendency to judge pop music intrinsically, the way poetry or jazz is judged. Social context is still important, as it is for most art. But although social and economic factors were

once an integral part of the rock aesthetic—indeed, defined that aesthetic—they are now subordinate to the music itself."[39]

Willis regretted this development, and her reasons were both subtle and thought provoking: "What it means is that rock has been co-opted by high culture, forced to adopt standards—chief of which is integrity of the art object. It means the end of rock as a radical experiment in creating mass culture on its own terms, ignoring elite definitions of what is or is not intrinsic to aesthetic experience."[40] She lamented the loss of the mass audience with its unifying and leveling effects on the genre and recognized the difficulty this loss would cause new musicians trying to break into the ranks of successful artists.

By identifying both the elements of more "high" art forms and the effect of their having been melded with a popular art form, Willis situated her discussion of rock music in the realm of class. In addition to being insightful, this approach is rare in rock journalism of the period. Few rock journalists were willing to tackle the class ramifications inherent in the privileging of technically virtuosic performers over those who were simultaneously part of and a reflection of a more mass culture. That so many of the rock journalists of this period were middle-class white males might explain their reluctance to engage this musical genre, and the changes happening in it, from a class perspective. Frankly, this privileging of technical virtuosity favored them, and people like them, as they were among the members of the society most likely to have access to the resources and opportunities necessary to become the most technically proficient at their art.

The excerpts above were also an indicator of Willis's approach to rock music journalism. Her contextualization of the music was not only unusual; it was also highly perceptive. Related to this facet of her writing was her willingness to praise all performers, regardless of their sex. Willis displayed an honesty toward female performers in her articles that is uncommon for the era. She neither "oversexed" nor "de-sexed" female performers in her discussions of them and their work, while writing essays and reviews of critical depth that display considerable intellectual acumen. Most male writers of the period displayed little willingness, or perhaps ability, to engage women artists in this manner.

Even though Willis was deeply involved with the radical wing of second wave feminism, she never used her own music writing as merely an offshoot of the movement. Radical feminism was so inherent to her thinking that it was merely one facet of her work, and often not the most definitive one, as the class-driven quotation above exemplifies. Willis's writing also consistently displays a keen awareness of the need to contextualize events in rock music. She almost always grounds her discussion of the music in the various social, cultural and economic factors that influenced the music and its artists.

When Willis turned her discerning eye on women in the rock music busi-
ness, her insights and analyses were impressive. In another article from 1968,
she described a trip she had taken to San Francisco to see and hear the bands.
Willis noted that even though the music scene there was the most robust in
the country, something had gone out of it. In her explanation of why this had
occurred, she displayed an awareness of the cultural, intellectual, political, and
economic events behind a musical environment: "Haight-Ashbury has passed
to the hoodlums and the meth [methamphetamine] addicts, the growing polit-
ical urgency has made music seem less important, and the media, after publi-
cizing the scene to death, have lost interest in it, which is even worse. It may
be that the mystique of community that characterized San Francisco rock
was based at least partly on wishful thinking; Grace Slick was never exactly the
hippie next door."[41] Slick was a graduate of Finch College, which she herself
described as "a finishing school for girls from wealthy or prominent families,
who went there (if they didn't have the grades to get into Vassar) to learn the
basics of how to get and keep a Yale or Harvard man."[42] In the passage above,
Willis is both knowledgeable enough to comment on this fact and honest
enough as a journalist not to overlook it because Slick was a woman or just to
maintain the scene's mystique.

This honesty, regardless of the sex of the performer, was also evident in
Willis's description of an all-woman band, the Ace of Cups, in the same arti-
cle. She began by praising the group's vocal abilities, then writes:

Their [Ace of Cups] melodies and arrangements are excellent. But they can't play at all.
(This is not surprising. There are plenty of female rock singers but, for some reason,
virtually no girls who play instruments seriously.) They pick at their instruments as if at
unwanted food on a plate—especially the drummer, who provides almost no beat. The
lack of virtuosity is no problem in itself—in fact, given my prejudices, it is refreshing—
but the lack of drive is. Their singing is so good that I hope they can overcome this
handicap; that they've been performing for a year without learning more is disturbing.[43]

In this observation, Willis perceptively commented not only on the qualities of
a particular all-woman band but also remarked on the situation of women
instrumentalists in general.

Not all of Willis's references to women were unflattering, however. She
was very supportive of and complimentary to Janis Joplin. In contrast to many
of the male rock writers, especially those at *Rolling Stone* who were upset by
Janis Joplin's departure from Big Brother and the Holding Company, Willis's
comments revealed no rancor: "as for Janis, she has always belonged to herself.
I hope she'll be well and not lose her incredible voice too soon." She then
described Joplin's latest album, *Cheap Thrills*, as a "classic" and an "immediate

pure pleasure." Her understanding of the dynamics of Joplin's move were cogent and cut straight to the heart of the matter, while addressing the negative responses from many in the rock press. "Still, audiences came to see Janis, not the group, and that fact made it hard to hold on to the myth of all-part-of-one-great-thing San Francisco communalism."[44]

Joplin was the subject of another Willis article, this one from 1969. This review of Joplin's first New York show after becoming a solo artist is an astounding piece of writing on many different levels:

When I saw Big Brother and the Holding Company at the Fillmore East last August, Janis Joplin put on the most exhalting [sic], exhausting concert I have ever been privileged to see, hear, and feel. Euphoric from Bill Graham's champagne, she sang four encores, and the audience, standing on the seats, wouldn't go home. Finally, she came back onstage. "I love you, honey," she said, gasping, "but I just got nothing left." Someday, we were sure, it would really be true—someday soon if she kept giving like that. I didn't know if I wanted the responsibility of taking; I felt a little like a vampire. From now on, I decided, after two encores I stop clapping.[45]

In this passage, Willis identifies the self-consuming aspects of Joplin's stage show, indicates that it made her feel ghoulish to contribute to it, and praises the singer's work—all at the same time. After Joplin's death, many writers commented on the ultimate toll they believed Joplin had paid for her vulnerability and self-sacrifice on stage. Few were prescient enough to have done so beforehand.[46]

Willis's review of Joplin's show was mixed. She said it "wasn't a flop" but also wrote that "it wasn't great, either." Willis characterized some of the difficulties as "growing pains" and happily reported that "Janis has apparently decided to stop killing herself." Her description of what she felt was the main problem with the show summed up her review: "What was missing was a sense of authority; Janis did not know exactly where she was going, and she was not completely at home with her band or (this may be projection) sure the audience would accept her." Here Willis states that her review might be based on the "projection" of her own thoughts and feelings. It is unusual for any critic, male or female, to acknowledge that an opinion is just that, an opinion. The usual practice is to assume an authority stance in relation to the readers.

Willis ended her review with a tightly written paragraph that was both witty and full of forgiveness for Joplin's mixed performance: "Oh yes. The audience loved Janis. A kid climbed up on the stage and gave her flowers. If the law of conservation of energy has any validity, for the next year or so she can earn her standing ovation just by showing up."[47] In this passage, Willis slyly commented on the cult of personality that had built up around Joplin, while indicating that her laurels were well earned.

Willis's writings on Joplin also act as a barometer of the state of gender relations and feminist thinking in the United States. Another Willis article on the singer, written after her death in 1971, reflects the rise of "women's lib" both in American popular culture and in Willis's own work. It revealed a much more gendered approach to Joplin, her fame, and its costs to her. Willis began by characterizing Joplin's death as being "in all likelihood a miserable accident." However, she stated that she had a difficult time regarding it that way. Willis's reasons for her reservations speak volumes about gender relations in the realm of popular culture. They also anticipate film scholar Laura Mulvey's analysis of the "male gaze":

Yet I persist in thinking of Janis as a suicide. And I keep flashing on another superstar, so different in style but with the same conviction that no one could really love her—Marilyn Monroe. Being a celebrity must be a lot harder on a woman than on a man. Men are used to playing games and projecting images in order to compete and succeed. Male celebrities tend to identify with their maskmaking, to see it as creative, and—more or less—to control it. In contrast, women need images simply to survive. A woman is usually aware, on some level, that she is not allowed to be her "real self," and, worse, that the image is not even her own fantasy but a man's. She knows she must serve this fantasy to be loved—and then it will be only fantasy that is loved anyway. The female celebrity is confronted with this paradox in its starkest form.[48]

Willis continued the article in this same gendered vein, but also added race to the equation: "Watching men groove on Janis, I began to appreciate the resentment many blacks feel toward whites who are blues freaks. Janis sang out of her pain as a woman, and men dug it. Yet it was men who caused the pain, and if they stopped causing it they would not have her to dig. In a way, their adulation was the cruelest insult of all. And there was nothing Janis could do about it but sing harder, get higher, and be worshipped more."[49] Willis ends the article, which also includes a cut-by-cut review of Joplin's posthumously released album *Pearl*, with a description of why she liked one of the songs and what it meant to her: "When the metaphysics of Janis's life and death begin to overwhelm me (did she have to turn the suicidal drive of her early music into the ultimate channel?), I like to stop and listen to her appeal [from the song "Mercedes Benz"]: 'Worked hard all my lifetime, no help from my friends, So, Lord, won't you buy me a Mercedes Benz.' To which I can only say amen."[50] All three of the quotations above illustrate that the scope of Willis's work in rock journalism was wide indeed. In them she addressed gender, race, and the price of fame for women.

The presence of Willis's feminism is also much in evidence in another 1971 article. She expressly addressed sexism in rock music and its environment of

musicians and fans. This article, "But Now I'm Gonna Move," discussed how sexism in rock had changed from the mid-1960s to what it had become at the time of the article's publication.[51] A lengthy piece, it touched on many aspects of sexism in rock: the status of women in the field; the nature of and the reasons for the changing sexism in rock; the impact of this sexism on women; and the reaction of women artists. It is a tour-de-force of journalism and unique in the period as it tackled a subject most male writers didn't seem to know even existed, much less how to address.[52]

Willis began the piece by attempting to clear up a common misconception about misogyny in rock. She contended that even though the women's movement had caused many people to talk about the misogynist and male supremacist aspects of rock and roll, all rock sexism was not created equal. "Most people seem to have missed a crucial point: there is an alarming difference between the naïve sexism that disfigured rock before, say, 1967 and the much more calculated, almost ideological sexism that has flourished since."[53] Willis maintained that the latter type of sexism was caused by rock music having been integrated into the "so-called counter-culture." This integration resulted in a reversal where that which "had been a music of oppression became in many respects a music of pseudo-liberation."

Describing the earlier type of rock sexism in more detail and explaining why it was less harmful to women than the current variety, she characterized pre-1967 sexism as "obvious," based mostly on the fact that few women were in the field. Of rock music in this era she writes: "Yet insofar as the music expressed the revolt of black against white, working class against middle class, youth against parental domination and sexual puritanism, it spoke for both sexes; insofar as it pitted teen-age girls' inchoate energies against all their conscious and unconscious frustrations, it spoke implicitly for female liberation. The Big Beat was a universal code that meant 'Free our bodies.'" However, these early male rockers did not get off scot-free in Willis's assessment of the era: "Since most of the traditional themes of rock and roll had to do with sex and rebellion, they were in one way or another bogged down in the contradiction between male-supremacist prejudice and revolutionary impulse. Male performers perpetuated the mythology that made women the symbol of middle-class respectability, and kicked over the pedestal without asking who had invented it in the first place." Many of the British bands of this era, who were certainly the most influential and popular, were singled out for special opprobrium from Willis. She asserted that women became "scapegoats" for these men's "disenchantment with the class system." Willis appropriately identified Mick Jagger as "the Stanley Kowalski of rock." She also included the female musicians and fans of the era in her discussion. She wrote that the rebellion of

the female singers was expressed "vicariously by identifying with a (usually lower-class) male outlaw." To support this assertion, she mentioned the Shangri-Las' song, "Leader of the Pack."

Willis also discussed female fans of rock music. She recognized that these girls and women identified with the male musicians, which resulted in "a relationship that all too often found us digging them while they put us down." She commented on the pragmatism of this position and the effect of the women's movement upon it: "This was not masochism but expediency. For all its limitations, rock was the best thing going, and if we had to filter out certain indignities—well, we had been doing that all our lives, and there was no feminist movement to suggest that things might be different."

Willis then contrasted this with the newer type of sexism prevalent in rock and roll in 1971, stating that rock had been co-opted by male "upper-middle-class bohemians" and "elite dropouts." This co-optation meant that rock "inherited a whole new set of contradictions between protest and privilege." She asserted that due to their privileged status, these men felt "superior" to just about everybody, and she described the nature of their sexism and how to spot it in song lyrics: "Their [the elite rock males'] sexism is smugger and cooler, less a product of misdirected frustration, more a simple assumption of power consistent with the rest of their self-image. It is less overtly hostile to women but more condescending. A crude but often revealing method of assessing male bias in lyrics is to take a song written by a man about a woman and reverse the sexes."

Willis's analysis does two important things here; first it explains why the number of women in rock music began to drop so precipitously around 1969. Second, it notes that although younger men were in charge of many aspects of rock music, their sexist attitudes toward women were not very different from those of their fathers. To illustrate her point, Willis compared a song from the earlier era of rock, the Rolling Stones' "Under My Thumb," with one from the present, Cat Stevens's "Wild World." The results supported her assertions. "Jagger's fantasy of sweet revenge could easily be female—in fact, it has a female counterpart, Nancy Sinatra's 'Boots' ["These Boots Are Made for Walking"]—but it's hard to imagine a woman sadly warning her ex-lover that he's too innocent for the big bad world out there."

Willis also believed that this newer sexism was less honest than the earlier variety. Her reasons for this are astute and damning of the roles men offered women in the counterculture: "The rock culture has not merely assimilated male supremacy but, with Orwellian logic, tried to pass it off as liberation. Reverence for such neglected 'feminine' values as gentleness and nurturance [sic] becomes an excuse to badmouth women who display 'masculine' characteristics like self-assertion or who don't want to preside as goddess of the

organic kitchen." She even references *Rolling Stone*'s essay on groupies (which I discuss extensively in Chapter 5), and in a statement that supports my assertions made later in this work, discusses its ramifications for women: "The classic statement of the rock attitude toward women appeared in a *Rolling Stone* supplement on groupies. It seems that rock bands prefer San Francisco groupies to New York groupies; the latter being coldhearted Easterners are only out for conquests; Bay Area chicks really dig the musicians as people, not just bodies, and stay afterward to do their housework. This sort of disingenuous moralism offends me much more than the old brutal directness. At least, the Stones never posed as apostles of a revolutionary life style."[54]

The impact of feminism on Willis's work is evident in her assessment of the effects that an excessive concentration on technical virtuosity had on rock music. In this same article, Willis expresses her belief that the admiration of technical complexity over other aspects of rock music was a bad thing for the genre. She called the new elite rockers "art snobs" and writes that "one facet of their snobbery is a tedious worship of technical proficiency," and asserts that a concentration on technical virtuosity had a negative effect on the women in rock music: "The cult of the Musician has reinforced the locker-room aspect of the rock scene. There, as elsewhere, musicianship, like most technical skills, is considered a male prerogative, and female instrumentalists—those few who have managed to resist pervasive cultural intimidation well enough to learn to play *and* take themselves seriously—have been patronized and excluded. Besides, the pretension, competitiveness, and abstraction from feeling that go along with an emphasis on technique are alienating to most women. (This may be why there are relatively few female jazz fans.)"[55] In addition to discussing this trend's effects on women in rock, Willis ties it to a larger cultural context by pointing to the bias against women harnessing technology.

Paradoxically, Willis argued that these oppressive conditions contained the seeds of their own destruction. "The same social events that produced a sexist 'cultural revolution' produced a sexist radical left, which, in turn gave rise to the women's-liberation movement." While rock music had been "particularly resistant" to the efforts of the women's movement, it was "not impervious" to it. Women musicians were beginning to make inroads into rock music and "a number of all-female rock bands have formed, some actively feminist, but as yet this remains almost entirely a local 'underground' phenomenon."[56]

Even though Willis's work for the *New Yorker* was highly literate and often intellectually sophisticated, it was always clear that she, much like Richard Goldstein of the *Village Voice*, had a passion for rock music. In an article from 1972 discussing Grand Funk Railroad, her words reveal this aspect of her love of the music: "I'm glad they're [Grand Funk] around as an anti-dote to James

Taylor and the other upper-class brats; their adrenaline is bound to do us all good in one way or another. But their records (I've never seen them perform) don't get me off. And though this has something—maybe everything—to do with my being fifteen years older than the average Grand Funk enthusiast, anyone who tries to define me as 'them' on that basis will have to drag me away from my jukebox kicking and screaming."[57] Here Willis acknowledges not only the influence that the march of time could have made on a reviewer's tastes, but also the class aspects of the new singer-songwriter genre of rock music, typified by Taylor and Carly Simon, who were popular at that point in time.

Willis also addresses rock music's failure to effect a longlasting cultural revolution in quite the way that she and other members of the left had hoped that it would. In a column that discusses the Rolling Stones and their performance in New York City as part of their 1972 tour, Willis comments that after the show she had heard Alex Bennett, a disc jockey who had been fired by WMCA radio in New York City over his politics, trashing both the Stones and anyone who liked their concert. Willis's reaction to him was pithy as well as humorous: "I reflected that it had been a free concert, a bona-fide counter-cultural scheme [Altamont], that had killed Meredith Hunter. What can you say about a cultural revolution that died? I unpacked my new Rolling Stones T-shirt—I would wear it tomorrow—and went to bed."[58] One had the opinion after reading this column that not only would she sleep well, but that she would enjoy the shirt the next day, too.

Another article from 1972 addressed the rock-and-roll revival then in full swing. Part of this revival was actually a backlash against 1960s countercultural-style rock music. Willis refused to jump on this particular musical band wagon, and her reasons were penetrating and perceptive: "I have mixed feelings about all this. For one thing, the bloodnraunch-forever approach to rock tends to degenerate into a virility cult. Besides, having lived through the fifties, I find it impossible to romanticize them. In spite of rock and roll, they were dull, mean years—at least for middle-class high-school girls. For all the absurdities of the counter-culture, it was better than what we had before; there's something to be said for a little cosmic awareness, provided it doesn't get out of hand. Still I do have a weakness for dedicated crudity and crassness."[59] Once again, Willis's reportage cuts straight to the heart of the matter and renders it in all its complexity. She refuses to become nostalgic for the 1950s, largely due to gender issues and her own memories of those years. At the same time she acknowledges the allure of 1950s-style big-beat rock and roll.

Part of what makes Willis's prose so engaging, even today when the subject matter is no longer current, is that her candor and dedication to her craft are very clear in her work. This candor extended to revealing herself as

someone's true fan, while still criticizing that same artist for a lackluster performance or product: "What's the matter with Lou Reed? Here's a man I think is such a genius that once when I was face to face with him in a hotel room I couldn't say a word (what I wanted to say was 'Your music changed my life,' which would have been most uncool), and his second album, *Transformer* (RCA LSP 4807), is terrible—lame, pseudo-decadent lyrics, lame, pseud-something-or-other singing, and just plain lame band."[60]

Willis's ability to personalize her reviews without losing any of the bite that placed her firmly among rock journalism's literati was also evident in her list of the best ten albums of 1974.[61] Included in her description of a live Bob Dylan album is the revelation that "when I saw Dylan and the Band at the Garden, I was too excited about Dylan to realize how amazing The Band's performance was. I realize it now." Even though she included Bachman-Turner's album *Not Fragile* on the list, she still comments that she had not "forgiven" former Guess Who member Randy Bachman for writing "American Woman," and that she still wasn't "crazy about his sensibility." At the same time she admitted finding the group's sound "irresistible" and loved the album's title.

Willis also displayed class consciousness in her choice of the best albums. Included on the list was Gladys Knight and the Pips' soundtrack from the feature film, *Claudine*. She writes that even though the movie was about a welfare family, it was nevertheless "a very middle-class saga." She mentions class in her description of Knight, whom she describes as "a woman who has shown among other things, that it's possible to be a frankly middle-class soul singer without being gutless."

However, it is in the description of her final choice for the list that Willis's mastery, for the lack of a better word, of the genre of rock writing becomes clear. The album was the recently deceased Gram Parson's *Grievous Angel*:

There are albums I played more last year, and albums I admired more, but none that moved me more. Parsons was one of the few singers who could make me feel an emotional connection to country music. It wasn't just that he brought an urban bohemian's sensibility to the songs he wrote or selected but that he went beneath the genre's provincial surface—which is exactly what most country-rockers dig on—straight to the bleak loneliness and vulnerability at its core. His singing on this album made me shiver more than once. It sounds like glib hindsight to suggest that he was hinting at his death, but how else can I take lines like "Put out the flames and set this cold heart free?"[62]

Willis's humanity, as well as her engagement with the subject and her picture-perfect prose, is much in evidence in this passage.

Like others who were the bright lights of rock writing during this era, including Greil Marcus, Richard Goldstein, Lillian Roxon, and Robert Christgau, Willis was able to encapsulate the zeitgeist of an era into writing so personal

that it could almost be described as confessional. Much to the field's loss, Willis would cease writing about rock music the next year, paradoxically with the advent of a new column for *Rolling Stone* (see Conclusion).

Willis's articles in the *New Yorker* reflect her role as female gadfly in the rock-journalism community and that gender was only one aspect of her analyses. She was just as likely to pan a female artist as a male one. Her integrity and honesty are evident in her work and the success she enjoyed in the field. That said, the history of articles on women musicians would have been much more one-sided and superficial had she not written what she did. Her membership at such a crucial time in the almost entirely male fraternity of rock writers was one of the decisive steps in women's entry into the field. Willis's essays also offer a glimpse of the evolution of one woman's discovery and adoption of feminism during its popularization in America.

Like her prose, Willis's reasons for joining the radical feminist movement were subtle. In the foreword to Echols's history of the movement, Willis revealed some of the incidents in her life that led her to embrace this struggle as her own:

Any woman who says that radical feminism has made no difference in women's lives is either too young to have lived through the pre-feminist years, or has thoroughly repressed them. I lived through them, and remember them all too well. I remember a kind of blatant, taken for granted, un-self-conscious sexism that no one could get away with today pervading every aspect of life. I remember as a Barnard student, wanting to take a course at Columbia and being told to my face that the professor didn't want "girls" in his class because they weren't serious enough. I remember, as a young journalist, being asked by an editor to use only my first initial in my byline because the magazine had too many women writers. I remember having to wear uncomfortable clothes, girdles and stiff bras and high heels. I remember being afraid to have sex because I might get pregnant, and too tense to enjoy it because I might get pregnant. I remember the panic of a late period. I remember when a friend of a friend came to New York for an illegal abortion, remember us trying to decide whether her pain and fever were bad enough to warrant going to the hospital and then worrying that we'd waited too long, remember her fear of admitting what was wrong, and the doctor yelling at her for "going to a quack" and refusing to reassure her that she would live. I remember that I was supposed to feel flattered when men hassled me on the street, and be polite and tactful when my date wouldn't take no for an answer, and have a "good reason" for refusing. I remember, too, feeling pleased to be different from other women—better— because I was ambitious and contemptuous of domesticity and "thought like a man," while at the same time, in my personal and sexual relationships with men, I was constantly being reminded that I was after all "only a woman"; I remember the peculiar alienation that comes of having one's self-respect be contingent on self-hatred.[63]

Most important for this work, Willis's writings offer a tangible alternative to the sexist and stereotypical writings on women musicians found in most

other periodicals of the day, especially *Rolling Stone*. Far from compromising the quality of her writing, the fact that she eschewed using the dominant discourse of the day, which was largely a sexist or stereotypical style of writing about women, gave her writing depth and allowed it to convey more information. Before the advent of second wave feminism, both male and female writers really didn't have much choice but to write about women musicians in the manner in which they had always been written about: as anomalies or in a sexist or stereotypical way. However, Willis and her writings demonstrate that with the reemergence of feminism in America there was little excuse for writers who claimed to be on the cutting edge of cultural commentary not to know better.

Of all the people who covered rock music in the 1960s and 1970s, Ellen Willis created the most cogent and complex analyses. A pioneering rock journalist, she wrote articles about men and women in rock and roll that did not ignore differences between the sexes, but rather explored them. For this reason, Willis's work forms the core of my analysis of female rock critics. A member of some of the earliest radical feminist groups in New York City, her articles often included a gender-conscious perspective on rock music and rock music journalism not present in most of the other articles, which were written primarily by men.[64] Significantly, thus, her articles demonstrate what nonsexist writing about rock and roll could be.

Another highly influential female music writer during these years was Lillian Roxon. She also became enamored of the genre during the very earliest stages of the creation of rock writing and brought to the field a wealth of experience from her many years as an entertainment columnist for Australian newspapers and magazines. The rock encyclopedia that she compiled was one of the earliest of the reference works in the field. I will, however, be discussing her work as a rock gossip columnist for the *New York Sunday News*.

The same year that Willis was writing about Janis Joplin, 1968, Lillian Roxon began the most ambitious project of her career: a rock encyclopedia. However, she was not the first author approached by the publisher to do the project. Roxon wrote a column called "Elevator" for *Eye* magazine, a journal discussed in Chapter 1, which commented on the varying fortunes of people in show business. After their first choice turned them down, Roxon was recommended for the project by her editor at *Eye*. She was advanced $2,500 for the project. Initially proposed as a paperback, the project ultimately topped 600 pages and was issued as a hardback.[65]

Roxon began writing in May 1968 and had initially assumed that the project would take her three months; it ended up taking seven. She was also still

working at the paper, a fact she comments on in the *Quadrant* article referred to above. "And naturally when you are writing a book, you have to work twice as hard as you ordinary would to prove to your boss you're not slacking."[66] Roxon hired researchers to help and even called on some of them to write entries.[67] When the book was published in the fall of 1969, it was called *Lillian Roxon's Rock Encyclopedia*.[68]

Some of Roxon's stated reasons for writing the book touched on her anomalous age and position in the rock community and were quoted in her obituary in the *New York Times*. "'I wrote my book for the parents so they could better communicate with their children.' She described herself as having 'my foot in both camps—I have friends who are 19 and friends who are the parents of 19-year-old [*sic*].'"[69] It appears from the book's reception that people of all ages enjoyed what was on its pages.

The press was largely enthusiastic about the encyclopedia. In the *Village Voice*, Howard Smith was glowing in his praise of both the book and Roxon. He described it as "an A to Zombies pleasure trip, tracing both the obscure and the grand groups, their members, instruments, bibs and discography (singles and albums), styles, influences, and managers and its producers. More than that, it's compiled by the perfect person for the task." Hinting at the esteem in which she was held, he goes on to describe Roxon as "one of those articulate offbeat newspaperwomen who has trekked every imaginable kind of scene and managed throughout to remain everyone's favorite person."[70]

S. K. Oberbeck was equally as complimentary in his review of the book for *Newsweek*, writing that it "encapsulates, characterizes and deftly judges the whole sprawling, whirlwind development and nature of rock." He also described the book as thorough and concise, possessing "stylistic verve and critically acumen" while being "devoid of 'hip' pedantry or florid overwriting." True to the approach of the men in the era's press, he also mentions Roxon's appearance, describing her as "a charming, rather plump blonde who refuses to mince her words or reveal her age."[71]

In her own article from *Quadrant* magazine recounting her writing of the book, Roxon describes the reactions of various other publications to the book. She reported that *Vogue* had recommended it as Christmas present, while the *Wall Street Journal* had dubbed it "delightful." Even the music trade magazines jumped on the bandwagon. *Cashbox* called it "magnificent" and *Billboard* gave it the ultimate seal of approval by selling it to their readers by mail. The *Los Angeles Times* hated it, while the *Los Angeles Herald Examiner* liked the book, as did the *Washington Post*, the *Chicago News*, the *Montreal Star*, the *St. Louis Post Dispatch*, and the London *Record Mirror*.[72]

Roxon's peers in the world of rock journalism also weighed in on the *Rock Encyclopedia*. Robert Christgau included it among the two reference books on rock that he liked and damned it with more than faint praise by writing that it, "could be more accurate and complete, but in the meantime is the only one we got [sic] and pretty useful and entertaining at that."[73] While Ellen Sander, rock critic for the *Saturday Review*, writes that "much criticism had been leveled" at it, "yet it is the most comprehensive and complete mass of organized information assembled. It's easy to second-guess so ambitious a project as an encyclopedia of rock, but Miss Roxon's Herculean effort, now available in excitingly practical paperback, tries harder and succeeds more expansively than any even vaguely similar effort."[74] Sander's reference to the book's issue in paperback hints at its commercial success.

The book was a smash and according to Milliken, made Roxon "a media celebrity." Six months after its initial offering, the book was into its third printing, quite a feat for a hardcover encyclopedia of rock. Roxon appeared on *The Tonight Show* and was profiled in the *New York Times*.[75] She was soon hired to write a column for *Mademoiselle* called "The Intelligent Woman's Guide to Sex," which she would write until her death.[76] In 1970, she also began writing a column on food and health for *Fusion* magazine, and in 1971 she began writing and reading the copy for a daily-rock music program called "Lillian Roxon's Discotique," which was syndicated to 250 radio stations in America.[77]

With her rock encyclopedia, Lillian Roxon became one of the most influential and widely read rock journalists in America until her death in 1973. Beginning in the mid-1960s, she harnessed her not inconsiderable journalistic talents and experience in the field to the genres of rock criticism and rock gossip. Her role as a gossip columnist allowed her to both exert a considerable influence over the rock community (especially in New York) and to act as an arbiter of standards and morality for its members.[78] Her column "Top of Pop" discusses many issues given short shrift by most male journalists as well as predicts many future developments in the rock-music business.

Lillian Roxon, born Liliana Ropschitz, was born in Alassio on the Italian Riviera in 1932. She was the daughter of a doctor and a housewife, Izydor and Rosa Ropschitz, Polish Jews from Lvov who had settled there in 1926.[79] Due to the rising tide of anti-Semitism in Western Europe, in 1938 the Ropschitzes began to look for a way out. After obtaining a Polish passport, Izydor took his family to London and applied for asylum in the United States and Australia. The family received its Australian Landing Permit on July 21, 1939. After Izydor found work as a ship's surgeon on the SS *Tyndareus*, the family sailed for Australia in July 1940, arriving in August of that year.[80] Although they escaped the

Holocaust, those in Lvov were not so fortunate. Of the 100,000 Jews in Lvov, only 3 percent survived the war. Izydor's parents and three of his five sisters were among the dead.

The Ropschitzes were not able to settle among the more urbane cities of Melbourne and Sydney, which also contained the largest Jewish communities in Australia. They moved to Brisbane due to the fact that barriers had been erected by the medical establishment to stop refugee doctors from practicing medicine in the larger cities. Also attributable to the xenophobia and anti-Semitism present in that country, refugees like the Ropschitzes were advised by Jews who had come before them to become inconspicuous and blend in. To this end, in November 1940 the family legally changed their name to Roxon, and Liliana became Lillian.

Lillian received her education in Australia. She graduated from State High in Brisbane in 1948 and entered the University of Sydney a month after her seventeenth birthday in March 1949. Lillian soon gravitated toward a group of freethinking Libertarians who would become known as the Push. Roxon's biographer Robert Milliken describes the Push: "what distinguished the Libertarians from the few others who criticized the fifties political and social order was that the Libertarian Push set out to *live* their definition of freedom, not just to argue about it." In contrast to the attitude of conformity that largely held sway in Australia at the time, the Push members were anticareerists, disregarded conventions (such as women drinking with men at the usually sex-segregated pubs), and believed in sexual emancipation, although the men in the group still upheld the sexual double standard. Analogous in many ways to the American Beats, the Push also paved the way for the 1960s counterculture. Other notable members of this Australian group were Germaine Greer, author of *The Female Eunuch*, and Margaret Fink, producer of *My Brilliant Career*.

After five years, in April 1955, Roxon graduated from the University of Sydney with a B.A. in English and philosophy. She then took a job in the advertising department of a Sydney department store in order to save money for travel and left for New York in 1956. Her sojourn lasted eight months. Roxon stayed with an aunt in Yonkers and then moved to Greenwich Village. During this visit, she decided that New York would eventually become her home, but she had to return to Australia first and figure out a way to make that happen. Upon her return she became the head of publicity for another department store in Sydney.[81] She would not stay there long.

Roxon's desire, and her ability to write, soon led her to a career in the print media. In January 1957, she became a staffer at *Weekend*, a weekly tabloid that was largely a scandal sheet. She soon became chief reporter and section

editor. The editor, Donald Horne, was very influential on Roxon's journalism. For four months in 1957 he produced weekly bulletins for his staff that both critiqued the magazine and provided how-to advice on the practice of popular journalism. Roxon kept these bulletins with her until she died. In early 1958, Horne also began to edit a bimonthly magazine of higher quality, the *Observer*. As her first assignment for this new magazine, Roxon produced a largely sympathetic article on Liberace. At these two magazines she received her principal journalistic training and her introduction to entertainment reporting.

Roxon would largely exercise that preparation in the United States. In mid-1959 she moved to Hollywood, where she continued to write a gossip column on the entertainment world for *Weekend*. She then moved to New York and took a job for one year with the *Sydney Daily Mirror*'s bureau there. After her departure from that paper, Roxon took a job on London's Fleet Street with the *Sydney Morning Herald*.[82] She returned to New York in late 1960, where she received two offers of employment, one from her old boss Horne, and another from the *Australian Woman's Weekly*. Both would have involved her return to Sydney. She declined the offers to try her hand at freelance writing.

During the course of her work as a freelance writer, Roxon wrote for many different publications and news services, including a British syndication agency that sold her work in Israel, the *News of the World* in London, and Horne in Australia. In 1961, she nearly landed a staff job at the New York bureau of the *Sydney Morning Herald*; however, the management in Sydney rejected her as they believed they already had too many women on the staff. In a letter to her mother, Roxon commented on the sexism in the newspaper industry in general: "Old-fashioned aren't they? It's not just me, it's the whole principle that women are useless luxuries on a newspaper."[83] After only two weeks on the job as a researcher and speechwriter for the Indonesian consulate, her work came to the attention of the editor of the Australian Broadcasting Commission magazine *TV Times*, which took her on as an accredited correspondent. The position provided Roxon with a foreign journalist's visa and ended the uncertainty concerning her immigration status, which had been shaky up to that point.[84] She also contributed to the Sydney *Sun*, the *Sydney Morning Herald*, *Women's Day*, and the *Sun-Herald*.

In 1963, Roxon finally became a full-time staffer at the *Sydney Morning Herald*'s New York bureau. She would work there until her death ten years later. She continued to cover entertainment news and articles of interest to women. Her approach was brash and made an impression on one young journalist who would become one of her closest friends. In 1966, author Danny Fields was the managing editor of an American teen magazine called *Datebook*. He first

became aware of Roxon during the summer of 1966 at a press conference called by the Beatles' manager Brian Epstein. Fields heard one question, asked by a small woman with blonde hair, which made him prick up his ears. "Mr. Epstein, are you a millionaire?" Roxon asked. Fields thought Roxon's question both savvy and cognizant of the fact that rock was soon to be big business and decided to meet her.[85] Fields spoke to Milliken of his relationship with Roxon, "But I just thought she was so funny and then we became instant friends. She was like a big sister to me and she later taught me a great deal about professionalism, how people should behave to each other and what people shouldn't do."[86] She continued to grow more interested in the rock scene and writing rock journalism.

Roxon's long experience in the world of entertainment journalism made her an anomaly in the world of rock writing. Most of those who wrote in the genre were young turks just starting out in the business. Ellen Willis spoke of this phenomenon: "I think in terms of music journalism this was something that had just started. It was like I was getting in on the ground floor of a genre and so the people who were influencing me were my peers who were developing it at the same time."[87] In contrast, Roxon was both older and an experienced journalist, thus most of her friends and colleagues were much younger than she. One of these was a wealthy, twenty-four-year-old junior fashion editor for *Town and Country* named Linda Eastman. Eastman soon discarded fashion and the upper crust to chronicle the rock scene with her camera. She and Roxon became the closest of friends. Eastman's decision to drop her as a friend after her marriage to Paul McCartney crushed Roxon, and they never reconciled.[88]

Much of Roxon's socializing, as well as her research for her work, centered on two places, Steve Paul's The Scene and Max's Kansas City. In a 1971 article for *Quadrant* magazine, Roxon chronicled how she discovered them. She was working a 5 P.M. to 1 A.M. shift for the *Herald*, which made her somewhat of a night owl. Roxon attributed finding the two clubs to this schedule:

> I don't suppose I would have ever got interested in rock music, though I have been watching developments in that field for about a year because I could see how overwhelming a force it was going to be, but there were only two places to go at one in the morning.
> One was a restaurant near my home called Max's Kansas City, a place rock groups found comfortable, glamorous and convenient for late-night meals. Another was a small club only a few minutes' walk from work called The Scene where groups played nightly and musicians hung out if they were lonely, bored or simply needing one familiar spot to focus on in a large, cold and often unfamiliar city.[89]

In May 1971, Roxon also began writing her "Top of Pop" column for the *Sunday Daily News.*[90] Milliken asserted that "at that time, the *Sunday News* claimed

4.5 million readers in New York City and its suburbs, New York's highest circulation."[91] Initially she shared a page with fellow entertainment columnist Rex Reed; however, based the popularity of her column, soon almost an entire page was given over to it. It was a mixture of the new style of rock journalism, which concentrated almost as much on the sociological aspects of the music as the music itself, and classic tabloid-style gossip, complete with blind items.

Even though things were going well for Roxon professionally, she had begun to have health problems and struggled with asthma. While writing the rock encyclopedia in 1968–69, she had developed this condition, and Milliken asserted that it was both her tiny—and untidy—apartment, coupled with the problems associated with big city air pollution, that alternately triggered and worsened her condition. He also offered up that Roxon's New York friends believed that the encyclopedia had killed her.[92] The cortisone she took, then the drug of choice to treat the disease, also worsened her weight problems, which in turn exacerbated her asthma.[93] She needed to leave New York City for a climate that was more conducive to her health, but refused to relocate. It was a decision that would cost Roxon her life.

It is not entirely clear exactly when Roxon died. In August 1973 some of her friends began to notice that she looked unwell. On August 8 she appeared at Max's Kansas City for the last time to watch her old friend Danny Fields perform. The following night she called close friend Lisa Robinson, who told her that she would have to call her back as she was just heading out to a party. Around 11 P.M. Robinson returned the call, which was answered by Roxon's answering service. The next day Robinson left several more messages that went unanswered, which was completely out of character for their relationship and communication patterns. She became alarmed by the middle of the afternoon, especially when the answering service revealed at 4:00 that Roxon hadn't called for her messages all day. Robinson took her husband and a friend, Danny Goldberg, to Roxon's apartment, where they banged on the door to no effect. Roxon lived across the street from a police station and the three went there to tell the police about the situation. Goldberg explains what happened next: "The cop came back with us and went in first. He came out and said, 'You don't want to see this. She's dead.' Lisa said to him, 'Can't you pound on her chest or something, can't you do anything?' The cop said. 'She's dead.'"[94] Roxon's death certificate said that she died from the effects of asthma on August 10, 1973. She was forty-one years old.

The regard in which Roxon was held by her friends and colleagues was clear in their reactions to her death. Upon hearing the news, Mary Cantwell, then the managing editor at *Mademoiselle*, went straight home and "sat in a corner of my living room and cried all day. I had my own wake with vodka."[95]

Richard Meltzer, author of *The Aesthetics of Rock* (1970), also had a strong reaction to Roxon's death. "I went up and cried on the Empire State Building. The next six months, every time I got drunk, I'd get all whimpery, 'cause she was, like, the saintliest person I'd ever met. Every day she'd call up every person she cared about to sincerely encourage every fucking hopeless tangent they were on, like, unconditionally."[96] Her close friend and *Village Voice* fashion columnist Blair Sabol wrote a tribute to Roxon in that magazine. Titled "Lillian Died Last Week," the piece made clear Roxon's support and encouragement of her friend. "She was a human being so experienced and seasoned, yet so open and spirited, that at times she insisted she was years younger than I. And she was."[97] Another friend and *Voice* contributor Tracy Young also wrote a tribute to Roxon for that journal. "I most often thought of her as a fairy godmother. Someone you talked to when your lover left. She was a nurturer. She was that to me. But the wonder of Lillian was that she moved in many worlds and she was as many different things to people as there are many different people who were her friends and who loved her."[98]

Both the establishment and the rock press noted Roxon's passing. The *New York Times* gave her a lavish two-column obituary and referred to her as "an authority on rock music and one of its leading chroniclers" and "one of the first journalists to pay serious attention to the new life styles that emerged in the nineteen sixties."[99] *Rolling Stone* commented on her death. Writer Loraine Alterman wrote perceptively about Roxon's ability to spot trends: "Always, Lillian sniffed out what was about to explode on the popular culture front before anyone else even noticed the fuse. Back in 1966 she latched on to the big business implications of rock & roll while everyone else was glowing with peace, love, and incense."[100] Alterman's characterization of Roxon also captured some of the author's many facets. "Lillian was the confidant of star and their fans, the Michelin of health foods, the Dorothy Parker of Max's Kansas City—all of this and more because she was a journalist, in fact, a journalist's journalist." These lengthy press pieces were in sharp contrast to what appeared the *Sunday Daily News* and the *Sydney Morning Herald*, which both gave her only four paragraphs.

Perhaps the best description of Roxon was offered by fellow Australian Helen Reddy in *Woman's Day* and reprinted in her *Rolling Stone* obituary:

Regrets? I don't think you would have any. You had a wonderful life. You traveled all over the world. Your peers were the most witty and intelligent of their generation. You saw a new art form arise and sailed at it masthead. You achieved success against discouraging odds and I think you were happy to go while you still looked so young and your bed was still warm. New York City has lost one of its legends and I don't want to walk into Max's Kansas City without seeing you holding court or having you clutch my hand and say "Darling, you *must* meet a fabulous person."[101]

Some of Roxon's most significant, and most undervalued, writing is her work as a gossip columnist, specifically her "Top of Pop" column in the *Sunday Daily News*. This writing also points to her role as social arbiter in the rock community, which she accomplished in the written realm largely through her gossip column. By approaching this column using theoretical models of the function of gossip in a community, it is possible to delineate a more complex discussion of Roxon's work as a mass-media gossip columnist, especially from the stance of gossip as gendered language.[102]

In large urban societies where those who meet casually in social or mercantile situations rarely have friends, or even acquaintances, in common, gossiping about stars and media figures has allowed people to assert their membership in a common group. Media gossip columns provide the fodder for these conversations. As such, they act as a font from which we are able to draw the information that allows us to continue to interact with other people in the atomizing urban landscape. This media gossip can also provide a "virtual" community of people whose personal lives can be followed privately by its consumers, which is another way to assert membership in a common group. Roxon's column, as well as *Rolling Stone*'s "Random Notes" section, contributed to this process in the community of rock fans.

Roxon's writing also cut across another aspect of gossip, namely that of gender. In fact, the meaning of the word has shifted over time and taken on a pejorative meaning based upon gender. In her fascinating discussion of the evolution (or mutation) of the word gossip, Melanie Tebbutt definitively established that the term went from referring to *godsibb*, a late Old English word that meant godparents, to by the early nineteenth century being defined as "a person, mostly a woman, of light and trifling character, especially one who delights in idle talk."[103] She offers an intriguing explanation for this largely male-initiated criticism of women's talk: "It is gossip's ability to make and break reputations which makes it so often feared, and it is this aspect which frequently forms the basis of popular perception of such talk. Such examples, in testifying to the power of women' words, suggest how gossip's associations with women may be seen as part of a widespread mythology which seeks to prevent them from gossiping, and thereby exclude them from the power and politics of everyday living."[104] When reading Roxon's column, these two facets of gossip become very clear; gossip is powerful speech and if anyone ever told Roxon she couldn't gossip, she didn't pay any attention to them.

Roxon's "Top of Pop" column was an intriguing mixture of the then-new style of rock journalism, reviews, plugs, slams, flirtation, and classic tabloid-style blind items. Running for a little more than two years, from May 1971 to her death in August 1973, the column appeared to aim its reviews at younger

fans, while its more gossipy items and plugs were directed at industry insiders. Roxon's long years of journalism, especially her early experience with the tabloid variety in Australia, made her column an anomalous mixture of old and new styles. Meanwhile, her personality, her catholic tastes, and her insider status in the rock community made her a credible, unorthodox, and informed source. "Top of Pop" thus acted as a site for the discussion of the social and moral facets of the rock community as well as taste-building cultures. Roxon was never shy about telling her readers what she thought was right and wrong, or good and bad.

Unlike many of her peers, Roxon often wrote with teen and pre-teen readers in mind. The column "Don't Knock Cradle Rock," in which she described an Osmond Brothers' show at Madison Square Garden, was a good example of this facet of her writing, as well as the expansiveness of her taste in music. "I have to admit to all you Osmond fans out there that I went to this concert to sneer. I went to poke fun at subteen passion and the whole phenomenon of cradle rock. But you know what happened? I had a good time!"[105] Proving that this was not just an aberration, Roxon also gave a positive review of a Jackson Five show from 1972.[106] She wrote of being "bombarded by letters from readers 14 and younger." Telling her readers that the rock stars loved getting fan mail, she provided the addresses of many of the fan clubs and record companies.[107]

Roxon had several purposes in reaching out to the teens, one of which appeared to be to educate them. After seeing Bob Dylan perform in *Pat Garrett and Billy the Kid*, she wrote, "what you see on the film, and this is why I love it and think it's historically important for those of you too young to have that perspective, is not the Guru Dylan, or the father and family man, the millionaire songwriter, the culture hero, but the kid who came to New York from Minnesota back in the early '60s."[108] Here she appears to be attempting to expose younger readers to facets of rock culture that they were too young to have experienced for themselves.

Another part of her efforts was to give the readers perspective on rock culture. In the final column published before her death, Roxon wrote about the need for this perspective, the cyclical nature of trends and why she enjoyed them: "I remember how bitter the old musicians were when Elvis moved in, and how, in turn, the Elvis follow-ups resented their temporary eclipse when the Beatles came along. Trends come and go, but I don't need to tell you what it takes to survive. Which doesn't mean trends aren't worth watching or that New York rock isn't the coming trend."[109] A more cynical reason that Roxon might have reached out to younger readers, but one which a savvy journalist like her would have been aware of, was that they represented the future. They were also likely to be the arbiter of new trends, which is the lifeblood of a gossip columnist.

In her column Roxon definitely did not neglect her peers, or the stars, in the industry. Almost every one contained some reference to either an exclusive party or revealed some insider's information on the stars and their lives. For example, in her first column in May 1971, she mentioned the fact that Janis Joplin's house was for sale, noted some of its features, and listed the cost, in addition to commenting that the "word from the jet set" had the Kennedys becoming chummy with Ike and Tina Turner.[110] Roxon also proved that she could be discrete when necessary. Introduced with "now it can be told," in May 1971, she revealed that Grace Slick had been in a terrible car accident and had been in critical condition for several days. "Even when it was finally clear that she was going to be all right, the possibility of brain damage was so great that the story was nervously hushed up."[111] Roxon also devoted several columns to details of rock press junkets and record company parties that she attended, and was plugged in on a global level, writing columns with U.S., British, and Australian datelines.[112]

Roxon also liked to expose new talent and bring more established artists to her reader's attention. One of the new bands to benefit from her largesse was the Modern Lovers, whom she plugged in a 1972 column. She reported in a subsequent column that seven record companies had tried to sign them to contracts after she had mentioned them.[113] She also made guitarist Sandy Bull almost a regular in her column. The list of stars that she interviewed and whose shows she reviewed ranged from the biggest names in rock, such as Mick Jagger and Alice Cooper, to soul singer Al Green and nightclub entertainer Paul Anka. She made it almost a private crusade to push Kinks' frontman Ray Davies on her readers, and fellow Australian and friend, Helen Reddy was similarly ubiquitous.

Roxon's subject matter was rock music, but she remained true to her tabloid roots and retained several stylistic traits common in that genre. One was the blind item, which is gossip that does not reveal the person's name but merely hints at their identity. Roxon's columns were peppered with these items throughout its run. The following is a typical example: "guessing game: What famous, famous name who hasn't set foot on a stage in years now plans a short concert tour with his wife as soon as she has her baby? I can't swear they'll do it but I can swear they're seriously talking about it."[114] Often Roxon would reveal the name of the person in a subsequent column. Some of the blind items were more personal in nature, such as "you'll never guess in a million years what beautiful rock marriage is already finished, but let's just say that the long separation didn't help any"[115] or "and what British male sex symbol just got a face lift?"[116] Rock insiders would probably know to whom these items referred while others could speculate and would consider Roxon "in the know," a must for a successful gossip columnist.

Some of Roxon's blind items illustrate gossip's ability to police morals, or to bring attention to breaches in a group's moral, ethical or taste standards. An example of this type of items includes the following tidbit: "That rock and roll princess who has decided that marriage is not for her, should make a formal and dignified announcement before the gossip becomes too evil."[117] Another exhibits how an interviewer could exact revenge for being refused. "The reason a much beloved but temperamental singing idol won't give interviews or even make concert appearances anymore is that he (and his band's exceptionally talented drummer) are totally out of it. Friends blame cocaine."[118] Several blind items reported marital infidelities: "what recently married major rock star has taken one of Joe Cocker's ladies on tour with him while his chic international wife goes home to the baby?"[119] Roxon's use of the blind item illustrates gossip's potential to allow a person of high status to put others in their place. Roxon would have had the last word with a very large audience and the rock stars knew it.

The blind item was not the only holdover from tabloid journalism in Roxon's columns. She also used distinctive phrases, à la Walter Winchell, to set up her information, including "wait for it" or "remember we told you first."[120] It was also clear that she was aware of the gossip columnists who had come before her. In one column she notes that one star's manager "thinks I'm Louella Parsons," a reference to the powerful Hollywood columnist who was affiliated with the Hearst media empire.[121] Roxon's age and long experience in the entertainment business was also in evidence. She compared Ray Davies to Gypsy Rose Lee, a burlesque performer of an earlier era,[122] and described rack jobbers (the salesmen who stocked records in stores) as "the most important men in the record industry," which, despite its accuracy, was hardly the most progressive view of rock in the era of the superstar and the independent producer.[123]

Roxon's subject matter and her authorial stance were anything but old fashioned. She was an early and vocal supporter of the women's liberation movement in her column, devoting several to the role of females in rock music and individual women artists, especially Helen Reddy. In her predictions for 1972 she wrote that "at least one new singer will be female and militant, and many new songs by men will reflect a new 'liberated' attitude toward women."[124] Reddy's feminist anthem "I Am Woman" would be a number-one song by June 1972, and she would also go on to win a Grammy that year. Roxon's "A New Role for Women in Rock?" from 1972 was ostensibly a review of the "Star Spangled Women for McGovern" rally, at which all the entertainers were female. In it, she questioned why there were no female concert promoters and so few women instrumentalists in rock. She wrote, "if so many talented women can get together for a political candidate, why can't they get

together for other important reasons? Like, for instance, to show what women can do in rock?"[125] In such columns as these, Roxon demonstrates her knowledge of and distaste for the double standard among rock musicians as well as clearly exhibiting her willingness to take on a role as advocate for women in the world of rock.

Roxon's personal touches expanded the approach of women journalists, especially in their treatment of men in the rock press. Much like fanzine journalists had always done, she commented on the physical beauty of her subjects. She described particular male artists as having "cosmic good looks," being "another beauty," or simply as "gorgeous," for example.[126] Reflecting her own battle with obesity, Roxon supported rock fans' efforts to slim down. "Two plump but beautiful groupies called Diane Soda and Sunshine Shake write a delightful lose-weight newsletter for chubby rock fans," and telling readers to send her a self-addressed stamped envelope for a free copy.[127] Her calling these women "beautiful" differed radically from the approach of *Rolling Stone* and the more mainstream magazines, who either ignored overweight women or wrote about them as if they were unattractive at their present size. Moreover, unlike her colleagues at *Rolling Stone*, her interest in musicians' physical qualities never served as a substitute for her judgment of their talent.

Roxon's prediction about Reddy was not her only bit of prescience; in fact, she was able to anticipate several important developments in rock culture. Her comments about commercial tie-ins, TV screens at concerts, music television, and rock museums also proved to be correct. In a 1972 column she discussed "how primitive" the commercial tie-ins were in the rock-music field and predicted they would be bigger, as indeed they became.[128] After witnessing the use of a large, multiscreen video playback at an outdoor concert, she predicted that "in the years ahead, I doubt that anyone will dare put on a big concert without it," and indeed few do.[129] In the wake of Don Kirshner's initial forays into rock television, Roxon enthusiastically supported the idea, writing, "as far as I'm concerned, I'd like to see a whole channel devoted to rock 24 hours a day, seven days a week."[130] Almost a decade after this suggestion, MTV became the first twenty-four-hour music television service. In a 1973 column, Roxon called for the creation of a rock museum.[131] The popularity of Cleveland's Rock and Roll Hall of Fame and Seattle's Experience Music Project attest to the soundness of her suggestion.

I detected a wistfulness in Roxon's column during the last couple of months of her life, as is evident in the quotation above that comments on the cyclical nature of rock music, as well as another from July 1973. Both hint that perhaps Roxon knew just how serious her health problems were. Or perhaps she had just come to that stage of life known as early middle age, when many

begin to gain some perspective on time and its passing. In an article titled "Recalling the '60s with Mama Michelle," Roxon writes of her memories of the beginnings of rock journalism and the counterculture: "I remember the excitement when the Mamas and the Papas had an article written about them in *Life*. It was the first time I truly began to feel a new life style was beginning to take over an entire country. It is so hard to believe it was so long ago."[132] A little over a month later she would be dead.

This brief examination of Roxon's music columns doesn't begin to exhaust her work as a rock journalist. Indeed her rock encyclopedia, which remains a useful reference work, could form the basis of a lengthy discussion of rock journalism in the late 1960s and early 1970s. Through her column especially, Roxon was able to act as an arbiter of standards and tastes for the rock community, particularly in the New York area, and her work and reputation allowed her to exercise great influence in the global rock community. That she chose to use her journalistic talents for the creation of a gossip column should not make it seem as if she wasted her time or efforts. Gossip, especially of the media variety, is an indispensable part of human relations and is a way for us to reach out to others and assert our mutual group membership in an urbanized society that offers us fewer and fewer opportunities to do so. That Roxon understood this so long ago, and was so successful at it, should be cause for praise, not scorn.

Both Willis and Roxon's work were exceptions to the rule. Their existence makes plain the available alternatives to the approach most male music journalists employed during the period. Rather than limit women musicians to narrow roles prescribed for them by patriarchal society, the authors of these articles sought to transcend those boundaries and portray women in all of their human complexities. That writers like Willis and Roxon were also some of the best and most well known in the field demonstrates that this nonsexist approach was commercially and critically viable. That Willis and Roxon were able to transcend the barriers that the largely patriarchal Fourth Estate had erected for them demonstrates that women could thrive despite the odds. That their work remains a viable object of study for cultural historians thirty years later reveals that women rock journalists contributed to the field of rock journalism in essential and undeniable ways during this formative period.

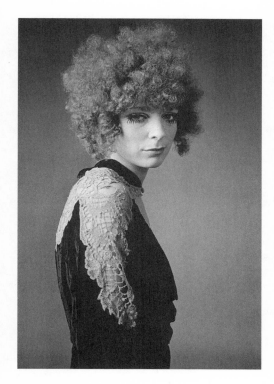

Karen—One of the best known of the images associated with *Rolling Stone*'s groupie issue, this photograph of Karen was used for both the ad in the *New York Times* that promoted it as well as the book version of the project published in 1970. Wolman stated, "She loved the photo. She just had the best time. I get the feeling that she'd done some modeling." Karen's style and knowing look capture perfectly the zeitgeist of both the groupie subculture and the era.

Baron Wolman Photo Gallery of Rock Women from the 1960s

A self-taught photographer, Baron Wolman became the first editor of photography for *Rolling Stone* in 1967. He was also the person responsible for the idea of an issue on the groupies. The nine photographs of the groupies and women musicians that follow are taken from his work at the magazine.

Wolman described himself as being drawn to photography by the access it gave him to the world: "With a camera, you could always get where the action is. It's like a privilege that you're given and it's turned out to be true forever. You were always allowed into the inner sanctum without paying the dues to learn about the situation that you were photographing, if you had a camera and if you were photographing for a legitimate purpose" (Baron Wolman, personal interview, 6 Jan. 2004; unless noted, all information in this section is derived from this source).

Wolman's idea for the groupie issue stemmed from his first-hand observations of the subculture. A resident of the Haight during the 1960s, he also had close ties to the San Francisco rock community:

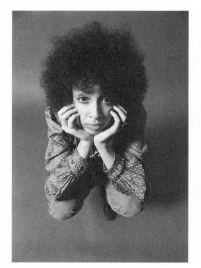

Jenni Dean—Dean was closely associated with Electric Ladyland Studios and was a fixture in the New York rock scene of the late 1960s. She was quoted by Jonathan Cott in *Rolling Stone* and Lillian Roxon in the *Village Voice* in their reviews of the film *Groupies*, in which she appeared. Of this shot Wolman said, "Those women knew a lot. I mean they were street-wise in order to do what they did and to have the self-esteem to go in and do what they did, and to be able to handle rejection as they often had to. They had to be pretty strong personalities." It was taken in 1969 in New York City.

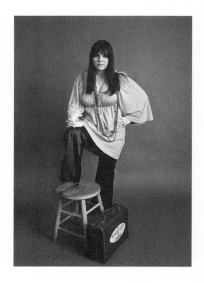

Cynthia Plaster Caster—Posed like a game hunter displaying her trophy and including a business-like briefcase with her group's name on it, this shot captures completely Cynthia's unique approach to being a groupie. Wolman commented that "The cast had to be in some of the pictures, it just had to be. That's what she was, what she did." This photo was taken in 1969 in Chicago.

We spent a lot of time backstage, obviously, because in those days it was more of a family affair with the musicians. They lived in the area, most of them were our friends, we hung out with them. So we would also go backstage before, during, and after the concerts. What I noticed every time I went back was these very attractive women back there and if they weren't attractive they were very stylishly dressed and put together. And I saw this over and over and I thought, "This is pretty interesting." Because I enjoy photographing women in any event, but I decided I wanted to isolate them and do portraits of them because they put so much into their commitment to being a groupie.

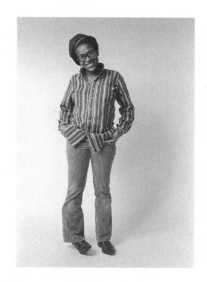

Henri Napier—After the first issue of *Rolling Stone* was published in 1967, groupie Henri Napier appeared at the magazine's offices and became its first receptionist. Her characterization of groupies as "rock geishas" appeared in both *Rolling Stone* and *Time* in 1969. She was in the advanced stages of a pregnancy when this shot was taken in San Francisco that same year.

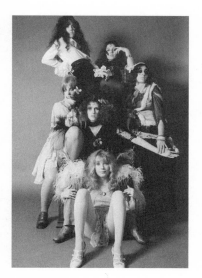

The GTOs—Closely associated with both the Los Angeles "freak" scene and Frank Zappa, the GTOs were both groupies and performers. Alice Cooper characterized them as "more performance artists," while a member of Zappa's band the Mothers of Invention was quoted as saying that they couldn't carry a tune in a bucket. That notwithstanding, the group released an album, *Permanent Damage*, in 1970. The group's most famous member, Pamela Des Barres, has made a cottage industry out of writing about her groupie past. This shot was taken at A&M Studios in Los Angeles in 1969.

Wolman then pitched the idea to the editorial staff at *Rolling Stone*:

I said, "This is a really interesting idea. This is an all-pervasive phenomenon." And it turns out in retrospect that this has been true since time immemorial. Any time there's somebody famous, you're gonna find groupies. Janis Joplin would complain on occasion that there were no male groupies, where were all the male groupies? It was pretty much women following men, that's what I discovered. Since it was clear to all of us that this was not something new, it seemed like a subject worth covering. Plus, I said to Jann [Wenner] and John Burkes, who was doing the piece, these are enormously photogenic

Cass Elliot—This is from the photo shoot that accompanied a 1968 interview by Jerry Hopkins. One of the earliest of the much acclaimed *Rolling Stone* interviews, it was also one of the few from this era to feature a woman musician. Of this image Wolman stated, "First of all it was a challenge because she was so heavy. I was always looking for a way to make people look as good as they possibly could look and that was the challenge here." The expressiveness in Elliot's eyes speaks volumes. This photograph was taken in Los Angeles in September 1968.

people and I think we're going to be able to have, at least, good photo sessions and I'm sure there are stories there too. And everybody agreed.

The result was an issue in 1969 devoted to the groupies and their subculture.

The approach that Wolman employed in his photographic sessions with the groupies resulted in work that has a stunningly revelatory quality:

I was always fascinated and inspired, actually, by the photographs of Irving Penn and Richard Avedon. What they would do, is they would isolate the people they were photographing in front of a plain background and ask the people to look directly at the camera and give something of themselves without any of the artifices of a background or any other environment. So I decided that was what I really wanted to do.

The other thing too I noticed in looking at all these pictures [of the groupies] is that they basically had one light source. You get a little shadow, but you get a nice even light on the people so that nothing would be hidden in the shadows. You would pretty much see what the women, in this case, brought to the presentation.

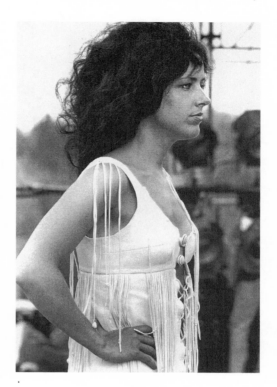

Grace Slick—Taken onstage at Woodstock in 1969, this shot captures not only Grace Slick's striking beauty and classic profile, but also her determination and sense of self-possession. At this concert, she would perform in front of a crowd estimated at 500,000. Wolman said, "In this one, she really did communicate that hard-edged chick with an attitude. She always had an attitude but when I had photographed her prior to that I was really looking for the feminine side because she was so beautiful. And this one is like 'Watch out!'"

The result is that the women's stories seem to leap out of these photographs. The range of expressions that Wolman captured mirrors some of the range of possibility that they possessed. These are photographs of people; interesting and unique, but still people.

When asked how he wants his work on the groupies to be regarded by posterity, he replied:

I'll tell you what I didn't want. I didn't want people to think that they were cheap floosies. They were very stylish. Many of them were very intelligent. I don't understand how people can become so obsessed with stars of any kind. Except I will say that when I photograph stars I seem to feel like they are different than you and me. But they're not. They just happen to have a talent and have been in the right place at the right time to express that talent.

I hope that people appreciate that I treated them [the groupies] with dignity. That I saw that they represented an important component of the world of music and I wanted to represent them in a very positive way. They were probably at the forefront of

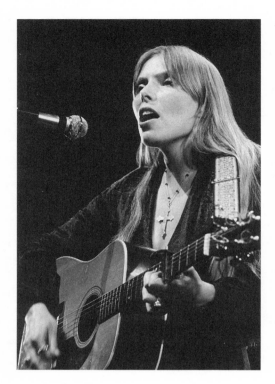

Joni Mitchell—Taken at the Newport Folk Festival in 1969, this photograph of Joni Mitchell manages to capture the intensity of her performance as well as the ethereal beauty of her hippie cum folk troubadour persona. The movement of her right hand is in stark contrast to the almost marmoreal qualities of her face in this shot.

the changing sexual mores. In one sense, you could look at them as being leaders and reflecting the radical change in attitudes towards sex.

Women musicians were also the subjects of numerous of Wolman's photographs. His attitude toward women subjects informed his work: "I don't see women as different than men in terms of their range of emotions, their range of abilities. They're just people. We're fellow travelers trying to make it through the night, each of us in our own way. What I brought to the sessions was a complete lack of judgment in terms of gender. It means a lot; it always has."

Many of Wolman's shots of these women capture them at seemingly unguarded moments. His methods reveal much about his approach to his art and how he achieved that effect:

Janis Joplin—A particularly fine example of Wolman's ability to elicit unguarded responses from his women rock-musician subjects, this shot reveals Joplin's vulnerability. Wolman said, "My feeling always with Janis was that, I don't care what she was doing at the time, she was still a little girl. She was a hurt little girl, a damaged little girl. But I knew that there were two sides and I always tried to get Janis to smile because when she smiled her face just lit up. That cape that she has on in the picture was subsequently stolen. That was her favorite." It was taken at her apartment in the Haight in San Francisco in November 1967.

I took the pictures and sometimes what I would do is I would sit with interviewers and take pictures while the conversation was going on. If I saw a particular angle that I liked, I would say, "Hold on one second. Can you look here, or can you look there?" I would be respectful to the interviewer and to the subject, but every so often I would interrupt so I could get a particular shot that I wanted. The only way you're going to get intimate portraits is if the subject trusts you. That's not the only way but that's the main way. So what you try to do is build up trust. When the trust is there, they will give you something more of themselves than just standing in front of a camera.

The results of his efforts in this regard speak for themselves. Wolman's portraits of rock women are some of the finest examples of this art form from this, or any other, era.

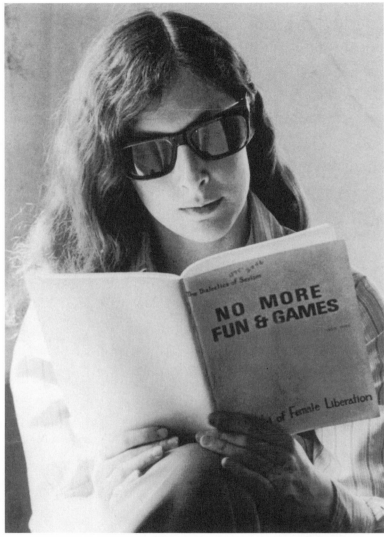

Ellen Willis—Taken of Willis for a 1970 article in *McCall's* titled "Five Passionate Feminists," this photograph captures her erudition as well as her sense of play. Rock music critic for the *New Yorker* from 1968 to 1975, Willis was one of the most insightful of the New York literati to turn her considerable talents to music journalism. The fact that she was also a member of some of the earliest radical feminist groups in New York City forms a unique bridge between both subcultures and is reflected in the subtle ways that she addressed gender in her work. Photo taken by Ira Hoogland in Colorado Springs, Colorado.

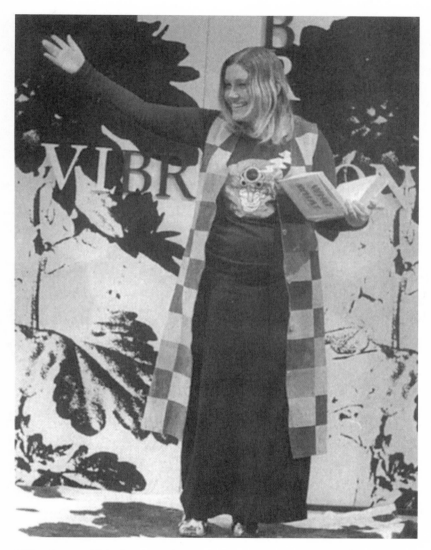

Lillian Roxon—This shot was taken at the book-launching party for Roxon's
Rock Encyclopedia held at Max's Kansas City in 1969. A seasoned entertainment
journalist who had learned her craft working for the Australian tabloids
(including those owned by Rupert Murdoch), Roxon brought a unique approach
to rock-music journalism. She combined elements of the classic gossip column
with countercultural and feminist sensibilities to create a signature style. Her
death in 1973 at the age of 41 from complications due to asthma robbed the
subculture of one of its most outspoken and flamboyant members.
(Photographer unknown. Reprinted with the permission of Robert Milliken.)

Margaret Moser—This shot of Moser and Velvet Underground member John Cale was taken in Austin in March 2000 at the *Austin Chronicle* Music Awards. Cale was in town at Moser's request to play a tribute to recently deceased fellow Velvet, Sterling Morrison. Moser continued to maintain contact with Cale long after she had retired from active participation in the groupie subculture in favor of a career in rock journalism. Here is an example of the long-term connections formed between some of the groupies and the musicians they met. Moser credits her knowledge of and access to the musicians that she gained as a groupie with helping her gain initial entry to the world of rock journalism. (Photograph by Todd Wolfson.)

Cynthia Plaster Caster Poster—This poster announced Cynthia Plaster Caster's exhibition of her casts at San Francisco's Art Rock Gallery in 2002. This exhibition is part of efforts to have her casts recognized as works of art. According to the gallery's manager, the exhibition's opening was a "smash." Cynthia continues to cast rockers, both male and female, and has quit her day job to pursue her art. (Philip Cushway/Artrock/Jahlion)

Album Cover for Lisa Rhodes's Shivers—The cover for the author's 1986 release, *Shivers*. The photograph was taken by Los Angeles-based cover artist Paul Maxon, best known for his melting face cover shot used by Peter Gabriel on his third album in 1980. Its "no pores allowed" approach is indicative of the role that high fashion and film photography and makeup played in some of the cover art of the era. (Photo/Design: Dockery-Maxon-Ross. Taken in Los Angeles in 1985.)

The Birth of the Groupie

I heard the term [groupie] quoted by Peter Noone, one of Herman's Hermits, and he used the term in a derogatory way. I can't remember his exact words but it sounded like he scoffed upon it because I think he was applying his little double standard. He didn't like the fact that girls were going around screwing many men that they didn't know, which was what he wanted to do with women.

—*Cynthia Plaster Caster, in a 2003 interview*

At the Rolling Stones' New York concert in 1964, Baby Jane Holzer exhibited an example of what would be described only a few years later as groupie behavior. Tom Wolfe described her as shouting to socialite Isabel Eberstadt, Ogden Nash's daughter, and inviting her to go backstage with her. "'With the Stones,' says Jane! 'I was backstage with the Stones. They look *divine*! You know what Mick said to me? He said, "Koom on, love, give us a kiss!"'"[1]

Holzer's twenty-fourth birthday party, held at photographer Jerry Schatzberg's apartment on Park Avenue, provided further evidence of her groupie status. Schatzberg was giving a party in the Stones' honor that night, but also provided a cake for Holzer's birthday; the blowing out of the candles took place in an upper, more exclusive room. The party's guests were well known and included Jean Shrimpton, Sally Kirkland, Jr., and Barbara Steele, star of Fellini's *8½*, while the all-woman band Goldie and the Gingerbreads played for the party. Wolfe wrote that the papers referred to the party as "the Mods and Rockers Ball, as the Party of the Year." Lillian Roxon alluded to this type of party, and perhaps Holzer's type of groupie, in her groupie definition. "There are socialite groupies who give big dances and have the singer later. The most clever groupies get jobs in the industry and often persuade themselves they aren't groupies at all."[2] It is not important whether Holzer had sexual relations with rock musicians. What is important is that she found them highly attractive, knew them personally, and sought them out, all earmarks of what would later be called groupie behavior.

In his essay, Wolfe felt keenly the lack of the correct phrase or title to describe Holzer: "Jane Holzer—well, there is no easy term available, Baby Jane has appeared constantly this year in just about every society and show business column in New York. The magazines have used her as a kind of combination of model, celebrity and socialite. And yet none of them have been able to do

much more than, in effect, set down her name, Baby Jane Holzer, and surround it with a few asterisk and exploding stars, as if to say, well, here we have . . . What's Happening?"[3]

Wolfe also made it plain that even though Holzer was a socialite and had a lot of money, she had not been embraced by the old guard of society in New York City. He stated that she was not a Social Register type of socialite, many of whom would not have considered inviting her to their events. "Furthermore, her [Holzer's] stance is that she doesn't care, and she would rather be known as a friend of the Stones, anyway."[4] Holzer's identification with rock music, Pop Art, rock musicians, and underground cinema was where she received her social power.

Like many of the later articles on groupies, Wolfe's "Girl of the Year" generated controversy and consternation among some of his readers. Wolfe alludes to this in the anthology in which the article later appeared:

I never had written a story that seemed to touch so many nerves in so many people. Television and the movies all of a sudden went crazy over her, but that was just one side of it. A lot of readers were enraged. They wrote letters to the publisher of the *Herald Tribune*, to the *Herald Tribune* magazine, *New York*, where it appeared, they made phone calls, they would confront me with it in restaurants, all sorts of things—and in all of it I kept noticing the same thing. Nobody ever seemed to be able to put his finger on what he was enraged about. Most of them took the line that the *Herald Tribune* had no business paying that much attention to such a person and such a life as she was leading. Refreshing! Moral Outrage! But it was all based on the idea that Jane Holzer was some kind of freak they didn't like. Jane Holzer—and the Baby Jane syndrome—there's nothing freakish about it. Baby Jane is the hyper-version of a whole new style of life in America. I think she is a very profound symbol.[5]

Baby Jane Holzer was born Jane Brookenfield on October 20, 1940, in Florida. Her father, Carl Brookenfield, was a successful Florida realtor. Holzer had longstanding ties to the New York City area,[6] which included her attendance at and graduation from Cherry Lawn School in Darien, Connecticut. She then attended Finch Junior College, a finishing school-style women's college in New York City also attended by Grace Slick and Tricia Nixon.[7] At twenty-two, Jane married Leonard Holzer, a graduate of Princeton and scion of a successful New York real-estate family. Business must have been good, for Jane and Leonard lived in a twelve-room apartment on Park Avenue with two paintings by Rubens worth half-a-million dollars on the walls.

Nicknamed "Baby Jane" by Carol Bjorkman, a writer for *Women's Wear Daily*, after the Bette Davis and Joan Crawford movie, Holzer was introduced to Andy Warhol in the spring of 1963 and soon agreed to be in the art movies that he was making at the time, including *Soap Opera, Kiss, Batman, Dracula,*

and *Couch*, all made from late 1963 to 1964.[8] Her last film for Warhol was *Camp*, made in October 1965, which coincided with her break from the artist, his studio called the Factory, and his retinue.[9]

Holzer also had close ties to photographers, models, and musicians in London. British photographer David Bailey was in attendance at the same dinner at which she met Warhol. Bailey also brought along Mick Jagger, then an unknown singer, who had been working as the maid for the sister of one of Bailey's models, Jean Shrimpton.[10] Holzer must have enjoyed their company, because she spent the summer of 1963 in London working with and being photographed by Bailey. Some of these photographs were published in the English *Vogue*,[11] and she would also be featured in its American counterpart as well as *Show* and *Life* magazines.[12] By 1964, she was dubbed "Girl of the Year" by members of the New York journalism community and became the subject of an exposé by Tom Wolfe in the *New York Herald Tribune* the following year. Reactions to the article would be a harbinger of the strong responses elicited by many articles on the groupies published in later years.

It has long been assumed that the *Rolling Stone* "groupie issue" of early 1969 was the first to put its finger on the pulse of this phenomenon. In fact, there were much earlier rumblings as the subculture emerged, which in turn generated several articles that featured or mentioned women who could be categorized as groupies, of which Wolfe's piece on Holzer was one of the first. The importance of such articles lies in establishing that *Rolling Stone*'s approach to groupies was just that: a single, but not singular, one. After the publication of *Rolling Stone*'s groupie issue, this fact became lost in all the hoopla surrounding the exposé itself and eventually, these alternate visions of what a groupie was (or could be) were discarded in favor of that offered by *Rolling Stone* and its highly sexualized and misogynist approach to groupie and rock culture.

Wolfe made it clear in his essay that Holzer's involvement with rock music and its subculture were central to her identity as "The Girl of the Year," by first establishing his piece with Holzer at a Stones' concert. "Jane Holzer is This Year's Girl, at least, the New Celebrity, none of your old ideas of sexpots, prima donnas, romantic tragediennes, she is the girl who knows The Stones, East End Vitality."[13] Wolfe explained how Holzer's involvement with various underground and subcultural groups, like the rock subculture, had made her "Girl of the Year." After comparing Holzer to previous Girls of the Year (dating as far back as Brenda Frazier in the late 1930s), he stated:

But Baby Jane Holzer is a purer manifestation. Her style of life has created her fame—rock and roll, underground movies, decaying lofts, models, photographers, Living Pop Art, the twist, the frug, the mashed potatoes [*sic*], stretch pants, pre-Raphaelite hair, Le Style Camp. All of it has a common denominator. Once it was power that created high

style. But now high styles come from low places, from people who have no power, who slink away from it, in fact, who are marginal, who carve out worlds for themselves in the nether depths, in tainted "undergrounds." The Rolling Stones, like rock and roll itself and the twist—they come out of the netherworld of modern teenage life, out of what was for years, the marginal outcast corner of the world of art, photography, populated by poor boys, pretenders. Teen-agers, bohos, camp culturati, photographers—they have won by default, because after all, they *do* create styles. And now the Other Society goes to them for styles, like the decadenti of another age going down to the wharves in Rio to find those raw-vital devils, damn their potent hides, those proles, doing the tango.[14]

Despite Wolfe's invocation of the groupie culture in his exposé of Baby Jane, the first time the word groupie, as it would come to be understood, was used in print was on June 16, 1966.[15] The reference appeared in what was arguably the first column by a writer the same age as the fans of rock music to appear in a major American newspaper or magazine.[16] Written by Richard Goldstein, a twenty-year-old Columbia School of Journalism graduate and an ardent rock fan, the column, which appeared in the *Village Voice*, was called "Pop Eye."

Goldstein's first "Pop Eye" column, "Soundblast '66," a review of a rock concert of the same name held at Yankee Stadium, makes first use of the term: "The Beach Boys came out of the pitcher's bull pen in a green armored van. The vehicle stopped short of the stage and was immediately surrounded by police. But it was a false miracle right out of *La Dolce Vita*. The anticipated riot of screaming fans never materialized, because the truck seemed miles away from the nearest female groupie, and males were distracted by the [female go-go] dancers."[17] It is difficult to glean any detailed meaning of the word and its usage at this time. It appears that Goldstein was referring to the young female fans who mobbed rock bands during this era, much like the Beatles' fans. However, he does make the distinction that he is discussing the *female* groupies. Although this usage of the word was the first by Goldstein, it would not be his last, nor certainly his most potent.

The next column in which Goldstein mentions the groupies offers much more detail about the word and the subculture that it evoked. The column, "Druids of Stonehenge," was about a group of teenage college students who had formed a band by that name.[18] They were the house band at Ondine's, a trendy Greenwich Village club. While describing the band's rehearsals, Goldstein writes, "Informal rehearsals—with a generous helping of groupies huddling appreciatively in the corner—is the fun part."[19] His allusion implies that the groupies were one of the band's perks; yet he offers no description of it aside from their presence. One could surmise that just having an appreciative

audience of girls was the advantage. Interviewing the band's vocalist and bass player, Dave Budge and Tom Workman, Goldstein becomes more specific about both the groupie subculture and what it offered to the boys in the band:

> Playing three shows a night at a jammed discotheque is like being trapped in the belly of a star. The only consolation is the groupies. "It's like no society on earth," says Dave. "There's no leader or anything, because to be so aggressive would make them less desirable."
>
> "It's very weird," Tom declares, "to go back into a club and see the chicks who have sworn undying faith to the group making with a guy playing the same instrument in a greasy [i.e. nonhippie/nonprogressive rock band] group."
>
> By acclamation, Ondine groupies are better than Barnard mods. "Ultimately," says Dave, "they're not as sticky. They don't look for anything meaningful in a relationship. And they know a hell of a lot more about hygiene."[20]

Budge asserted that the groupies at this time had a "society," yet he described it as anarchic with no sort of leadership structure. His statement about aggressiveness rendering the groupies "less desirable" appears to be merely an example of his ascription to the sexual double standard prevalent at the time. Thus his statement may or may not have reflected the presence of a pecking order or hierarchy among the groupies. The fact that they were willing to "make it" with guys from other bands in front of the Druids does seem to suggest that these women had their own agendas and were not dominated by the male band members. While the term "making it" is also ambiguous, it is unclear whether they were referring to sex, as Workman asserted that the activity took place in a club.

The band's unanimous agreement about the groupies who were not "sticky" and who did not want "anything meaningful in a relationship" highlights how the groupies were regarded at this time, at least by the members of one band. The musicians were looking for women with whom they could have ephemeral good times, not serious involvements. This statement can be read reflexively: on the one hand, it could mean that the band members were only looking for women who were sexually available with no attachments, the classic definition of a "bad girl" under the sexual double standard. It could also mean, however, that the groupies were looking for men with whom to have a good time and didn't want any serious attachments. The comment about the women's hygiene makes it plain that there was some sort of physical, and possibly sexual, contact. Either way, it is clear that the women the Druids described were groupies in the sense that they broke down the barrier between performer and audience and had personal contact with the performers.

Another "Pop Eye" column from 1966 conflated these two aspects of the groupie subculture and used the word to describe both aspects. "So Who

Believes in Magic?" reviewed a Chicago performance of the Lovin' Spoonful. Goldstein used the word several times to describe the hordes of female fans who followed the bands, but had little personal contact with them. He writes, for example, that "the last word on 'good time music' comes from the fans. Every combo inspires a crush of thumping teen libidos, but the Lovin' Spoonful groupie reaches out, struggling with pimpled sexuality, and the music reaches in—way in."[21] Goldstein then quotes from several fan letters sent to the band. It is clear from the letters that none of these women and girls have had any substantive personal contact with the band. For example, one referred to the fact that one of the band member's hands had brushed hers when she was getting an autograph and another wrote about shouting at one of the musicians as he was walking into a club.

Goldstein then describes several other encounters with the large groups of female fans, again describing them as groupies. He writes about the band having to dodge and outrun the fans waiting for them at their hotel: "They make it unscarred into the car, because Spoonful groupies are a shade more polite than Beatle fans."[22] He also described the sound of the shouting of the crowd that was audible in the car as they were leaving as a "distant groupie-echo." The women and girls mentioned above had a strong, probably sexual, attraction to the band, but their attraction and desire to get close to the band went largely unreturned and unrealized.

That the term groupie was in flux at this time, at least in print, is made plain by a comment from one of the band members. There is a hint that, at least in one band member's imagination, a sexual aspect was implicit to the word, realized or not. Goldstein recorded guitarist Zal Yanovsky's comments about groupies. "His [Yanovsky's] ideal groupie is 'a schwartze [black woman] with an overbite and a big, juicy snatch.'"[23] Aside from the crude racism and sexism of the remark, this comment further elucidates the fact that the sexual component of the word was intended, as well as foreshadowing the emphasis placed on that facet in later articles that used the term, or focused on, groupies.

During 1967, Goldstein would mention groupies in his column five times. Four of these were mentions asides and not terribly enlightening as to the word's meaning and the activities of the groupies themselves.[24] In one example, however, he delved into the subculture and delineated his conception of the term. The column, "Rock'n'Wreck," was about the Who's American debut at the RKO 58th Street Theater in New York City. Goldstein describes the scene backstage and the behavior of the women and girls he characterized as groupies:

Muffled scratching is audible from behind the stage door. The Groupie brigade. They bribe the doorman with a wink, a kid-giggle. You can never lock them out totally. They squat outside the dressing rooms, scratching like exiled cats. "Let them in; it's a party,

isn't it?" The big one with the braces and a huge distended tongue is eying Keith [Moon], the drummer. Paper cup in hand, he slips on the corridor floor. "Better watch it," she murmurs.

"Why?" Keith laugh-answers.

"Cause I might jump you."

Even though this is New York and it is cold and rainy out, the groupies are scratching. In Germany, Peter [Townshend, guitarist for the band] had to haul off on an especially demonstrative cat. In London, they rip clothing. In New York, they scratch on doors. The big one raced down the gray stairwell, past Mitch Ryder [singer for the Detroit Wheels] in his purple see-through plastic shirt. ("He sat on me," she exalted. "Keith sat on me.")[25]

Goldstein then followed the band to a press conference where they encountered more groupies:

"John," she is sobbing. "I love you. More than anything in the world." She leaps at her idol with a groupieclutch (something like a half-nelson with love). She is squat and curly with an over-lipsticked grin set against the peacoat uniform. She knows everything about the Who—especially John Entwistle, the one who never breaks anything. "Herman got on the radio and said you were ugly with no talent." She confides, "All of us hate him anyway." She whips out a camera and snaps away, pausing every roll or so to wind the film. John stands paralyzed by her side, arms around her shoulders, shushing whenever she cries. At last she looks up from her vantage point within John's armpit and tells Peter: "Ya look sad. Don't worry. I got a big nose too."

Peter winces and sips the dust off a gin and tonic. It is the Hotel Drake, sequestered in provincial endtables and bowing busboys—the ideal place for a band to hide. So naturally, the groupies discover it in no time. Thirty professionals assault the lobby. Inevitably, three make it into the room where the Who are holding court for the American press.[26]

In the final reference to groupies in the article, Goldstein provided not only Moon's opinion of the groupies, but also an interesting fact about his own interview methods: "'Groupies lack something,' he [Keith Moon] explains against the sound of diminishing squeals from down the hall. I pump him on the subject. Fans are something most pop musicians hate in person, but adore in principle. 'What's your ideal groupie?' I ask. It is my trademark question: open-ended enough to provide a flawless self-portrait. Sometimes she is sexy, sometimes appreciative, sometimes tender. Keith eyes the lime in his drink and answers: 'Someone who writes for a national paper.'"[27] When I questioned Goldstein about the reasons for this being his trademark question, he responded that he was really very shy, a big fan of many of the musicians, and wanted to allow the artists to lead the interview. He also wanted to ask more serious questions than most other interviewers at the time, most of whom still employed hackneyed fanzine staples like asking about the musician's favorite

color. He explained that one groupie in particular, Linda Eastman (Paul McCartney's future wife), was also very helpful to him in gaining entrée to the rock stars. She was ostensibly a rock photographer but also, according to Goldstein, a groupie. He explained that the musicians would put up with him and answer his questions so that they could interact with Eastman.[28]

In 1968, Goldstein mentioned groupies only two times in his published work,[29] one of which helps to flesh out aspects of the status system in the groupie subculture. In commenting on John Lennon and Yoko Ono's album, *Two Virgins*, in which the pair appears nude on the cover, Goldstein reflects: "That jolly portrait of John Lennon's endowment hit the underground on both coasts like the great balls of fire. The trend toward groovy-nudity is bound to continue, with superstars virtually hanging from the rafters. I wonder whether the Rolling Stones—in doing their alter-ego thing—will now appear in their girlfriends' bodies? Or will we be graced with folds of foreskin in repose [Lennon was uncircumcised]? At any rate, the whole thing is bound to take a lot of the exclusivity out of being a groupie."[30] It appears from this remark that one of the things that gave groupies "exclusivity" was their knowledge of the stars that could only be gained through intimate contact. It also seems that, at least according to Goldstein, groupies were a relatively small cohort at that time.

Yet the majority of Goldstein's remarks are ambiguous enough to make it unclear whether, during these earliest years of the groupie subculture, there was an obligatory or tacit sexual component to the groupies' behavior. Were they merely wily children who could slip past security guards? Were they sad cases who wept and said silly things to their idols? Or were they potential (or assumed) sex partners for the musicians? Though his articles are largely ambiguous on these points, it is clear that Goldstein considered the groupies to be ubiquitous, and important enough to use as part of his "trademark" interview question.

Goldstein would soon be joined by other journalists who began to weigh in on the groupies. Meanwhile, individual women would cultivate their own distinctive ways of gaining access to and status among male rockers. One such figure was Cynthia Plaster Caster, one of the best known and most unique of the groupies from the 1960s and 1970s. Based in Chicago, she became well known among rock bands and groupies due to her approach to meeting bands. Cynthia made plaster casts of the erect penises of the rock stars and collected them as art objects.[31] Working with another groupie whose identity changed over the years, Cynthia and her assistant du jour would fellate the subject and then plunge his erect penis into a mold filled with dental alginate. The resulting mold would then be filled with plaster and a cast would be the result. Cynthia's

introduction into the rock groupie subculture during the earliest years of its development are very illuminating and provide details that Goldstein (and perhaps Wolfe) omitted from their work, or of which they were not aware.

In addition to being integral to the early history of the groupie subculture, Cynthia's story also integrates the idea of the sexual revolution discussed in Chapter 1. Her description of how, as the 1960s wore on, reticence in sexual matters began to be discarded by her in particular and the society around her in general is representative of the stories of thousands of America women in during this era. Cynthia's account describes the evolution of one young woman who helped to create the rock-groupie subculture during that decade. Although it is anecdotal and certainly doesn't reflect the experiences of all rock groupies and fans in this era, it is worthwhile to describe it at length.

Initially Cynthia was attracted to Broadway stars, but like thousands of other young girls, the advent of the Beatles altered her cultural compass. The popularity of the Beatles and other bands of the British Invasion meant that meeting these musicians would take perseverance, craftiness, and imagination, because hundreds of other fans wanted to meet them too. When at first Cynthia tried to gain access to the musicians' hotels, security guards turned her away from the elevators. She realized, however, that they failed to guard the stairwells, which meant her climbing fifteen or twenty flights of stairs and then dodging the guards stationed on the floors on which the musicians had rooms. This process turned into an elaborate game of cat and mouse between the girl fans and the guards.[32] Cynthia's experiences at this point in her proto-groupie career echoed those Goldstein described in his articles for the *Village Voice*.

In addition to finding a way to differentiate herself from the other fans and bypass security, Cynthia had other pressing needs. She was, presumably, like many of the young groupies, sexually innocent and in search of experience and first-hand information. "Because in '64 I was 17, I was Catholic, and obviously a virgin. I didn't know sex was meant for anything more than reproductive purposes and none of my friends knew anything about sex, or would admit to anyway, because sex was evil and a sin."[33]

Cynthia chose rock stars as the sources from whom she would obtain her information. "I had all these crushes on British musicians and my crushes were starting to change a little bit, having a little bit of a different dimension. I started noticing that they wore these tight tailored trousers over in Europe that were conveniently packed with very mysterious bulging crotches, and the sight of these 3-dimensional bulges were giving me strange rumblings in my own crotch." It was not only the musicians who attracted her, however. "Without realizing it, I was experiencing sexual attraction to musicians but almost as if

it was to the music itself. I mean the sound of a catchy pop tune would make my vagina kind of flicker and flutter, I swear. My spinal cord would tingle, I'd get goose bumps. I mean it was almost like it was from the vibration of the sound waves." Cynthia's sexual desires were becoming conflated with her enjoyment of the music and her fan behavior toward the musicians. She would not remain content to merely look at, or chase, the musicians for much longer. However, her evolution into a plaster caster necessitated a few more twists in the road, so to speak.[34]

In order to gain the sexual knowledge she desired, Cynthia need to get close to the musicians. Her solution was both unique and successful. It was at this point in 1966 that Cynthia was able to combine two disparate elements, an insider's knowledge of British slang and her art studies, to create that which would differentiate her most decidedly from other fans and bring her to the musicians' attention. Her strategy reveals not only more details about the nascent groupie subculture but also the creativity, imagination, and dogged determination that characterized many groupies of the era.

Cynthia happened by chance on the first element, Cockney rhyming slang. "I thought it would be funny and very appropriate to bring up the subject of those mysterious bulges, [but] I had no idea what they looked like behind the zippers. I had never seen a penis before and I would wait and see what would happen if I brought up this subject, somehow. I didn't have the language or the words yet." A serendipitous meeting of some British ex-pats proved useful. Cynthia met and befriended an obscure band of British musicians, the Robin Hood Clan, who had relocated to Chicago. According to Cynthia, "nobody has ever heard of them and this older kind of chicken hawk guitarist befriended me, named Pete, and I started talking to him about his bulge, but he could see that I had difficulty articulating what I was trying to talk about." Pete taught her about Cockney rhyming slang and she learned phrases that would not only allow her to discuss these "bulges" with her idols but also gave her a vocabulary not possessed by many in the United States—an insider's knowledge of sorts that gave her immediate entre. She learned that "Hampton wick" was slang for dick and "Barclay's Bank" meant a hand job (wank in British slang). She also learned other nonrhyming slang. For example, "charva" meant fuck, "plate" was the term for a blow job and "rig" another word for penis. "So now I had myself my secret code language with which I could talk dick with my English sweeties." Cynthia would soon put this language to use with promising results.

Like the other fans, Cynthia decided to write notes to the musicians, except that she would use her newly acquired explicit British slang:

So I wrote one that said, "We are the Barclay's Bankers of Chicago. We have convenient night banking hours. Would you like to make a deposit? Signed, the Charva Chapter." That one I passed on to the drummer of Gerry and the Pacemakers [Liverpool band in Beatles' manager Brian Epstein's stable]. I handed it very quickly to him as he was sitting on bus through a window and the end result of this was a long distance call all the way from somewhere in Ohio, I got the phone before my mother did. Only for him to find out very quickly that I not only [didn't] know what a Barclay's Bank was I didn't even know what a hand job was and so he politely hung up on me, but it didn't matter. What mattered was that I was making progress in my ultimate goal to get my foot into one of those hotel room doors.[35]

As creative and sexually aggressive as this method may have been, it would soon pale in comparison her next approach to meeting musicians.

Cynthia soon added the making of plaster casts to her repertoire of tricks to get her closer to the bands. By 1966 she was an art major in college. She received a homework assignment to make a plaster cast of something solid. Cynthia immediately thought of penises. Coincidentally, Paul Revere and the Raiders, Billy Joe Royal, the Hollies, and Gary Lewis and the Playboys were in Chicago that weekend as part of the Dick Clark Caravan of Stars. She decided to go to the hotel to see if any of them would let her cast their penises. Cynthia would have success that weekend, but not at casting penises.

By combining her knowledge of how to evade security and plaster casting, Cynthia was finally successful in gaining sexual knowledge and experience from one of the bands. It appears, however, that the British slang was gild on the lily, as the band member to whom she made her suggestion, Mark Lindsay of Paul Revere and the Raiders, was an American. After she returned with some plaster, she had "a very romantic conversation with Mark Lindsay on the fire escape, just like something out of 'West Side Story,' and somehow casting was all forgotten, for now. And that week I lost my virginity to, not a Beatle or a Stone, but someone whose song had been number one in the charts for five fucking weeks. [This was a] very important factor." More important was the fact that she had found her niche. That weekend Cynthia, and her friend who had accompanied her, named themselves the Plaster Casters of Chicago. "We were the talk of the entire Dick Clark Caravan of Stars, just for popping the question! So we had ourselves a new shtick."[36] Cynthia's desire to have sex with rock stars, initially, subsumed any ideas of art or collection. Which was a good thing, as it would be nearly two years until she would actually make her first cast.

Cynthia's language to describe her casting activities is very aggressive and contains some elements of "belt notching." For example, she referred to the musicians whom she wanted to cast as her "hit list." Also, when describing her

casting of Jimi Hendrix in 1968, her first of a musician, she stated, "Yep, I captured him, and I bagged him." Such an attitude occasionally caused her some trouble.

When wielded by a woman in the 1960s and 1970s, this sexually aggressive approach could be problematic; not all bands were friendly or accommodating. For example, Cynthia had nothing good to say about Led Zeppelin. "They basically raped and pillaged their way across the United States. They threw me into a swimming pool, tore off all my clothes. They beat up one of my girlfriends, and I will never forgive them for that."[37] This problem would not be the only one created by Cynthia's unique approach to meeting rock stars.

The sexual double standard was firmly in place at this time and caused Cynthia, and at least one of her partners, some difficulty. In an interview, Cynthia related that she didn't encounter much resistance from the bands to her attempts in dismantle it. Of course, her actions during this era could also be categorized as an imaginative riff on "bad girl" behavior, as it was conceived under the sexual double standard.[38]

The sexual double standard also caused the partner with whom she was pictured in *Rolling Stone*, Diane, to quit the Plaster Casters. After they actually started to make casts, Cynthia employed the services of a partner to fellate the musicians, as she was more concerned with mixing the materials. After the *Rolling Stone* groupie issue, Diane quit the group. When I asked why, Cynthia replied, "Diane wanted to get married and as time was going along and she didn't like the reputation that was building that she was perfectly willing to give casual blow jobs to strangers and that's all she was good for. [She] thought it was preventing her from getting married."[39]

Cynthia Plaster Caster's story, while hardly typical, is nevertheless important to the story of women in rock and roll as well as to the general history of women's shifting gender roles in the 1960s. It is clear that the traditional behavior expected of women and girls in this era was simply too narrow and joyless for Cynthia and countless others. Rock music and the people who made it during this era were one of the nexuses between women and their changing sex roles. As the culture surrounding rock music grew in popularity, more attention was paid it by those in the Fourth Estate.

With the increasing popularity and notoriety of the rock culture, starting in 1968, other writers began to allude to the topic. These pieces differed greatly from one another, and from much of what had been written previously about the groupies by Goldstein in the *Village Voice*. The first three come from disparate sources, while the rest are by various authors, excluding Goldstein, who wrote for the *Village Voice*.

The first was a 1968 article in *Life* written by Frank Zappa. Titled "The Oracle Has It All Psyched Out," it was a rambling mixture of Zappa's ideas about American society, his music, and performance. In a section of the article on high-school dances, Zappa slips in a one-sentence reference to some groupies who were to figure prominently in *Rolling Stone*'s special issue. "Free love, groupies, the Plaster Casters of Chicago and such bizarre variants as the GTOs of Laurel Canyon in L.A. didn't exist then."[40] As I discuss in more detail in the next chapter, in light of Zappa's economic and personal relationship with these two groups, his mentioning them was a canny plug for his own business interests as well as a way of popularizing the idea.

A second article was an odd character study of one LA groupie that originally appeared in *Cheetah*. "Groupies: A Story of Our Times" by Tom Nolan focused on a self-described teenage groupie named Sherry Sklar, who, according to the article, cut a wide swath through the musicians, both local and touring, who played in Los Angeles in the mid-to late 1960s.[41] Though well written, the article gave little general information on the groupies as a phenomenon, but rather concentrated on Sklar as an exemplar of the kind of girls who became groupies. The article was written from the point of view of an older hip man, Nolan, who saw the groupies as alternately vicious and laughable.

Nolan began his article at the Monterey Pop Festival in 1967, but telescoped back and forth in time between Sklar's antics during the British Invasion of 1964-1965 and the time it was written, which was late 1967.[42] Nolan made it clear that he was quite a bit older than his subjects, setting the tone of his piece, for example, by invoking an unnamed James Agee work from 1945 as his epigram. In it, Agee compares the teenage girls of that time to "cancer tissue" and stated that he feared how their children would turn out, hardly a ringing endorsement of their activities.[43] Nolan further revealed his generational and cultural distance in yet another passage, in which he compared rock songwriters to Hemingway and Fitzgerald, Zal Yanovsky's leaving the Lovin' Spoonful for a solo career to Harry James's leaving Benny Goodman, and the drug busts of the Rolling Stones to that of Gene Krupa.[44] His references to what had become canonized authors as well as his use analogies from the swing era, as opposed to the more recent one of 1950s rock and roll, not only marked Nolan as being at a cultural and generational distance from those young people about whom he was writing, it also gave him the critical distance to indict the subculture as a whole.

Nolan described the approach of Sklar toward the rockers as being predatory. Some, like the following passage, merely hint at unnamed aggressions on the part of the groupies: "But while those legions of wistful bell-bottomed girls are dreaming about Paulie [McCartney] and screaming for Mick [Jagger] to

come up here where I can get my *fingernails* into you! there are an ambitious few who are doing something about it" (italics in the original).[45] The writer's emphasis on the word "fingernails," while perhaps accurate, certainly implied that these girls and women were endowed with the ability to inflict harm, whether literal or metaphorical. Nolan's description of Sklar at the Monterey Pop Festival was more overt in its assertion that the groupies preyed on the groups they followed: "At about this time Sherry is wandering around the same backstage area, looking as she does, pale, blond, reasonably attractive, in orange-tinted shades (which if she removed them, reveal the faintly predatory look most often seen in Hollywood starlets-on-the-make, a look that always sadly surprises when found in one so young—Sherry is nineteen)."[46] Despite the wistfulness present in this passage and his use of the word "faintly," this is surely damning with faint praise when taken as a whole.

The existence of such self-serving behavior is supported by statements Cynthia Plaster Caster made. When asked about the difference between Chicago and Los Angeles (Sklar's hometown), Cynthia remarked: "In Chicago it was different than LA. Chicago was a more wholesome, clean cut kind of groupie scene. I noticed that in LA there were more girls who hung out with the bands who wanted the musicians to help them out with their careers, acting or music. A lot of them were cocktail waitresses at the Whiskey a Go Go. They didn't seem like real fans to me. They were girls looking for ways to make money. But that was just one portion of them. Then there was me and Pamela [Des Barres] who were real fans."[47] Admittedly, Cynthia was talking about Los Angeles during a later period and Sklar was no cocktail waitress on the make, but her comments, taken with Nolan's description, highlight regional differences in groupie culture.

Presaging the creation of the term super groupie, Nolan remarked that:

Sherry has attained a certain status. She is not your run-of-the-mill groupie: when she goes somewhere it is because she has been invited. At Monterey she travels with a member of one of the most famous groups: she is his guest, having all the privileges of same; she is part of pop society, even if only the fringes, but retrenching all the time; and even though she may not absolutely be *the numero uno* (there is a girl in New York rumored to have had *both* Jagger and McCartney, and another girl who has only had Keith Richard, which is, after all, not the same as having had Jagger, but this is made up for by her having had Lennon, who counts for two times with McCartney), nonetheless she is *known*, a person in her own right, and whenever major crises come up she is there to help. Like when a famous teenybopper idol raided one group to refill his own depleted ranks, causing a certain amount of bad feeling, why, Sherry was right in there, acting the intermediary, hopping in her car, let's find out what all this is about! Let's settle this!" (Italics in the original.)[48]

Here, in addition to describing the ranking system of the groupies of this time in New York City and Los Angeles, Nolan also intimates that groupies could serve musical or professional functions for the bands.

Nolan's description of Sklar's introduction into sexual activity echoes that of Cynthia Plaster Caster during the same era. He stated that Sklar's infatuation with the bands dated from the British Invasion, much as Cynthia's had. Like Cynthia, Sklar too was sexually inexperienced: "Because you must understand Sherry was really *innocent*, not that she had any particular scruples then, just a vague sense of respectability, due mainly to her not yet being exposed to any intrusion (in the form of some randy back-seat young hard-breathing son of a golfing tycoon) that would break the vacuum of and expose the half-ridden hypocrisy behind her parents' country-club world of what proper young girls did and did not do—Sherry, then was innocent."[49] Echoing Agee's epigram, Nolan portrays Sklar as being morally rudderless while taking shots at her parent's social status as members of the upper middle class.

Nolan also discusses Sklar's awakening sexual urges in almost the same language Cynthia used. "She noticed the beginnings of what she could only think of as . . . strange . . . *stirrings*, which began about the same time she went to see the Rolling Stones . . . near the end of the show Sherry had run down from the balcony outside to the stage door to see the Stones, but really, it was something *else*, she couldn't say quite what" (italics and ellipses in original).[50] As she continued to pursue rock musicians, Sklar was, much like Cynthia, introduced to sex.

Also like Cynthia, Sklar had her first sexual experiences with rock musicians. The first involved a musician fondling her breasts. "She was wearing a darling little A-line dress with rather large buttons over the, uh, breasts, and he [an unnamed rock musician] just pressed the buttons firmly. And this pretty little innocent blond girl just didn't know what to *do*, she just didn't know *what* to do; so she went home" (italics in the original).[51] Her experimentation with sex and rock musicians did not stop there, however.

Nolan's paragraph in which he described the loss of Sklar's virginity and her gradual initiation into the groupie subculture is worth quoting in its entirety, because although this description does bear some resemblance to Cynthia's story, it makes clear how one young girl became a groupie in the mid-1960s:

But it [her encounter with the fondling musician] was a brush with fame, and Sherry liked the hint of something she had sniffed, and somehow couldn't just stop now. And so, to put it briefly, decided to take the Ultimate Step—not so hard as some might imagine, in fact ridiculously easy to arrange, and although the details are boring, it was with a fairly popular English group that has since faded into obscurity, but they weren't

a bad beginning, pretty auspicious in those days; and she would eventually make it with much bigger groups. And once she got over her initial shyness, why, you'd think she'd been doing it all her life! Rolling around in a giant bed, the four of them, she and her newfound friend Karen, and two members of a Philly White-Soul group, trading, switching, tumbling around—those guys, Sherry concede, when she starts remembering the good old times in a misty-wistful kind of way, those guys, *remember*? those guys were . . . *probably* . . . the best. (Ellipses and italics in the original.)[52]

That Nolan condensed Sklar's initiation into groupie-style sex with musicians into one paragraph makes it appear that it all happened rather rapidly, as indeed it may have. But not all of Sklar's groupie encounters with bands ended so benignly, for the young women or the musicians.

Nolan recounted a groupie situation where there were serious repercussions for the musicians and the young women involved. One night, Sklar and her friend Karen decided to take another friend, Linda, to meet an unnamed leader of an English band. The two girls dragged Linda out of the shower and took her wet and naked to the musician's hotel room. Nolan described Linda as being "seventeen and *incredibly* pure, never been with *anyone*." After dragging Linda into the musician's room, he gave her his robe, at which point she retired to the bathroom to put it on. At this point things became troublesome:

> Meanwhile there is a knock on the door and in burst her [Linda's] parents, with the hotel manager, and Linda emerges from the bathroom in this star's dressing gown, with her father yelling about aliens! coming over here! and—oh! and everybody is shouting and explanations are demanded and papers are seized and—finally, this nice guy with his faggoty glasses and his beard is deported, and can never come back to America again, and—because record-plugging tours are often essential—will never have a hit here *ever again.* Wow, remembers Sherry, it's all too funny! And she wouldn't have even let him do anything with her! Oh *wow*![53]

Far from having any remorse for the musician, or her friend Linda for that matter, Sklar is highly amused by his deportation and her friend's embarrassment. Nolan intimated that Sklar was a bit vicious, in that he described her memories of this encounter as being "fond" and "funny." This incident is also noteworthy as it portended what could happen to musicians who were discovered in compromising situations with underage groupies, as discussed further in Chapter 6.

The last non-*Village Voice* article on groupies that preceded *Rolling Stone*'s issue came from *The Realist*.[54] Written by Ellen Sander, "The Case of the Cock-Sure Groupies," which detailed the activities of the Plaster Casters, differed from the *Rolling Stone* special issue in several notable ways.[55] Sander's article uses pseudonyms when referring to the groupies, it portrays at least some of

the groupies during the British invasion era as aggressively pursuing sexual relationships with the bands, characterizes the groupies more complimentarily, and it provides a female perspective of an encounter between the women and male rock stars.[56]

Many of the details in Sander's article corroborate Cynthia's description of her behavior during the era. For instance, Sander states that the women who later became known as the Plaster Casters pursued sexual relationships with the bands during the British invasion, and she also notes their use of sexually explicit language in their fan letters, reprinting several missives in her article. In these letters, the Plaster Casters were clear about their desire for the musicians' bodies. One of the letters written by the proto-Plaster Casters to Keith Richards is illustrative:

To the Rolling Stones:
Dear Keith (Richards),
 We watched you on teevee [sic] the other night and the first thing that grabbed our eyes [sic] was your hampton wick. After that we did a little [sic] besides study it. We're not kidding, you've got a very fine tool. And the way your pants project themselves at the zipper, we figure you've got a beauty of a rig. Sometimes we hope you'd whip it out or something but they don't have cameras that would televise anything that large, do they? Hey, tell Mick (Jagger) he doesn't have to worry about the size of *his*, either: we noticed that (really, who could help, *but*?)
 Keith, we're serious. We judge boys primarily by their hamptons because they're so exciting to look at and contribute so much to a healthy relationship. We can hardly wait until you come to Chicago in November; maybe then we can find out more about what's inside your pants.[57]

A statement about the Plaster Casters' experiences as groupies in the article also supports the idea that the women were interested in sex: "They've both been grouping for almost five years, and they told me rather proudly that all of their sexual experience has been with groups."[58] As will be seen, such an account differed markedly from the one offered by the male musicians in *Rolling Stone*'s groupie issue. Sander also described the Plaster Casters' sexual activities in greater detail than the *Rolling Stone* authors. She admitted witnessing "hand-jobs" and voyeuristic group sex, and described the use of fellatio in the casting process. Sander's article portrayed the Plaster Casters as seeking out the rock stars for sex and finding it enjoyable.

Unlike the *Rolling Stone* article, "The Case of the Cock-Sure Groupies" was much more sympathetic in its characterizations of groupies in general and the Plaster Casters in particular. In Sander's general descriptions of the groupies she portrayed them in a positive manner:

Groupies. Their legions, bless their little rock and roll hearts, are growing geometrically. Often they work in pairs, sometimes gangs. Their techniques for getting backstage, which run from bribing, fucking or knocking out security guards, and their methods of tracking a group down would put a private dick to shame. When I have the opportunity to watch them in action, it is not without a genuine sense of admiration that I note their acuity. But when they [security guards] try to keep the groupies from their prey, they haven't got much of a chance. For the groupies are girlchild guerillas with a missionary zeal.[59]

Here Sander demonstrates that she regarded the groupies in general as able and dedicated to their goal of meeting their favorite rock stars. This passage also corroborates much of the earlier material from the *Village Voice* and that Cynthia provided.

Unlike the *Rolling Stone* writers, Sander took seriously Cynthia's artistic abilities and training. Of Cynthia's casts, Sander writes: "Rennie [Cynthia] is an artist, she don't look back. She feels if her collection were put in the hands of somebody who believed in it, it would be a significant thing . . . a tribute to and reflection of the sexual revolution, a radical change in morality" (ellipses in original).[60] Sander also writes that Cynthia had a "dedication [that] is a joy bordering on abandon" about her art and includes the fact that Cynthia had studied with artist Roland Ginzel at the University of Illinois. In contrast, *Rolling Stone*'s groupie issue does not mention Ginzel's name, although it includes the fact that Cynthia had studied at the University of Illinois. Clearly, Sander was trying to establish that Cynthia had serious training and professionalism, as well as commitment and zeal. Compare this to *Rolling Stone*'s characterization of the Plaster Casters' activities: "The Plaster Casters of Chicago regard what they do quite prosaically. Rock and roll musicians are the girls' life-focus, but casting genitalia in plaster is merely a means of overtaking other groupies, getting to a rock star first, as ordinary a means of making contact as, say, writing an especially good fan letter."[61] While the excerpt above supports Cynthia's assertions that initially the casting was secondary to meeting and having sex with the rock stars, Sander's article, perhaps due to the personal contact she had with the Plaster Casters, has more foresight and rightly (as time would demonstrate) places more emphasis on the artistic facets of the casts.

Yet Sander does not overlook the sexual aspects of the art "objects" or the artist and her status as a groupie. After her trip to Chicago, Cynthia had written a letter to Sander in New York to report on her latest activities. In it Cynthia intimates that rock musician Terry Reid's manager had called her to come to his hotel: "Maybe by now they [the Plaster Casters] do indeed have Terry Reid casted [*sic*]. But then again, maybe not. Because Rennie [Cynthia] is a true plaster caster, yes, an artist, a pioneer, right up there in the front lines of the

new morality. But rock and roll rigs, *object d'art* or no, are rigs nonetheless and ever so, well, *distracting*. And Rennie [Cynthia], bless her little rock and roll heart, is first and foremost a super groupie. And that's a *very* high art in itself."[62]

Sander's reasons for seeking out the Plaster Casters illustrate the newness of women fans openly seeking out their favorite male stars for sex. In her article, Sander writes, "When I first heard about the Plaster Casters of Chicago via the pop grapevine which claimed Zappa as the source, I honestly didn't believe it. Yo-ho [*sic*], another paranoid Zappa fantasy unleashed on the unsuspecting great unwashed." When questioned years later about her reasons for seeking out the Plaster Casters for an interview and her opinion of them and their casting, Sander commented that: "I just wanted to meet the Plaster Casters. They were some of the most entertaining people I met on the rock scene. They were having fun. They were more creative and more fun. It was an interesting package [laughs]."[63]

Sander's attitude, as it was expressed in "The Case of the Cock-Sure Groupies," was a far cry from those of several of the male rock stars in *Rolling Stone's* groupie issue. Most notable among those musicians expressing uncomplimentary opinions about the Plaster Casters in this article was Steve Miller. He described the women as "grim, sick people" and "medieval mental cases." Miller called their casting a "fanatic sickness" and a "cheap, trashy trip." He also states in that same article that the Plaster Casters "came after me" when he played in Chicago. He ended by stating that "when it came down to the nitty gritty and I saw what these chicks are really into I just told them I wasn't interested."[64]

Sander's article, however, puts a different spin on Miller's experience with the Plaster Casters. Sander had contacted Miller's press agent Mike Gershman in Los Angeles and asked him if he would ask Miller "to cooperate" with the Plaster Casters in their making a cast of his penis: "I really wanted to witness a casting and I had a pretty good idea the Plaster Casters would go for him, such a pretty face. So I had called Miller earlier that day and I told him I'd already located the Plaster Casters and would be arriving at the club [where he was playing in Chicago] with them."[65] Sander also states that Miller was already familiar with the Plaster Casters because "remember, they're legend in San Francisco, *legend*" (italics in the original).

However, once she and the Plaster Casters went backstage, she began to doubt that the casting would take place. In the article she wrote that Miller was "in a really weird mood" and Diane had begun flirting with the musician in whom Cynthia had initially expressed an interest. When Sander introduced Miller to Cynthia, his first reaction was to doubt her authenticity: "'How do I know you're the real plaster caster?' he demands, all too eagerly. Rennie

[Cynthia] is *not* prepared for *this*. She hands him the card [one of their business cards]. Very proper. But Rennie's [Cynthia's] mind is elsewhere, with Lonnie, the bass player who is maybe her very second best favorite popstar next to Noel Redding [bassist for the Jimi Hendrix Experience]" (italics in the original).

In Sander's account it appears that Miller *and* the Plaster Casters nixed the casting. After the show they all retired to the band's motel, and Sander described the scene:

Miller is still bitchy. "Let's hear this, girls, what is this about what you do?" But Rennie [Cynthia] is in no mood to discuss it, no mood at all. Lonnie is in his room across the hall and Miller is badgering her mercilessly. Marie [another groupie] is there and Lisa [Diane] is whining because after all, it's so uptight and she's all but retired from being a plaster caster [she was attempting to quit the group] and she just doesn't want to be there at *all*, not after how Rennie [Cynthia] *bitched* at her for talking to Lonnie first. I resign myself that I'm not going to see a plaster casting tonight. Shit! (italics in original)[66]

Sander's subsequent comments in the article suggest she was sympathetic with the women in this situation. After it became clear to Sander that the casting would not take place, she asked drummer Tim Miller if she could sleep in his room. The Plaster Casters also slept in the rooms of other members of the Miller entourage. The next morning Steve Miller was surprised to see Sander still at the hotel: "Steve Miller is *really* irritable. He's looking at me half surprised to see me there. He knows that Rennie [Cynthia] was with Lonnie and Lisa [Diane] was with the road manager and he's figuring I was with Tim [Miller, the drummer], and boy, he's pretty crabby 'cause *he* spent the night *alone*. And in my mind I'm going hahahahah, eat your *heart* out you stupid garbagemouth, bugging the Plaster Casters like that, hahahahah."[67] Thus, even though Sander was a rock journalist and made her living interviewing and critiquing rock musicians, she believed that Miller had behaved badly vis-à-vis the Plaster Casters and was willing to say so in print.

When asked about the *Rolling Stone* article, Cynthia responded: "I think one of the differences was that Ellen actually hung out with us for a few days. She became part of the groupie action, not quite that far, but she was quite literally at the hotel with us. She saw it all. Maybe it has more of a warm feeling just for that reason. I remember that they [*Rolling Stone*] interviewed us over the phone. They sent Baron Wohlman to photograph us, which was a great thrill, but I don't think there was actually a journalist in Chicago. That's probably why the *Rolling Stone* one sounds kind of sterile."[68] Cynthia's insight highlights the crucial divide between the two articles, namely that Sander's was based upon close observation and personal interview, while *Rolling Stone's* was based upon a phone interview and informed by misogynist stereotypes.

From January 1968 to the publication of *Rolling Stone*'s groupie issue in February 1969, there were five articles published in the *Village Voice* that mentioned the groupies, attesting to the term's increased popularity in the rock subculture, especially in New York City. Each usage contributes facets to what we can know about the groupie subculture during this era using periodical sources.

Chronologically, the first of the *Village Voice* articles to mention the groupies was "Zappa & the Mothers: Ugly Can Be Beautiful" by Sally Kempton, published on January 11, 1968. This piece was very prominent given that its coverage, which began on page one, was also accompanied by a rather large photograph of Zappa and his wife Gail. Kempton's description adds a different dimension to the groupie's function: "And when they [the Mother's of Invention] played a long stretch at the Garrick [a New York theater] last summer they were beset by loyal groupies. Perhaps the groupies sensed the presence of a governing intelligence, perhaps they simply dug the perversity. In any case, the Mothers have an audience."[69] Here Kempton not only implied that the groupies could provide a band with an audience, but also that they had the capacity to be savvy about the music and the musicians.

To underscore the fact that the groupies were becoming more known, even outside rock circles, another article that mentioned them in the *Village Voice* came from the world of fashion. In 1968, Stephanie Harrington and Blair Sabol co-wrote a fashion column called "Outside Fashion." This particular edition of that column compared the *fashionistas* who attended high culture events to those that attended openings at Bill Graham's Fillmore East in New York City in 1968: "Nevertheless, in fashion terms a Fillmore East opening night deserves as much coverage as the Philharmonic Galanosed [American designer, James Galanos] Galas, with some tribal differences. It's a scene-making pageant whether they're seeing Lenny [Leonard Bernstein] at Lincoln Center or Jimi [Hendrix] at the Fillmore, whether it means being packaged by Norell and Valentino or being stamped and sealed by Limbo and the East Indian Shop. Both audiences have their peacock strutting groupies, who could be classified ad infinitum."[70] Here the writers' comparison of high and popular culture fashion echoes Wolfe's assertions from four years earlier in "The Girl of the Year." The writers asserted that "both audiences" had their groupies, which interestingly enough they believed had infinite subdivisions. This mention is the first usage of the word that augurs the term's eventual evolution into a general label for a fan, regardless of the endeavor.

Two of the articles in the *Village Voice* that use the term groupie were written by the same writer, Annie Fisher, appearing in her column "Riffs" in 1968. In one instance, Fisher reiterates Kempton's assertions that groupies were fans that provided audiences for the bands. Fisher described her efforts to see

the Jefferson Airplane and the lengths to which she went in that undertaking: "Last year I schlepped all over the countryside, like out to Stony Brook, to hear the Plane [the Jefferson Airplane], then snuck into the Café Au GoGo [a New York nightclub] like a full-fledged groupie every night they were there for two weeks."[71] Here Fisher commented on the loyalty, or at least the ubiquity, of the groupies vis-à-vis their rock idols.

Fisher's next usage of the term came in an article describing a rock festival she attended in Miami, Florida, in 1968. She used groupie twice in this passage and appears to be describing the groupies in both the inner and outer circles at this particular event:

For all its transplanted Northerners, Miami is crackersville, frank in its racism. The word nigger is not impolite in polite conversation. Audience and performers, the festival was almost lily-white, as befits a proper rock festival anywhere. And it's no contradiction that getting to Jimi Hendrix was the aim of the hordes of groupies who mobbed the motel. The motel was the pop music version of "The Moving Picture Ball" [Hollywood movie event of the 1910s and 1920s]: all the stars were there—Frank Zappa and his mothers [sic], Jimi and Mitch [Mitchell] and Noel [Redding, the members of the Jimi Hendrix Experience], Blue Cheer, crazy Arthur Brown and his group—etc. et al., their managers, promoters, technical help, and groupies, GAC and ABC-TV, the rock press establishment, all goofing on a Miami holiday.[72]

Much as in Goldstein's articles, it is unclear whether the groupies that were referred to initially were merely screaming fans or potential sex partners. It seems however, that some groupies were a part of the inner circle at this event, while others were relegated to mobbing the hotel.

The most intriguing of *Village Voice* articles that mentioned groupies was written by Howard Smith in 1968. Smith wrote a regular column called "Scenes," where he reported on cultural happenings, usually from the countercultural fringes of society. In this column, he provided a lot of information about the groupies and also mentioned a new twist on the subculture that I have not seen mentioned elsewhere during my research:

Emerging on the teenybopper end of the rock spectrum is a new echelon: groupie-groupies. Groupies, for those of you who came in late, are those tenacious Lolitas who scheme to get to know the famous groups. The groups in turn get to know the groupies in the Biblical sense. Then the girls brag to one another about their most recent electric conquest. Now a groupie-groupie is a young boy who hangs around coveting the successful groupies. A girl who has screwed a lot of the top rock people has magic by association for these boys who seem to hope that some of "it" will rub off in bed. One of the more successful groupies told me that she isn't especially pleased with being elevated to a celebrity—it crowds her style. Nervously glancing over her shoulder in the lobby of the Fillmore last weekend, she explained that these preying boys are using the very same stalking tactics on her that she had used on her quarry. Now is a groupie-groupie-groupie is . . . (Ellipses in original.)[73]

Here Smith provides quite a bit of information about groupie culture as he understood it. He intimated that anyone who was not familiar with the groupie phenomenon "had come in late," that is, they were out of touch. He also described these women as "Lolitas," alluding to Vladimir Nabakov's sexually precocious prepubescent character from the book of the same name. By calling them Lolitas, he intimated that the groupies were young girls who were under the legal age of consent, and he took that further, stating that the groupies get to know "the bands in the Biblical sense," that is, sexually, making plain that he believed sex was an integral part of the definition of a groupie. His statement that the girls then "brag to one another" indicates that he believed that sexual contact with popular rock stars was a form of currency or a status enhancer in the groupie subculture, thus potentially resulting in the groupie-groupie.

Although similarities exist between the portrayals of the groupies offered in these articles, some subtle differences are also present, and taken together they provide a portrait of early groupie culture. Initially, the groupies appeared spontaneously in various cities. There were also differences among the groupies at this time, usually based on geography. They were primarily a phenomenon known only to those in the rock and rock journalism subcultures. Slowly, beginning in 1968, the groupies began to be mentioned in more mainstream magazines like *Life*. However, these mentions were fleeting and likely only meaningful to the *cognoscenti* in the rock realm. The groupies were a spontaneous singularity and a wonderfully kept secret. Only a few rock journalists realized their intrinsic interest to a culture in the midst of a revolution in its sexual behavior. Some authors, such as Goldstein, played down the sexual aspects of the groupies in favor of the more fan-oriented behavior, while others, such as Sander, offered a more nuanced and complex picture of the groupies, including a discussion of their aggressive sexuality.

Despite these differences, and the fact that all the articles predate *Rolling Stone*'s groupie issue, these depictions of groupie life would not emerge as the most well known in the periodical literature on groupies during this period. Instead they would be subsumed into the *Rolling Stone* approach and the journalism that it spawned. However, their existence establishes that there were other, sometimes dissonant, voices writing about groupies early in the subculture's genesis, voices that intimated a potentially different identity than that which came to be prevalent after *Rolling Stone*. After its issue, much of the negotiation of the groupie's identity would cease.

Chapter 5
Groupies Take the National Stage

*The major fuckup on the part of most groupie chicks comes at the point
they forget that no matter what goes down they're still women. The same
double standard exists in rock society as in the society as a whole. A man
may shed every vestige of self-respect and still retain the respect of society
because, after all, he is still a man. Not so for a woman.*

—Henri Napier, groupie, "Groupies and Other Girls" (1969)

On Wednesday, February 12, 1969, New Yorkers who opened their
copies of the paper that purported to contain "all the news that's fit to print"
may have noticed an advertisement for a small, San Francisco-based music
magazine.[1] Visually the ad was rather stark. It contained only a photograph of
an unsmiling, young female hippie of the freak variety. The large-print copy of
the ad read: "When we tell you what a Groupie is, will you really understand?"
Advertising the magazine's special issue devoted to their story, its small-print
copy explained that "Groupies are the all-purpose girls who pursue the rock
and roll stars from dressing room to dressing room, and from motel to motel."
The ad further claimed, "If you are a corporate executive trying to understand
what is happening to youth today, you cannot be without ROLLING STONE."[2]
Outside the realm of rock-and-roll music, *Rolling Stone* was a little-known
"sea-level" music magazine for teenagers and young adults. Why had it seen fit
to buy a full-page advertisement on the back page of the most highly regarded
newspaper in the nation, and how could it possibly have afforded it?

The advertisement was the idea of *Rolling Stone* editor Jann Wenner, and
its $7,000 price tag had practically depleted the bank account of the fledgling
magazine. But Wenner believed the issue was something special and deserved
extraordinary publicity.[3] One of the magazine's investors remembered having
quite different thoughts; Charles Fracchia was, at the time, a thirty-two-year-
old banker who had become an investor in the magazine's publishing company,
Straight Arrow Publishers Inc., and a member of its board the year before. "I
was horrified," he recalled. "Here we were, hand-to-mouth, and he tells me
we've just spent seven thousand on an advertisement."[4] Indeed, the number of
subscriptions generated by the ad was paltry in light of its expense: *Rolling
Stone* historian Robert Draper alleges that only three responses were received,
not including a fourth that consisted of a box containing dog excrement.[5]

In the long run, however, the advertisement and the magazine it touted were a success. The ad served as a shot across the bow of the more conservative and well-established periodicals. In the eyes of the mainstream press, *Rolling Stone* established itself as not just another underground, hippie music paper, but as a magazine that wanted to play with the big boys of journalism. Draper wrote that "Jann's audaciousness intrigued the New York press. Underground rags, it was noted, did not take out full-page ads in the *New York Times*."[6] Even Fracchia, the horrified investor, had to admit that Wenner eventually secured a "great deal of mileage out of relatively little money," but it is doubtful that even canny Wenner knew at the time what a cottage industry stories about groupies would turn out to be, the eventual extent of the issue's influence, or even that the term groupie would have such a strong impact on American popular culture.[7]

Due to its approach and popularity, *Rolling Stone*'s groupie issue forever linked rock groupies with a particular construction of compulsory sexual behavior. There is a reason for this linkage, and in this chapter I discuss the groupie issue and some of the letters it generated from readers in response. As the most well known of the 1960s era writings on the groupie subculture, the issue had a far-reaching, though somewhat reductive and limiting, effect on the idea of the groupie in American popular culture.

My effort is not solely etymological, however, for the word itself, the way *Rolling Stone* disseminated it, and the connotations it came to possess have been highly limiting to women, especially those in the groupie subculture. Much of this is due to the sexual double standard that prevailed at the time and is still firmly in place. Because of the article's language and its construction of groupie sexuality, labeling a woman or girl a groupie became a way to reduce her options and, perhaps, even her power.

As we have seen, by the late 1960s, the writers at *Rolling Stone* were not the only ones to become interested in the groupie subculture. Indeed, given the male-dominated world of the period's rock journalism, it is not surprising that the idea of the groupie was a popular one. The prospect of doing projects on young women who were free with their sexual favors and who also gravitated to the world of rock music offered a powerful lure for many others who were intrigued with the groupies. In the wake of *Rolling Stone*'s groupie issue, other periodicals, publishing houses, and record and movie companies released material on the groupies. Admittedly, many of these projects had little widespread distribution or success. However, others were very widely disseminated and contributed greatly to crafting the groupie image in American culture.

While the journalistic approach initiated by *Rolling Stone*'s groupie issue continued unabated, some voices of dissent were also present. Not everyone

regarded these women as merely titillating, many writers believed that this new categorization of women had less than benign implications, for the groupies, for society, and for women and girls in general. Some of these dissenting opinions can be found in *Off Our Backs*, a radical feminist journal; in the *Christian Century*, a semi-mainstream magazine; and two pieces penned by counterculture writers, including Lillian Roxon. Though present, these voices are nowhere near as prevalent as those who subscribed to *Rolling Stone*'s approach to the groupies.

In February 1969, *Rolling Stone* published a long cover story titled "Groupies and Other Girls" written by John Burkes, Jerry Hopkins, and Paul Nelson.[8] As the one of the first in-depth treatments of the groupie phenomenon in an American magazine, the groupie issue, as it became known, was only the fifth cover to feature women in the almost two years since *Rolling Stone* had begun publishing, despite the enormous success of female artists such as Janis Joplin and Tina Turner, who had both been on the cover, and Grace Slick and Aretha Franklin, who had not.[9]

Part of the negotiation of a subculture's identity is the defining of it in the broader society, a facet of the process that can be quite slippery and is usually contested.[10] *Rolling Stone*'s groupie issue is an object lesson in this process.[11] Part of this negotiation is apparent in the attempts, by the writers and their subjects, to define the term groupie.[12] The first page contains no fewer than five definitions by the women featured, the first being a female who "balls" (i.e., has sex with) star musicians. The writers also describe her as "a chick who hangs out with bands." One groupie characterized herself and other groupies as "a non-profit call girl. Like a Japanese Geisha in many ways, and a friend and a housekeeper and pretty much whatever the musician needs." A musician is quoted as saying that groupies were variable and could be "friends, like San Francisco girls, and [like] those Los Angeles and New York girls who are making a religion of how many pop stars they can fuck. The sex angle is important. But no more important than girls who are also good friends and make you feel like family." Finally, another groupie described these women by saying, "A girl is a *groupie* only if she has numerous relationships, like where they'd overlap within one group which so often happens where a groupie will hit [have sex with] three people all in one night from the same group."[13]

The article is also problematic in that the rhetoric of the authors functions in such a way as to deny independent agency to women in rock and roll, whether groupies or not. On the second page, this denial can be seen in their description of a woman from whom they had solicited a definition. They

described this nameless source as "one chick who is a groupie by the way she lives, if not by her own descriptions."[14] Thus, the characterization of this woman as a groupie, even if she said she was not, denied her the right of self-definition. This characterization is especially contradictory when the ostensible purpose of the article was to determine just exactly what a groupie was.

Denial of agency is echoed in another comment on that same page. The authors write, "Groupies may tend to think of themselves as unselfish vehicles of love, but those who've studied the groupie ethos see them otherwise. 'They treat sex the same way an accountant treats his new Buick,' says Los Angeles Free Clinic psychologist Gerald Rochman—'as a status symbol.'" Here the authors invoked Rochman as an "expert" source because he was a member of the medical establishment. The implication of this gesture is that however these women thought of themselves, a male expert knew what they *really* were.

The authors finally acknowledge the contested nature of the term only when they begin to discuss the phenomenon of male groupies. "There is little agreement as to who is and who is not a groupie. There are even *male* groupies—by no means as numerous as female groupies, but still a factor on the scene."[15] Included in the list of possible male groupies were roadies, drivers, equipment managers, male fans, Augustus Owsley Stanley III (a well-known LSD chemist), Rodney Bingenheimer (whose claims to fame included his former role as stand-in for the Monkees' Davy Jones and his unofficial title as mayor of Sunset Strip), Alan Pariser (the original backer of the Monterey Pop Festival), and Steve Miller (a San Francisco-based rock musician). The authors further muddy the water concerning who was or wasn't a groupie by including a quotation from Miller in which he stated, "We're all groupies sometimes," in reference to his admiration for Eric Clapton's guitar playing.

Up to this point in the article, the authors had not made any explicit judgments about whether being a groupie was a lifestyle to be admired or reviled. Of the male groupies, however, they write, "Like so many other people in the tale, they are groupies only in a limited sense; the pejorative sense of the word 'groupie' applies only lightly; primarily they are social butterflies."[16] We, the readers, are left to decide for ourselves exactly what this unspecified "pejorative" sense is. I believe that the male groupies escape inclusion with the "pejorative" groupies because they were men in an era where the double standard about sexual agency was nearly universal and their activities were not sexual. Thus, the authors are demonstrating both a sexist and an antisex bias in their approach.

In a statement remarkable not solely for its bluntness, the authors write, "The problem with male groupies is that like the girls they want to be part of

what's happening, but unlike the girls they have nothing immediate or obvious to offer. Thus, you can pretty much rate a male groupie by what it is that he uses as a vaginal substitute." With this observation, the authors unequivocally established sex as an essential part of the definition of groupies, with the implication that sexuality was the females' primary exchange commodity. No other functions of the female groupies were deemed important enough to mention, nor was any homosexual behavior on the part of the male groupies mentioned above elaborated upon.

Subsequently, the writers acknowledged the existence of homosexual male groupies, but, in a startling admission for investigative journalists, revealed they were unaware of the extent of this type of sexual activity: "Undoubtedly homosexuality is a part of the picture, and there are the usual tales and 'true stories' about this one and that one, and even, you know . . . but if homosexuality is a significant factor, it is one of the least publicized" (ellipses in original).[17] Evidently the authors did not, or could not, shed any light on this subject, even though one of the groupies offered a tantalizing bit of information on the subject. A self-described groupie from San Francisco named Sunshine states that "a lot" of English rock stars were bisexual. "'I know a lot of [English rock stars] who have slept with men to see what it was like. American men are constantly trying to prove their virility.'"[18] Thus, the authors' reluctance to pursue this subject may have had more to do with their, or their audience's, anxieties rather than lack of information. Moreover, it would not make as exciting copy: male homosexuality, unlike its female counterpart, was not generally regarded as being a "turn on" for the larger readership of straight men that seemed to be the primary market for *Rolling Stone*.

Conversely, lesbianism was mentioned five times in conjunction with female groupies, and again the views of the authors and their male informants did not agree with those of their female informants. The authors support their assertion that female homosexuality was prevalent among groupies by quoting rock stars as sources: "The incidence of lesbianism between groupies is high, [Frank] Zappa finds. 'Very high,' he says, 'and they think nothing of it.'" Another rock star also claimed the prevalence of homosexual sex (in conjunction with bisexual sex) among female groupies and even isolated it geographically: "'You look for certain things in certain towns,' explains Jimmy Page. 'Chicago, for example, is notorious for sort of two things at once—balling two chicks—or three—in combination acts.'"[19]

Yet the female groupies who otherwise showed no reluctance to admit to a veritable *Kama Sutra* of sexual activity did not suggest that they engaged in homosexual sex. When the authors questioned the GTOs, a collection of five women who were self-described groupies, about lesbianism, they replied "Girls

Together Only [a play on the name GTO] are lesbians. But the GTOs (the group) are not lesbians; they are merely girls who happen to like other girls' company." The GTOs categorically denied they were lesbians as well: "We love boys to death. Some people think we're dykes and they're disappointed when they find out we aren't." Karen, another featured groupie, also denied that she engaged in bisexual or homosexual sex of any kind: "Pleasing people does have its limits. 'I'm game for anything,' Karen says, 'so long as it's not too bizarre— and it's with a man. There's nothing wrong with anything, so long as it's your trip. But when I hear like "I know these five chicks . . ." and somebody's trying to get together a thing like that, forget it. That isn't for me.'"[20]

Though the groupie issue, much like *Rolling Stone* generally, concentrated on the experiences of the male rock stars who were depicted as the primary recipients of the groupies' favors, sexual or otherwise, the authors mention male groupies who pursued female stars. The only one discussed by name was a seventeen-year-old male groupie named Pogo, whom they characterize as having been initially fixated on Jim Morrison and Mick Jagger. Pogo described both his infatuation and encounter with Janis Joplin. "She got me so sexually aroused—the way Mick Jagger and Jim Morrison do, but without the guilt."[21] Pogo may have been aroused, but the extent of his contact with Joplin was one kiss (though he did boast that he kissed her using his tongue). Still, compared to the article's stories about the sexual escapades of female groupies with their male rock-star idols, Pogo's was very tame indeed.

It is notable that the authors fail to quote Joplin (or indeed any female rock star) in the article and refer by name to only one other female musician. By comparison, twelve male rock stars are quoted in the article, and many more are referred to by name. Once again, women were denied agency—and active participation in the process of self-definition—and the readers were left to decide whether women rock stars typically had, or availed themselves of, groupies.

One section of the article in particular was most injurious to women because it impugned the reasons why they were working in the music business. Ostensibly, this portion dealt with women who had jobs or careers that put them in close proximity to rock stars. The authors began by relating a story that Bob Hite, singer for the group Canned Heat, had told them: An unnamed "girl reporter" for an underground paper in Detroit had taken Hite to her apartment to "interview" him. "But first she seduced me, *then* she interviewed me." The authors' analysis of this situation was telling: since bands needed all the press they could get (and in a not-so-disingenuous plug for their own magazine) especially from the underground press: "This chick is in a position to work something like blackmail as she adds names to her list of achievements."

Hite was quoted later as saying that he didn't have anything to do with groupies when he was at home in Los Angeles, but that the situation was different when he was on the road. "It's the tension on the road, man. Groupies relieve that tension. You get laid and it's cool. You don't feel like hasslin' anybody."[22] Since Hite was in Detroit for a road show, one has to wonder, retrospectively, just exactly who profited from whom in this situation.

The authors also mentioned several other women with careers or jobs that gave them access to rock stars. These included two women who were tailors and another who was an office manager for a rock publicity agency. "Some of the girls of rock—girls who are very much part of the scene—everybody knows them—never were groupies in the strict sense, but are, somehow, cut of the same fabric."[23] One of the women to whom they refer by name is "Dusty the girl recording engineer." According to the article, Dusty Street began her career as an FM rock engineer at KMPX, a hip station in San Francisco, after being trained at San Francisco State University in radio and TV. Securing a job at KMPX was a rather large feather in her professional cap. In 1967, disc jockey Tom Donahue had taken over the small FM station, and KMPX had become one of the prototypes for the underground rock stations that characterized FM radio in subsequent years.[24] Editor and music critic Ralph J. Gleason described KMPX as "the first hippie radio station broadcasting the San Francisco rock music."[25] Street was a member of this seminal radio station's staff before she was twenty-one years old, and at the time of the groupie issue's publication, she was training as a recording engineer with Mercury Records and had already engineered a demo session for Johnny Winter, an up-and-coming guitarist from Texas. Clearly, she was a "player" in the rock-and-roll business in a serious and credible way.[26]

Despite her achievements, the authors characterized Dusty Street as a groupie. After listing her accomplishments, the authors wrote that Street "says she's in it because she digs the music, not so she can ball musicians. 'Musicians impress me primarily as minds, as creative forces. What I love is good solid music that makes you *feel*. But I don't hang out with musicians.'" In their framing Street's reasons for being in the music business with the phrase "she says," however, the writers cast doubt on her true motivations, leaving room for speculation about a sexual component.

The authors employed this strategy a second time while describing her job at KMPX. They quote her as saying, "'Everybody thought the girl engineers were balling everybody' she laughs, 'That was so funny because it never happened,'" but then add: "She *did* get love poems from one male listener, nearly everyday. And at KMPX she acquired the nicknames 'Dusty Superchick,' in honor of her tall comely figure and the roses in her cheeks; and 'Lusty Treat,' in

honor of something (real or fantasized) else." Here the authors describe Street based on the way her male fans and co-workers treated her, adding superfluous details about her physical appearance while ignoring her own statements about the reality of her life at KMPX. They instead include an observation designed to titillate straight male readers while reducing her accomplishments and place as a legitimate member of the music business. The linkage here between Street and the groupie subculture, with its *Rolling Stone*-added compulsory sex component, further diminishes her professional accomplishments.

Although Street moved in fairly rarified circles of the music business, Mercury Records was a successful, mid-sized company, and the interview was an opportunity for *Rolling Stone* to offer readers some insight into her future plans, such as what artists she was going to record next. Instead the authors questioned her once again about her sex life: "Do musicians hit on her now, after recording sessions? 'Oh, when I was first learning sometimes,' says Dusty, 'but now it's more like a business relationship, like: how can we make this thing sound best. They're all very sweet to me.'" By reminding the writers that the music came first, Street trumped her interviewers and reemphasized her professionalism.

The next section, one of the most disquieting, introduces Frank Zappa, one of the foremost promoters of the groupies and their lifestyles and one of those most responsible for the negative stereotypes in this article and elsewhere. Of the groupies attracted by his own band, the Mothers of Invention, Zappa said, "And the kind of chicks we pull [have sex with] are kinda *weird*— by weird I mean the 12 and 13 year olds that Don Preston [a member of the band] was dragging across international boundaries in Europe." Zappa's characterization of these children is chilling:

During their five-month stay in New York, the Mothers were dogged day and night by groupies. They would follow exactly 15 paces behind the band. Really young chicks— Cindy, Anne, Janell and Rozzy—aged 13 to 15. Zappa thought it was far-out. "They really surprised us. They had really groovy minds. More imagination than I've ever seen in girls so young." But sometimes a mite vicious. "I have a tape of a 14-year-old going through a fantasy where she was going to kill my pregnant wife so she could get me. It's a little scary, but it's actually very flattering, too."[27]

Zappa also explicitly describes the sexual activities of groupies and employed a pseudo-sociological analysis of the groupies and their behavior:

"These chicks are ready for anything. They'll give head"—oral intercourse—"without thinking about it, anyplace: backstage in the dressing room, out in the street, anyplace, any time. And they're ready for anything. I think pop music has done more for oral intercourse than anything else that ever happened, and vice versa. And it's good for the girls. Eventually, most of them are going to get married to regular workers—office

workers, factory workers, just regular guys. These guys are lucky to be getting girls like these, girls who have attained some level of sexual adventurousness. It's good for the whole country. These guys will be happier, they'll do their jobs better, and the economy will reflect it. Everybody will be happier."

In short: A happy nation sucks.[28]

Zappa's analysis of the groupies and their effect on society did appear to do away with the "soiled dove/fallen women" aspect of the sexual double standard. After all, he did say that "most" of the groupies would get married "eventually." The groupies would know how to "please their man" due to their experiences as groupies but couldn't necessarily expect to find any analog of their "sexual adventurousness" in the "regular guys" they would be marrying. Such a characterization appears to be a simple retooling of the sexual "bad girl" from earlier eras: groupies are marriageable, unlike the "damaged goods" of years past, but they are still only concerned with male sexual pleasure and must find their own pleasure within its confines.

Zappa's interest in groupies extended beyond the sexual. He was closely connected with two featured groups in *Rolling Stone*'s groupie issue, most notably, the GTOs. In her autobiography, Pamela Des Barres, one of the members of the group, writes that they were signed to Zappa's label, Bizarre Records, and received a salary from him as well.[29] She related that another of the women, Miss Christine, was Zappa's housekeeper and nanny for his infant daughter, Moon Unit.[30] Although four of the women had been friends before Zappa signed them to a record deal, he had added the fifth member and included them in several shows with the Mothers of Invention. Although their musicianship was somewhat in question, Des Barres quoted Alice Cooper as diplomatically describing them as "more of a mixed-media event than musicians."[31] The authors of the groupie issue were not so gracious in their description of the women: "The act they [the GTOs] debuted at the Shrine Exposition Hall here [Los Angeles] a few weeks ago was beautifully choreographed and so what if one of the Mothers [of Invention] thinks they're astonishingly flat, can't carry a tune in a bucket."[32] They also hinted that Zappa might have another reason for supporting the groupies:

Zappa may wind up the ultimate historian of the groupies, whom he sees as freedom fighters at the avant garde of the Sexual Revolution that is sweeping Western Civilization. He's got hours of interview and conversation with groupies on tape; plus all the diaries of the GTOs, plus all the diaries of the Plaster Casters, plus several other diaries and hundreds of letters and photos; and he's already gotten the whole thing together into a book to be called *The Groupie Papers*. The manuscript is already in the hands of the publishing company Stein & Day, although Zappa has heard no reaction from them.[33]

It is clear that Zappa's support of her work—indeed he would soon after bring her to Los Angeles and act as her manager—was essential to Cynthia's belief that her casts were works of art.

In an inspired bit of hucksterism worthy of P. T. Barnum, Zappa also whetted the readers' appetites for more "information" on the groupies. In addition to *The Groupie Papers*, Zappa was considering including some of the tapes in his own work: "Some of the tape may appear on the Mothers next LP, or maybe the one after that. 'I'm not sure the public is ready for that yet, and some of the girls are under-age,' says Zappa, 'so there's the ethical problem.' His tapes contain the whole groupie rap: comments on various rockstars' ('cockstars' Zappa calls 'em) penis length and diameter, hairiness, body smell, duration of intercourse, number of orgasms by him, number of orgasms by her, type of drugs preferred, etc., etc."[34]

Zappa's "information" is framed in the language of eroticism with the graphic nature of its descriptions and its concentration on sex, as well as paying a passing nod to tabloid journalism with its revelatory aspects about the stars' personal lives. That Zappa would employ this rhetorical tactic was no accident. He was no stranger to pornography, and he knew that sex sold. In her book *Rock 'n' Roll Confidential*, Penny Stallings claims that Zappa had been a pornographer and included a newspaper clipping from the *Ontario Daily Report* chronicling his arrest. The article's subhead was "2 A-Go-Go to Jail" and describes the details of Zappa's arrest.[35] However, it appears from the article that Zappa's bust was for a relatively minor offense that would not be punishable by law even a few years later.

Zappa's listing of the ages of some of the groupies raises the subject of underage girls in the groupie "scene." In addition to the girls alleged to have been involved with the Mothers of Invention, several of the women featured in the article were underage when they first began to be involved sexually with rock stars. The article discussed an Los Angeles groupie named Catherine James who gave birth to a child allegedly fathered by an English rock star before she was seventeen years old.[36] Diane, one member of the Plaster Casters and the member of the group who performed fellatio on the rock stars in order to get them erect enough to cast, was a seventeen-year-old-high-school student at the time of the article. Yet another groupie, whose real name was not used in the article, claimed she was fourteen when she started having sex with musicians and had a child fathered by one at age fifteen., In a story that is an eye-opener even for the 1960s, the authors comment on the decline in the groupies' ages: "The fantasies are broadening into the culture and cutting through age lines, and groupies are getting younger and younger. The Grateful Dead have in their collection a letter an 8-year-old girl wrote to Jerry Garcia: 'I want to

know all about you. I want to know what kind of women you prefer. I want to fuck with you when I get to San Francisco.' The Dead's secretary wrote the mini-groupie that Garcia had an old lady for the time being, and advised patience."[37]

The youth of some of the girls in this story brings up some difficult issues. To object to the sexualizing of children requires an agreement with the moral system that labels it taboo. As already discussed, many involved in the counterculture of the 1960s did not subscribe to the existing moral system for both personal and political reasons. To further complicate the matter, the rules governing sexual behavior were in enormous flux during the 1960s; what today may be widely labeled as pedophilia was viewed in the 1960s by some as sexual experimentation, which may partially explain why none of the authors made any editorial comment about the youth of some of the groupies in the article. That they did not comment on the moral ramifications of adult men having sex with minor female children could also be ascribed to a disdain for the moral system that underpinned the legal age limits for sexuality.

Even so, the authors' casual treatment of sex with young girls demonstrates another example of the sexual double standard that was in full force between American men and women. For an adult to have sex with a child comes down to questions of power and power relations; children are at a disadvantage when they are in a relationship with an adult, sexual or otherwise. For an adult rock star (male in this case) to have had sexual relations with girls who were underage could be an example of this uneven distribution of power. It could allow him to use his power as a celebrity to circumvent the legal codes of the day, although, in many cases, the musicians were only a few years older than the young women with whom they were having sex. Some were young women who, in many cultures, would have already been allowed to decide for themselves when they would begin having sex or would already have been of the legal age of sexual consent. This issue is a thorny one and, in order to acknowledge its complexity, should be viewed through the lens of 1960s culture.

According to the authors of the groupie issue, these unequal power relations not only applied to situations where the groupies were children. The authors frequently referred to the almost slavish devotion that adult groupies had toward the men they idolized. Such ardor, which often bordered on obsequiousness, ran the gamut from the literal iconography of the Plaster Casters to more attitudinal varieties. An example of the latter type was the case of Sally Mann. Mann lived at the Jefferson Airplane's Fulton Street house, a pseudocommune where the band lived at the time of the groupie issue's publication. In the article, the authors describe her role at the house: "[Mann] serves as house mother preparing meals, washing the dishes, answering the phone,

answering the door, screening unwanted visitors and a host of other chores, for which she is paid nothing except the gratitude of the Airplane."[38] This arrangement is surprising in light of the fact that the Jefferson Airplane was one of the most financially successful groups in rock and roll at the time and that Mann needed money. She had a baby who was cared for by her mother, who lived "in a small, sparsely furnished San Francisco apartment living partly on Sally's $150 monthly welfare checks." Sally's story, unlike those of many of the women in this article, had a more happy ending. She eventually married Spencer Dryden, the drummer for the Jefferson Airplane.

If the groupie issue is any indicator, one of the sources of the disparaging attitudes toward groupies originated with male rock stars and their managers. In contrast with the opinions of Zappa and Hite, many rock stars saw groupies as everything from thieves and nuisances to free whores and mentally unbalanced people. Guitarist Jeff Beck, in particular, had nothing good to say about groupies and believed groupies would steal if given the chance. During his last tour, Beck had lost an expensive pair of sunglasses to an Los Angeles groupie: "She just fucked off with them and I never saw her again. They're like that. You've got to watch everything you own." He also revealed that he had lost "nearly a dozen lace shirts" as well. Like Hite, Beck also said that he did not associate with groupies when he was at home: "They [groupies] have this nasty kind of cunning way of seeping inside your scene and into your life, when really you don't know them at all. I mean it's one thing when you're traveling, but at home—*never*." Beck continued his diatribe against groupies: "Groupies use groups, man—*groupies* use *groups*—not the reverse, the way it might look. It's all for their own egos. It's got very little—very, very, *very* little—to do with giving or sharing, so far as they're concerned. It's saddening really. It's why I cannot wait, *cannot wait*, to get home."[39]

Steve Miller, a bandleader from San Francisco mentioned in Chapter 4 in conjunction with Ellen Sander's article on the Plaster Casters, also agreed that involvement with groupies could be problematic, but said it was worth it for the sex. As mentioned in the previous chapter, the writers of the groupie issue presented a much more one-sided account of Miller's and the Plaster Caster's encounter, writing exclusively from Miller's viewpoint which basically implied that, in this instance, the sex did not outweigh the groupies' approach or attitude.

The writers described the meeting where the Plaster Casters approached Miller to make a plaster model of his penis for their collection of rock stars' genitalia. Initially interested, he became less than enthused after meeting them: "But then I met these chicks and they're sick. They're such grim, sick people. They look like medieval mental cases. They're just little girls who are absolutely nowhere, man. If they were groovy it would be one thing, but the way

they go about it it's sort of fanatic sickness, really a cheap, trashy trip. When it came down to the nitty gritty and I saw what these chicks are really into I just told them I wasn't interested."[40] It appears that the Plaster Casters' approach to their activity, not the activity itself is what caused Miller's objections. It is notable that Miller, bona fide member of the counterculture, employs the normative values of the mental health industry, conventional feminine beauty, and class consciousness in the framing of his disapproval.

Stu Kutchins, manager of the Youngbloods, also had little good to say about groupies but didn't rule out sex with them, even if it was problematic. "The only thing they're [groupies] good for is relieving tensions and picking up a dose of the clap." Michael Bloomfield, guitarist for Electric Flag, was even less complimentary: "[Groupies] just want to talk to the cat, see where he's at, watch him do his thing and the only way they can do it is to give him something. And the only thing most of them have to offer is their cunts."[41] That the groupies had their own agendas and plans, and were occasionally able to realize them, is evident in the rock stars' dissatisfaction with their encounters.

Though some of the male rock stars expressed positive feelings about groupies, in many cases they were coupled with condescension. A quotation from Country Joe McDonald, leader of Country Joe and the Fish, is illustrative of this approach: "'Sure, some chicks are just star-fuckers,' says Country Joe McDonald. 'But it doesn't matter what their motivation is, you know. There's these times when they come around after somethin' and you're after somethin' too, so you get it together and everybody's happy. Groupies are beautiful. They come to hear you play, they throw flowers and underpants, they give you kisses and love, they come to bed with you. They're beautiful. We love groupies.'"[42] McDonald's attitude was echoed by Jimi Hendrix: "'I only remember a city,' he says, 'by its chicks. Instead of saying "We're part of the love scene," they're actually doing it. They take you around, they wash your socks and try to make you feel nice while you're in town because they know they can't have you forever. Used to be the soldiers who were the gallant ones, riding into town, drinking the wine and taking the girls. Now it's the musicians.'"[43] Steve Miller also repeated this refrain with examples of damning with faint praise: "'Some groupies are kinda churning themselves out, they live so fast and hard, but there's a beauty in that that you don't find in normal people,' Miller says 'They're [groupies] a little unusual because they don't want any lengthy relationships with other people, but I don't want them myself, so I get along with groupies fine. A lot of groupie chicks are stone cold crazy, but they're good lays. It's true they're on a whole fantasy trip—but that's groovy. *Most* rock and roll people are on a fantasy trip anyway, so it's natural that musicians and groupies are drawn together. They're the same kind of people.'"[44]

Whether musicians liked or condemned groupies, they were an acknowledged part of the rock-and-roll scene by the time *Rolling Stone's* groupie issue hit the newsstands in 1969. Bands had always had zealous fans. Yet, based on the statements in this article, it is difficult to ascertain whether the groupies' relationships with musicians had changed somehow from those of a few years earlier, or whether the journalists had finally decided to reveal the sexual aspects of groupie behavior. During the British Invasion, the media had portrayed female groupies of the bands as primarily engaging in two activities—screaming at and chasing the musicians—but some intriguing passages also discuss the interaction between the groupies and the musicians.

Two statements sought to draw a direct correlation between the screaming girl fans of the British Invasion of five years previous:

It was all different four years ago during the earliest Yardbirds [a British rock band] tours, according to [Jeff] Beck. "It was all a teeny-bopper scene then, with all these screaming chicks who would just come for the music, mainly, and just scream. That's *all* they did. For the most part. And sometimes older women—strange chicks in their 30s—would try to pull [have sex with] us. But now the scene has changed completely. *Completely.* Maybe groupies are in reality grown-up groupies. I don't know."[45]

The authors echoed Beck's speculation on the origins of the groupie with one of their own. In their discussion of the resurgence in popularity experienced by British bands in the 1968–69 touring seasons, they too speculated that groupies might have once been screaming girl fans of four years earlier. This resurgence was "the largest since the Dave Clark/Herman's Hermits era, and perhaps it is even the same girls, only now weaned from screaming and fainting ways into more sophisticated pursuits."[46] To suggest that some of the young girls who screamed for the Beatles and the Rolling Stones in 1964 grew up and became groupies normalized the groupie/star relationship. As it was described in this instance by these writers, this normalization included a particular construction of groupie sexuality and sexual expression. Their framing of the discussion not only privileges this construction, but it also emphasizes a certain approach to sex over any other, as well as the other services that the groupies provided for the musicians that had already been mentioned in the article. The authors also implied that becoming more "sophisticated" meant girl fans had become no-strings-attached, on-demand sexual partners for rock stars. Once again, it appears that a woman's sexual favors were the most important thing that she had to offer, according to the writers of this article.

These considerations aside, the way that the *Rolling Stone* writers portrayed the groupies was reductive and reeked of the sexual double standard that prevailed during the era in which it was published. In light of the successes

enjoyed by the female performers of the era, it could be that some of these screaming girl fans grew up and became rock stars themselves, yet the authors did not even consider that possible. It is true that not very many female rock stars existed in this era, but were there very many groupies either? The authors never gave any specific number of the women, or girls, who were groupies. The screaming girl fans of the British Invasion numbered in the hundreds of thousands. To characterize them all in this manner was to portray all female fans of rock music, past and present, as potential groupies, with an obligatory sexual component. Much like the narrow stereotypes used to describe women artists I discussed previously, this characterization of all women as potential sex partners for male rock stars rendered them little more than passive physical beings who needed men in order to realize their identities.

Whether the readers loved or hated it, *Rolling Stone*'s groupie issue appears to have generated tremendous discussion among the magazine's readership, and this discussion indicates the contested nature of the groupie's larger cultural meaning. On average, letters in *Rolling Stone*'s "Correspondence, Love Letters & Advice" section usually numbered no more than eight or ten in each issue. Those published in response to the groupie issue greatly exceeded this number and were by far the largest number printed by the magazine in a single issue up to that point.[47]

Letters about the groupie issue were published in the issue for March 15, 1969, which coincidentally (or perhaps not) featured Janis Joplin in her second appearance on the magazine's cover, this time with the dubious headline, "A Report on Janis Joplin: The Judy Garland of Rock?"[48] More than thirty pieces of correspondence commenting on the groupie issue were included in the letter section.[49] Their points of view ranged from the congratulatory to the highly condemnatory. A few ran to several paragraphs but most consisted of only a paragraph or two.[50]

The reasons that people wrote to *Rolling Stone* regarding this issue varied. Some wrote to complain that the subject had been addressed at all, while others wrote to congratulate the magazine for its choice. Another subject that generated intense discussion and passionate rhetoric centered on what the groupies were "really" like. Some readers' complaints were with individuals included in the article. Whatever their reasons were for sending them, the letters act as a window into the readership of *Rolling Stone* at that point, though admittedly through the filter of its editors.

The largest number of letters printed were those opposed to the article. These ranged from disgruntled older generation readers to those who believed *Rolling Stone* was degrading journalism by even addressing the subject. Two

letters I categorize as older generation because older readers or younger ones who closely identified with the values of that generation wrote them. Although the letters had very different tones, both objected to the groupie issue because they believed the groupies or *Rolling Stone*'s reporting of the phenomenon corrupted America's youth. The more condemnatory of the two read: "I want to cancel my subscription to that trashy garbage you call a magazine. I'd sooner lose the money than have that filth come into my home.

I have utter contempt for people of your ilk who demoralize them [*sic*] teenagers just to make a buck. Money earned that way can never bring you happiness. Since you don't have a conscience, it won't bother you."[51]

The other older generation letter was much longer but the last two paragraphs conveyed the gist of both the author's meaning and tone:

> The inevitable plight of today's groupies then, and all those to come in the next decade or more, is the loss of any real future or productive lifetime, which tends to be very dominant in the youth of today anyway. As apparent as it should have been to me before, I can now see where celebrities find their major source of dope traffic, as well as one-night stands of true love with some gaudy little slut with a burnt-out mind and an intellect to match.
>
> Makes one wonder if anyone connected with a market for young people can ever grow up. The added item (fact?) that more than 90% of all pop stars are heads [slang for drug users] of one form or another also might lead to a complete upheaval of the rock scene by an intellectual-minded public, but if the groupies remain extant I doubt it.[52]

It is unclear whether this last writer was more concerned with youth's ability to adopt the standards of the older generation or whether he is more concerned about the effects of the groupie and musician lifestyles on the members of these subcultures. I believe it is instructive to note this writer's use of the word "slut," a normative and value-laden term, and his disapproval of the recreational use of drugs. In his last sentence it also appears that he was blaming the rock star's access to drugs and the lack of intellectual content in rock music on the groupies.

Several other readers responded negatively to the groupie issue with letters that were sarcastic and reflected the authors' concerns about the magazine's standards. "After reading the 14 pages [*sic*] of trash on groupies, I begin to wonder what *Rolling Stone* is coming to."[53] One letter seemed to be particularly concerned that the journalistic approach characteristic of the more "teeny-bopper" magazines was seeping into *Rolling Stone*: "*Rolling Stone* is a sophisticated newspaper never to be confused with teeny-bopper magazines. Teeny-bopper magazines tell you who's going with who and who married who. *Rolling Stone* tells you which groupie balled which star. Outtasite [*sic*]. I'm looking at the next issue before I buy it."[54] Finally, another letter, though more

inarticulate than others, seemed to sum up the tone of these letters. "Is all this shit really necessary? I thought we'd all been through this trip. I mean I think you're really weird."[55]

Several of the letters printed in response to the groupie issue did not object to the article, but rather took issue with the attractiveness of the women featured in it, and most mentioned the Plaster Casters of Chicago by name in this regard: "I must admit that a few of the girls were pretty, but most of them are the most disgusting thing next to Frankenstein's bride, in fact I couldn't tell the difference between the two. A few girls in your article defined a groupie as a girl who chases a rock star, but my definition after reading this article is an over-sexed, hardup prostitute, and in the case of the Plaster Casters, that's probably the only way they'll ever get their thrills."[56] Another letter in this same vein was more profanely to the point, "If this developing life style I keep hearing about is a pack of chubbily promiscuous teen-age whores, forget it. Your Plaster Casters?—two fat cunts, two bullshit girls who seem to be a little hung up in the head."[57] It is noteworthy that the author of this letter described the Plaster Casters as "chubby" and "whores," since both words insinuate that there is but one "correct" value system, presumably where the women are all thin and chaste.

Two letters also objected either to Zappa or his championing of the groupies and their lifestyle. One author seemed to question Zappa's sincerity toward the groupies based on some of the anti-groupie lyrics in his songs (two of which, "Motherly Love" and "Plastic People," were included in the groupie issue).[58] "If Frank Zappa thinks they're so groovy, how come his songs are such putdowns?"[59] This author then ended his letter with a rather pointed editorial comment: "Frank Zappa has the soul of a pimp!" Another letter, signed Doris Wilkes, objected to Zappa's support of the groupies: "Frank Zappa, a mature man, is sick and/or evil to champion such human waste. And doesn't he have a baby girl, himself? His endorsement truly shocked me."[60]

Two of the correspondents did not object to *Rolling Stone*'s coverage of the groupies but rather believed that the whole phenomenon reflected the general venality and corruption of American society:

I have just read your February 15 issue on the Groupies and I want to vomit. Not on *Rolling Stone* because all you have done is hold up a mirror to Pop and the whole cult which has evolved around it. And I don't even want to vomit on Pop and the cult because they are just a reflection of our civilization.

I just want to vomit and vomit and vomit. Then I want to join the Motherfuckers [underground group that advocated the overthrow of the system through violence], make lots of bombs and blow up everything. Or maybe it would be better to pray that there is a Dr. Strangelove plotting somewhere on the face of the earth. Let's wish him

luck. I'm sorry but LSD and hash aren't strong enough anymore to keep all this shit down.[61]

Another of these, Wilkes's letter quoted above, also reflected the nascent feminism that was gaining strength in America at that time: "These sad little girls' lives are a comment on the American Experience. They've bought the media-induced concept that women are commodities and Happiness is Being Used by the Consumer of Your Choice. (Or someone rather like.) In a pitiful parody of American know-how they've found the quick! easy! sure! way to their goal. Sold on the lie of instant fulfillment, what should be the culmination of a relationship becomes the relationship."[62] Here the writer also intimates that there is but one "correct" value system; however, women are not allowed to seek out sex for its own sake with the partner of their choice. Both letters demonstrate there was at least some negotiation of values and sex roles on the parts of some of the readers who read the groupie issue.

One letter condemned some parts of the article and praised others. In the condemnatory sections of her letter, the female author upbraided "male rock critics" for not including details of the physical appearances of male performers. She also noted the discomfort the authors exhibited on the subject of male homosexuality. "It seems from the way your writer avoided the homosexuality issue among male Groupies with a clumsy paragraph, that he too is hung up with guilt." The author ends her letter with an admonition to rock critics in general on the subject: "Rock critics need to stop avoiding the sex issue by escaping into too sterile intellectualistic [*sic*] music criticism—like let's put the sex back into Hendrix's 'energy' and articles will be easier for both sexes (and also teenies) to relate to—right?"[63]

However, many letter writers expressed positive opinions about the groupie article. Positive letters tended to fall into two categories: letters that were mixed, though generally positive, and those from people who had a professional interest in the music business or the groupie phenomenon. The letter just cited contains wording that was typical of those from the first group. She begins, "I really dug the article on Groupies and women of rock! Like it's the first article since the passing of Beatlemania that gets into rock from the feminine point of view." Another letter writer says, "While *Rolling Stone* is always a groove, your February 15th issue is really out-a-sight with its coverage of the groupie scene."[64]

The letters received from those with a professional interest in the groupie phenomenon were much more numerous than those from readers who merely praised the article as a good read. One of the letters that fell into the former category was from a reader whose wife was a psychologist. He mentions

exposing a member of academia to the article: "Just finished your treatise on Groupies— so did my wife, who is in psychology. It's a classic! We've discussed it with a number of friends also into this bag and they all agree. In addition, we've passed it on to Prof. George Geothals [*sic*] of Harvard, whose particular interest is contemporary adolescent psychology. Congratulations for extremely perceptive, insightful and intelligent writing."[65]

Those involved in the music business also weighed in on the groupie issue. These ranged from someone who participated in the business at the highest levels to those who were still aspirants. Jerry Wexler, then one of the most powerful executives at Atlantic Records, took the time to write.[66] "Congratulations on your Groupie issue; it is a truly heavy sociological document and an example of superb reporting."[67] "Another letter was from a reader who was also a journalist and implied that his interest was professional: "My compliments on your issue dealing with groupies. It had been tried before (remember *Cheetah*?), but where others failed miserably, your articles were well-written, informative and entertaining, plus a contribution to sociology. You can't ask for much more. You missed at least one batch of groupies, however: the writers and photographers who follow the bands. They (we?) may not offer what the girls do, but newsmen have always been known as whores of sorts."[68]

Of all the letters printed by *Rolling Stone* in response to its groupie issue, the most interesting and revealing are those written by groupies themselves. Intriguingly, aside from those which were derisive, this category contains the most letters. Most of the groupies who wrote in had a complaint about the article. In one such letter, even though she calls the issue "your great Groupie masterpiece," a former groupie from New York complained that the article had "practically neglected the East Coast, especially New York."[69] Another letter writer, a groupie who had been quoted in the article and described as "Henri, a now pregnant old-timer *Yenta* of the San Francisco groupie scene," complains about omissions and provids supplementary information. Henri, who had been associated with *Rolling Stone* almost from the magazine's inception, had joined the magazine's staff as a volunteer after the publication of its first issue and was its first receptionist.[70] Her letter was a scathing attack on editor Jann Wenner's hypocrisy: "Your article on the Groupies was pretty accurate except for one minor point: When you mentioned male groupies you left out your very own editor, Jann Wenner, one of the most obvious male groupies I've ever met. He introduces himself as 'Jann Wenner, you know, the editor of *Rolling Stone*.' Any reasons why he was left out? It couldn't be mere oversight, could it?"[71] The magazine's response to this letter was savage. Next to the letter they included a picture of the very pregnant Henri topless. This is not simply a case of male versus female or boss versus employee. It points out that no matter

what the groupies might have thought about *Rolling Stone*'s portrayal of them, the men at the magazine would always have the last word.

Two other letters from groupies were even more damning. The first was from another woman mentioned by name in the groupie issue, Genie the Tailor, a clothing designer from Los Angeles. The authors of the article describe her as one of the "hip tailor ladies who make on-stage apparel for bands."[72] Her letter echoes some of those mentioned above that were concerned the Groupie issue had compromised the magazine's journalistic standards. The first lines of her letter are deep with meaning: "Your article is really fucked. *Rolling Stone* has never before been guilty of printing so many lies, misquotations, mistruths, distortions of facts as here." In these comments the level of esteem that many young readers from the counterculture had for *Rolling Stone* is evident; she seemed to imply that normally the magazine could be depended upon for reliable information. However, this time *Rolling Stone* had let its readers down: "You could have done something groovy but instead gave up halfway through and settled for a cheap sensationalistic approach—that's not journalism and certainly not worthy of *Rolling Stone*. Hopefully this article will pass away unread into oblivion and you can redeem yourself in the next issue. Just remember that the *truth* is the most important thing you can write."[73]

Two other comments by Genie further illustrate that the groupie issue was the work of misogynist writers who had failed to consult even the groupies mentioned in the article itself, much less a broader range of social experts. First, Genie casts doubt upon the centrality of Zappa's role in the Los Angeles groupie scene: "Nobody cares about Frank Zappa; nobody listens to him except himself; no one cares about the GTOs." In a postscript she then chides *Rolling Stone* for not consulting her about her experiences in the music scene mentioned in the article. "P.S. If you had wanted to know the facts and the truth about many of the situations glossed over in the article, all you had to do was ask."

Genie's complaints were about the article's quality and accuracy. However, another groupie letter writer believed that even though the article was accurate, it was also exploitative: "The *Rolling Stone* article on the Groupies was an act of capitalist prostitution on [*sic*] the struggles and hardships of these people. *My* people. Sure it was true, but the format and advertising was strictly out of a *True Confessions Magazine*. We chose this life because there really wasn't any choice, and it's the only one we could have made. So hey you, you *better* stay off my cloud."[74] This self-identified groupie named Isabel touched on some important themes in the issue. She rightly noted that the male writers and editors at *Rolling Stone* had embarked on this project primarily to make money. Isabel doesn't quarrel with the content of the article, but rather its

approach. She observes that its language has much in common with tabloid or pornographic writing aimed at a male audience. Isabel also comments on the lack of opportunities for women in the music business and ends with a warning not to engage in this type of subcultural "poaching" again.

Two groupies also wrote in to complain about one of the profiled groupies, Anna. By far the groupie most cited in the article, Anna was quoted fifteen times.[75] It is not only the number of quotations from Anna but the tone and content of those quotations that made her stand out from the other groupies. Many of her remarks were obsequious to men or deprecating to her and other women. An example is her view of the relative merits of English musicians, both sexual and behavioral, versus those of their American counterparts: "One guy told me that it's different with Englishmen because it's like a mother thing, so you treat women with more respect—women are an important part of a man's life and women there aren't dominating like they are in America, you know." On the subject of other groupies she states: "The fear of other women is a very great thing. Because the younger ones are extremely brazen. They come on so strong with whoever you're involved with. They're very possessive, they don't know any better. It's like watching a young child pouting. The young ones are really far-out. They're so aggressive. And hostile."[76]

By far Anna's most provocative statements were included in her feature section. For example, in her answer to the question, if she could "spend some time with" any musician in the world, who would she choose was, "It would be an honor to, um . . . It would be enough just to be sexually involved with someone like John Lennon. It would be very flattering to have him even notice me" (ellipses in original). The interviewer also asks her if being friends with a musician was enough for her or if "your impact on him is not complete unless you ball him?"

> When you first meet them you just have to get that out of the way. I think you have the feeling that if you don't get into something sexual with them, what are they going to bother with you for?
> [Interviewer] Is that really the case, though?
> [Anna] Yes. It is. If a chick was really that beautiful, she'd be, I mean offended if he didn't come on to her sexually.

Anna also exhibited a venal streak mixed with a tendency to condemn the other women in some of her comments about the groupie lifestyle: "There are so many chicks getting used. And it's definitely their own fault. They should never let it happen. I mean, at least get a good meal out of it to be basic and realistic about it. But at least be down to earth enough to get a little bread

out of it, or, uh, something to eat or some way to live if you don't have any money."[77]

One of the two groupies who wrote to *Rolling Stone* to complain about Anna's views noted this venality in her letter: "Our [the groupies'] trip is very groovy, our trip isn't to hustle the stars." However, both writers seemed to be more concerned that Anna was not what she had represented herself to be. One writes: "The first time I read *Rolling Stone* Mag. I was appalled at your article on the Groupies. 'Little Plastic Ringnosed Anna' [she had a nose ring] is and never was a 'Groupie' as your arousing article said. You missed the boat on that one. You have been put on, Sirs: Ask little Miss Anna how long she has been in California. Ask little Miss Anna what brand of Scotch she drinks."[78] This last comment was in reference to the fact that since Anna drinks, she must not be a "real" hippie, as "real" hippies would not use alcohol because of its association with the older generation. The other groupie also doubts Anna's "authenticity" as a groupie in her letter: "I am sorry to say that the ring in the nose is a thorn in the back. Anna who?"[79]

Two non-groupie readers who wrote in about Anna also doubt the veracity of her and her statements. One states, "Anna (groupie who was hung up on sex) or Plastic Anna—grow—grow up. 'Hung-up Anna'—'Ego Anna'—'The most hung up chick in the article,'"[80] while the other writes: "Anna must be a put on. I cannot believe anyone can really believe in what she says."[81]

All four of these letters cast doubt on whether Anna was authentic. Considering the number of times the authors quote her, any questions about her veracity might have had serious repercussions on the credibility of the article. These questions also cast doubt on whether the authors of it were as "plugged in" to the groupie scene as they, and *Rolling Stone*, purported themselves to be. How could men as hip as the authors and editors of the coolest music magazine in America be snowed by a twenty-five-year-old wannabe groupie? None of this was addressed in the magazine by the authors or the editors. Instead Anna's words form the lion's share of the "expert" quotations in the article, since she claimed to be a groupie. Again, the contestation over the term is evident, with some of the letter writers not wishing to give Anna her own self-definition and to acknowledge a complexity in the experiences of self-identified groupies.

Questions about Anna's authenticity are not the only journalistic issues pointed out by readers' letters. An intriguing letter was from Don Hiemforth, an Los Angeles gay man who wanted to comment on homosexual behavior by people in the entertainment industry in general, and that of the GTOs in particular. His letter gives a rare glimpse into the gay entertainment community

that the authors of the groupie issue seemed unable to locate and investigate. Hiemforth begins by writing that he didn't want to "blow the scene on the GTOs," but since they had made such a big deal out of saying that they were not gay, he felt obligated to respond. Interestingly, Hiemforth noted that his letter was not "meant necessarily for publication" or, if the editors decided to print it, "a certain amount of further consideration perhaps should be given [it]." Clearly, this gay man wanted to give the editors of *Rolling Stone* the inside story on the GTOs' sexuality but didn't necessarily want to "out" them to the world at large. The editors apparently printed the letter in its entirety, since it fills up almost an entire column of the letters pages. In it, Hiemforth admits that he had never personally "seen any of the GTOs ball another chick," but one of the gay members of the band had told him that one or two of them were lesbians.[82] He didn't object to their sexuality but rather wanted to set the record straight for the editors: "Even if none of them are betty-bulldykes (who cares?) they manage somehow to have a predominately gay entourage of cats. In some circles they would be known as faghags [gay slang term meaning straight women who spend a lot of time with gay men]. In fact, in some circles they *are* known as faghags."[83]

Hiemforth's letter suggests not only that homosexuality existed in the world of the rock-and-roll groupie, but also that Zappa had a hand in it as well. Hiemforth writes:

> If you're gay and in the entertainment hype scene and don't want the word out and around, you keep it cool. If you don't care if anyone knows you do your bit whenever and wherever and fuck the world. If you aren't and don't want people to think you are, it's rather a dumb-dumb to rap it down. Being gay, I know the multitudinous games my compatriots play—or don't play.
>
> The BTOs, another Zappa creation before the FBI got too close to one of them, was exclusively gay.[84]

It is curious that the authors of the groupie issue did not investigate groupies who were the gay male counterparts of the GTOs. Zappa's support must have certainly "legitimized" them in the eyes of the authors, much as it did the GTOs and the Plaster Casters. Perhaps it had something to do with the fact that, unlike female homosexuality, male homosexuality was regarded as much more threatening to straight men. For whatever reason, *Rolling Stone* did not follow up on Hiemforth's letter nor did they include the BTOs in their next project on the groupie phenomenon, published in 1970.

At the end of the letters section, the editors include information about their future plans for the groupies and a request for help with this project from the readers: "We are planning to do more about groupies—possibly in the form

of a book—and we would like to hear from any groupies who were left out and would like to be counted in this time. Or from anybody who knows about somebody we left out. Or anybody with an [*sic*] information on groupies, groupie culture, groupie society or whatever we left out. Go ahead. Super duper neat treatment guaranteed."[85]

What the editors and writers at *Rolling Stone* couldn't have known was how successful their promotion of the groupies would be. In their approach to this project, however, the language and methods they employ situated women fans within a discourse that was reminiscent of those found in tabloid journalism and pornography, hardly a benign aspect of the groupie issue. In doing so, *Rolling Stone* broadly disseminated the concept of the groupie as an almost obligatory sexual being. At issue was not whether some groupies used their sexual partners as status symbols or simply enjoyed sex with famous men, or indeed had sex with them at all. What was at stake here was whether these women had any determining voice in the characterization of the groupie.

Not all of the men who worked on the groupie issue approached their work from a misogynist stance, however. Photographer Baron Wolman, who had been the first one to suggest the idea of a groupie story, treated the women with great sensitivity in his photographs, endowing them with a range of human possibilities. From the knowing gaze of Karen to Henri's open smile to the GTOs' girlish exuberance (all included in the photograph section in this book) to Lacy's smoldering exoticism, Wolman's images were in stark contrast to the puerile reportage that accompanied them. His fascination with these women and their subculture was made plain in his portraits of them. Wolman glorified the groupies and presented them in the most positive of light.

With the advent of the groupie issue the writers and editors at *Rolling Stone* had launched a pop-culture phenomenon, spawning a host of material on the groupie and transforming the word into a part of the international vocabulary of popular culture. The narrowness of the frame used by these men would, however, haunt most groupies, as well as subsequent portrayals of them. Gone were many of their complexities and much of their power. Groupies weren't courtesans, or muses, or even the coolest chicks on the block anymore. Instead, they became just an interesting riff on the "bad girl" trope in the sexual double standard.

Powerful elements of the mainstream press wasted no time in jumping on the groupie bandwagon after *Rolling Stone's* article was published. The first was *Time*, which published an article on the groupies in the same month that *Rolling Stone's* groupie issue was published. Appearing in the magazine's "Modern Living" section under "Manners and Morals," this unattributed article,

"The Groupies," appeared on February 28, 1969, two weeks after *Rolling Stone*'s groupie issue. Aside from introducing the term to its readership, this author appears to be most concerned with normalizing the groupie phenomenon by describing it as a new variation on an old theme.

The tone of the first paragraph makes immediately clear the difference between the readership of *Time* and *Rolling Stone*. The author begins by demonstrating his, and presumably his readers', erudition by citing a passage from Juvenal that "railed bitterly" against Roman women who found gladiators attractive and by referring to the "Ziegfeld girl." At this point the author stooped to make a connection with the *hoi polloi* referring to the "mass hysteria" of the fans of Frank Sinatra and Elvis Presley. The author then compared these fans to present-day groupies: "Such adulatory demonstrations were mild, however, compared with those of a new and even more liberated breed of female hero-worshiper. They are the groupies. Their heroes are rock musicians—and their worship knows no bounds."[86] His use of the word "liberated" during this era of the sexual revolution implies precisely what bounds had been breached.

The *Time* author then attempted to define his terms. He used a familiar source, Frank Zappa, for his definition. Quoting him, a groupie was "a girl who goes to bed with members of rock-and-roll bands." The author then adds credibility to that analysis by noting that Zappa had a "sociological bent" that presumably gave some insight into the groupie phenomenon. At this point, the author attempts to normalize the construction of the groupies as primarily sexual beings, a move that was an important step toward the widespread adoption of this construction of the term in the popular press and society at large. Quoting Zappa again, the author states: "'Every trade has its groupies. Some chicks dig truck drivers. Some go for men in uniform—the early camp followers. Ours go for rock musicians.'"[87] So in fact, groupies were just a new twist on an old phenomenon. "The basic distinction between yesterday's hysterical fans and today's groupies is that the groupies—also known as 'rock geishas'— usually manage to fulfill their erotic fantasies." If this reference to "geishas" sounds familiar, it should since Henri Napier, a groupie quoted in the *Rolling Stone* article, makes the same comparison.

In his next statements the *Time* author copied *Rolling Stone* without attribution. He quoted another source familiar from the groupie issue, Anna. "'A girl is a groupie only if she has numerous relationships. A groupie will maybe sleep with three people all in one night from one group—from the equipment man to whoever is the most important.'" When compared with its corresponding passage in *Rolling Stone*, the "similarities" become outright plagiarism: "'A girl is a *groupie* only if she has numerous relationships, like where they'd overlap within one group which so often happens where a groupie will

hit maybe three people, sleep with three people all in one night from the same group. From equipment man to who's ever the most important.'"

Using the same quotations was not the only similarity between the groupie articles in *Rolling Stone* and *Time*. Like *Rolling Stone*, the *Time* author refused to speculate on how many groupies there might have been, but he did quote Zappa's speculations on their origins and ages: "'They come,' says Zappa, 'from any home that has contact with rock and roll and with radio and records. That's everybody.' Zappa contends that there are thousands of them, ranging in age all the way from 50 ('Although they have to look damned good at that age to get any action.') down to ten."[88] The *Time* author also tried to find musicians willing to come out against the groupies and their behavior: "Some musicians, however, profess to find them a nuisance." However, among his anti-groupie musician sources, he quoted Dick Barber, manager of the Mothers of Invention; Josephine Mori, whom he described as a "public relations girl for a rock record company called Elektra"; and Marty Pichinson, the drummer for a rock band called the Revelles. Barber and Mori are not musicians, while Pichinson's comments (in which he stated that sometimes you just want to have a pillow fight with the guys) definitely run counter to those expressed by many other musicians quoted in the two articles.[89]

Despite the lack of attribution to *Rolling Stone*, the *Time* author persisted in his pseudo-academic, rather ethnographically styled approach when categorizing the groupies. However, his information does not agree with *Rolling Stone* in nomenclature; he names "the great groupie middle class" the "gate crashers." Describing them in a decidedly martial manner, the author comments that the groupies spent their time "posting lookouts" and having "their quarry pinned down." If they failed to be invited backstage, they became more direct and offered dope to the performers "in exchange for their favors" or offered money to security guards to gain entrance to the star's hotel rooms. The author recounts the experiences of Harlan Ellison,[90] "a California freelance writer," in his travels with the Rolling Stones on their 1965-66 tour of America: "Spotting a young groupie crawling along the ledge outside his second-floor hotel room, he opened the sliding glass door to let her in, but she slipped, fell into the ocean—breaking her wrist—and had to be fished out by the Coast Guard. Ellison had barely recovered from that fright when another girl walked through his door and asked him if he was a friend of the Stones. When he said yes, she stripped and flopped onto his bed."[91]

The *Time* article also contributed a new phrase to the groupie subculture, one that would persist to today: super-groupie. "The *grande dames* of groupie society, the Super Groupies" didn't need to employ the crass and vulgar approaches used by the "gate crashers." "Beautiful, usually intelligent and often

well-heeled, they are welcome—in fact, sought-after—company." Steve Paul, owner of The Scene, a Manhattan nightclub, described the super-groupies' lives as full of travel and fun with the rock bands. He continues: "'they live the life that every other so-called groupie aspires to'; [he also] estimates that 'no more than ten groupies actually qualify for super status.'"[92] Comparing them to "the women who gravitated to the nineteenth century British Romantic poets, [in that] they are artistic as well as physical helpmeets," the author tries to normalize the groupies and their lifestyles by implying, again, that these women were just a new twist on an old idea.

The *Time* author offset these tales of the high life with an editorializing cautionary tale of groupie-life-gone-bad: "For every such success story, groupie life has presented scores of tragedies—made worse by the preoccupation with sex and dope that is integral to rock culture." Following this statement with a Jack Webb-esque example of an anonymous former groupie who was, at thirty-three, a Manhattan waitress and recovering junkie, he quotes her: "'I've made it with all the early biggies, and more. You know what I've got to show for it? Three kids from three different guys—which three, I'm not sure. I've gone the dope route, been busted twice, and taken the cure at Lexington, Ky.'"[93] The author begins the following paragraph with "most groupies may be luckier."[94]

Time's circulation in 1969 was a formidable force in American periodical journalism, and as such, its story on the groupie phenomenon was certainly the most widely distributed source of information on the subject available to the general public. That its editors chose to cover the subculture, and did so without a nod to *Rolling Stone*, says two things: they thought the story would interest the magazine's readers, and they had no regard for the journalistic reach of the latter magazine—it is only prudent to steal ideas from magazines that you are sure your readers won't already have read. Despite this, the significance of the *Time* coverage was to reinforce the image, and construction, of the groupie established in *Rolling Stone*.

It is also significant that *Time* did not attempt to incite a moral panic based upon the groupies' sexual behavior.[95] Just a few years earlier, reports that young girls were having sex with multiple partners and veritable strangers, especially rock-and-roll musicians, would have set off torrents of invective accompanied by much hand-wringing by the self-appointed guardians of public morality (and *Time*'s editors and readers). That *Time* chose to approach the groupies as a titillating phenomenon perhaps had as much to do with the sex of the writers as the times. Its staff, like *Rolling Stone*'s, was largely male. *Time*'s most serious disapproval was reserved for the groupies who mixed their sex with dope, like the junkie waitress described above. It is clear that by 1969 the

days when reports of young girls having sex with rock and rollers could stir up enough outrage to provoke a moral panic were long gone.

Little time was wasted in the creation of a fictionalized version of *Rolling Stone*'s groupie. In the spring of 1969, the New English Library published a novel about a groupie who lived in London. Written by Jenny Fabian and Johnny Byrne, *Groupie* was a thinly veiled roman à clef about Fabian's exploits as a groupie.[96] Though a work of fiction, many of the characters, bands, and locales were easily recognizable to followers of British music. The novel provoked a firestorm of attention from the press, especially on the British side of the Atlantic, but it is a rather tame read today. What appeared to have ignited the most debate was that author Fabian was not a working-class girl but a solid member of the middle class and intelligent to boot. This aspect of her background intrigued the press and she became, for a short while, a media figure in England. "She pontificated on late-night television; *The Sunday Times*, then the apogee of middle class chic, ran a deliciously voyeuristic feature asking, 'What would you do if your daughter . . .', then kept the story going for another week or so with the answers" (ellipses in original).[97]

Aside from further reification of the term, *Groupie*'s most lasting effect has been its impact on English slang. The Oxford English Dictionary credits it with introducing many slang words and phrases. "Indeed, the lexicographers must have loved her: *Groupie* gets 22 citations in the Oxford English Dictionary, from 'downer' to 'trippy' and 'splif' to 'uptight,' a mini-lexicon of Sixties-speak." In addition to its popularity with wordsmiths, *Groupie* also counted several members of the intelligentsia as fans. "Arthur Koestler, the *echt Mitteleuropa* intellectual, ostensibly the least predictable of worshippers, loved it; Desmond Morris, he of *The Naked Ape*, followed suit."[98] Morris appreciated the work for its social commentary and instructed readers to view it as "a sociological document." Indeed its value today lies mostly in its ability to conjure up 1968 London and as a window into the motivations of one particular female fan.

Employing the style of the *bildungsroman* the story begins with Katie, the protagonist, starting her quest to become a groupie and learn the "scene." Indeed much of the book describes her various sexual and chemical experiments, usually with people involved in the rock-music scene. These experiences enable Katie to decide better for herself what it was that she wanted her life to be. She starts with only vague notions of what a groupie is and how they behave. The book ends with Katie as a successful groupie who has seen through the hype of the lifestyle. That is, she is a groupie but on her own terms.

When one reads *Groupie* today, two things stand out immediately: for the women characters, the "sexual revolution" was nothing of the kind, and the

male characters were incredibly sexist by today's standards. In many instances, Katie's observations are keen and show a clear understanding of the prevailing double standard for women and men in that era and subculture. Early on in the book, Katie meets a groupie of much repute who has just been left by her rock-star lover. Her assessments of this woman's situation suggest an in-depth understanding of the groupie lifestyle and all its perils, even though she had yet to experience them for herself:

She [Roxanne, a groupie of much repute] seemed to have pulled all the best musicians around, and I noticed it was always the leader of the group. I liked the way she called all these guys by their christian [*sic*] names, assuming, of course, that I just had to know who she was talking about. It made me wonder whether I'd ever be in a position to do that, though now I was beginning to wonder whether her particular position was as cool as I had first thought, because here she was, she had pulled them all and ended up living with one of the best known. But it seemed that underneath it all she was a terri-fied chick, because she couldn't hold her scenes together any more, and, having had the best, she couldn't start downgrading her pulls now. From the way she told it, it struck me that something else was needed apart from looks and being groovy, to successfully get things together, grooving around with lots of famous guys who lived constantly in the public eye and who spent enormous amounts of bread didn't mean that you were equal to them, like she thought.[99]

Katie became determined not to make the same mistakes.

Though firmly ensconced in the youth subcultures of the day, several times Katie betrays her middle-class origins. Echoing the bourgeois preoccu-pation with appearances, she realizes that financial independence and appear-ances were the keys to making the groupie lifestyle work for her. "Maybe I wouldn't pull so many faces [celebrities], but I'd cover up my mistakes better than she [Roxanne] did, and I'd make sure I'd got a work scene together so I had a sort of security." To these ends, she found a job as a ticket-taker, book-keeper, and eventually, booking agent for a popular rock club.

Regarding appearances, Katie selects most of her boyfriends from the high-status pool of rock stars and managers. She keeps her hand in, so to speak, among the men of the straight world as well. One of Katie's friends, Reginald Chatterton, whom she describes as "a well-known freelance writer on the glossies," occasionally dates and sleeps with Katie. Of him, Katie says, "He makes an interesting change from the none-too-intellectual group members. And he's clever and successful, so I like to be seen out with Reginald, it extends my image."

In the beginning of the story, Katie is very much at the mercy of her boyfriends' and lovers' whims. She seems to have little control over her own life and makes statements that, on the surface, seems to deny her any independent

agency. If these utterances are examined more carefully, however, a streak of self-interested pragmatism can be detected just below the surface. The most notorious utterance in the book, and the one commented on by at least one reviewer, concerns her feelings about "plating," British slang for performing fellatio. In one instance, Katie discusses her feelings about having oral sex with men and describes several sexual encounters involving this activity. She states that she had no "hang-ups" about "plating" men she hardly knew in order to further her career. Then she concludes with a statement that seems impossibly innocent in the era of AIDS, "My only worry was that sperm might be fattening."[100]

Much like the men Katie "plated" to move ahead, star musicians were a means to an end, and not always a pleasant means at that. Though she may desire rock stars the most, she also looks down upon them with their working-class manners and lack of education. When Katie attends a "deb dance" with a friend who did light shows, she meets the bands hired to play for the party and ends up eating dinner with them: "All the others are behaving very badly, getting pissed [British slang for drunk] and doing their aggressive non-educated bit. And I'm thinking, really, aren't these guys animals. They were being so rude to the butlers and maids who were serving us all this delicious food, and I wondered why I dug people like this. They are really spoilt little monsters abusing their ridiculous prestige."[101] It was not only in their table manners that the denizens of the rock world betrayed their lack of education. In one instance Katie's road manager boyfriend Grant tells her they were going to the movies to see a Roman war film. It turned out to be a film of *Oedipus the King*, which Katie acknowledges having previously read.

Though not very well educated by middle-class standards, the people in the rock-and-roll subculture provide Katie with an education of sorts in the art of achieving goals and enhancing prestige. About two-thirds of the way through the book, she admits that her attitudes about people have changed: "I was ruder and less tolerant to people who didn't matter, and more at ease and confident with people who did. I had learned how to operate now, not perfectly, but successfully enough to get the things together that were important to my career. I knew how things worked on the scene. I knew how people made bread and how people got power, and knew what power and bread meant and how they could be used. So, when the opportunity presented itself, I would recognize it and know what to do to turn it to my advantage."[102]

Though her attitudes about people may have changed, Katie still shows remarkable obsequiousness to her boyfriends and lovers, doing their laundry and cooking for them. However, on one occasion she makes comments that seem to belie her actions and reveal a more calculating side to her behavior.

Katie tries to convince her boyfriend Grant to take her home with him after a concert. He refuses, and she has to decide how to respond: "I know I'll never get my way by playing Grant's game back at him. I mean, if I was cool, I'd say, OK and walk away, and that would be that. But I know he digs it when I humble myself, and I can do that, I'll do anything to get what I want."[103] This is the first hint that Katie's relationship with Grant contains a large element of role-playing in it. Much in the manner of those who practice consensual bondage, she becomes compliant because she knows her lover likes it, but it is she who was in charge nonetheless, because it is what she wants as well.

Close to the end of the story Katie confirms the suspicions of role-playing. A former boyfriend, Joe, asks her why she allowed Grant to treat her as he did. "I smile tolerantly at him, 'You know I like to be bullied, Joe, you were always telling me that. Besides, he does it so *well*.'" At this point the narrator makes it apparent that Katie fully understands the game and its rules. She is aware that any man could bully her and that she had chosen to be treated in that manner. However, not just *any* man would do. Katie wanted a boyfriend who was *good* at it as well, asserting not only her control over the situation but also a high degree of sophistication about her needs and wants.

In one instance, Katie even reveals a bit of nascent feminism. While she is at a lover's apartment, his roommate begins to criticize women and makes a pronouncement about "birds being slags" (women being sluts, roughly translated from the British slang). She responds with a proto-feminist lecture on women and men:

I told him that he'd better open his eyes and look about, because chicks these days didn't have to put up with scenes like that anymore, not unless they were clearly mindless. There were enough men around who realised that chicks had minds, bodies, needs and roles to play just like them, even though there would always be idiots like him with small minds who'd put down chicks who enjoyed being screwed without any guilt to hang them up. I told him we could do without guys like this because they didn't know where anything was at, and he got all offended.[104]

By the end of the novel, Katie ceases to care about the opinions of others. A rock star who had been her boyfriend in the beginning of the novel writes her a letter telling her he would be returning from a six-month tour of the United States and expresses a desire to see her again. Her lack of engagement is evident in her comments about him: "Hard as I examined his photos, and deep as I went into our thing together, the more I realised that I didn't care what he thought of me anymore. Even the fact that he was a big name now didn't really impress me. It was enough to say I knew him."[105] Katie had gone beyond the need for a rock star's approval and instead found confirmation of

her worth within herself. A little later, she even eschews approval of her activities from those within the rock-and-roll subculture. "I'd got past caring whether people knew or not which group member I'd pulled. I'd done it and that was enough."

This new attitude results in Katie objectifying someone further down the rock-and-roll subcultural hierarchy than herself and she begins treating him in much the same way she herself had been treated in the beginning of the novel. She found herself attracted to a pretty young boy, Norman, who closely resembles Ben, the first rock star she had slept with at the beginning of the book. His beautiful violet eyes and skinny body, as well as his resemblance to Ben, captivates her. However, all similarities to that first encounter end there. Unlike her experience with Ben, Katie is always in control in this relationship. She takes Norman back to her apartment and tries to get him to seduce her. He is reluctant and finally tells Katie why he hadn't tried to have sex with her: "'I wouldn't even try. I'm sure you'd just laugh in my face if I did. I've seen the kind of people you go around with at the Kingdom [the club where she works], and I'm not like them. I've seen the way you look at the customers, like they're dirt, and the way you only talk to groups and people who are important.'"[106] Eventually Norman relents and decides to have sex with her. Her comments at this point indicate her objectifying attitude: "It was nice to look into his fantastic face, and now that he'd stopped speaking it was even better." Predictably Norman becomes attached and wants to have a relationship with Katie. She lets him down hard and breaks his heart. To her credit, after doing all this, she says that she didn't feel "too good." The story ends with ambiguity as to whether the men who had treated Katie in a similar fashion also felt badly or whether she just wasn't cut out to treat people in such an uncaring manner.

The affair with Norman seems to have been a watershed event for Katie. After that encounter, she resolves to take a different approach to her sexual partners. "And now I don't sleep with people just to sleep with them because it just doesn't seem to work out for me, and anyway, it's better to have scenes with people who really turn you on. This meant that from now on I would be doing the choosing, and while they had to be faces [celebrities], it didn't matter whether they were lesser or greater faces provided I dug them and their music or the scene they had going." The book ends with Katie turning down sex with a famous rock star because he was too loaded and doesn't show enough interest in her.

Though following the *Rolling Stone* lead in creating the female fan as a particular type of sexual entity, *Groupie* nonetheless exposes a more complex picture of sexual relations in the groupie subculture. In the novel, Katie is often the one who decides the terms of her sexual liaisons and her reputation

as a groupie gives her power, especially over men who aren't musicians. Her understanding of the dynamics of consensual sadomasochism also gives her the capacity to enjoy that type of relationship. Her work in the rock subculture, and the knowledge and power that accrued from it, could also be used to her advantage in her sexual encounters with the musicians and their entourages. *Groupie* is clearly a much more complex picture of the groupie subculture than those offered by *Rolling Stone* and *Time*.[107]

The year 1969 also saw the introduction of another work on the groupies —this one in audio. A New York record producer, Alan Lorber, created an audio documentary titled "The Groupies."[108] Released on Earth Records, the album was a thirty-minute recording of four groupies talking about their lives. The album jacket contained a reprint of an article about the project from the *Village Voice*.[109] In the article Howard Smith explains Lorber's reasons for wanting to make the record: "It was done by Alan Lorber, an arranger and producer who had been reading the proliferation of groupie stories in magazines like the *Realist, Rolling Stone*, and *Time* and thought, 'Why not?' He chose six girls, flying some of them in from California and ended up using four in the session."[110] Smith also mentions that the recording of the album took twelve hours and that Lorber had spent one hundred hours editing tapes to produce the album. He described the "girls" who took part in the recordings as being between the ages of seventeen and twenty-one.

Smith's take on the women on the record is worth exploring in detail. He comments on the inconsistencies in their remarks that reveal some of the tension then present not only in the groupie subculture but in the larger culture as well: "One thing that came across is the ambivalence in the groupie's sex habits. On one hand, you have the living, walking result of the sexual revolution. They take the pill. They feel that there is nothing to lose and don't bother counting how many guys they make it with in a day. But rather than being free to do what pleases them most, they are free to submit completely to what the musician wants. The conversations described how the groupie will totally degrade herself in complying with her idol's wishes."[111] The way Smith frames this discussion makes it appear that the groupie's choice of sexual expression is the logical result of the changes made in society due to the sexual revolution. It is true that the two are not unrelated. However, to state that the groupie construction of female sexuality, in this or any form, is the norm is fallacious; it is merely one expression. Smith did acknowledge the discrepancies between this seeming "freedom" and their behavior, as he understood it from this album, with the rock stars. This "degradation" that he referred to is also supported by some of Cynthia Plaster Caster's statements about "groupie groveling,"

although she represented herself as looking for a way out of that position, rather than embracing it.[112]

Smith also comments on other facets of the groupie-musician nexus. His comments make clear that there was a strong element of mutuality, commented upon by some of the musicians in the articles discussed in Chapters 4 and 5:

Another facet of the group-groupie relationship is its symbiotic quality. Of course the girls achieve a kind of status in being with the people they worship. But the rock stars get something more out of the fuck than the sex. Musicians find touring very disorienting and tiring. Whirling from one unfamiliar town to another, sometimes playing two places in one day, they get lonely. I've spoken with a lot of top groups lately and without exception they all say they feel isolated or desolate on tour. Whether or not they like to admit it, they need the comfort of a warm body and the reassurance of unreserved affection.[113]

Smith was basing his analysis of this situation on his conversations with musicians. Aside from the status they receive, he did not speculate on what else the groupies could be receiving from their encounters with musicians, and he also failed to comment on the groupie's sexual satisfaction.

Most significant in this article is Smith's speculations on the reasons for the record's likely popularity: "I think 'The Groupies' will sell for a lot of reasons. For those on the scene but removed from this particular activity, there is a double-edged fascination. It is both morbid and vicarious in an attraction-repulsion way. The record also probably will be a handbook for teenyboppers with groupie aspirations. For the parents of teenage daughters, it will be the scare record of the year."[114] Here Smith's comment on the "morbid" facets of the record appear to imply some normative judgment about the groupie's activities, or at least that he believed that some people "on the scene" might view them that way. His remarks about "teenyboppers" and "teenage daughters" are indeed prescient when one considers the groupie culture as it developed in the early 1970s, which included a decline in the ages of those involved.

Also included on the record sleeve is a "groupie glossary" of twenty-nine terms. Many of these terms are words used in common parlance today, such as "pop star," "head," "stoned," and "out of it." Several are British slang words still in use today in that country; these included "randy," which means sexually aroused; "wank-off," which means to masturbate; and "slaggy," which means sluttish. The women on the record use many of these words during the course of the recorded conversations. Discussing their experiences as groupies in the rock music scene, they give details of their sexual encounters with rock stars.

For purposes of differentiation I will designate them as Groupie A, B, C, and D. Groupie A has a very high-pitched, youthful-sounding voice. Owing to her New York accent and the fact that she mentions going to several clubs in New York, I believe that is where she lived. Groupie B had a deeper voice but also a New York accent and mentioned "hanging out" with Groupie A at clubs in New York. She also says that Groupie A had introduced her to life as a groupie.

The two women's comments are full of information about their lifestyle, and they often talk over one another and interrupt each other. An example of this is the following:

> Groupie A: A lot of status connected with this. Connected with hanging out
> Groupie B: Right, there's a whole status thing now. There's super-groupies. I mean
> Groupie A: with certain cats. And the professionals. The professional groupies, the
> chicks that eat by hanging out with guys in groups.[115]

According to these women, status and pecuniary considerations mattered to these groupies. They also use the term "super-groupies," which is mentioned in the *Time* article discussed previously.

The two other groupies tend to view the groupie phenomenon from a more cultural context. Although their ideas are more insightful and their message clearer, Groupies C and D are more difficult to pin down geographically. Groupie C is by far the most articulate of the four women, as demonstrated by her comment on power relations between groupies and rock stars: "The pop stars know that they are getting a commodity. Because a groupie is a commodity. I mean, it's bought for and paid for not in cash but in identity. And there she is and she's so enamored with you, with your exchange of identity for sex, that she's ready to do anything for you and these cats take full advantage of the fact. I mean especially the more chicks they ball [have sex with] the more jaded they become and in turn ask more of the chicks they're with." As the comments above suggest, financial considerations were present in groupie society, and much like women in more traditional roles, the groupies turned to men for status and money.

Groupie C also points out the similarities between women in "straight" society and the groupies in terms of their relations with men: "These chicks [some groupies] really believe that they're going to meet their great prince charming who plays fabulous guitar and he's going to take them away and marry them and it's really a drag because these cats don't think that way." Groupie C believed that many of the groupies, much like their sisters in more conventional society, were looking for "Mr. Right." She implies that what defined "Prince Charming" for this type of woman was different than what it was for, say, a sorority co-ed. The groupies' perfect man, for example, had to

play fabulous guitar. However, both women were still looking for a man to "take them away and marry them."

Another of Groupie C's comments points out that rock society was not that different from more conventional society in the realm of gender and power relations. "It's [rock music] a sick establishment. All this anti-establishment has led to an establishment of its own, with its own groupies, with its own leaders." None of the four women mention the possibility that women could be atop this "anti-establishment" hierarchy. Even though Groupie A states that she had had all sorts of music and dance lessons and that she wanted to "be famous," none of the women mention rock stardom as a possibility for them, nor do they discuss female rock stars. Three of the four mentioned that they would get married; however, that prospect did not seem to enthuse them. About this subject Groupie A says, "And what happens when you get married? Everything's over."

Groupie D addresses the fact that the girls currently entering the groupie lifestyle were younger and younger: "Now that I'm older and I'm involved in other things, you know, I don't go down I don't hang out as much as I do [sic]. But when I do, what's really amazing me and when I see the chicks that have like moved in and like second-generation groupies and they're fifteen-year-old chicks." Groupie A also addresses the youth and ubiquity of sexual activity among girls in the music scene. "I mean how many musicians are really going to marry virgins? Where are they going to find 'em?"

Groupie C's comments echoes the opinions of Susan Hiwatt and Lillian Roxon, both rock critics who assert that it was the women who gave rock music its sex appeal. Based on her comments on the record, Groupie C believed that as well. "Nobody'd go there [to music clubs] if the girls weren't there, 'cause the girls make the whole scene, right?" It appears from these women's comments that even though women may have given the rock music scene its sex appeal, these women's sexual expression was firmly subordinated to direction by men.

Though this album does give us the groupies' words spoken in their own voices, like the *Rolling Stone* groupie issue, they come to us through a male filter, in this case the record producer. The album stresses, as the *Rolling Stone* article does, that sexuality was key to the groupie experience in the rock scene, ignoring many aspects of the environment, including the music and a much broader community of fandom. It seemed that because of their sex, male writers and journalists could only look at the shadows of these women's experiences. Based on the amount of material on the groupies generated by male authors, they seemed to have no compunction about presenting these "shadows" as "reality." Though it provided information on groupies that was in their

own words, yet another project on the groupie subculture would be even more revealing than the album.[116]

The first hint that groupies might finally make it to film came in July 1969. *Village Voice* columnist Howard Smith reported that the groupie album was "only the beginning of the teeny-putsch" and that Bob Weiner, a movie producer, who was "once an anonymous face in the Scene or the Café Au Go Go [New York clubs] is suddenly being stormed by foxes from all four corners of the rock bag."[117] Smith reported that the reason for this popularity was the fact that Weiner and directors Ron Dorfman and Peter Nevard were in the midst of making a feature film, "a kind of extravaganza-verité on groupies resulting from three month's research." He then gave some details on the number of groupies that would be in the film as well as the names of some of the bands that were participating.

The film, titled *Groupies*, had its world premier at the Fifth Avenue Cinema in New York City on November 8, 1970. However, it must have been screened earlier for critics, as the advertisement that announced this fact contained a frankly mixed review of the film by critic Judith Crist from *New York* magazine.[118] The movie has a *cinema verité* style of production, with moving cameras and no set dialogue. It films several groupies in their homes, backstage at concerts, and interacting with musicians, although no explicit sex was included. Several of the better-known groupies of the period were filmed. The overall effect of the film is one of revelation, but only of certain parts of the subculture.

A brief discussion of the film's contents and structure is useful, especially in order to make sense of the critic's reviews that follow. The movie begins with a list of the music venues at which the bands and the groupies were filmed, including both Fillmores (New York and San Francisco), the Whiskey a Go Go and Thee Experience in Los Angeles, the Scene and Ungano's in New York City, the Kinetic Playground in Chicago, the Grande Ballroom in Detroit, the Asbury Park Civic Center in Asbury Park, New Jersey, and the Boston Tea Party in Boston. Additional scenes were also shot at the Gallery of Erotic Art in New York City. The audience is informed that the footage was shot entirely on location over a nine-month period and that "the scenes, raps, and action actually happened. Nothing was staged for the camera."[119]

The participants in the movie, both groupie and musician, are fairly recognizable and extensive, though the musician's names are listed first. Most were well known and included Ten Years After, Joe Cocker and the Grease Band, Terry Reid, Spooky Tooth, and Dry Creek Road (only the last band was not very well known). The better-known groupies included Cynthia Plaster Caster and her new partner Miss Harlow, and Pamela Des Barres. There is also

brief footage of Jenni Dean talking while riding in a van and Emeretta Marks with a line or two as well. Besides these, the credits list Goldie Glitter, Chaz (a gay male groupie featured extensively), Iris, Brenda, Diane, Lixie, Katy, Andrea Whips, Shelly, Joel, Donna, Nancy, and Patti Cakes.

The film begins with Des Barres and Harlow describing why they like being groupies. It then cuts to a former groupie describing the LSD-inspired epiphany that led her to quit the subculture. "I looked at myself and I said 'You fucking whore. What have you gotten yourself into?'" Another groupie explains why she likes to go out with musicians: "They dress the way I want all guys to dress, they have long hair, and they talk with British accents." Then Dean gives a short rap on how the only way anyone could "out-groupie" Linda Eastman would be to take John Lennon away from Yoko Ono (she predicts it would take two years for that to happen) or to take Mick Jagger away from Marianne Faithful (which she predicts could happen at any time). The filmmakers then feature Alvin Lee, the front man for Ten Years After, talking about groupies. The shot is framed to include a woman, presumably his date. The fact that she was sitting right next to him listening to his comments made me slightly uncomfortable, as if she might have been one of the women he was talking about. "There's not many of them [the groupies] have that much to offer really. If they got [sic] something special that'd be cool, but most of the chicks that are flaunting it around, they're just the normal run of the mill stuff." This segued into Des Barres stating that "they [the musicians] get used to it. All the girls really falling at their feet." At this point the film's title credits and participants are listed.

The first long section of the film centers around two New York City groupies named Diane and Brenda. They were filmed at their apartment, in various states of dress and undress, and then the filmmakers follow them to the Scene where various people comment on the groupie scene. Diane goes back to the hotel of Spooky Tooth's guitarist, Luther Grosvenor, whom we are subsequently told had had sex with Brenda the night before. The scene then shifts back to the groupie's apartment where they are in the process of writing scathing poetry about Grosvenor and commenting on his lack of sexual prowess and physical endowment. At this point, Brenda makes a statement that sheds some light on the status system in the groupie subculture as she understood it: "By the time he gets to be famous he's already fucked everybody there is. He's no challenge. Anybody could fuck him. Not like Page or Zeppelin or any of them. You can't fuck them. Nobody can get to them. They're hard to get to. They're the pop stars but not Luther. He runs around chasing the chicks. Chicks don't have to chase him. He's disgusting." Thus, it appears that proximity and the level of difficulty in gaining access to the musicians factored in, at

least with these two groupies, on how big a star someone was and thus, how much status accrued to the groupie who slept with them. They ended their tirade against Grosvenor by stating that they were going to kill him. The filmmakers then cut to Grosvenor who states, "She's [presumably one of the two groupies] not a kind of chick I could stay with. A good shag [sex] that's it." The negotiation of needs and status among groupies and musicians is clear in this encounter.

In a roundabout way, the filmmakers also address the subject of male groupies. They show one musician stating that "a guy doesn't know about male groupies" and intimates that some musicians were invited to gay parties but were not aware of that fact. The filmmakers then show Terry Reid and his band performing a song, aptly titled "Bang, Bang," while interspersing this footage with clips of a gay male groupie, Goldie (who had a crush on the band's drummer) talking about his infatuation. They then show Goldie inviting the drummer to a party at his house.

The party at Goldie's house supplies us with several interesting pieces of information about the groupie subculture. First, Harlow and another groupie are heard comparing Jimi Hendrix's sexual techniques. Then Harlow tells the cameraman that she thought plaster casting was "funny" and "campy." She says that "Cynthia's dead serious about it and that's what's so beautiful about her trip. But I just think it's fun." From this remark, it is clear that the groupies sometimes compared notes and that they could engage in the same activity (Harlow was Cynthia's fellator) and yet regard it differently.

At this point the filmmakers begin a section in which they film Danie taking a bath and brushing her teeth. They question her about her involvement with Led Zeppelin:

It was their first tour and they had all this money. It's really fun to stay with a group that's got a lot of money. They stayed at the Chateau Marmont [an exclusive hotel in Los Angeles]. We spent a lot of money and we ate like it was going out of style and did cocaine. We tore up Thee Experience [a Los Angeles club]. That was when it first opened. We had the run of the place. It was open until four o'clock in the morning. Jimmy Page had a whip and every once in a while Jimmy would just reach over and whack me across the ass with his whip. Oh, it was a gas. They were just great people. Just fun.

Danie's story is a harbinger of the type of groupie activity that would become more common later on in the 1970s. Cocaine would become more prevalent, budgets would get bigger, and bands would have more money. Also, the destruction at Thee Experience, and even the sado masochistic activity, are more characteristic of band's behavior later in the 1970s when destroying hotels and dressing rooms became de rigueur for rock bands.

The filmmakers then return to Reid's show at the Fillmore West, where a homosexual male groupie named Chaz is filmed extensively. He is very intoxicated, very fey, and very young. The first in-depth footage of Chaz starts with him complaining about being beaten, and it is clear from the footage that he is bleeding from a small cut on the bridge of his nose. He keeps asking for Reid, and Reid's drummer tells Chaz that Reid is not of legal age, to which Chaz replies, "Neither am I." He follows that statement with "Everyone in America is bisexual." Chaz then says, "I'm only 16. But when I'm 23 I'll be so hip." Except for whoever had beaten him, everyone else treats Chaz with a great deal of forbearance. The drummer even puts his arm around Chaz while he patiently explains that Reid is not a homosexual. They don't have him tossed out or berate him in any way. They all seem amused by his level of intoxication but that was about as far as it went. Of course, it is important to remember that cameras were present.

The film demonstrates, contrary to the *Rolling Stone* piece, that there was a tremendous amount of variety among those in groupie and rock subcultures. Even though there were few who could be described as super-groupies among those filmed, a fact that several reviewers would comment on, the film reveals aspects of the culture that were sometimes given short shrift, especially the male homosexual groupie subculture. The variety of groupies featured also underscores the tremendous negotiation of sex roles and standards that was taking place in the rock and groupie subcultures during the late 1960s and early 1970s. The film has its limits, many of which will be discussed in the reviews below; however, for what it is, it performs an adequate job of describing a portion of the groupie subculture.

Judith Crist, who was quoted in the film's print advertisement, was merely the first in a long line of film reviewers and cultural commentators who would weigh in on *Groupies*. She described the film as "excellent a stunning and unforgettable portrait of the lost ones—hard-bitten whores, teeny-boppers, girl-next-door lovelies, neurotics and near-psychopaths—caught up in the drug and rock scene."[120] However, Andrew Sarris, a film critic at the *Village Voice*, refused to review the film in depth and instead advised, "Meanwhile, try to avoid 'The Groupies' [*sic*], the nastiest movie of the year, a murkily photographed slice of Spiro Agnew cinema at least three years out of date, and the latest demonstration of ripping off the pop-youth scene with calculated contempt."[121] These polar opposite reviews would be indicators of what was to come.

The next mention of the movie was in *Newsweek* in a review from November 16, 1970 titled "Group Therapy." The writer, Alex Kenyon, states that the film "offers a glimpse of some of the girls who traded in their bodies for a little glitter and gilt by association." He mentions Cynthia Plaster Caster and

Jenni Dean (although he didn't record the latter's last name) and writes that "by conventional standards, most of the groupies are not very pretty but have an undeniable insouciant charm in front of the camera."[122] He praises the directors camera work and ends the piece with the cautionary comment that "a few scenes show that some of these people haven't got it all together: floundering, hungering for approval, they remind us, if we needed any after Altamont, Hendrix and Joplin, that what we've cultivated is not all a rock garden of earthly delights."

Rolling Stone registered its opinion of the film in the December 2, 1970, issue. The review, by Jonathan Cott, was called "A Rock and Roll 'Mondo Cane'" and is both a review and an interview with the filmmakers and some of the stars.[123] Cott's chronicling of the film's distribution woes, which were varied and informative, is an aspect not addressed by any other reviewers: "Released by Maran Films, it almost didn't find a distributor. The major companies moved away from it at first contact. A United Artist executive described the film as 'sick, pathetic, and aberrent' [*sic*]. Another studio spokesman said that it 'wasn't dirty enough and that the 'girls weren't pretty.' Paramount stated that the film was 'too hot to handle.'"

Cott also interviewed the filmmakers about their reasons for making the film, which differed markedly from one another. Weiner's statements on this subject make it clear that even the people who made it had different opinions about not only the movie, but the subculture from which it sprang: "'Some people think it's a sociological statement. That was furthest from our mind [*sic*]. We've gone out of our way not to make *Groupies* a titillating picture. The reactions to the film are wild. It's really in the eye of the beholder. Ron, who photographed and edited the film, thinks it's a gassy interesting scene. I think it's a put-down of the drug and backstage scene. None of this peace and love bullshit.'" Dorfman's reasons for making the film were less reactionary and more complex, Cott quotes him more extensively:

Depending on how you're predisposed, on what your political position is, you can see the film as being about drug freaks or about real human relationships. It's a matter of consciousness. If you're predisposed to seeing a cultural rip-off, then that's what you're going to see. I had no didactic point to make whatsoever. I wasn't out to say the girls are moral or immoral. The point the film makes is totally in the experience, the girl's experience. The emphasis is on the non-intellective side of life. The film fucks the mind of people who want to see a point. I didn't want, like [Jean-Luc] Goddard, to pick apart the situation. And I never wanted to deny that film must convey a kind theatrical experience.

Cott's interview with Weiner also uncovered a link between the film and the groupie issue: "'I've been a Fillmore East regular since the Fillmore opened.

In February 1969, *Rolling Stone* came out with its issue on Groupies. It intrigued me and I became curious, having seen the girls hanging around backstage.'" However, the groupie issue proved to be a double-edged sword for Weiner: "'At one point during the shooting, the guy who put up the money for the film asked me: "Where are all the pretty girls I saw in *Rolling Stone*? All you bring back are pigs and whores." In every place we shot, though, we found the same situation.'" Yet again, the physical attractiveness of the girls appears to have been a consideration for those making and viewing *Groupies*.

Interestingly, in this article groupie Jenni Dean supplied information on the groupie subculture, as well as giving an insider's look at the film's authenticity:

"The film isn't an overall documentary on the groupies. It's such a myopic view—sex and far out. But that's only a piece of it. The real scene the filmmakers were shooting happened before the film was ever thought of, back with the Yardbirds and Jeff Beck, and the film's just got the leftovers—the freaked-out hangovers. It's an incredible piece of propaganda for whoever is going to grab onto it. And the film's got nothing to do with the good old days. For me it's all over. But *Groupies* doesn't have the class and the glamour. It's just an incredibly one-dimensional skin flick without the skin. To be naked with clothes on—the casualties."

Cott wasn't complimentary of the movie either; he describes *Groupies* as "a 90-minute whiff of filmic nausea." His inclusion of the phrase "Mondo Cane" in the article's title also clearly indicates that he believed the movie to be a filmic excursion into the bizarre.[124] However, some of his comments render it difficult to pinpoint whether he objected to the film, its portrayal of the groupies, or the groupie lifestyle in general. For example, Cott's description of the plaster casting of one rock star's genitals: "This scene of triumph, almost of revenge, is the film's one extraordinary moment, conveying a sense of mock-seriousness, turned-around religious dedication and devotion—the only kind of permanence the groupie scene, in the film at least, will allow." His final assessment of the film is less ambivalent: "But *Groupies*' final effect is that of depicting an incredible portrait of self-hatred and real exploitation, one against all."

Two additional reviews were published on December 5, one in the *New Republic* and the other in the *New Yorker*. The reviewer for the former, Stanley Kauffmann, basically pans the film based on its content, its production, and its filmic values. He starts by stating that "We're told that its 92 minutes were condensed from 80 hours of film; if they'd kept condensing to 29 minutes it would have been a better picture."[125] He also describes Dorfman and Nevard's work as "acceptable but without distinction," and he reserves his harshest words for the film's digesis, which he felt revealed nothing about the subculture it

was examining. In the course of describing the film's content, Kauffmann also comments on the physical attractiveness of the groupies: "There's a section with a California girl called Iris—the only really attractive girl in the film— very 4-H Club in her Groupiness." Much like the *Newsweek* writer, he intimates that he believed all the groupies should be physically attractive to him. He then compares the film unfavorably, to a 1967 documentary on a drag-queen beauty contest called *The Queen*. He ends with, "Gaping at eccentric people— merely gaping—is now called a study; it used to be called a freak show."

The *New Yorker* review by critic Pauline Kael is titled "Current Cinema: World's Apart."[126] In addition to their date of publication, several similarities exist between these reviews. Kael compares the film unfavorably to *The Queen*, and discusses the women's appearance, attributing their bad complexions to too many drugs. She also does not believe that the film shed any light on the subculture, mentioning the Plaster Casters by name. The most noticeable difference between the two articles is Kael's characterization of the groupies as prostitutes: "They're not sad, lost girls like Reenie [the teenage groupie from the film *Alice's Restaurant*], they're a spooky bunch of junior hookers and hardened name droppers." Or, "some are obviously just precocious drabs—tough, cheerfully, foul-mouthed baby prostitutes, unappetizing but not yet the abject streetwalkers they will probably become." And, "Are groupies just the latest style in how girls become prostitutes or, sometimes, stars or mistresses or wives of stars—or do the groupies represent a whole new thing?" All of these comments also refer to the youth of the women in the film. Kael becomes more explicit on this point, writing, "It's understandable that we rarely see the girls in the same backstage-life shots as the musicians (that would present legal problems, because so many of the girls are under age)." She describes the groupies as "depressing" and ends by writing, "*Groupies*, unfortunately, exhausts the commercial interest in a good subject without getting into the subject."

In January 1971, *Saturday Review* film critic Henry S. Resnik reviewed *Groupies* as part of an article on rock movies called "The Rock Pile."[127] He liked the film better than the previous three reviewers on every level, deeming Dorfman and Nevard's work "highly inventive" and stating that they had "created a series of endearing caricatures." However, some of this praise may stem from the fact that Resnik did not find the film or its subjects depressing, and in fact describes it as "hilarious." He also believed that the film was perceptive: "*Groupies* doesn't judge, although it suggests that groupies are pathetic; the film offers some broad insights into the rock culture, however, and for this reason alone it's an important document."

This point of view was echoed in my recent interview with Cynthia Plaster Caster:

They portrayed me very, very well. I always thought it was a brilliant film. It really wasn't a good idea I think in some girl's minds to acknowledge that they were super groupies by talking about it and allow [*sic*] their photos to be shown, that might deter their efforts to get laid by more superstars. The girl that really shines is the girl from down South [Brenda]. She's brilliant. I mean she had so many choice lines they probably didn't have enough room. That girl April [Inez], I don't think her story was very interesting; they were trying to get something out of not very much: The young girl who gets swept away into groupiedom. There were a lot of runaways that hung out with us because that was the scene. The scene was hippies and rock stars and drug addicts and that was what the rock scene was.[128]

Cynthia's largely positive view of the film offers not only insight into her own portrayal, but also the veracity of the rest of the film's characterizations of the groupie subculture.[129] Her comments about some groupies not wanting to be photographed or acknowledge their participation in the groupie subculture is echoed in the comments offered by the next author that I address who discussed *Groupies*.

The most insightful and in-depth article on *Groupies*, "Who Are the Real Groupies?" by Lillian Roxon, was published in the *Village Voice* on November 26, 1970.[130] This piece is more of a social commentary, or what is now referred to as "cultural reporting," than a traditional review. She addresses the movie, but spends the majority of the piece discussing the phenomenon of the groupie and their treatment by the media. According to Roxon, those who had previously created media works about the groupies had erred in several fundamental ways.

Roxon begins the article, "The most fabulous groupie I ever knew had more class than Jacqueline Onassis, more professional expertise than Gloria Steinem, and more self-assurance than [member of Congress from New York] Bella Abzug." She continues by describing the way that this unnamed groupie behaved backstage and with rock musicians: "She had a way of walking into a rock star's dressing room that made him think she was doing him a favor (which, of course she was)." Roxon also explains that this groupie had started "not at the bottom, which is the way it has to be for most groupies, but at the top which was the only level she operated at ever." She ends the story with the fact that this groupie had married "a musician so rich, so beautiful, so clever, and so famous that even today no one can quite believe it." It is almost certain that Roxon was talking about her friend Linda Eastman, who had married Beatle Paul McCartney.[131]

After this opening, Roxon then asks, "so what I want to know after all that extravagant wordage is—where the hell was *she* when Robert Weiner made his movie 'Groupies'?" She continues, "How come with this and a whole bunch

more happy-ending groupie stories, which I'm perfectly willing to tell in detail to anyone who asks, we have to sit through 92 minutes and watch a long parade of slags [British slang for sluts], scrubbers [British slang for reform-school girls], and band molls?"[132]

In her subsequent comments it appears that Roxon was not disputing the film's portrayal of the groupie subculture:

Please don't get me wrong. A lot of the film may be deeply depressing, but every minute of it is true. I've seen every one of those sad misguided little faces, not so much the exact ones, though those too, but certainly ones like them, in every musty dressing room and sleazy club and plastic motel from Village East to Fillmore West and back. Rock and roll is full of delusions and illusions and I suppose it's important to have a few punctured now and then if reality is still your trip. Not that reality was ever what rock and roll was about.

Thus, it seems that Roxon was saying, much like Jenni Dean in the Cott article in *Rolling Stone*, that the filmmakers had told only part of the story, that of the groupies in the lower echelons of the subculture. This analysis is supported by her subsequent comment: "Still except for the dignified Miss Harlow and smattering of others in 'Groupies' where are the great ladies of rock, the legendary courtesans, the friends, the mistresses, the confidantes?"

Roxon also includes a description of another groupie that she had known, the likes of whom she also did not see in *Groupies*. "The second most fabulous groupie I ever knew, who admittedly didn't have quite as much class as Jackie O. or as much brain and poise as Steinem-Abzug, was blessed with the kind of beauty you only see in Baron Wolman's photographs. Her foolproof technique for making contact with any group, she didn't mind telling anyone this, consisted of nothing more than a friendly smile, a good warm frank open smile, and of course it goes without saying the girl had good teeth." Thus, Roxon was not saying that all groupies had to be, or were, of super-groupie-courtesan-muse variety; some were just stunningly beautiful and friendly.

At this point in the article, Roxon begins to grapple with the thorny issue of defining the groupie subculture: "Don't give me that 'but they weren't groupies' answer Mr. Weiner. As if groupies were only 14-year-old girls with spotty faces. I don't buy that copout definition, I never did. Listen in the golden days of rock, *everyone* was a groupie. Hell, half the fun was watching those glossy magazine editors and prissy little publicists letting their virtue crumble with some former plumber's assistant from Manchester who wore a ruffled shirt." In this passage Roxon is wrestling with the difficulty of coming up with an all-encompassing definition of the term, especially in light of the reality of the subculture during the "golden days of rock." Although she may not have

been able to formulate a definition of the groupie, Roxon is equally certain that Weiner had only shown the more pubescent members of the subculture.

Roxon's comments also reflect her memories of the effects of changing sexual mores on the rock subculture and relations between the sexes. Some of the groupies in her memories had power and weren't afraid to wield it. Due to their panache, beauty, sex appeal or chutzpah, these groupies were extraordinarily powerful in the rock subculture, and status devolved on the rock stars who could attract them. This type of groupie belonged to the top echelon of the rock subculture, yet the creators of *Groupie*, except in a few instances, didn't tell their story, something Roxon believed was a fatal flaw of the film. The same might be said of many of the projects about the groupies.

Roxon subsequently delves into Weiner and Dorfman's motives for making the film as well as their approach to the groupie subculture. "Now what worries me about Weiner's *Groupies* movie is that there aren't very many good teeth in it. Didn't this mean he was just looking for the worst groupies?" In her article she asserts that many who had viewed the film believed that Weiner had elected to show the "dark side" of the groupie subculture. Indeed, Roxon's read on the filmmaker's motives is consistent with Weiner's, at least as he described them in the Cott article. There he characterized the film as "a put-down of the drug and backstage scene."[133] Dorfman, however, denied these charges.

Roxon also disputes that *Groupies*, as far as she was concerned, presented the "median picture." "Cynthia Plastercaster [*sic*] a median! Some of you may feel that Cynthia's game of casting in plaster the private parts of the great names of rock is hardly an average in the world of groupies, but Weiner and Dorfman say that some of the groupie footage they shot in Chicago was so foul they stopped the cameras. That, you understand, dragged the median way down."[134] Although this assessment may have been accurate of the filmmakers' footage, it is impossible for those outside the project to corroborate and is thus merely anecdotal.

Roxon's article also reveals tensions between the filmmakers' expectations of the groupie subculture and the reality that they found when they began to make their film in addition to their cinematic approaches. Both Dorfman and Weiner initially wanted to make a movie about women who were traditionally pretty but sexually free. When that didn't work out, Weiner became disappointed, while Dorfman shifted his vision of the project to a *cinema verité*-style documentary, in the mode of *Medium Cool* (1969).

Roxon supports this analysis in her description of how the filmmakers' positions on the film and the subculture changed over the course of their shooting the film. "Both he [Dorfman] and Weiner started the film with the illusion that it would be an up movie—girls straight out of the sumptuous

Baron Wolman portraits *Rolling Stone* ran in its Groupie issue." This approach to the subculture "depressed Dorfman who saw the girls as a lot less ornamental." He was pleased when the movie began taking a different direction and still believed that it was "a very happy movie" and "scoffed" at the idea that the groupies in the film were "degraded." However, Weiner's experience had been the polar opposite of Dorfman's. He had wanted to make a film about the pretty groupies he saw in the groupie issue and had become depressed when he did not find that to be the reality of the situation. "He [Weiner] now finds the scene totally sordid, can't understand why Dorfman thinks 'Groupies' is a happy picture but like Dorfman insists it's 100 per cent accurate."

Roxon also casts doubt on the filmmakers' characterization of the movie as an accurate portrayal of the subculture. She reported that after seeing the film, Kip Cohen, the manager of the Fillmore East, had asked, but what about the other side? To which Weiner had responded, "There *is* no other side." Roxon disputes this by pointing out the film's under-utilization of two of its subjects: "The film shot of two 'other side' super groupies, Jeni [*sic*] Dean and Emeretta Marks was unusable, said Weiner, nothing but dull static rap. Dull. Dull. Dull? Those two? If you made a film about nobody except them, it would have to walk away with every prize at Cannes." Dean was a long-time member of the groupie subculture, an acknowledged super-groupie and sometime-girl-friend of Jimi Hendrix. It is difficult to believe that she had nothing to add to the filmmakers' understanding of the groupie subculture, much less that her "rap" was dull. The footage on them that was included, which I discussed above, was very informative and interesting.

However, Roxon's discussion of Dean and Marks brought her back to the problem of defining just exactly who and what groupies were:

In a way, it's almost unfair to call either of them groupies, certainly by the Weiner-Dorfman definition implicit in the film, but for Jeni [sic], for instance, it was a word she was very honest about using, unlike some others, less talented and less special, who would be shrill with indignation and betrayal and would certainly slap a suit on me were I to identify them by name in a story of this nature. And I don't blame them. Who is Bob Weiner to take the magic away? Who'll ever want to be a groupie again after seeing your film Bob?

Here it is clear that, to Roxon at least, the film had tainted the term groupie. However, her comments lead one to believe that there was already some contestation going on over the meaning of the word. She also, in classic tabloid-gossip-column fashion, personalized her attack.

Roxon continued wrestling with the meaning of the word groupie. This time, however, she was concerned with the usage of the term as it related to

musicians, male and female: "Groupies. Was Judy Collins a groupie when she fell in love with Steve Stills? Was Joni Mitchell a groupie when Leonard Cohen and Graham Nash fell in love with her? Was Nico [female singer for the Velvet Underground] a groupie when she captivated Jim Morrison, Tim Buckley, Jackson Browne, and Iggy Stooge in something like that order? Or were the men the groupies? Think about that." Roxon's questions reveal elements of the debate waged both in and out of the rock and groupie subcultures over the endless reflexivity of meaning this term could feasibly embody, and it is clear that this issue was far from settled, at least in her mind.

In the passage above, Roxon was also acknowledging the complexities created when women musicians began to become important members of the rock subculture. As is the case in many organizations that have been largely homosocial, when women join them, the rules must change. The male-female love affairs that involved two artists brought up an entirely new set of questions. What was the relationship between male musician-female groupie relationships and those of male and female artists, for example? Were they comparable? If not, how did they differ and why? It is notable that it was a female rock critic who brought up these points while *Rolling Stone* largely ignored them.

Roxon ends her article on a characteristically well written and wistful note. "If it's true, as Jonathan Eisen says in his book about Altamont, that the festival marked the death of innocence and the end of the Age of Aquarius, and if it's true, as Bob Weiner says, that he shot only what was already there, then we have lost a dream that sustained us nicely through some bad times." [135] Roxon's article was insightful and written from the perspective of a member of the rock subculture and an insider in the groupie subculture. However, she ends her article by intimating that perhaps *Groupies* reflects the reality of the groupie subculture as it existed at that point in time. Her comment about some women objecting to being labeled a groupie also points out continued problems with the term and the pejorative connotations connected with it. This may also hint at why "the other side" was not represented in this film, or indeed any film of this era.

Readers wasted no time in writing in to the *Village Voice* in response to Roxon's article. In the December 10, 1970, issue, two letters were printed that commented on the article. The first, titled "Groupie Grope" by the editors, was from New York-based feminist activist Ruth Herschberger. She writes:

The Voice could do a good turn to feminism—which the press in general is killing with boredom—and also a good turn to Voice readers by perpetuating the debate about "The Groupies" [*sic*]—look how eloquent and powerful Lillian Roxon's article is plus the pronouncement "dreary" in the official Voice movie listing [Sarris's non-review]. I

found the movie happy, and the men in it (including, charmed, embarrassed photographers) much nicer than most of the male chauvinists one meets. Yes, the discussion of "The Groupies" [*sic*] would be the key to it all.[136]

Hershberger not only enjoyed the polar opposites of Roxon's and Sarris's viewpoints, but she also believed that some debate on the film would cast light on the larger issues then being discussed about relations between men and women.

The second letter, titled "Write On, Roxon" by the editors, was from a reader named William Kloman from Washington, D.C. He writes, "Lillian Roxon's story on the real groupies was delightfully written, soulfully sane, and generally wonderful to read. More Roxon, please."[137] No further articles on the subjects of either *Groupies* or the groupie subculture, by Roxon, Sarris, or any other writer appeared subsequently in the *Village Voice*.[138]

The media was an active arena for the negotiation of the term groupie and its meaning in American popular culture. It is clear that the creators of these various works were grappling with issues that were the product of changes in previously agreed upon (at least through lip service) sexual standards and that had no ready answers. Their ubiquity and variety make it plain that the concept of the rock groupie offered many an arena in which to address not only subcultural issues but also those that affected society in general. Sexual relations as well as power relations between men and women were being negotiated in these portraits of the groupies. The film, album, novel, and the various periodical articles discussed in this chapter also make it plain that this topic was a heated one during this era. It is also clear that *Rolling Stone*'s groupie issue set the tone for many of these works. Despite the variety of mediums and authors, however, most of these portrayals are largely recapitulations of *Rolling Stone*'s groupie issue, with Roxon's work and the groupie novel as notable exceptions.[139] Nevertheless, there were some during this same era who did not subscribe to this construction of the groupie and who said so in print.

As might be expected, some from the radical feminist camp weighed in on the groupie debate.[140] One article with a dissenting opinion about how to represent groupies came from the July 31, 1970, issue of the radical feminist newsjournal *Off Our Backs*.[141] Highly ironic in tone, "Culture Vulture: Groupies, et. al. [*sic*]" written by Bobbie Goldstone, offers a rare example of how a feminist author of the period represented groupies and illustrated the differences often present in the styles and approaches of men and women who wrote about groupies.

Goldstone begins by stating that "groupies exist as a category in the sexual

netherworld of my mind, along with other fantasy figures like California girls and ski bunnies, conjuring up images of male and female bodies greased with cocoa butter coupling in various combinations and permutations."[142] For this reason Goldstone was interested in reading "two new paperbacks" on the groupies, the previously discussed *Groupie* by Jenny Fabian and Johnny Byrne and *A Rolling Stone Special Report on Groupies and Other Girls* edited by Jann Wenner. She dismisses the first work with one sentence: "*Groupie* subtitled 'A Sex-Rock Odyssey' is only of interest to those who want to know that blowing is called plating on the English rock scene."

The rest of her article discusses *Groupies and Other Girls*, which she refers to as "The Report," characterizing it as being "badly written to the point of absurdity." "It does, however, offer an object lesson that any 'liberation'—sexual or otherwise—for women on the rock scene seems pretty much a myth and/or Ann Landers was right—men (from rock stars to Richard Nixon) don't respect you if you do the dirty of the dirties in non-monogamous fashion."

Goldstone compares and contrasts the representations of "bad" versus "good" groupies, as described in "The Report." Mocking the conclusions that it reached concerning "bad groupies," she writes: "'Star-fuckers are balling names, not people, and this is basically inhuman' intones The Report. For their inhumanity to rock stars, bad groupies get their 'just' desserts in the form of being left pregnant and stranded." Goldstone astutely points out that "good" groupies didn't fare that much better than the "bad" ones: "The ultimate reward for being a good groupie is becoming a rock musician's 'Old Lady' (although it's understood that he'll fuck bad groupies whenever he's on the road)." But, "The Report" cautions, "because many are called and few are chosen, many good groupies are left pregnant and stranded."

Goldstone also criticizes *Rolling Stone*'s attempts to inject socially relevant commentary into what she describes as "a voyeuristic, slightly titillating set of interviews and fantasies about groupies." She singles out the quotation from the Los Angeles Free Clinic psychologist who compared rock stars' attractiveness to groupies to the attraction that bankers had for young girls in the straight world. Goldstone then asks "as a point of information, can someone tell me if young girls in straight culture are attracted to bankers?" Her conclusions are biting, to the point, and an interesting spin on *Rolling Stone*'s style of music journalism: "From reading this tasteless little document, I developed some little respect for bad groupies. They're certainly not your passive female sexual stereotype. It's true that groupies (good or bad), like most women, use men to give them status—but talk about deriving your status from being in with rock stars, talk about treating them like commodities—*Rolling Stone* is the biggest groupie of them all."[143]

A second dissenting voice comes from a totally different type of source: a religious magazine. *Christian Century* was then one of America's most respected Protestant magazines. Nondenominational in approach, the magazine never shied away from unpopular stances and even went so far as to adopt a highly unpopular position after the Pearl Harbor attack toward America's involvement in World War II.[144] In 1942, *Christian Century* was also the first national periodical to denounce the U.S. government's internment of Japanese Americans during that same war.[145] In 1963, they were the first national magazine to publish Dr. Martin Luther King's "Letter from a Birmingham Jail."[146] Using plain language and employing a sometimes controversial editorial stance, *Christian Century* has provided its readership with reflective discussions of contentious issues.

Groupies certainly fell into that category. The particular aspect of the groupies discourse that *Christian Century* addressed was the record album *The Groupies*.[147] Charles E. Fager wrote the article, "Prey to Charisma," which appeared in the March 17, 1971, edition. Fager describes what a groupie is and discussed *Rolling Stone*'s role in the popularizing of the subcultural identity: "The existence of this subcult was brought to wide public notice only about a year or so ago by a series of informative/exploitative articles in rock papers like *Rolling Stone* (the *New York Times* of the 'alternate culture') and elsewhere. Details of the subject were lurid, tantalizing, shocking—and the term 'groupie' is now part of the language of rock fans and commentators."[148]

Fager then describes the album *The Groupies* and comments on the inconsistencies that he heard in the groupies' conversations, describing their lifestyle as "a tissue of contradictions." For example, he notes that they claimed to love the groupie life, then said things like "what have I got to lose?" Not surprisingly, they all described themselves as "super-groupies," which purportedly allowed them to decide with which rock stars they would have sex. Of this Fager writes, "but the easy contempt of their descriptions of less successful rivals and the degrading antics they ascribe to them make the listener wonder." He then expresses doubt that all the groupies said was true and wondered, if indeed they were lying, what would have caused them "to fabricate such stories?"

Fager did, however, believe that *The Groupies* had a role to play in the lives of his readers: "If you don't mind the frank language, this is just the record to liven up the old parents' Sunday school discussion group or kick off an intergenerational encounter." In a style characteristic of many articles I have read in *Christian Century*, Fager concludes the piece with some thought-provoking commentary: "One thing to keep in mind while listening is that groupie-ism is not something that is confined to the surreal world of popular music. It—or

something very like it—is likely to be found wherever that intangible but volatile thing called charisma figures prominently in a social phenomenon. In chronicling groupie-ism so graphically and provocatively Lorber has done us a real service."[149]

Fager's approach to the groupies reflects the tremendous fluctuations in Americans' sexual practices at this time. Far from painting these women and girls in a prurient light, he attempted to restore a measure of their humanity and contextualize them within the rubric of larger society. In his comments, he sought to draw the reader's attention to the fact that charisma often causes people to want to have sex with those who possess it, and noted that rock and roll had no monopoly on that quality. He was also able to see through some of the groupies' bravado and noted inconsistencies in their comments which revealed that all was, perhaps, not as it seemed with them. His questioning of their motivations humanized them in a way that only Wolman and Roxon had done. Far from decrying the graphic depiction of these women and their lives, Fager applauds the material, reflecting the shifting moral norms and conventions in progress in America at that time.

The next two dissenting voices that discuss the groupies are found in two books written by members of the counterculture: *Lillian Roxon's Rock Encyclopedia*, published in 1969, and an article from 1971 written by Susan Hiwatt.[150] Roxon divides the groupie entries in her encyclopedia into "groupies" and "groupies (male)." The general "groupies" entry deals exclusively with female groupies, and practically all of the information in it was derived from articles previously discussed in this work. However, Roxon's nonhierarchical approach and her conclusions about what the whole phenomenon meant were unique among all the articles written on the subject.

Roxon writes that it was the term "groupies" and not the phenomenon that was new. She defined them as "girls whose sexual favors extend exclusively to rock musicians."[151] Roxon further deviated from the commonly held timeline for the term's coinage and usage, stating that "the term came to use late in 1965 or early 1966 with the emergence of local rock bands." Thus, being a fan became something girls could do, more or less, on a full-time basis because of the sheer numbers of bands, both of the local and touring variety. Availability made the local bands more attractive and allowed women to confine their sexual activities to musicians and men from the rock scene.

Like many of those who wrote on this subject, Roxon describes different types of groupies. Yet in a distinct departure from the almost exclusively male authors, she does not hierarchize them. Roxon's prose is so different in tone from the other authors who weighed in on this subject that it deserves extensive quoting:

Sad groupies who never get any further than screaming and wishful thinking; apprentice groupies who cut their teeth on the local high school band; compromise groupies who are prepared to settle for the road manager or even his friend; daring groupies who bravely scale walls or dangle from helicopters to get their prey; bold groupies who ride up and down hotel elevators until one of "them" gets in and then minces no words in propositioning him. There are expert groupies who can get to anyone, who have guards bribed and hotel managers snowed, desk clerks distracted and bell boys and house maids on their payroll. There are the socialite groupies who give big dances and have the singer later. The most clever groupies get jobs in the industry and often persuade themselves they aren't groupies at all. Finally there are groupies who don't kid themselves: they know what they are; they know what they want.[152]

Roxon concludes her entry with a characterization of groupies that encompasses both their complex cultural position as well as the range of their humanity: "Groupies can be high class and rich, they can be gentle confidantes, they can be ribald courtesans or ugly desperate children that English stars contemptuously call 'scrubbers' or 'band molls.' But they are what give rock its sex appeal and its magic. They are the fans who have dared to break the barriers between the audience and the performer, fans with one thing to give, love, who want nothing in return but a name to drop. Unlike the male authors who wrote on the subject, Roxon endows the groupies with tremendous diversity in character and power. She invests the groupies with a range of human behaviors and motivations and moves the representation away from the "good girl/bad girl" simplicity of the virgin/whore binary so prevalent in male writings on the subject.

Roxon's entry for male groupies, like the general entry, categorized men and boys into discrete groups without hierarchizing them. The first designation she makes concerns nonsexual male groupies: "Male stars have male groupies who envy them, run errands for them and want to identify with them, breathe in the golden air around them (and perhaps even pick up a female groupie on the side.)"[153] This description makes these groupies appear to be more like sidekicks or assistants than the sycophantic nuisances they were portrayed as in *Rolling Stone*'s groupie issue.

Roxon also addresses the homosexual possibilities inherent in the idea of a male groupie. "There are also discreetly homosexual male groupies, many of them sublimating it all by finding themselves jobs in the business side of rock—management, etc." This characterization is not only more astute than the portrayals of male homosexual groupies offered in other publications, if indeed they were offered at all, it also acknowledges the realities of the homophobia inherent in the rabidly heterosexist, largely all-male society of rock and roll. Homosexual groupies existed, Roxon is saying, but she was realistic enough not to dwell on the fact implied by her entry; if there were homosexual

groupies, then there were male stars who engaged in same-sex activities. That latent or closeted gay males worked in the business was a subtle idea and reveals a substantive insider knowledge.

A valuable portion of Roxon's entry addresses the male groupies of women rock stars, a subject given only cursory attention in *Rolling Stone*'s groupie issue: "Male groupies for female performers are less common, female performers on the road being, on the whole, less available than male ones. Janis Joplin was one of the few female performers to bewail the shortage of male groupies. The truth is female performers are groupies of the very worst kind, eternally forming alliances with the most starstudded of their colleagues. They would never be seen with a male groupie."[154] Roxon's comments here are rich, insightful, but also equally stereotyping. Her singling out of Joplin might have suggested to women that they did not have to play by the rules of the sexual double standard. However, Joplin's death had problematized her as a role model. Moreover, Roxon's portrayal of female musicians as more courtesans than independent agents accomplished two things. First, it portrayed the system through which many of these women had to negotiate. The approach of Jefferson Airplane's Grace Slick to band relations was an object lesson in this type of behind-the-scenes power-brokering.[155] Second, Roxon's portrayal of women musicians drew attention to the fact that rock-and-roll women were not all that different from their less famous sisters. Women unaffiliated with men were an anomaly in rock music, just as they were in the rest of society. Thus, Roxon's characterization of female musicians as little more than talented groupies made clear to the reader that the counterculture was anything but, at least for women. Rather, a female musician, barring a few notable exceptions, received her power offstage vicariously through her famous boyfriend or husband and would never have openly sought sexual pleasure from a male groupie. Still, her description remained at the level of a generalization rather than opening up a variety of experiences for these people.

The other dissenting voice from the counterculture was that of Susan Hiwatt, who wrote "Cock Rock," which was included in the 1971 anthology *Twenty-Minute Fandangos and Forever Changes*.[156] Although much of her essay discusses her personal feelings about rock music, Hiwatt also addresses the subject of the rock-concert audience. "Even after I realized women were barred from any active participation in rock music, it took me a while to see that we weren't even considered a real part of the listening audience."[157] This exclusion became apparent to Hiwatt when she realized that the male musicians were speaking to the audience as if it were comprised only of men. "It was clear that the concerts were directed only to men and the women were not considered people, but more on the level of exotic domestic animals that come with their

masters or come to find masters. Only men are assumed smart enough to understand the intricacies of the music."

Hiwatt's conclusions about women's role in the rock audience obliquely mirrored those of Roxon: namely, that while women were essential to rock culture, they weren't usually active players in the medium: "The whole rock scene (as opposed to rock music) depends on our being there. Women are necessary at these places of worship [concerts] so that, in between the sets, the real audience (men) can be assured of getting that woman they're supposed to like."[158] Hiwatt extends this analysis to groupies: "For the musicians themselves there is their own special property—groupies." She also quotes Henri Napier's comment from the *Rolling Stone* groupie issue about groupies being rock geishas. Thus, Hiwatt produced a more symbiotic description of the groupie/star relation, with the men represented as requiring the female fan to prove his worth.

"Cock Rock" ended with a discussion of how Joplin fit into this largely all-male world. Hiwatt believed that Joplin had not been spared the indignities all women involved in rock had to suffer. "This total disregard and disrespect for women is constant in the rock world and has no exceptions. Not even Janis Joplin, the all-time queen of rock." As a singer, Joplin's body was her instrument, a fact that made her more easily exploitable in the rock world, one that subscribed so completely to the sexual double standard: "So it is not surprising that Janis became an incredible sex object and was related to as a cunt with an outasight [*sic*] voice. Almost everyone even vaguely connected to rock heard malicious stories about how easy she was to fuck. This became part of her legend, and no level of stardom could protect her because when you get down to it, she was just a woman."[159] In this last comment it is unclear whether Hiwatt is merely reporting on the double standard or subscribing to it. I suspect the former, based upon the tone of the rest of the article.

Roxon and Hiwatt wrote about facets of groupie culture, and female sexual expression for that matter, not addressed in the works that adopted a stance similar to that of *Rolling Stone*'s groupie issue. Roxon's discussion of male groupies for the female performers highlights the sexual double standard that held sway then. Male musicians could have multiple sex partners with impunity while women stars were not afforded the same privilege, whether they wanted them or not. This is also true in Hiwatt's description of how Joplin's freewheeling sexuality was used against her, rather than enhancing her reputation or forming a positive part of her legend as a rock star, which it would have had she been a man.

Hiwatt's article served much the same function as Roxon's work and the quotations from the women in *Rolling Stone*'s groupie issue. They allowed women to speak about their place as fans of rock music. That their tone differs

so markedly from that of the articles in *Rolling Stone* and those written by other male journalists gestures toward the negotiations and outright warfare— the contestation—among men and women over sexual mores and agency. At times it appears that the men and women writing about groupies were really writing about totally different subjects, and perhaps they were. The men were largely either subscribing to the sexual double standard or writing reportage designed to uphold its primacy. By contrast, in their work the women appeared to be attempting to dismantle the sexual double standard or at least make some protest against it for women, in an attempt to gain sexual prerogatives for the distaff side.[160]

By the time Roxon's encyclopedia and Hiwatt's article appeared in the early 1970s, the groupie subculture, which had been populated by people as varied as Linda Eastman, Jenni Dean, Cynthia Plaster Caster, and the GTOs, was changing. This change happened gradually and was caused by many factors, which included a continued lessening of sexual reticence on the part of those in the rock subculture, but without any noticeable diminishment of the sexual double standard. These factors appear to have led to a situation where the women and girls (and increasingly many more were pubescent and teenage girls) in the groupie subculture were more sexually available and active, but were not any more in control of the situations in which they expressed themselves sexually than had been their progenitors in the 1950s.

The increased profitability of rock music was also a major factor in the groupie culture shift; the more money there was to be made, the larger the venues, and the higher the stakes. Rock music became big business in the 1970s, and this profiteering changed the functions that many groupies had performed for the musicians in the 1960s. No longer were the musicians struggling, in need of a place to stay or their washing done. No longer were the groupies savvy members of the nascent counterculture, helping to orient musicians in the unfamiliar, and potentially hazardous, landscape of American culture. In the 1970s, counter cultural standards had spread even to the suburbs. At the same time, the rock-music subculture became populated by jet planes, cocaine, business managers, and savvier, though often less complex, groupies.

Chapter 6
Second-Generation Groupies

I always regarded the East Coast and West Coast or the big city groupies as being out of my league because I was never the prettiest in the group. And I remember saying that to Iggy. "I'm 30 pounds overweight, I haven't shaved my legs or anything. There are good looking girls over there." He said, "You're smart." I just said, "Oh, I'm yours."

—Margaret Moser, author, journalist, and former groupie

As the 1970s progressed, the groupie subculture continued to grow and change, especially in response to transformations in rock music itself. The latter became big business during the early years of the decade: gone were the days when rockers were struggling and needed to sleep on the groupies' floors. Those at the top of the business began to exhibit the trappings of the super-rich: private planes, luxury hotel suites, huge venues, and massive amounts of cocaine became de rigueur for the rock stars, as well as for many of the groupies they attracted. Many of these young women and girls were too young to have chased the British Invasion bands. They had different points of cultural reference. Also they, like many young people in society, had fewer restrictive ideas about sex and sexual expression, which radically altered the groupies, their subculture, and their interaction with rock stars.

In particular, the early 1970s saw the advent of a new style of groupie that changed the subculture in stylistic as well as in more fundamental ways. They were often associated with the glam-rock scene and reflected the tremendous profitability newly associated with rock music. The groupies who received the most periodical coverage during these years were from Los Angeles and were centered around one particular bar, Rodney Bingenheimer's English Disco, located on Sunset Strip in Hollywood. Two groupies—Pennie Lane and Margaret Moser—illustrate the new facets that these girls and young women brought to the subculture.

One aspect of the groupie subculture that had initially received little attention from writers and the public was the fact that many of these young women were actually girls who were too young to legally have sex with anyone. In the 1970s, however, more and more people, especially among members of the legal community, took notice as one male musician would discover, and sought legal redress for this activity. It doesn't appear, however, that this

instance was the harbinger of a moral panic, but rather an isolated instance. The reactions among those in the legal profession, the press (especially that of the counterculture), and the public to this incident reveal much about the changing sexual mores in America. They are particularly illuminating of the role the groupie played in those changes.

On March 27, 1970, thirty-two-year-old Peter Yarrow pleaded guilty in District Court in Washington, D.C., to "taking immoral liberties" with a fourteen-year-old girl. The case doesn't sound notable unless you recognize Yarrow as the Peter in Peter, Paul, and Mary, one of the most popular folk acts of the era. The case is especially intriguing because Yarrow's attorney, famed defense council Edward Bennett Williams, incorporated the cultural discourse around the "groupie" in his defense of the singer. Williams argued that Yarrow should be shown mercy based on the fact that the girl and her seventeen-year-old sister, who was also present at the time of the sexual acts, were groupies; thus, the normal approbations regarding underage sex were not relevant.

In my discussion of this incident in Yarrow's life, I have the very difficult task of placing his actions in the context of the 1960s. I might argue that Yarrow's "experimentation" with teenage group sex was very much in keeping with the fluid boundaries of the rules governing individual behavior during the sexual revolution. Yarrow was definitely a member of the left-of-center artistic *intelligentsia* in America, and that group was certainly at the forefront of many of the efforts to expand people's understanding of human sexuality and sexual practices. I believe, however, that those in the legal community to whom he appealed for help during his legal woes reveals, at worst, opportunism and at best, hypocrisy on his part.

Yarrow never contested the fact that he had sexual relations with the un-named fourteen-year-old. On March 26, 1970, he appeared before Chief Judge Edward M. Curran represented by attorney Robert X. Perry.[1] During the fifteen-minute hearing, he pled guilty, dispensing with the need for a trial. The facts in the case are undisputed: the offense took place at the Shoreham Hotel in Washington, D.C., on August 31, 1969. The girl, in the form of a statement read aloud by Judge Curran, detailed the events. According to her account, she and her seventeen-year-old sister arrived at the hotel about at 11:30 A.M. and phoned Yarrow's room from the lobby. The singer invited them to his room and "greeted the girls at the door naked." During the hearing where Yarrow entered his plea, Judge Curran asked him what had precipitated his actions toward the young woman. Yarrow answered, "The girl in question was affectionate. She gave me a hug and a kiss." According to the girl's statement, a few minutes after they entered his room, she and Yarrow "engaged in an illegal act"

while her older sister watched. Yarrow maintained that his sexual activity with the girl was by "mutual consent." The girl's statement "indicated the she had resisted Yarrow, but did not shout or attempt to flee."[2]

After Judge Curran read the girl's statement, Yarrow's attorney Perry requested that his client be released until the sentencing hearing which was to be held at an unspecified date during the next two months. The judge was silent for a moment, then rose and said, "Have him committed," leaving the courtroom with both prosecution and defense lawyers trailing after him.[3] Perry filed an immediate appeal of the decision in which he cited as mitigating circumstances Yarrow's recent marriage and his ongoing psychiatric treatment.[4] Yarrow was freed after spending four hours in jail in the U.S. courthouse basement.

After this frankly disastrous hearing, Yarrow decided to change his legal counsel retaining the services of one of the most powerful defense lawyers in America, Edward Bennett Williams. This choice was an odd one given Yarrow's position as a countercultural icon. That Williams was not as far to the left as Yarrow is evident in the fact that so partisan a right-wing author as William F. Buckley, Jr., described him as merely a "Democratic official with less than jerky-left positions."[5] Whatever his politics, his credentials as a defense counsel were unimpeachable, as is evidenced by his impressive list of clients from both ends of the political spectrum, including both Senator Joseph McCarthy and Congressman Adam Clayton Powell, Jr.

The old cliché about "a better lawyer knowing the judge" was definitely true in Williams's case. At the time of Yarrow's trial, he was not only was a senior partner in a Washington law firm, but also he was good friends with both Senator Eugene McCarthy and Judge Curran.[6] That Yarrow had drawn Curran as the judge in his case was described as a stroke of "bad luck" due to the fact that he was "a strict Catholic and moralist." Yarrow and McCarthy's connection was familial: on October 18, 1969, the musician had married McCarthy's niece, Mary Beth.[7]

On the merits of the case, Yarrow had no defense, since the victim—willing or not—was underage, and Williams planned to plead for leniency at the sentencing hearing. His first approach was to ask another lawyer close to Judge Curran to "lean on the judge for the shortest possible jail term." This tack was unsuccessful. Seasoned defense attorney that he was, Williams also realized that a personal appeal to the judge in chambers might not hurt either. The description of this meeting makes it obvious that Williams was fighting an uphill battle: "Curran was sympathetic to Williams, but not to his client's crime. 'Eddie, I love you, I want to help you, but *this . . .*' the judge told Williams, shaking his head over the sinfulness of teenage sex. A young lawyer

in William's firm, Tom Patton, watched these 'two old Catholics'—who called each other 'Eddie'—arguing about sin and repentance" (ellipses in original).[8]

Thus, at the sentencing hearing, Williams hinged his defense of Yarrow on three ideas: Yarrow suffered from psychiatric problems; the two girls in the case were groupies; and aspects of pending legislation were related to the case and might mitigate the crime. His plea before the court took forty-five minutes, which made the sentencing hearing much longer than one involving a "lesser-known" defendant.[9] Peter Osnos, the correspondent who covered the hearing for the *Washington Post*, describes Williams's plea as a "detailed and oft-times emotional exposition on Yarrow's [psychiatric] background, on that of the girls involved and on the law under which Yarrow was charged." He then had Yarrow's psychiatrist testify about the singer's mental state.[10]

Most relevant to our purposes is the second part of Williams's defense strategy in which he characterized the girls involved in the incident as groupies, as it provides a glimpse into their larger cultural significance. Tellingly, Judge Curran was unfamiliar with the term and asked the lawyer to both spell and define it for the court.[11] Williams defined a "groupie" as a "liberated breed of female hero-worshippers" who followed rock musicians, then moved in for the kill.[12] He stated that Yarrow had met the younger of the two sisters at least twice before the day of the incident, and then used the two weapons favored by defense lawyers in sex crimes cases involving minors: he stated that the sisters were "sexually mature and sophisticated" and that the fourteen year old had lied about her age. Both Williams and Judge Curran, however, surely knew that the law was clear on the matter—whether or not the adult knew the true age of the individual, if he had sex with a minor, it was statutory rape.[13] In this instance, describing the girl as a "groupie" replaced labeling her as a "prostitute" or a "whore." She may have been fourteen years old, but she was not an "inexperienced" girl; she was a "liberated woman" and consensual partner. In this case, then, Williams counted on the groupies' cultural identity as sexually aggressive and morally reprehensible young women to cast doubt on the defendant's claims to innocence.[14]

The government lawyers indicated that "the government had no recommendation for sentence.[15] Yarrow then made his own statement to the court: "'I am deeply sorry,' Yarrow said, speaking softly on his own behalf, 'I have hurt myself deeply. I hurt my wife and the people who love me. It was the most terrible mistake I have ever made.'"[16] Judge Curran appeared to have been unmoved by all that had transpired in the courtroom, however. Following these remarks, he commented on the case while handing down his judgment: "I hate to think we've reached a point in our life's history when morality has gone out the window. What he [Yarrow] did was bad."[17] Judge Curran then

gave Yarrow a three-month jail sentence followed by a one- to three-year period of probation.[18] The long-term effects of his sentence were more severe, but it was noted at the time by a reporter covering the case that Yarrow's jail time might end up being less than three months: "The length of Yarrow's sentence means that his civil rights, including the right to vote and hold federal office, are revoked. With time off for good behavior, Yarrow could be released from D.C. Jail in about 75 days."[19] Thus, it appears that Williams's attempt to use the "groupie defense" to lessen his client's punishment was largely unsuccessful, though its employment would be more successful among members of the Fourth Estate.

Both the *New York Times* and the London *Times* covered the sentencing hearing. The placement, the length, and in the case of the British paper, the content of these pieces varied. In its original coverage of Yarrow's plea hearing, the *New York Times* had placed its three-paragraph story on page twenty-one, section one,[20] but buried the two-paragraph story reporting his sentencing on page fifty-three, section two.[21] The *Times* of London deemed the sentencing hearing more newsworthy than the plea hearing, as it did not even include coverage of the latter. It too buried the article on the sentencing hearing by placing it on page five, section three. However, in this article, the writer mentioned Williams's use of the term "groupie" in his client's defense. "His [Yarrow's] defence counsel described the sisters as 'groupies,' girls who deliberately provoke sexual relationships with pop stars."[22]

Rolling Stone also covered Yarrow's legal battle and sided with Yarrow in much of its coverage, continuing to invoke the representation of the female fan or groupie, regardless of her age, as a consenting sexual being.[23] Its October 29, 1970, article on the impending hiatus for the group Peter, Paul, and Mary is especially relevant because it provides insight into some of the courtroom strategy used by Williams, the attitudes of Yarrow's fellow bandmates concerning his incarceration, and the particular "spin" that *Rolling Stone* put on the case in its aftermath.

The apparent reason for the article was the band's announcement that it was taking a year off for a sabbatical to decide what to do next. The author listed Yarrow's imprisonment as a precipitating reason for the announcement and also briefly described Yarrow's offense. He wrote that Williams had said, in his plea during his client's sentencing hearing, that Yarrow "was now planning to quit professional music."[24] Amidst its discussion were defenses of Yarrow. including one by bandmate Mary Travers, who discounted William's statement and was quoted as saying, "Peter is certainly not going to quit show business. A great deal of what was said in court was for effect." Travers also denied that his imprisonment had anything to do with the band's decision: "It [the band's

sabbatical] has nothing to do with Peter's situation." She also reiterated that the band would re-form at the end of one year. Travers then gave information on Yarrow's whereabouts and how he was doing in prison. "'He's [Yarrow] doing clerical work in jail and he's in good spirits. He said the food is better than Cornell's.' Yarrow will complete his sentence on a prison farm in Pennsylvania."

Travers's comments on the judge in Yarrow's case are revelatory of her attitude that she did not believe that his sentence was a fair one: "The judge, Mary said, 'was one of the judges in the Hollywood 10 case,' a highlight of the anti-Communist crusade of the Fifties. Yarrow is known in Washington as an organizer of various Moratorium and other anti-war events, and Mary acknowledged: 'His political involvement probably had something to do with the trial.'"[25]

The relationship between Yarrow's having sex with the fourteen-year-old girl and his political beliefs were unspecified. It is understandable that Travers would want to come to the aid of her old friend, but her implication that what Yarrow did was commonplace and that he was only prosecuted for it because his political beliefs are left of center ignores the facts of the case. While it is almost certainly true that other male musicians were having sex with other underage girls at this time, all of them knew the legal consequences were they to be caught by authorities.

The article's author also reinforced the view that the young women were consensual partners by calling them groupies: "On trial, Yarrow had admitted contact with a 14-year-old girl—precipitated by the girl—who, with her 17-year-old sister, visited his Washington hotel room August 31st, 1969. The mother of the girls, both known as groupies in the area, filed charges in November."[26] Also significant is the magazine's use of unsubstantiated gossip to support its assertions that the young women were groupies. The author stated that they were "known" as groupies, without specifying either the source of this information or any evidence to back it up, which is particularly ironic considering that *Rolling Stone* employed the term "groupie," as they were so integral in its popularization.

Rolling Stone's role as advocate for Yarrow because the women were groupies did not end with this article. Each year the magazine put together a section called "It Happened in [insert the year]," which was a collection of pseudo-awards: for example, Drug of the Year and Bust of the Year, along with items of a more serious nature such as Obituaries, Band of the Year, and Album of the Year. Yarrow was included in the 1971 feature, the year following his conviction.[27] Mentioned in a section called "Human Relations," Yarrow received the "Most Valuable Player Award," bestowed without editorial comment.

Less than a year after Peter, Paul, and Mary's announcement that they were only taking a year off, the band announced its break-up. The story, from

the *Rolling Stone* April 15, 1971, installment of "Random Notes" reports that Mary Travers was the first member of the band to go her own way by releasing a solo album and touring alone to support it. Also noted was her severing of business ties with Albert Grossman, the group's long-time manager, to sign with Harold Leventhal, another high-powered personal manager of the era. Yarrow's legal woes were also mentioned. The way the piece refers to the conviction reveals a further attempt on the part of *Rolling Stone* to normalize Yarrow's criminal actions by minimizing his culpability in the crime. The magazine reported, "The break-up has nothing to do with Peter Yarrow's groupie bust."[28] The magazine's word choice is significant.

In that same "Random Notes" entry, Travers reported that Yarrow was "co-producing an album for a group called Shiloh and writing some songs."[29] Despite his arrest and imprisonment, Yarrow appeared to have landed on his feet professionally. The singer's imprisonment seems not to have led to his "professional destruction," as Williams had stated in his plea at the sentencing hearing; Yarrow was still working and involved in the entertainment business, which adds credence to Travers's earlier assertion that much of what Williams said in court was for effect. Yarrow's ability to find work in the industry continued unabated. Less than a year after the announcement of the band's break-up, another "Random Notes" entry reported on his activities: "Upon Chilean government' invitation [*sic*], Peter Yarrow recently played at the Vina del Mar International Song Festival. He reportedly found the occasion somewhat bourgeois and later, when he met Dr. Allende, the President, Yarrow suggested he plan a real song festival for them. The prez [*sic*] said OK."[30] With this entry, it is clear that Yarrow's international reputation had been rehabilitated. He was not only performing but also meeting with Chile's president, Salvador Allende. At this meeting the two also planned future activities together, so it is also clear that this appearance was not a professional dead-end for Yarrow.

These actions hardly conform to the image one usually has of an entertainer who has experienced "professional destruction," as Williams had asserted at the sentencing hearing. Nor does it appear that Yarrow had "given up concert tours and would remain in New York so that he may receive [psychiatric] treatment without interruption," as his psychiatrist had asserted during that same hearing.[31] This all occurred less than two years after his original sentencing, at which time the judge had placed him on probation for one to three years; however, Yarrow did not serve the maximum probationary sentence. Granted that the Chilean market was not as large or an influential as the American one, nor was the Vina del Mar folk festival as prestigious as the one in Newport, but he had hardly been forced from the business due to his unlawful activity and imprisonment.

It did not take Yarrow long to return to the stage in America. *Rolling Stone* reported on his first high-profile performance on an American stage in the article "New York Rallies: Newman Bugs Out," from the July 20, 1972, issue.[32] This article reviewed a rally held at Madison Square Garden on July 14, 1972, to raise funds for presidential candidate George McGovern. Many celebrities were present on this occasion; a partial list of the luminaries included Judy Collins, Shirley MacLaine, James Earl Jones, John Kenneth Galbraith, and fashion model Verushka. Some were "seat escorts" and acted as ushers for the event; included in this group were Warren Beatty, Jon Voight, Jack Nicholson, Ryan O'Neal, Michael J. Pollard, Maureen Stapleton, Julie Christie, Dustin Hoffman, and Paul Newman.[33]

The list of entertainers was just as impressive as that of the "seat escorts" and included Dionne Warwick, comedians Mike Nichols and Elaine May, Simon and Garfunkel, and Peter, Paul, and Mary. The latter three acts reunited for the occasion. This fact was not lost on Nichols and May, who slyly poked fun at it during their act. "We're laboring at a disadvantage compared to the other teams on the bill. They quarreled bitterly and broke up only a few months ago [*sic*]. We haven't spoken in 12 years."[34] The critic gave Peter, Paul, and Mary a glowing review and did not mention Yarrow's legal troubles, although the picture of the group used in the article is notable as it sounded the one note of dissension in the "rehabilitation" of Yarrow's professional reputation in America—it showed only Mary Travers and Paul Stookey, and its caption read, "Paul & Mary brought controlled excitement."

It should not be construed from *Rolling Stone*'s omission of Yarrow's picture in the article mentioned above that it had abandoned its support of the singer. In its following issue, the magazine published an article on the singer written by one of its best-known writers. In "Peter Yarrow, Singer-Organizer" Chet Flippo covered one stop on a tour undertaken by the singer to support his new album. Flippo mentions the singer's arrest and imprisonment, stating that after those events, "the group [Peter, Paul, and Mary] broke up, and Yarrow had to start all over."[35] In the largely positive article, Flippo describes Yarrow as a "resurrected folksinger" and reports on the positive effects of Yarrow's activism.

Two of the things that made Flippo's writing some of the best ever printed in *Rolling Stone* were his subtlety and his commitment to quality journalism. His treatment of one episode on Yarrow's tour reflects both of those qualities: during an "autograph party" for his album held at a local shopping mall, Yarrow appropriated a stage and began to sing songs for the shoppers and fans. After singing several songs and giving a speech decrying the mining of Haiphong Harbor and the Vietnam War in general, he left the stage to sign

autographs and shake hands. Flippo writes, "He [Yarrow] addressed the teen-
age girls as 'munchkins.' Each received an autograph, hug and a kiss. They gig-
gled appreciatively."[36] It is unlikely that a journalist as savvy as Flippo was
unaware of the implications of including this episode in the article.

As the 1970s rolled on, Yarrow continued to rub elbows with the famous
and powerful, and *Rolling Stone* continued to report on his activities. In a 1973
entry from "Social Notes," which was a short-lived column that reported on
events involving people from the music community, Yarrow was mentioned
once again. The blurb also refers to the existence of glam-rock kids:

> Peter, Paul and Lindsay: There's a special kind of slumming that goes on at Max's
> Kansas City, the kind when people like Robert Redford and Mayor John V. Lindsay turn
> up among the glitter kids at the Park Avenue landmark to pay tribute to someone like
> Peter Yarrow. New York's most jaded set, which ordinarily lets famous Max's regulars
> like Alice Cooper drink in peace, comes a little unglued at the sight of someone like
> John V., who incidentally is wearing more make-up than any boy in the place.
>
> But everything turns out just great. Lindsay hops up on the stage to join in "Puff
> the Magic Dragon" and everyone's basking in the spirit of great showmanship. And that
> was just part of Yarrow's week at Max's, a spectacular kick-off to something of a come-
> back. Peter is trying to get back to his audience. "My 36 gold records don't mean any-
> thing here. Only my relationship with the audience counts."
>
> His relationship proved to be as good as ever. His new band, sometimes called
> "the Yarrowettes," and his new material featuring numerous reggae numbers worked
> well with the Max's regulars and distinguished guests.[37]

The magazine also included a picture of Yarrow and Lindsay hugging, which
was captioned "Not so odd couples Mayor John & friend."

It is clear from the information presented above that Yarrow's lawyer and
Rolling Stone used the term "groupie" in an effort to reduce the severity of his
crime in the eyes of the court, the media, and the world at large. Whether the
tactic was at all successful is not clear, since other arguments were part of
Williams's defense of Yarrow and, more significantly, Judge Curran seems to
have imposed a harsher sentence than the prosecution requested. While other
lawyers may have employed this same defense and argued that because girls
were perceived as groupies they were, despite their ages, consensual sex part-
ners; it is unlikely that the courtroom tactics of a lawyer as well known as
Williams would have been ignored by those in the profession.

My purpose in discussing Yarrow and his press coverage is not only to
point out the way in to which the word groupie was applied and *Rolling Stone*'s
coverage but also to illustrate how the sexual double standard was employed in
this situation. Imagine for a moment if a female musical star, for instance Mary
Travers, had been convicted of having sex with a fourteen-year-old boy while

his seventeen-year-old brother looked on. It is doubtful that she would have been pictured in the press hugging Mayor Lindsay during her professional comeback a mere three years later.

I alluded above to how important it is for scholars of popular culture to consider the problem of judging events in the past. Sometimes temporal distance from events coupled with new theoretical models, can allow us to explain and understand those events differently from the way they were viewed earlier. The 1960s were a time of tremendous re-negotiation of sex roles and sexual activities. Women were becoming more sexually active and having sex because they enjoyed it, much as men had always done. Few people were willing to draw lines in the sand concerning what was and what was not appropriate sexual behavior. However, some segments of society had already drawn those lines and people had sworn to uphold those standards. The legal system was such a place. It is important to note that in the long run, Yarrow escaped serious punishment for his activity with a fourteen-year-old fan. Yarrow, both as a solo artist and as a member of Peter, Paul, and Mary, still performs frequently.[38] Williams's assertion that the girls in the case were "groupies" is an example of an individual using a representation to characterize a woman's identity as based on only one of its facets. In this case, that value construct was "the groupie."

The groupie is the polar opposite of a value construct described by Greer Litton Fox in her article, "'Nice Girl': Social Control of Women Through a Value Construct."[39] She argues that the idea of the "nice girl" allows men to exert control over females' behavior and limits their ability to move about freely. Fox's definition of a "nice girl" is as follows: "as a value construct the latter term [nice girl] connotes chaste, gentle, gracious, ingenuous, good, clean, kind, virtuous, noncontroversial, and above suspicion and reproach."[40]

The majority of her article deals with the "nice girl"; she also briefly discusses the females who do not adhere to this system of social control. It is these women that I am concerned with in this work, as I believe that the groupies fall into this category:

Beyond this, however, is the cost to women who do not comply with the demands of the nice girl construct. To such women are reserved some of the most sophisticated forms of punishment devised by social groups. In addition to forfeiture of personal physical security, the not-nice woman becomes the target of ridicule, ostracism, and psychological punishment directed not so much at her behavior as at her person. The group withdraws its approval from her and attacks the worthiness of her self; it negates her moral existence as part of itself, and by doing so it absolves itself of the responsibility for the fate of its "unworthy" members.[41]

In the Yarrow case, Williams attempted to shift the young girl from "victim" to "groupie" and thus, not entitled to protection under the law. The manner

in which *Rolling Stone* dealt with Yarrow's arrest and imprisonment reinforced this reconstruction through a consistent portrayal of Yarrow as the victim and the young girl as a consensual sex partner, when the difference between their ages and professional status clearly points to the opposite conclusion. Yarrow's choice of advocates also brings into question the possible characterization of him as a pioneer of the sexual revolution. The image of two right-of-center, old guard, Catholic jurists coming to the aid of a left-wing, Jewish folk singer alone should be proof of that. That Yarrow appealed to them for help in the first place makes him appear less like a true believer in the sexual revolution and more like an opportunist (or a hypocrite) only interested in saving himself and his career.

In the end we are left with the question of what sort of relationship exists between the written word and people's actions? While I cannot answer that question, I can offer a piece of information that relates to the Yarrow incident. We know from the testimony offered in a court of law that Yarrow was in Washington, D.C., on August 31, 1969, as that is the day that the incident for which he was imprisoned took place. He was in the city to play a series of concerts at the Carter Barron Amphitheater with his group, Peter, Paul, and Mary.[42] Ironically, on the day the incident with the young girl took place, the *Washington Post* ran an article that mentioned groupies. Titled "They Change Hair and Clothes but Not Their Minds," the writer listed in the article's byline is James S. Kunen, author of *The Strawberry Statement*, a fashionable book on the counterculture published in 1969. The piece was an interview with Frank Zappa.[43]

Though many different subjects are covered, groupies were also included. At that time, Zappa was compiling a written-word work on the groupie phenomenon (the often cited but never published *Groupie Papers*) and promoting the work of two groups of self-described groupies, The GTOs and the Plaster Casters.[44] Due to these facts, and in the wake of *Rolling Stone*'s groupie issue of the previous spring, the subject was definitely one that either the interviewer or the subject, or both, wanted to include in the article. Kunen wrote: "Groupies, I said, are new and different. They are the girls who follow rock groups to see how many stars they can make. What does he [Zappa] think of them? 'Groupies are marvelous,' said Zappa, who somehow gives the impression that sheltered within all his freakiness is a very straight boy, 'because they like sex, which is more than you can say for their mothers and fathers. Unfortunately, they do it for some strange reasons.' "[45] I do not know if Yarrow read the article, nor do I know if it would have influenced his behavior if he had. I only know for sure that another article on groupies was in a different American periodical on that day.

As mentioned earlier, the rise of the second generation of groupies can be traced to the early 1970s and coincides with both the rise of rock music as big business and the advent of glam rock. Many of these groupies began their involvements with the bands at an earlier age than had a lot of their counterparts in the 1960s. Although I address articles on these younger groupies, focusing primarily on the groupie scene in Los Angeles, the majority of my discussion of the groupies from these years will involve the experiences of two of the better-known groupies from that era, Pennie Lane and Margaret Moser.

Far fewer articles on the second-generation groupies exist in the periodical press. Most of this information, primarily from the *Village Voice* and *Rolling Stone*, concerns the activities of a few Los Angeles groupies who were most notable because of their ages, which were between twelve and fifteen, and their adoption of glam-rock clothing styles, especially those that were gender-bending or salacious. The scene to which these girls and young women (the male members of this subculture were rarely mentioned) were attached centered on a succession of discos operated by Rodney Bingenheimer. This connection was not his first to the groupies; he was mentioned in the groupie issue as a male groupie.[46] The GTOs also included a song about him on their album from 1969, *Permanent Damage*, which alludes to the fact that Bingenheimer preferred young teenage girls as his dates.[47]

Bingenheimer was a well-known scenester on the Sunset Strip in Los Angeles. Best known in the 1960s as the stand-in for the Monkees' Davy Jones, he maintained a close connection to the rock scene through his ubiquity and a series of low-paying jobs at Capitol and Mercury Records.[48] In February 1971, Bingenheimer surfaced again in *Rolling Stone* as part of a year-end round-up of stories from the previous year. He is referred to in an entry under the heading "Sex and Violence."[49] The writers recapped a story covered in *Rolling Stone* in summer 1971, when the magazine had reported that Bingenheimer and a date had been kidnapped by four "thugs." He managed to escape by throwing himself out of the car as it careened along at 40 mph, sustaining only minor injuries; however, his date was subsequently raped by the four men. Another incident involved Bingenheimer being "attacked by the brother of a friend of one of the teenyladies staying at his place." The writers ended the piece by relaying the fact that after all of his woes had been reported in *Rolling Stone*, he was fired from his "$25 a week PR gig."

These events are notable because they hinted at Bingenheimer's preference for teenage girls and subsequently precipitated his move to London. While there, he associated with glam-rocker David Bowie, who suggested that Bingenheimer return to Los Angeles and set up an English-style disco. After returning to California, he established a partnership with a producer named

Tom Ayres, and they opened the E (for English) Club on Sunset Blvd.[50] Bowie visited the club as his glam-rock alter ego Ziggy Stardust a week after its opening in October 1972. LA music historian Barney Hoskyns writes that also in attendance were "several of the barely pubescent boys and girls who would go on to become the real star(let)s of the scene when the club was moved eastwards along Sunset to No. 7561 and renamed Rodney Bingenheimer's English Disco."[51] From the very beginning at Bingenheimer's club, the kids were notable for their youth.

The girls who frequented Rodney Bingenheimer's English Disco were flamboyant and involved in the glam-rock music culture; some were also sexually precocious and/or groupies. Two thirteen-year olds who frequented the club were future rock star Joan Jett and Laura (Mackenzie) Phillips, the daughter of Mamas and Papas' founder John Phillips.[52] However, the most well known of the groupies who hung out there was fourteen-year-old Sable Starr and Lori Lightning, also known by her real name Lori Maddox, who became one of the big draws for the British musicians.[53]

The English Disco, as is clear from its name, favored everything British. The DJs played the newest British glam rock and British beers were sold, cementing the club as a regular stop for touring British musicians who were performing in Los Angeles. Glam rockers such as Bowie, Iggy Pop, Suzi Quatro, Marc Bolan (of T. Rex), and the members of Led Zeppelin and Sweet were frequent customers.[54] Live music was also occasionally featured, including the improbable double bill of Shaun Cassidy and Iggy Pop in 1973.[55] America's answer to British glam rock, the New York Dolls, also played there in 1973.

Yet even non-glam, non-British musicians, including Elvis Presley, came to check out, in the words of Barney Hoskyns, "the black-lipsticked, Quaalude-gobbling, platform-booted groupies."[56] Longtime Los Angeles musician and producer Kim Fowley characterized these girls by saying, "the groupies [at Rodney Bingenheimer's English Disco] were usually girls who did not have fathers, lived in disenfranchised homes and had mothers who worked. They came for feminine men who weren't queer. Of course, anyone who had Bowie-esque qualities automatically got lucky."[57]

New Musical Express journalist Nick Kent was one of the few Brits not to avail himself of the groupie's sexual favors. He was horrified and disgusted by the young groupies at Bingenheimer's disco:

The really famous groupies were extremely tough and unpleasant. Jimmy Page told me that one of his Hollywood girlfriends bit into a sandwich that had razorblades in it. I mean, seeing these conniving, loveless, little girls really affected my whole concept of femininity for a while. Talk to the bass player from Sweet [British glam rock band] and he would probably say those were the best months of his life, but to someone with a bit

a taste, who wasn't just hopelessly addicted to pussy, it was pretty sordid. It was a period of time when, if you were skinny and English and dressed like some horrible Biba girl [British clothing manufacturer and designer], you could have anything you wanted.[58]

Needless to say, Kent's opinion was not widely shared or expressed in the periodical press.

The first mention of Bingenheimer's disco by the East Coast press that I have been able to locate was from the *Village Voice* on March 15, 1973. Howard Smith and Tracy Young, in their "Scenes" column, report on the disco, the youth of its patrons, and their glam-rock style. The column was accompanied by a picture of Bingenheimer holding hands with a young teenage girl:

> Used to be that teenage girls picked up their style from movie actresses. Clothes, makeup, language, even behavior came from the honky Hollywood ladies. No more. Male rock stars are the new fashion shoguns. Mick Jagger, David Bowie, Lou Reed. And nowhere did I see it clearer in evidence that at a new nightclub called Rodney Bingenheimer's English Disco, where every night Rodney himself holds sway over an incredible corps of junior high sexpots. I mean, to see dancing wraiths with glitter-slapped faces, their humpy bodies clothed in triple play drageroo [*sic*], talking as if they have lived through all the satyricons there are, and then to discover they are all of 12 years old, *is* a new experience, not unlike a Halloween fetish cult.
>
> So young are the girls that a 16-year-old would feel herself over the hill. Also, I've never seen so many 11, 12, and 13-year-old boys looking sensual instead of goofy.
>
> If California is actually six months ahead of us in trendiness, then New York mothers better lock up their own little Pinkies [slang for young girls, sometimes used in pornography] before the gloss hits the East Coast. (Italics in the original.)[59]

Smith and Young's article is one of the few that mentioned the young boys as well as the girls in this scene.

Young and Smith again comment on the youth of the denizens of the Los Angeles scene in another "Scenes" column, this one from April 12, 1973.[60] In it they report on the creation of a new magazine called *Star* that catered to young girls, especially those in Los Angeles where it was published. The writers refer to the periodical as "*Cosmo*'s [*Cosmopolitan* magazine's] baby" and allege that *Star* actually had little in common with the former except for "having adopted a lot of its female chauvinism and trickery." They also state that *Star* was aimed at "the teeny-weeny set, the L.A. humpy pinkies who queue up outside Rodney Bingenheimer's English Disco on weekend nights."

That the groupies were not out of *Star*'s "hearing" is clear from a June 1973 article from the magazine, "Sunset Strip Groupies: Who, What, When & How (Wow!)."[61] Written by Carole Pickel, the piece is primarily an interview of Sable Starr and another groupie named Queenie. However, Pickel begins the piece with a couple of paragraphs describing how she had arranged the

interview. "I had told Rodney [Bingenheimer] (Hollywood's Number One male groupie) that I wanted to interview the most popular groupies on the Sunset Strip for *Star*, so he said that we should come down to the club Friday night (tonight) and meet Sable and Queenie—the two hippest groupie chicks on the Strip." Pickel then describes the club, its regulars, and the stars who frequented the place, but reserves the most attention for the outfits the two groupies were wearing. Classic glam-rock wear, the outfits included garters, silver lamé hot pants, and six-inch silver wedge platforms. Pickel relates that "they [Starr and Queenie] had incredible tales to tell and were charming to talk to."

The interview covered several subjects discussed in earlier articles on the groupie subculture, but also incorporates some new features. It starts off with Starr being asked to define the term groupie, which sounds more like an escort and precludes any mention of sex. Both young women explained how they had become involved with the subculture and how other young girls could become members: "you have to be very flashy, sometimes even sleazy-looking in a way, sort of cheap-looking." Then they explained how to cultivate connections in the rock music subculture: "just hang around the third billing bands even if the guy is 120 years old you have to be kissie with him 'cause he might make good connections for you." They also spent considerable time describing their favorite outfits (classic glam) and the rock stars they had met.

Acknowledging that at this point groupies had been around for a while, Pickel asked Starr and Queenie about some earlier LA groupies. Their responses about how these two second-generation groupies felt about their predecessors are enlightening:

STAR: Alright girls, calm down. Queenie, how about the groupie clique called Miss Pamela and the GTO's?
QUEENIE: Well, they aren't around anymore. We don't have to worry about them. They're too old. God, they're *real* old. Like in their late 20s and early 30s.
STAR: That's old?
QUEENIE: Sure, A lot of them sit at home and babysit and make clothes and stuff. A lot of them are traveling around with old men getting their money and using their credit cards.
SABLE: Yeah, they're just blocked out, you know. Like they'll be sitting there talking to a band. And as soon as we walk in, they might as well jump out the window.[62]

This intergenerational rivalry is corroborated by members of both groups.

Des Barres discusses her encounters with these younger groupies in her first book, *I'm with the Band*, and makes it clear that Starr's assessment was at least occasionally accurate, as well as the fact that there was no love lost between the two groups.[63] When I questioned second-generation groupie Pennie Lane about whether she had met any of the earlier groupies, she replied,

"I never did [meet them] because they were about ten years older than me. We all met the same people but Pamela [Des Barres] was in it ten years before I was. She wanted to marry a musician and did and that was her career."[64] When I asked Cynthia Plaster Caster about groupies in the 1970s, she replied, "It became a trend. It was like a badge of honor for a guy to have sex with a teenage girl, you know, badge of achievement. That seemed to become more of a trend and it hasn't ended."[65]

Reflecting both the youth of this new type of groupie and the girls for whom *Star* magazine was intended, Pickel asked the two young women about their parents:

STAR: Do you still live at home? What do your parents think of your groupie antics?
SABLE: I still live at home, but I just say "Hi" and "Goodbye." I just sleep there and that's about it.
STAR: How about you, Queenie?
QUEENIE: Oh they get mad but they figure, you know, that I know what I can get away with. And I know what I'm doing. Like I never get into any trouble.[66]

This response tends to support Fowley's assessment offered earlier, regarding the home situations of the girls who were part of this groupie scene.

Starr and Queenie's comments also suggest that they had several reasons for being groupies. When asked if she considered being a groupie a career, Starr replied, "No, it doesn't pay—it's more like an ego thing. Just to be able to call up girlfriends the next day to say who I was with last night. It's really my pastime because I'm still in school." Starr's groupie activities enhanced her reputation among her peers, although she does not make clear whether her "girlfriends" were also groupies. In these aspects of the groupie subculture, Starr was not alone. The information contained in this passage is corroborated below in my discussion of Lane and Moser and their groupie activities.

It is also clear from their responses that one of the reasons Starr and Queenie were groupies was because they were fans of the music. When asked what they talked to the rock stars about, Sable replied, "I always ask them about their music. Like I tell them how neat they are, and I [sic] how I think their music is great. And then they tell me more, in detail, you know, what they plan to do in the future." However, Queenie answered that question by relating that many of the musicians liked to talk about their wives and kids, but that they "usually want to find out about you—what you're into."

Pickel asks the two groupies, "what the ultimate dream of any groupie would be?" Echoing the responses of the anonymous groupies on the album *Groupies*, Queenie replied, "I think the wish that's always inside, in the back of

your mind, is to really have a famous guy fall in love with you and take you all over the world with him. Like to marry him. Some girls are just out to marry a superstar." Starr responded, "Just meeting a fantastic guy that's just darling to you. And just to travel with him wherever he goes." Starr's response, and the fact that she doesn't mention marriage, resembles Lane's approach to being a groupie discussed below.

Pickel ends the interview with a question about what the groupies intended to do after they had finished "with the groupie scene." Starr responded, "I want to be an Andy Warhol star and do bizarre movies. David Bowie wrote a song about Andy and so did Lou Reed. He had girls like Ultra Violet and Bianca Jagger. Since last July I've been writing a diary—in complete detail. It should be something else." Her diaries are reminiscent of those of Cynthia Plaster Caster, and her desire to become a Warhol superstar makes clear that there was a cultural connection between these youthful habitués of the groupie scene on the West Coast and the glam-rock scene back east. In fact, the connection appears to have been more than cultural. A few months later, *Rolling Stone* reported in its "Random Notes" section that Starr (described as a "well-known and much loved L.A. glitter groupie") was engaged to New York Dolls' guitarist Johnny Thunder.[67]

In late November 1973, Bingenheimer's Disco and its scene was the subject of several articles in the periodical press. One of these was Terry Atkinson's "Teen Deco-Disco: Striking a Pose on Sunset Strip," which appeared in *Rolling Stone* on November 22.[68] The writer begins his piece with pseudo-sociological discussion of where the kids came from who frequented the English Disco:

The hills around Los Angeles are inhabited by stalwart Americans who worked hard to get way up where they are, and who worked just as hard rearing their kids to be the kind of upstanding young men and women you could introduce to the president of Lockheed without embarrassment. Despite the dedication, failures abound. By the time the kids hit 13, 14, 15, their parents are calling them fags or whores and screaming at them to "leave this house" several times a week, coinciding with the kids' wishes and making everything hunky-dory. It's a way of life, and on Friday and Saturday nights, when the garbage is thrown out, the kids flee 20 or 30 miles down the freeway toward the Great Central Garbage Dump . . . Hollywood, USA. Sometimes they head for the Whiskey [a Go Go] or the Palladium. But only when T. Rex or the New York Dolls or Mott the Hoople are playing. Otherwise it's Rodney's. (Ellipses in original)[69]

Atkinson's assessment of the disco patrons' ages agrees with those previously offered by Smith and Young. However, his characterization of these kids as having two parents or parents who are concerned about their children differs from Fowley's.

Atkinson also gives a history of Bingenheimer's associations with music

celebrities, both before and after the club was opened. Much like the other journalists, he describes how this bar was appealing to British touring musicians and how it was one of the few places that one could hear English dance-rock, mentioning many of the same acts referred to in the other articles. He concludes the piece with a description of the bar and one of its patrons, Sable Starr: "With that music blasting out, one can play a little pinball, or stand around with a Watney's [British brand of beer] and scoff at those glittery garbage girls and boys out on the dance floor, watching themselves in the mirrors that surround. It's all so . . . boring, yes, but look at Sabel [*sic*]—this bleached, 15-year-old, super-skinny queen of the starfuckers—look at the way she dances to the music, bending over backwards, stretching the satin front of her hot pants over her pubes, establishing a style, wallowing in this *fab*-ulous boredom that is Rodney's" (ellipses and italics in the original).[70] Atkinson's relegation of Starr to a "starfucker" is the lowest status position in the groupie subculture, according to other groupies and articles on the subject. The article was accompanied by a picture of an open-shirted, young female groupie kissing Bingenheimer while embracing him.

The relative paucity of material on second-generation groupies, with the exception of those at Bingenheimer's Disco, is a glaring absence when compared to the wealth of works on their predecessors. It appears that it was no longer newsworthy just to be a groupie and only became so if you were under the legal age of consent. This difference is indeed a sea change from journalistic discussions of the groupies from 1966 and points out how much American society and its popular culture had changed in a relatively short period of time.

Pennie Lane and Margaret Moser

The experiences of Pennie Lane[71] and Margaret Moser appear to typify those of many of the second generation of groupies in America. Although markedly different from one another, their encounters with rock musicians have more commonalities than variances. Both were involved in the subculture in cities that were outside major metropolitan areas. As such, they were able to operate largely on their own terms. Both were around the same age, sixteen and fifteen respectively, when they became involved in the subculture in the early 1970s, and both spoke of the seductiveness of the opulence and freedom of the rock musician's lifestyle. Additionally, both were able to adapt experiences that they gleaned as members of the groupie subculture and use them to achieve success in the traditional business world.

Much of Lane and Moser's stories jibe with the picture of groupies offered

by *Rolling Stone*. Indeed, Moser recounts how reading the groupie issue was influential on her decision to become a groupie in the first place, while Lane did not recall reading the article. However, facets of their accounts offer a more complex construction of the rock-and-roll groupie and its subculture than that offered by *Rolling Stone*. Both women commented on the friendships that they made, both with the musicians and with other groupies. They also talked about the fact that their own desire for sexual pleasure, not solely the desire to satisfy the male musicians, was a driving force behind why they entered the subculture. Far from believing that membership in the groupie subculture diminished their status, both spoke of the fact that they drew self-esteem from their activities. Finally, Lane and Moser commented frequently on their love for the music and its effect on them.

Pennie Lane was one of the best known groupies of the 1970s in America. She and a group of four other young women were known as "The Flying Garter Girls" and operated out of the Pacific Northwest, based in Portland, Oregon. Lane became involved in the groupie subculture while still in high school, which was not unusual for groupies in the early 1970s, although her involvement in the subculture does have several anomalous features. These include that from the beginning she decided to be a groupie for only a set period of time, she and her friends in the Garter Girls eschewed the use of drugs and alcohol, and she applied business-like methods to her groupie activities. The movie *Almost Famous* is a fictionalized account of her groupie experiences.

In an interview, Lane explains how she became involved in the groupie subculture:

I didn't set out to become a groupie. I had met a man from Steppenwolf and he invited me to go to Los Angeles with him. He was on tour. I was working at the time so I could only get away for a weekend and I spent a weekend with him in Los Angeles and he asked me to house sit for him because he was going on tour with Steppenwolf and the Faces. He had a pregnant cat [laughs]. I consequently made up a horrific lie to my parents and moved to Los Angeles. I stayed with him for four weeks; he was in the studio making an album before he left and while he was there every rock musician available came by because he was a very good musician and he was on a lot of other albums. So there was just a virtual trail of superstars walking through the house and I was serving drinks and being the little wife person. Anyway, I met a lot of people in that way and he went on tour and he came back and I moved back home to Portland. Then I started seeing bands when they came to Portland because I'd already met them through him. I mean I had a taste of it when I lived with him and the life was very seductive.[72]

Thus, once Lane had initial entry into the rock-music subculture, she was able to turn her familiarity with the musicians into a more permanent situation. This entrée was made easier by the fact that she did not live in a city that was

a major market, such as Los Angeles or New York, where there would have been more competition for the musician's attentions.

Lane soon organized a group of four other girls, who were also interested in rock music and musicians, into the Flying Garter Girls: "And the thing about the Garter Girls is how I met them. They're so interesting. They came from totally different economic backgrounds, some of their parents were on welfare. They were from all parts of the city; I would've never met them, our paths would have never crossed. But we were the girls who were in front of the stage screaming our heads off because we were so into the music and that's how I met every one of them. And we became friends and there is no way that any of us would've ever met otherwise."[73]

The way that she phrased her description of the other Garter Girls makes it clear that these young women were fans first and groupies later. It also makes plain that although they were economically diverse, they treated one another as equals and friends, based upon their love of music. Thus, it seems that in this case, Lane and the Garter Girls were assembling a peer subculture based on rock fanship.

Adding credence to this conclusion is the fact that Lane also spoke of not being popular during high school. However, she and the other girls found that "musicians didn't care if we were prom queens. It didn't matter, today you have to be a supermodel or a porn star to meet bands and things. I was just like the girl next door. I was nothing special and I managed to meet and get to know every single person I wanted to meet."[74] It appears from these comments that these young women were interested in raising both their own status and self-esteem by becoming groupies.

Further cementing their peer group identity was the fact that they also dressed distinctively: "We were always well turned out. I was totally into the 1940's vintage look, hair, hats, gloves, stockings and beautiful dresses w/beading etc. Every day. Always. The other girls had their own look—glitter rock was in, but we spent a great deal of time/money on our 'look' and it separated us from the hippies of the day. It was a very cool thing and the bands always knew who we were by our look. Nothing about us looked sleazy. We looked different and we looked together. And we were."[75] So it seems that it was not only their sexual activities as groupies that set them apart, it was also their appearance, which was both calculated and original. They used both activities and style to form a peer group in the groupie subculture.

Lane maintained that from the beginning she set out to be a groupie for a specific period of time, and that the goal of this was to have a good time, not to marry a musician:

I was very strict. I said here's what we're going to do. If you want hang with me and get backstage and meet musicians, you can do that. But if your goal is to marry a musician, I don't want any part of you because that's not what I'm about, that's not what this is about and I don't want to pick up the pieces when your heart's broken. We're in it for a good time. We're going to see the world and meet some great people, we're going to have fun and we're going to walk away and I just set a three year timeline. When I retired I said, "Ok, I've met everyone I wanted meet and I'm done." And that's when I walked away, it was a little bit before my timeline but I'd met everyone that I totally admired and I got to know them and they'd been through Portland five or six times or L.A., you know I'd see them in another city. But it was a small world really. The other thing was that I knew that I was going to fall in love with somebody eventually, and I knew it was going to hurt and I knew that I wanted to be married.[76]

For Lane, her decision to join the groupie subculture was to enable her to have a good time. To have sexual pleasure and the enjoyment of meeting of the musicians that she admired were most important to her. Lane eventually left the subculture to attend college on a four-year fencing scholarship.

Lane also demanded that, like herself, none of the Garter Girls drink or do drugs:

I didn't take drugs at the time I was a groupie. I didn't drink or take drugs. I was trying out for the Olympic [equestrian] team when I was eighteen. I tried out when I was seventeen. I had a very strict riding instructor—I was riding competitive jumping horses and I just never felt a need to do it. I just wanted to be as sharp as I could and I enjoy paying attention. Cameron [Crowe] never did drugs and I think that was the goofiness of both of us at the same time—it was something that pulled us together. I mean there were just masses of drugs everywhere. I mean there were bowls of cocaine, everything. But I just never did it, it never occurred to me to do it. [And] I didn't like the taste of alcohol.[77]

She did mention that one of the Garter Girls became involved and lived with a well-known American rock musician and developed a drug problem, but it appears that the rest of the group also declined to use drugs and alcohol while they were members.

In gaining access to rock musicians when they came to Portland, Lane employed a business-like approach. For example, in order to ensure her and her friends' entrée to the musicians, Lane made appointments with local promoters: "I went in, sat down, and put all of my cards on the table. I told them that I would bring the finest women to the shows, we would look good, we would not be drunk or high, we would stay out of their way and the way of the crews. In return, I wanted up to 12 passes for each show, PLUS a reserved parking space (it rains a lot in Oregon and we had our hair to worry about). We were not going to have sex with them or any of their staff. Period. Each

promoter agreed. We shook hands. It worked."[78] Lane's business-like approach gave her and the Garter Girls a leg up on the other women and girls who were groupies in the Portland area.

Lane also discussed the fact that her groupie activities were empowering to her and the other Garter Girls.

I wasn't a victim, and there were a lot of bands at that time that really liked women. It's not like the MTV world it is today. But what happened was some musicians were great but there were some that were really boorish and they were unpleasant and they were egotistical and they were condescending to everyone, not just to girls, you know to their managers, promoters. They would trash dressing rooms, not just the normal high jinks of throwing the occasional TV out the window. They were just bad boys, they wanted to be bad boys and they were really high most of the time. But those people who weren't polite to us and didn't treat nicely, we would just walk. And maybe that was the point that Cameron [Crowe] realized was different because we really didn't need them and that was why I was insistent that the girls that hung out with me, that they stay in school that they get good grades—we all did our homework before we went to concerts. I kind of had it under control because I knew if I didn't it would fly so fast, it would go the other way and we would all be in trouble. We saw the [other] girls and we saw how men talked about them. It was so funny because I wasn't smart enough about men to know that if you acted like you didn't care it made them like you more. I didn't know that then. I just did it because we had to do it, because we had to keep going with our lives.[79]

Thus, Lane found her groupie activities not only empowering but also used her association with her other groupie friends as a way to protect herself and to offer the same to the other young women. She also spoke of the Garter Girls having enough self-esteem so that they refused to accept any sort of treatment just to associate with rock stars. Lane spoke of enjoyment of sex being part of her sense of empowerment: "I wanted my own career. To me sex, and that's what it all boiled down to eventually, the sex part of it for me was pleasure and that's why I'm very careful about not talking about my memories and these things. I don't want to sell these guys out, everybody has families, everybody's married. I wouldn't do it for money, I have a career for money. For me those are priceless memories and I'm not going to kiss and tell about them."[80]

She also exhibited a great deal of savvy about her sexual desires and, much like Cynthia Plaster Caster, was very premeditated in deciding to lose her virginity to a rock star:

And I remember when I decided to lose my virginity to a musician. It could be a guy from my high school, I could be at his house sleeping on a mattress on the floor with a pound of weed on the floor and drinking some cheap wine, you know the sheets were probably not really clean, you know you never know about high-school boys. Or I could be in the most beautiful suite in the world and everything was clean and sparkling. And I could have a romantic dinner and be with the person I loved in the most pristine

surroundings overlooking the city. I thought "My virginity is important because I'm not going to wait until I get married. I'm not going to just throw it away." I want to make it memorable for myself. And so I made that conscious decision and I don't regret that. Because the musician respected that and made it even more special for me. So it was a very special night.[81]

Lane's decision to engage in intercourse for the first time at age seventeen with a rock star, and her reasons for eschewing a high-school-age partner, reveal a tremendous amount of forethought on her part as well as specific tastes. However, Lane and her friend's experiences were not unique within the subculture.

Margaret Moser was also a well-known groupie during the 1970s and early 1980s. Like Lane, she was involved in the subculture in cities that were outside major metropolitan areas, namely Seattle, San Antonio, and Austin. Her groupie activities date from 1970, when she was fifteen years old. She remained active in the subculture in Austin until the early 1980s, but subsequently became strictly a rock journalist. Unlike Lane and Cynthia Plaster Caster, Moser does not protect her identity; and she is quite open about her activities, both in print and at conferences, and has supported efforts to revise ideas about the groupie in American popular culture.

Moser was born in Chicago, Illinois, on May 16, 1954. Her parents are Phyllis Jackson Stegall and Dr. Willard C. Moser. Her father was a university professor specializing in English literature who graduated from Tulane University. Moser has stated that her years in New Orleans were "those that shaped me, when my individual understanding and sense of music was developed. (As opposed to the classical and church music I grew up with.)"[82] Upon her father's completion of graduate school in 1966, the family moved to San Antonio, where her father taught at Trinity University. In 1968, her parents divorced and her mother moved to Seattle.

Moser's language and her writings reflects the fact that she is a very savvy person and highly intelligent, as does her analysis of her groupie experiences. She has been able, in retrospect, to construct a very nuanced description of her life as a groupie in the 1970s and 1980s. Part of the subtlety of her analysis comes from her intellect, but another part stems from her candor and openness about her groupie experiences. Moser believes that her groupie past is something to be celebrated and discussed and that it is an inextricable part of her understanding of the rock subculture.

In an article from 2000 on her life as a groupie, "Lust for Life: Memoirs of an Unrepentant Ex-Groupie," Moser explains how she became a groupie: "From the first time I read about groupies in a 1969 *Rolling Stone*, I wanted to be one. I probably wanted to be one from the first time I saw the Beatles on *The Ed Sullivan Show*, but the soonest I could get to it was when I broke up with

my boyfriend in April 1970 and slept with one of the members of Blue Cheer. He was the second guy I slept with. I was fifteen."[83] In a subsequent interview, she reiterated and elaborated upon these points: "I came of age in the late sixties and started reading *Rolling Stone* pretty early on. I think the fourth issue was the first issue I picked up. I don't really remember where I first became aware of the fact that there were other girls out there who had the same feelings I did about the musicians they were watching, which was that they just wanted to throw themselves at them, do with them whatever was you did. At that point, I'm talking like eighth and ninth grade, so I'm aware of sex and everything but I'm not really sure what is involved. However, I'm a big reader of 16 Magazine, and they had like lots of these cute, cuddly, close-up pictures, spelled with K. And the thing is I was really reading those and then the Monkees came out and this all happened to me in the eighth grade. The Beatles and the Rolling Stones had already been around for a while and before the Monkees came out."[84] Thus, it is clear that in this instance at least, the groupie issue and its construction of the female groupie were influential in encouraging some young women of the era to want to join the subculture. In addition, it appears that in Moser's case it made her realize that she could associate with other girls who felt the same way. It is also clear that Moser, like Lane, was under the legal age of consent when she initiated her sexual activities with rock musicians.

Different rock-music artists as well as rock journalism influenced Moser to move from the pre-pubescent fan culture of *16 Magazine* and the Monkees to a more sophisticated understanding of the subculture. She felt that these things somehow connected her to the wider world, especially that of major metropolitan areas:

All of a sudden, within the same year as the Monkees coming out, some friends of my parents—my parents had one of those faculty parties—left a Frank Zappa album there and so I got *Freak Out*—no, wait a minute, *Absolutely Free* was the one. So here I have the Monkees and Frank Zappa—they also had left a Velvet Underground album and stuff like that. So somewhere in there Jimi Hendrix is coming down the way too. And all of a sudden the Monkees get pushed aside and I'm more focused on this more mature kind of rock and listening to Frank Zappa sing all this stuff about Suzy Creamcheese and stuff. I'm in San Antonio—this is not L.A. or New York City; you didn't get the kind of culture back then in heartland USA that you would get there, you kind of had to take it wherever you got it. So I would get little bits off TV or out of *Rolling Stone* or what I could glean from the albums or magazines, because I quickly gave up 16—the Monkees went by the wayside—to magazines like this publication called *Eye* magazine.[85]

According to her statements, it is clear that Moser's ideas about rock culture initially began as mediated communication, which in turn fostered her desire

to personally become a part of the rock and groupie subcultures. Much like Roxon, Moser was attracted to what has been traditionally thought of as female communication, that is, gossip. Her groupie activities put her in a position to have access to the musicians in a more intimate setting. This in turn gave her insider knowledge about the musicians and their activities. Along with Moser's writing abilities, she was able to eventually combine this access and knowledge into a career as a rock journalist.

From the very beginning of her participation in the groupie subculture Moser, like Lane, found the rock musician's lifestyle seductive and attractive. However, unlike Lane and Cynthia Plaster Caster, Moser had already lost her virginity before she became involved with the groupie subculture:

They [Blue Cheer] were playing down at the San Antonio Sunken Gardens and I remember I saw three girlfriends of mine there and they were kind of dancing around and one of the guys in the band was winking at them. So as soon as they finished their set, we just went backstage and all of a sudden we're with the band and the next thing I know we're over at the hotel. This is just like, whoa, this is really cool. So I ended up sleeping with the drummer and that was the second guy I ever had sex with. So it was great; the sex wasn't that great, but it was fun. Here I am hanging out with this musician, wearing a long fringe vest and he's looking real cool and he's got a pocket full of cocaine and we're smoking really good pot and we're up in, I forget which hotel. This is 1970. April 1970. We're ordering room service up and this is great. Well, things were not going real great in my personal life at the time with my parents. My parents were splitting up and stuff.[86]

Like Lane, Moser was attracted to the luxurious aspects of the rock musicians' lifestyle. However, unlike Lane, it was not only the sex but also the drugs in the rock subculture that Moser enjoyed, and she also used her groupie activities to help to ameliorate a painful home situation.

After her parent's separation, Moser and her mother moved from San Antonio. However, she found that the opportunity to be a groupie traveled with her:

My mom decided that the best thing to do would be for me to go with her in her move to Seattle. So in May 1970, we moved up to Seattle and I hadn't been up there six weeks when I kind of just thought "Well, I'm bored, I'm here. Think I'll go down to the Seattle Center." That was where they'd had the World's Fair. That was where they had the convention center and stuff. I just went down there. I'd already picked up on the sound check. That was the first thing I figured out. Sound check, they're there in the afternoon. I guess, Crosby, Stills, and Nash were playing. So I cruised down there and had a good time. What I found out was that Seattle was a hot place to be and it was on the West Coast but there was no competition there for this kind of stuff.
[Interviewer: There were no other groupies?]
Not to speak of, none that I saw. So the next thing I know, I'm pretty much freely

coming and going, you know, with Jethro Tull and John Mayal. These weren't ones that I necessarily slept with but I hung with them. And that was the challenge to me was to get backstage and get the pass, not to get the musician in bed necessarily. So that was the first challenge and I've said this since then that I've always really regarded it as military strategy.[87]

Moser's comments echo those of the anonymous *Time* magazine writer in her characterization of her groupie activities in martial terms. Her revelation that she didn't always have sex with the musicians she met is also notable. This statement is evidence that at least on some occasions, groupies were companions to, or merely eye or arm candy for, the musicians.

Like Lane, aspects of Moser's experiences in the groupie subculture were also anomalous. Cynthia Plaster Caster spoke of having to leave home after her mother read a diary in which had she chronicled her sexual experiences with rock musicians.[88] Lane still protects her identity to ensure that her surviving parent doesn't find out about her groupie past. However, in Moser's case, her parents were somewhat supportive of her groupie activities:

I saw the groupie gssue and my mother bought me the book [*The Groupies and Other Girls*, 1970]. My mother actually bought me the book in an HEB [a Texas grocery-store chain], the one that *Rolling Stone* put out. Actually what it really did was intimidated me. I thought they were so beautiful and they were so glamorous and they were living in New York and L.A. and San Francisco. Here I was stuck in Seattle, or San Antonio ultimately, and it just seemed back then like the other end of the universe. On the other hand, they, [other groupies] weren't there. I had no competition and so the same guys they were talking about were coming up to Seattle and it was very easy to just kind of move in on them.[89]

Her father also supported her activities. She discusses this in the article "Lust For Life": "Being the hip dad that he was, he didn't flinch much when his only daughter called to inform him she was partying at a hotel with Jethro Tull or Yes. He did seem annoyed when I called him after a party with Rod Stewart & the Faces. 'Daddy, can you pick me up at the hotel?' 'It's two in the morning!' he hollered at me. 'At least I'm not spending the night out,' I whined.'"[90] During an interview Moser elaborated on her father's attitude toward her groupie activities: "And when I was living in San Antonio particularly early on, my dad was pretty cool about everything. He was even trying to be cool about me being a groupie and stuff like that. And I'd occasionally call him up. My poor dad would find that to be a reasonable excuse and come pick me up."[91] Her parent's approach was in sharp contrast to those of Cynthia Plaster Caster's mother, while Moser's own lack of reticence with her parents differs markedly from Lane's desire for privacy.

Lane felt differently about revealing her groupie activities to her non-groupie peers during her active membership in the subculture. She stated: "And it's so weird to me because when we were groupies we never spoke about it. We never talked about it. Once in a while we'd start to get a boyfriend or somebody normal. And we'd mention the fact or say something to them and they'd just be horrified. And so we learned early on that men were intimidated by it and girls were jealous of it. And so it didn't serve us and so we never discussed it."[92] Lane's reticence to discuss her groupie activities, much like Moser's candor, appears to have dated from the time she first became a groupie.

My interview with Moser also revealed some details about the groupie subculture, specifically, how she was treated by the musicians and especially how she regarded the activities of other groupies. Earlier Lane stated that she and her friends would just walk away from abusive musicians. When asked if Moser was always treated well by the musicians, she answered:

Pretty much. I mean there'd be a point later on in which groupies would be not treated so well and I think that was as much the fault of a lot of groupies as it was the musicians.

[Interviewer: Why?]

Why? Because they were sluts, and I'm saying that in the sense that they didn't take care of themselves. They would carry disease or stuff like that or they were just rivals. [Laughs.] A rival's enough to be a slut. Because we were there first and then these other girls were moving in on our turf and stuff like that. But we were usually there first. So it wasn't that big a deal.

[Was there rivalry between the groupies?]

Yeah, there was but it was never very serious because there were usually enough musicians to go around and only a few of us supplicating ourselves so freely.

[Is that what differentiates between a groupie and fan who just wanders backstage and gets a pass?]

I mean, the groupies, I think go after the musicians knowing that they're going to go after a musician or maybe somebody with the band. I mean, I've never been so much of snob that I said, if you sleep with a roadie, you're not a groupie. If you sleep with a roadie you're a groupie. You're a roadie groupie. I slept with a few roadies in my day, I met some pretty cute ones, you know.[93]

Here Moser characterizes groupies as "sluts" based on their hygiene and health as well as the level of threat they posed to her as a rival, not based on their sexual activities. Her characterization of the women in the subculture, like Roxon's, is largely linear and does not reveal a hierarchy, merely differentiation.

In our interview, Moser also spoke of the fact that her activities as a groupie were often nonsexual:

I learned very early on that being smart was not necessarily a bad thing and so in a lot of ways a lot of my groupie career was less sex than just company and talk with a lot of

people. And a lot of groupies will tell you that too. Especially the ones that really lasted. And it's partly because you know just the names and links get old after a while. "How good was he?" "Well he was fine." But it's much more interesting to really have spent a lot of time [with the musicians]. I got to be in a hotel room with John Cale and Sterling Morrison when they had not seen each other in years and years and years. I found myself in a hotel room listening to these two legends of rock and roll talk about Third World governments and stuff like that. And this was always much, much, much, much more interesting to me. All the drugs and stuff were fun, make no mistake about that part, that was fun and it got really old. You can only tell so many stories about that. It's much more interesting to be involved in conversations because they'd remember that the next time, you know.[94]

Moser's involvement with various musicians made it possible for her to differentiate herself from other groupies, and she found her intelligence to be an asset while in the subculture.

At the beginning of this chapter I remark on the fact that earlier groupies had provided various nonsexual services to musicians, that is, lodging and domestic services, while these later groupies did so to a lesser extent. I would like to compare Moser and Lane's experiences in this area to discuss how the subculture's functions in regards to the musicians were shifting in the 1970s. In our interview, Moser spoke not only of the groupies helping to orient the traveling musicians in a new town, but also of the domestic-type services that they provided them as well. She also discussed how she considered some of the functions that groupies in this era performed as domestic—sewing on a button or washing a shirt—but was sure to add that it wasn't just "enslavement-type stuff." She also related how she and another groupie friend helped some musicians locate drugs. However, Moser usually stated that she and her groupie friends went to the musician's hotels and mentioned luxuries like room service, limos, and expensive drugs.

Lane on the other hand, laughed when I mentioned the fact that groupies in the 1960s often provided some essential, nonsexual services for the traveling musicians. She was aware of this facet, and despite having mentioned that she had "played wife" for a musician during her introduction to the subculture, explained that her reality in the groupie subculture was very different: "I mean there was so much money it was ridiculous. I tell bands that are starting up now about what it was like and they don't even believe me. If there wasn't a private plane, there was always first-class and it was always limousines and it was always the best hotel. And it was always the presidential suite and it was always just so first class. That's what blew me away because I had never seen that life. When I met bands they were at their absolute peak and the ones we knew were the top ten bands of all time."[95] The reality of Lane's groupie life, as well as

facets of Moser's experiences, reflect the enormous influx of capital into rock music that occurred in the early 1970s. However, it is clear that there was a range of possibilities for groupies who were active in the subculture during these years.

Both Moser and Lane commented on the fact that they were able to harness aspects of their groupie lives and use them to their advantage in their lives today. One of these uses has been their continued friendship with musicians whom they met while groupies. Lane explains:

> I've realized that I still enjoy meeting bands who were really successful a decade or two ago, and who are now touring playing smaller venues. Without actually planning anything, some friends and I go, meet them, and they end up back at my ranch playing music. We have many mutual friends and although the sexual tension (!) is there, we are all ok and just happy to be friends. They perceive me with surprise, and then respect me when they leave, I think we have a mutual admiration. They have made a point of telling me that I am unlike anyone they have ever met. I am flattered, and amused. Why don't other girls get it?[96]

Lane's time in the groupie and rock subcultures has made her an insider. She is thus able to relate to the musicians, discuss friends in common, and maintain contact with them. However, her financial status—it is her ranch to which they retire—and her own fame in the wake of *Almost Famous* make her more these musicians' peer than would be the case with many former groupies from the 1970s.

Moser, too, has remained friends with many musicians she met during her groupie days. Her career as a rock journalist has enabled her to stay involved in the rock, if not the groupie, subcultures:

> I have developed over the years some wonderful relationships with musicians who I may not see for ten years at a time, but I'll see them again and they just brighten up because they remember that maybe, I don't know, maybe I did suck their dick but in all likelihood I probably took them all to the club afterwards, or something like that, or made sure they all got in all right or something like that. I'm still in love with John Cale, but 22 years after I met him, I can call John or we email each other. He sent me pictures that he took out of his loft, which was two blocks away from the World Trade Center on September 11th, and stuff like that and I can bring him to town to do the Sterling Morrison thing at the awards show [a posthumous tribute to Morrison at the Austin *Chronicle*'s Music Awards Show].[97]

Moser's intelligence, her personal warmth, and her continued involvement in the rock subculture have facilitated her connection with the musicians she met as a groupie. The first two attributes may have been possessed by many groupies in the 1970s, but very few are still players enough in the music industry to both stage a tribute to one rock star and convince another to travel to the event.

Both Lane and Moser stated they believed that what they learned in the groupie subculture helped them to succeed in the more traditional business world. For seventeen years after receiving her M.B.A., Lane held major marketing positions with Fortune 500 companies and formed her own company in 1992.[98] As for Moser's success, I will let her words speak for her: "I always thought that was a kind of fun and ironic thing to do was to take this basically reviled sort of 'Oh groupie!' kind of thing and just fucking turn it inside out and yank the rug out from under people with it. Like, 'Yeah, I was a groupie and I work for NPR and I'm a senior editor and I'm a paid full-time writer and I write for Sony Records and I'm on VH-1, so fuck you.'"[99] Moser continues to be a senior editor at the *Austin Chronicle*, is in charge of the *Chronicle* award shows, and is involved with the SXSW Music Festival. She has authored three books, one of which was optioned to VH-1 for a future television project.

Both Moser and Lane exhibit a thorough understanding of the business aspects of rock music, which I believe reflects not only their personalities and intellects but also the fact that by the start of the second generation of groupies, rock was big business. Additionally, countercultural values had spread from the cities to the hinterlands, making the rock and groupie subcultures much more omnipresent than they had been in the 1960s. Also gone was the sexual reticence that had typified journalistic discussions of the groupie subculture in its earliest days.

Moser's groupie experiences led directly to her career in rock journalism. She explained:

I differentiated it [being a journalist as opposed to a groupie] by, I stopped sleeping with the local musicians. [Laughs.] I know as silly as that sounds, that was my thing. Because I understood the politics of girlfriends and wives, and girlfriends and wives were much more important to me as a writer than fucking their boyfriends or husbands was as a groupie. It was more fun with the touring musicians anyway. They didn't know me and they went away and they'd just be gone. And they'd come back another time and we'd have fun again. I mean, I was learning the pattern of this kind of thing. I really enjoyed that part of it. Honestly, my very first effort as a writer was because of that [being a groupie]. I had started working at the Austin *Sun* in 1976 and my job was to clean the bathroom and answer the phone. They had this column that had been going in there for three or four weeks, no, it was every other week so it was three or four times it had been in. It was called "Backstage," and I remember hearing them say in an editorial meeting, which I wasn't actually invited to be eavesdropping on, that they didn't have anything for the "Backstage" column. So I waited until the editor came out and I said, "Spirit is coming to the Armadillo [a concert hall in Austin, Texas] and I know Randy California and so would you like me to do something on him?" They didn't even say, "Can you write?" They just said ok and so I wrangled one of the photographers to go down with me and I saw Randy. I had met him in San Antonio a few years before. I wasn't sure whether he really remembered me or not but he seemed happy enough

to see me. I mean, we were sitting in the bathtub together. And I remember thinking, "Should I take notes or should I just try to remember it for later?" So I just tried to remember it for later and that was how I did it. It was really a terrible piece, I'm so glad that almost no copies of that paper exist anymore.

Regardless of the quality of the piece, the fact remains that Moser was able to parlay her access to musicians that she had gained through her experiences as a groupie into a long and successful career in music journalism.

Moser commented on the connections between her groupie and her writer experiences. The comments exhibit her astuteness and openness:

As a writer and as a groupie and I don't really know how to answer your question because those two things are so inextricably entwined for me. As much as I could try to pretend at one point that I didn't mix the two, of course I mixed the two. It was that access that gave me the insight, that gave me the detail. I did watch and often I felt like much more the voyeur than the participant in there because it was really true. I would end up sending the girls off with the musicians and I would end up sitting with the promoter or the roadies in the bar and then I'd leave. That was very often the case.[100]

Moser's abilities and her proclivities toward journalism led her to become a professional rock writer. However, as she points out, it was her experiences as a groupie that were the catalyst in making her desires for a writing career a reality. Few groupies have followed her lead and been so candid.

Lane also believed that her experiences as a groupie contributed to her success in business. Her parents had instilled a strong work ethic in her; she had her own business boarding horses from the age of thirteen:

So it [the music business] was fascinating to me and I was always interested in the management of the bands, as much as the musicians. Because the managers were the guys that made it all happen. I was sitting in promoters' offices and watching guys get paid hundreds of thousands of dollars in cash sometimes. And I was talking to the managers and befriending them and hanging with them. I think it was partly my relationship with the management that made us so pleasant to be around, because if they said, "Hey we need a moment," we'd go. We wouldn't argue with the managers. Most other groupies would just hang with the musicians and the managers would just be pissed off because they were trying to get the musician's attention all the time when there needed to be something that had to happen. So we became friends with promoters and managers and that's how it all started. It was fascinating to me to watch the record companies and how they schmoozed the guys in the band. I'd never seen that. I'd never seen people cater to people with money and fame. And so what I learned was that some of the musicians knew they were doing it and some of them didn't. And it showed me a whole new side of business and humanity. But I think the most important thing about business that it taught me was that everybody has a weakness and anything is possible if you want to exploit that weakness. And it also taught me how vulnerable men are with women. That's from a sexual side and I learned that lesson very early. As a woman you have power.[101]

Like Moser, Lane was also drawn to the business side of the music industry. Her proximity to those in that aspect of the business allowed her to further develop her own understanding of business and how it worked. Her personal contact with the musicians and their handlers also gave her the feeling that she had a weapon, her sex, to use in encounters with men in the business world.

Far from making her believe that her sexual activities in the groupie sub-culture put her at a disadvantage in the more traditional business world, Lane believed it gave her an advantage:

> It was an interesting education, a very interesting education and I wouldn't have traded it for the world. It helped me so much in business, because I had a lot of egotistical bosses. This was when women were just starting out and we were wearing little Brookes Brothers suits and the ties and all that back in the day and trying to get equal wages. We were trying to really get ahead. And you had these bosses that still weren't used to women in the workplace and they were still having problems with it, even though they said they weren't, they were still having big problems. They still have problems with it. I mean they were just learning about it because they hadn't seen it before, because it had been an old boy's club forever. And when you infiltrate that it was very strange. I mean they had a lot of intimidation tactics that they would use to keep you down. So they could pay you less money and they could give less perks and all that crap and the way they'd make you grovel when you went to ask for time off and they'd make you feel like you weren't a team player but yet they'd go play golf and stuff. You know, shit like that, that guys do.
>
> Well it was really funny because it never really worked on me and sometimes that attitude really cost me my job sometimes because I wouldn't buy it. I mean I just looked at them and I thought, you know, "If your pants were around your ankles right now it'd be a whole different story, buddy." You just realize that they're only men. They get up in the morning and put their pants on like everybody else and I just was not impressed. I was impressed if they were ethical in business and they were leaders and they were fair, there were things like that that totally impressed me. And there are a few men that I have such admiration for in business. But a lot of them were really squirrelly.
>
> I saw totally through it and it pissed them off that I didn't cower and I wasn't intimidated. But they didn't know what I had known. No clue. And when they'd take you on their private jet, and you're just supposed to say, "Oh, thank you so much! Oh my god, this is so cool!" And I'd sit down in the jet and I was home. They had to do something better than that for me. So I guess [laughs] I wasn't as successful in the corporate world as I could have been. I mean, I was pretty successful, but that's why I got out and started my own company and now I have clients that I like.[102]

Lane used the sexual experiences that she had gained as a groupie to help her fight sexism when she encountered it in the corporate world. She was also non-plussed by the corporate perks like private jets, because she was already very familiar with them. This lack of awe, however, was a double-edged sword, as it was sometimes perceived by her male bosses as a lack of deference.

Both Moser and Lane continue to speak positively about their groupie experiences. On this subject, Moser commented:

I think that it's very interesting, let's see I started in 1970—that's 31 years, obviously I haven't been active in a really long time—but, I mean, the result of that is still ever-present in my life. Whether it's the boys of Cowboy Mouth who are just like my little brothers, they're just like my babies, or Candye Kane who used to stay at my house all the time, she and Sue [Palmer, her former pianist] would always come and stay, and I've even put up the whole band there before. My other lesbian girlfriend, Michelle Malone from Atlanta, I met her at the first SXSW and just became really tight; she's stayed at my house with her band dozens of times. That is very, very, very much the heart of being a groupie for me with all that. The fact that I still occasionally put up a musician or something like that is a source of great pride to me. All this is a result of having done that over all these years. And I really treasure that kind of thing.[103]

Moser's forthrightness about her groupie past, both personally and in print, supports these statements. Lane's assessment of her groupie past is also largely positive. She wrote that: "I watched, I listened, and I learned. I saw how people manipulated, robbed, lied, flattered and bartered. It was a great education. When I came to understand this big picture so early in life, it opened my eyes. I paid attention in college and forced myself to diversify my classes to become stronger in my weak areas. It was not fun but I knew that I had to."[104] Her feelings about her groupie past reflect her business background and the reality that that world can often be brutal, especially to women.

Lane's decision not to reveal her identity might make some believe that she does not have completely positive feelings about her groupie past. After speaking with her about the subject, I don't believe that would be an accurate assessment of her feelings or her motivations. Lane has three main reasons for not revealing her true identity. First, she wanted to protect her parents from any pain that the truth might cause them. They were born in 1912 and 1913 and so, she believes, had very different sensibilities than the parents of most of her peers. Her father is still alive and in his 90s. Second, Lane lives on a small island and wants to maintain a good relationship with her neighbors and their children and believes that her groupie past would interfere with that. Finally, she wants to encourage an air of mystery around her groupie persona. On that subject, she writes:

In addition, the illusion of Pennie Lane is part of the appeal, I think. There is a mystique around it all. There always has been. The finality of a name contains an identity, but when you have a secret identity there is no certainty.
This was obvious when *Almost Famous* came out. So many fake Pennie Lane's popped up. She was on tour with Limp Bizkit, was seen in NY and London, etc. and

BeBe Buell actually had the balls to go CBS' *Good Morning* and say she was the real Pennie Lane (just to promote her book!). My lawyers got all over THAT [caps in original].

But in the end, it is ok. Because I never really say who I am, people just have to wonder. And anyone can be Pennie Lane. Even when I meet people, they say, "How do I know that you are the real Pennie Lane?" I smile and say, "You don't," and then turn and walk away.[105]

Another commonality that Moser and Lane have is a true love for the music. They are fans in the deepest sense of the word. Moser's career in music journalism and continued involvement with the rock-music subculture supports this assessment, and both women spoke of their love of the music and how it affected them. Moser discussed the fact that her desire to do things to help the musicians stemmed from how much she liked the music: "Anything to help you perpetuate and make that music that's going to make me want to, you know. [Smiles broadly.] So I really felt it was very reciprocal."[106]

Lane's comments on the subject reflect the changes in the groupie subculture that are discussed in the conclusion: "I think if you're just doing it [being a groupie] for the love and the respect because that guy wrote a song that you listen to those words over and over and you relate to them so much and you think, 'God, he's just like me, we have something in common. I want to talk to him about it.' And it's all wonderful and it's sweet and it's innocent and it's just admiration. I think that's a different thing and you're not going to meet him because you want to talk to the tabloids the next day and make ten grand."[107] In these words it is possible to catch a glimpse of the fervor Lane has for the music as well as the power that rock music can have over a person's life.

Conclusion

There was no hegemonic, monolithic groupie culture; rather, there were dissenting opinions in the press about the groupies from various sources of the cultural spectrum. The approach of the second-generation groupies often bore little resemblance to that of those who had come before them. Groupies in the hinterlands and smaller towns had thriving communities that exhibited regional variations. At least two groupies were able to turn their experiences in the subculture into successful careers in business. Most important, however, this information makes clear that the groupies were not stereotypes, they were not pornographic tropes, they were not just mindless starfuckers, nor were they inconsiderable in their influence on American cultural and legal history. They were an important part of the landscape of popular music's history in America.

Also clear is the fact that between 1965 and 1975, the groupies were bat-tling a centuries-old sexual double standard and that they were winning that battle. Only one of the three groupies that I interviewed for this book, however, is willing to use her real name. The other two protect their identities, because they don't want their parents to know about their groupie activities. Thus, it seems that the war against the sexual double standard has not yet been won.

Conclusion

The big lie of male supremacy is that women are less than fully human; the basic tack of feminism is to expose that lie and fight it on every level.
—*Ellen Willis,* Rolling Stone, *1977*

In the years since 1975, women's struggle for equality in the rock music subculture has not been a series of uninterrupted victories. It is true that women rock journalists and musicians are more numerous; however, the lot of the groupies has been seriously eroded. Hollywood's greater interest in the groupie subculture in the twenty-first century bodes well for attempts to reassess the groupie subculture in this era, but its long-term effects remain to be seen. Whatever the situation of women in the rock subculture currently, the efforts of the female journalists, musicians, and groupies during 1965 to 1975 were integral in the constitution of that subculture in its present form.

By 1975, *Rolling Stone* was firmly ensconced as the leading arbiter of youth culture and music. That it had achieved such a position while simultaneously engaging in stereotypical and misogynist journalism (when it deigned to write about women at all) speaks volumes about the position of women in American popular culture at that time. That it had made its version of the groupie the most well-known female habitue of the rock world further eroded women's position in the subculture, owing to the sexual double standard that still prevailed there and in the culture at large.

During the 1970s, the magazine showed signs of improving its record in the gender realm, even if this change happened far later than some believe it should have. In 1974, then-managing editor and former *Newsday* editor John Walsh hired a woman, Marianne Partridge, who profoundly altered gender relations at *Rolling Stone.* Walsh hired Partridge away from *Forbes* to become his copy chief. Considering the conditions for women staffers at *Rolling Stone,* she had her work cut out for her when she sought to improve their lot at the magazine.[1]

Before Partridge arrived, women staffers may have in actuality kept *Rolling Stone* running smoothly, but they had little status and held few titles. *Rolling Stone* historian Robert Draper described the reality of the working conditions there before Partridge joined the staff:

It was difficult for a female employee to contemplate the *Rolling Stone* experience without thinking of opportunities withheld; of the business manager who habitually brushed

up against their backsides; of the accountant who urged staffers to lean out their windows so as to witness a woman performing oral sex on him in the parking lot; of the prohibitively macho conversations [managing editor Paul] Scanlon, [writer Joe] Eszterhas, and [writer Tim] Cahill had at Jerry's Inn [a bar the writers frequented] about Hemingway and other suitable role models; and of the reactions several male staffers gave to the hiring of Partridge: "What does she look like? Does she have good legs? Does she have big tits?"[2]

Had they any idea of the changes that Partridge would initiate at the magazine, the writers might have been less concerned with her physique.

Partridge was a no-nonsense professional feminist who was strong-minded, brilliant, and experienced in the field.[3] After her arrival at *Rolling Stone*, she realized that not only were the women there being treated as, in Draper's words, "serfs," but they were also being underutilized in light of their educational levels. Scanlon's assistant Sarah Lazin had an M.A. in history, while Eszterhas's secretary Christine Doudna a master's in English, and Harriet Fier, the subscription director's assistant, had been a Phi Beta Kappa at Smith. Draper characterized their position at the time of Partridge's arrival at *Rolling Stone*: "These weren't office bimbos. They weren't even 'chicks.' They were dormant resources buried under a heap of paper clips, coffee filters and flatulent male egos."[4]

Partridge realized this and gave all of the women meaningful work to do. Doudna became the assistant copy chief, while Lazin and Fier were put in charge of the newly organized research department, which Draper described as being "modeled on *The New Yorker*'s venerable fact-checking system." The four women also started a weekly consciousness-raising session, in which they were joined by long-time proofreader Barbara Downey. Draper stated that the men at the magazine saw them as "a cabal."

In 1976, Partridge left *Rolling Stone* to accept the top editorial post at the *Village Voice*. Draper's description of Jann Wenner's response is telling: "'You fucking cunt!' Jann screamed, and threw a chair across the room. She had betrayed him. He had her former New York office repainted immediately after she vacated it, and openly grieved for days like a lover spurned."[5] As far as the role of women at *Rolling Stone*, the die had been cast. They had their foot on the rung of the staff ladder.

In 1978, Wenner made Fier the managing editor of *Rolling Stone*. Unfortunately, the feminist solidarity at the magazine didn't survive her trip to the top. Draper speculated that the reason for her promotion over the other three women was that her feminism stopped short of "stridency" and that "unlike the other women, Fier enjoyed belting back a few at Jerry's Inn, matching wits with the boys."[6] According to Draper, after her promotion, Fier's demeanor toward

her female colleagues at the magazine changed and she assumed a more author-itarian approach toward them. The other women realized that their dream of egalitarian feminism was over, but the change did not occur without a fight. Downey recounted that: "There was a lot of fighting, the way women fight: a lot of not recognizing the other person exists, leaving the bathroom without a conversation and letting certain comments get back. It wasn't direct con-frontation. It wasn't blatant. But it was very intense."[7] By the end of the year, both Doudna and Lazin had stopped working at *Rolling Stone*; Doudna left the organization entirely and Lazin took over as head of *Rolling Stone* Press. Only Downey remained at the magazine.

Another development that signaled a change in the lot of women at the magazine was that *Rolling Stone* began publishing work by Ellen Willis—an article in August 1975, and then another in March 1976.[8] In August of that same year, Willis began contributing a monthly column called "Alternating Cur-rents." From 1976 to 1978 she continued writing the column and had three fea-ture stories published. Her association with *Rolling Stone* ended in April 1978.[9]

The subjects of Willis's articles were varied and surprisingly, only one of them—a three-page article on Janis Joplin—had anything to do with music. I asked her why she didn't write more about music for the magazine: "I never particularly wanted to write about music for *Rolling Stone*, whose criticism was by and large much more narrowly focused than the kinds of larger aesthetic and social questions that interested me; and in fact by that time (mid-70s) I was no longer that interested in writing about music, period. The Janis Joplin piece was a special assignment, written for the *Rolling Stone History of Rock and Roll*, and was actually a revision of an earlier article I'd done for the *New Yorker*."[10] Instead, Willis often used the discussion of artistic works, including plays, books, and movies, to act as the starting point for her discussions of much broader themes.

An example of this approach is an article from August 26, 1976, "Memoirs of a Non-Prom Queen."[11] Willis begins the article by mentioning a recently published book, *Is There Life After High School?* by Ralph Keyes, and then dis-cussed how high school had affected her and some other well-known people in the arts, the female condition in high school, and the damage that these years did to her psyche. Although reminiscent of her "Rock, Etc." columns for the *New Yorker*, these articles were much more in the Joan Didion-Tom Wolfe mold of social commentary than were the earlier ones. Willis's radical feminist perspective was quite visible in these articles. It was certainly a step forward for *Rolling Stone* in their otherwise dismal coverage of women and gender.

After its nadir following *Rolling* Stone's groupie issue, the idea of the groupie enjoyed a renaissance during the 1990s and early 2000s. Much of the

attention during the later years was caused by the release of *Almost Famous*, a general-release motion picture.[12] The film is the autobiographical story of *Rolling Stone* writer Cameron Crowe and his involvement with groupies in the mid-1970s, most notably Pennie Lane. The story portrayed the groupies as being taken for granted by the band members. In one particularly loathsome scene, the band members and their road managers traded groupies to one another for cash and beer.

I asked Lane what she saw as the differences between her own life and that of Crowe's filmic creation. "The most obvious thing was that I never overdosed on drugs. I didn't take drugs at the time I was a groupie. I didn't drink or take drugs. I never did anything like that, nor would I ever kill myself over some musicians. I mean, I loved them; there were men that I truly did love, but I knew that it was never going to go anywhere."[13] Lane also touched on the fact that Crowe's film helped to ease some of the stigma of being a groupie for her and others: "I think that was the wonderful thing about Cameron Crowe's film. I think he brought the groupie home. You should see all the e-mails I get from women and men all the time, and they just like, 'Oh, we love Pennie Lane.' And it's so weird to me because when we were groupies we never spoke about it."

Margaret Moser also has a favorable opinion of *Almost Famous*, which she described as "a valentine from a secret admirer," and believed that the script would have been "dull" without the Pennie Lane character. She also thought that the film had an impact on society's ideas about groupies:

Cameron's cinematic portrayal of groupies was to film what Ann Powers' 1993 *New York Times* story was to their journalistic profile. Since the release of *Almost Famous*, I've had to do a lot less explaining about that part of my life. People now have a frame of reference for it and what a charming and tender image for them to have! It also spurred one of those waves of interest in groupies that happens every few years and has created that unofficial sorority of Belle Epoque groupies that places me in [with] my heroes of the day: Pamela Des Barres, Pennie Lane, and Cynthia Plastercaster.[14]

Moser also had a more personal affinity with the film due to her identification with one of the supporting characters: "I completely recognize my type in Fairuza Balk's character Sapphire Loveson. She's really the leader, if you watch the film. She's the first one to be seen in a limo with the passes. She's the one confidently going through the dinner line. She's the one who runs into a wall. That's me with the Texas Blondes!" *Almost Famous* was just the first of Hollywood's forays into the groupie subculture.

The groupies' popularity in Hollywood continued unabated, and in 2002 another film about groupies, *The Banger Sisters*, was released.[15] Starring Academy Award-winners Susan Sarandon, Goldie Hawn, and Geoffrey Rush, the

movie was the creation of veteran television writer Bob Dolman (*WKRP in Cincinnati* and *SCTV*), who wrote and directed the picture.[16] Unlike *Almost Famous*, the film is set in the present and focuses on the lives of two women who had been famous groupies in the 1960s and 1970s. Sarandon's character had married and settled down, without telling her husband about her past, while Hawn's character had remained in the subculture and celebrated her past. Their reunion after many years created an occasion for both women to reassess how they felt about themselves as groupies. Considering the fact that it dealt with the consequences of their membership in the groupie subculture, this film was addressing deeper questions than Crowe's film. Aside from the improbably neat Hollywood ending, *The Banger Sisters* was a thought-provoking film that raised questions about the impact of the sexual double standard, then and now, on women who were groupies. As the polar opposites of one another, Sarandon's and Hawn's characters reveal the hard choices inherent in either renouncing or adhering to the groupie lifestyle over the long term.

I was interested to see if this portrayal bore any relation to the reality of groupies' lives. To that end, I questioned Lane about the film.

I loved it. I thought it was classic. In fact, Susan Sarandon played the part of one of our Garter Girls and she is exactly the same. [Laughs.] Oh my god. She's finally come around but she hasn't quite confessed to her family and her children yet. It was classic. I mean the Whiskey [A-Go-Go] scene was so right on. The whole thing, I mean it was a little far-fetched, but the uptight guy and the groupie, it was classic. It was so funny. I mean to me it was such a lark. It was pretty believable except that I don't think the Susan Sarandon character would have cracked as easily as she did. Because [name omitted] certainly hasn't yet but you know we all can relate to that. But the pictures, the Polaroids [of the rock stars' penises], I mean that was just hilarious.[17]

Lane's response was in marked contrast to Moser's opinion: "The idea was interesting but the story was rotten. I found Goldie's character completely believable but Susan Sarandon's a little less so, yet nothing could save that embarrassing script." The fact that both films did well critically and commercially demonstrates that America has not lost its fascination with the groupie. For *Almost Famous*, Crowe received the Academy Award for Best Original Screenplay and the film garnered other nominations, most notably Kate Hudson's for best supporting actress.

Despite these richer more complex images in American culture, the women who are now currently involved in the subculture bear little resemblance to the groupies of the 1960s and 1970s. Both Lane and Moser were members of a panel on women rockers at a 2000 conference sponsored by the Seattle women's rock magazine *RockRGirl*. Fellow panelist Stefanie Eulinberg,

the drummer for Kid Rock, described for them the present state of groupies on the rock scene. For example, Eulinberg related that Kid Rock has four colors of backstage passes: strippers and hookers receive one color, the press another, and supermodels and actresses yet another. The girl who does the most unusual sex act to acquire a backstage pass gets yet a different color. When Kid Rock and the management see the girls walking around backstage, they can immediately identify them and thus avoid behaving inappropriately with the press.[18]

Lane also related Eulinberg's statements about an increase in lawsuits based upon what happens backstage.

A lot of the groupies, you know beautiful women that are like hookers or whatever, they go backstage as the band walks from the dressing room up onto the stage. Usually they just walk down the corridor and they'll mount the stage and everybody's standing on the side. The security guys clear the way and it's no big deal because it's backstage and it's controlled. Well, now they [the band members] have an army of security and lawyers present with them on tour because women on the way lining in the corridors will throw themselves in front of them or trip over them, and rip their dress and rip their shoe and scream lawsuit and they're being paid off hundreds of thousands of dollars sometimes in the corridor. Now they have to have lawyers on the road with them.[19]

Lane attributed some of this change to litigiousness, but the majority of it to MTV and its emphasis on visuals.

Moser's thoughts on the subject echoed Lane's assessment of the changes in the groupie subculture and added some of her own insights as well: "I think being a groupie nowadays is a whole different ballgame and it's not just because of age. I think it's because of MTV. Groupies nowadays are topless dancers for the most part. They're titty bar dancers or something like that or porn stars. One of my favorite sites beside the groupiecentral.com is Donna Anderson's stuff. I think she's pretty much what they want these days for groupies and that was not us. These are silicon darlings with their bleached hair."[20] When asked to amplify the reasons for these changes, Moser again attributes them to MTV. "I think it's largely about visuals and I think music, for the worse, is so visually driven these days. And me, the person who championed MTV in town first. I think it's been one of the worst things that has happened to women's rock or women in rock. In some ways some women were able to empower themselves." When asked if she was referring to Madonna's success in the medium of rock television, Moser replied, "Well, she sure did, but there aren't that many Madonnas out there and that's why she's in such a class of her own."

It is clear, at least from the vantage point of these two former groupies, that the subculture has changed. Both women stated that most groupies today bear much more resemblance to sex workers than to music fans. This change

might be attributable to lawsuits, or MTV, or changes in the fan culture itself. I also believe that the change is a result of the long-term business success that rock music has experienced in the years since 1975. With the arrival of big business in the music world in the early 1970s, everything was commodified. It shouldn't come as any surprise that groupies were included.

In the final analysis, what are we to make of the press's influence on popular-culture representations of women musicians and fans in America from 1965 to 1975? Did the work represent a radical departure from the way these women had been represented previously by the media? Did *Rolling Stone*'s framing of the discourse on groupies act to limit discussion of these women, or did it, by popularizing the term, allow them to express themselves to a wider audience?

One work on the girl groups suggests that the media experiences of women musicians from 1965 to 1975 was simply more of the same and not a radical departure. Alan Betrock, in *Girl Groups: The Story of a Sound*, comments on the lack of media exposure that these women experienced in the early 1960s. Aside from *American Bandstand*, the girl groups found prime-time television coverage difficult to come by, while, between 1960 and 1964, numerous male rock and pop groups appeared on the *Ed Sullivan Show*, the most popular variety show in America at the time.[21] During that same four-year period, only two singers even tangentially associated with the girl groups, Linda Scott and Lesley Gore, appeared on the show. Betrock writes: "Not a single girl group appeared on the show until October 1965, when the Supremes made their debut—and this only after the group had notched 5 #1 singles in a row!"[22] Nor could these girl groups' exclusion have been based on race; both Jackie Wilson and Ray Charles, who had appeared on the show, were African Americans. Furthermore, some of the female groups were white.

Girl groups of the early 1960s fared no better in the film industry. Many male solo artists, and even a few groups, were featured performers in films.[23] While some of those groups even had speaking parts in these movies, most of the women usually only performed the songs that they were "plugging" at the time and rarely had speaking parts. Betrock lamented the paucity of "decent footage" or print material available on the girl groups of the period, and compared this to the fact that "scrapbooks on Fabian, for example (who actually only had five Top Thirty hits) could fill up a warehouse." Betrock's final assessment of the reality of the girl groups' relationship with the media in America tentatively supports my assumptions that the lot of female musicians during 1965 to 1975 was not that different from the experiences of earlier female musicians: "Public exposure for the girl groups was extremely minimal, hindered *sometimes* by the choices of the girls themselves, *usually* by their manager's lack

of vision and conflicting interests, and *almost always* by society's own inbred and institutionalized exclusion of blacks—and girl-group performers in particular—from the mainstream mass media" (italics in the original).[24]

As for the ultimate effect that *Rolling Stone*'s representations had on the groupies, it is difficult to assess. Virtually no contemporary sources were written by the groupies themselves. That said, the few articles by women writers and the material from the groupie interviews make clear that the groupie experience was more varied and complex than *Rolling Stone*'s presentation of it. Even the comments by the groupies themselves included in the groupie issue and the letters to the editor in response to it intimates that the groupies regarded themselves as far more than just sex partners for the male musicians.

What is certain is that the paucity of women rock journalists profoundly altered the discussion of women musicians and groupies in the journalism of the era. My comparison of the work of men and women music journalists has revealed differences, both great and subtle, in their work on the women in the rock subculture. It is not simply that the women didn't employ sexist stereotypes or endowed their subjects with more human variety. The articles have a qualitative difference that stems from the fact that these women journalists didn't see the female musicians and fans as interlopers in the previously all-male club of rock-and-roll musicians. Like the journalists, the female musicians—and even the more self-possessed groupies—were attempting to expand the social possibilities for all women in the face of hostility and indifference. Because the majority of the journalists were men, however, women in the rock subculture ended up being described by people who might not have a clear understanding of their experiences. Although male writers like Michael Lydon, Robert Christgau, Vince Aletti, and Richard Goldstein demonstrated that this is not always the case, the majority of the male writers quoted in this work demonstrate the necessity for more equal representation in the profession. This parity, unfortunately, has not been achieved in journalism in the present day.

Notes

Chapter 1. The Tenor of the Times

1. Alfred Kinsey et al., *Sexual Behavior in the Human Male* (Philadelphia: W. B. Saunders, 1948); Alfred Kinsey et al., *Sexual Behavior in the Human Female* (Philadelphia: W. B. Saunders, 1953).

2. John D'Emilio and Estelle B. Freedman, *Intimate Matters: A History of Sexuality in America*, 2nd ed. (Chicago: University of Chicago Press, 1997), 285.

3. Ibid., 286.

4. Ibid., 302.

5. For my discussion on *Playboy*, I relied on the following works: D'Emilio and Freedman, *Intimate Matters;* Stephen Byer, *Hefner's Gonna Kill Me When He Reads This* (Chicago: Allen-Bennett, 1972); Frank Brady, *Hefner* (New York: Macmillan, 1974); Thomas Weyr, *Reaching for Paradise: The Playboy Vision of America* (New York: NYT Times Books, 1975); Russell Miller, *Bunny: The Real Story of Playboy* (New York: Holt, Rinehart and Winston, 1985).

6. John Heidenry, *What Wild Ecstasy: The Rise and Fall of the Sexual Revolution* (New York: Simon and Schuster, 1997), 66.

7. Helen Gurley Brown, *Sex and the Single Girl* (New York: Bernard Geis Associates, 1962).

8. D'Emilio and Freedman, *Intimate Matters*, 304.

9. For my information on *Cosmopolitan*, I relied on: Carole Marjorie Pierce, "*Cosmopolitan:* The Democratization of American Beauty Culture," Ph.D. diss., Bowling Green State University, 1985; and Ellen McCracken, *Decoding Women's Magazines from Mademoiselle to Ms.* (New York: St. Martin's Press, 1993).

10. D'Emilio and Freedman, *Intimate Matters*, 250.

11. David Allyn, *Make Love, Not War* (Boston: Little, Brown, 2000), 32.

12. D'Emilio and Freedman, *Intimate Matters*, 250–251.

13. For my information on the birth-control pill, I relied on the following works: D'Emilio and Freedman, *Intimate Matters;* Bernard Asbell, *The Pill: A Biography of the Drug that Changed the World* (New York: Random House, 1995); Elizabeth Rose Siegel Watkins, *On the Pill: A Social History of Oral Contraceptives in America, 1950–1970* (Baltimore: Johns Hopkins University Press, 1998).

14. William H. Masters and Virginia Johnson, *Human Sexual Response* (Boston: Little, Brown, 1966).

15. Heidenry, *What Wild Ecstasy*, 33.

16. Ibid.

17. Ibid., 33–34. According to Heidenry, the publication of *Human Sexual Response* made Masters and Johnson overnight celebrities. Though they declined to appear on television talk shows and a $100,000 offer for the book's movie rights, they

did appear on the *Today* show and granted interviews to *Time, Newsweek, Life,* and the *New York Times.* Another good source on Masters and Johnson is Vern Bullough's *The Sex Researchers* (New York: Basic Books, 1994).

18. William Burroughs, *Naked Lunch* (New York: Grove Weidenfeld, 1992). This edition is a reprint of the original Evergreen Edition from 1959.

19. Allyn, *Make Love, Not War,* 68–70.

20. *Attorney General v. A Book Named Naked Lunch,* 218 N.e. 2d 571 (1966).

21. Jacqueline Susann, *Valley of the Dolls* (New York: Bernard Geis Associates, 1966).

22. Robert Rimmer, *The Harrad Experiment* (New York: Bantam, 1967).

23. Allyn, *Make Love, Not War,* 71–72.

24. Ibid., 73. Rimmer was a successful printer by trade and a graduate of the Harvard Business School. His respectability and the books' pseudo-intellectual pretensions legitimized it among many who otherwise might not have dared read it.

25. Philip Roth, *Portnoy's Complaint* (New York: Random House, 1969); Paul R. Abramson and Mindy B. Mechanic, "Sex and the Media: Three Decades of Best-Selling Books and Major Motion Pictures." *Archives of Sexual Behavior* 12, no. 3 (1983): 185–206. I am grateful to Eric Shaefer for bringing this article to my attention.

26. Allyn, *Make Love, Not War,* 27.

27. Ibid.

28. Ibid.

29. Heidenry, *What Wild Ecstasy,* 61.

30. Ibid., 84.

31. Ibid., 40–47.

32. Ibid., 47.

33. Ibid., 87.

34. Ibid.

35. Ibid. *Playboy* also began showing the vulvas of the models that it featured at this time. I am grateful to William Stott for this information.

36. Ibid., 86.

37. Ibid., 56;, Gordon Schindler, ed., *A Report on Denmark's Legalized Pornography* (Torrance, Calif.: Banner Books, 1969).

38. Allyn, *Make Love, Not War,* 184.

39. Ibid., 130.

40. All of my information on the effects of *Stanley v. Georgia* comes from Allyn, *Make Love, Not War,* 130.

41. "Anything Goes: Taboos in Twilight," *Newsweek* 13 November 1967: 74.

42. Flora Davis, *Moving the Mountain: The Women's Movement in America Since 1960* (New York: Simon and Schuster, 1991).

43. All of my statistics on matrimony and the pay gap between men and women in these two paragraphs are from: Davis, *Moving the Mountain,* 17, 37–38.

44. Although I realize that the terms are not necessarily interchangeable, I will refer to the type of feminism characterized by the more moderate groups such as NOW, which pursued a more integrationist approach to the feminist struggle, as liberal feminism.

45. Betty Friedan, *The Feminine Mystique* (New York: W. W. Norton, 1963).

46. Paul Boyer, Clifford Clark, and Joseph Kett, et al., *The Enduring Vision* (Lexington, Mass.: D. C. Heath, 1996), 2: 972.

47. Davis, *Moving the Mountain*, 39. For a well-written history of the behind-the-scenes politics that resulted in the inclusion of Title VII in the Civil Rights Act of 1964, see 38–45.

48. Ibid., 45–47, 53–54.

49. Ibid., 57.

50. "NOW's Statement of Purpose," 1966, in *Major Problems in American Women's History,* ed. Mary Beth Norton and Ruth M. Alexander (Lexington, Mass.: D.C. Heath, 1996), 445–447.

51. For a good discussion of these women, see Sara Evans, *Personal Politics: The Roots of Women's Liberation in the Civil Rights Movement and the New Left* (New York: Vintage Books, 1979).

52. Mary King and Casey Hayden, "A Kind of Memo from Casey Hayden and Mary King to a Number of Other Women in the Peace and Freedom Movements," in Mary Elizabeth King, *Freedom Song: A Personal Story of the 1960s Civil Rights Movement* (New York: William Morrow, 1987), appendix 3, 571–574.

53. Alice Echols, *Daring to Be Bad: Radical Feminism in America, 1967–1975* (Minneapolis: University of Minnesota Press, 1989), 37. Two good histories of the New Left in America are R. David Meyers, ed., *Toward a History of the New Left: Essays from Within the Movement* (Brooklyn, N.Y.: Carlson, 1989); Todd Gitlin, *The Whole World Is Watching: Mass Media in the Making and Unmaking of the New Left* (Berkeley: University of California Press, 1980). For a study that includes more of the contributions of women to the New Left, see Wini Breines, *Community and Organization in the New Left, 1962–68: The Great Refusal* (New York: Praeger, 1982).

54. In a related note, the poster featured Joan Baez and her sisters, one of whom, Mimi Farina, was also a musician.

55. For histories of the SDS, see James Miller, *"Democracy Is in the Streets:" From Port Huron to the Siege of Chicago* (New York: Simon and Schuster, 1987), and G. Louis Heath, ed., *Vandals in the Bomb Factory: The History and Literature of the SDS* (Metuchen, N.J.: Scarecrow Press, 1976).

56. Evans, *Personal Politics*, 10.

57. Echols's chapter, "Prologue: The Re-Emergence of the 'Woman Question,'" in Echols, *Daring to Be Bad,* has a carefully researched account of the experience of women in the SDS.

58. Echols, *Daring to Be Bad*, 49.

59. Ibid.

60. This information comes from the "About the Author" section of Shulamith Firestone, *The Dialectic of Sex: The Case for Feminist Revolution* (New York: Bantam, 1971).

61. Davis, *Moving the Mountain*, 78.

62. Firestone, *The Dialectic of Sex.* The hardback version was published by Morrow in October 1970; the paperback came out in April 1971.

63. Echols, *Daring to Be Bad*, 114. Unless otherwise noted, all my information on this event comes from Echols, *Daring to Be Bad*, 114–120.

64. Willis to Echols, 117. I discuss Willis and her work as a rock journalist in Chapter 3.

65. I am using a reprint of the *Guardian* article from an alternate source: Ellen Willis, "Women and the Left," in *Notes from the Second Year: Women's Liberation; Major*

Writing of the Radical Feminists, ed. Shulamith Firestone and Anne Koedt (New York: Radical Feminism, 1970), 55.

66. Echols, *Daring to Be Bad,* 153.

67. Ibid., 152.

68. These include Susan Lydon, "Politics of Orgasm," mentioned in note 116; and Alix Shulman, "Organs and Orgasms," in *Women in a Sexist Society,* ed. Vivian Gornick and Barbara K. Moran (New York: Basic Books, 1971), 198–206; in addition to Anne Koedt, "The Myth of the Vaginal Orgasm" in *Notes from the Second Year: Women's Liberation; Major Writing of the Radical Feminists,* discussed below.

69. Koedt, "The Myth of the Vaginal Orgasm," 40.

70. For a good discussion of the utilization of sex by radical feminists, see Alix Kates Shulman. "Sex and Power: Sexual Bases of Radical Feminism." *Signs: A Journal of Women in Culture and Society* 5, no. 4 (summer 1980): 590–604.

71. For a good history of lesbianism in twentieth-century America see Lillian Faderman, *Odd Girls and Twilight Lovers* (New York: Columbia University Press, 1991). For work that contains a good discussion of the class elements of butch-femme role playing in one lesbian community see Elizabeth Lapovsky Kennedy and Madeline D. Davis, *Boots of Leather, Slippers of Gold* (New York: Routledge, 1993).

72. Echols, *Daring to Be Bad,* 213.

73. For a good discussion of Brown and her role in direct actions with the group the Lavender Menace, see ibid., 214–215.

74. Ibid., 284.

75. Mary Thom, *Inside Ms.: Twenty-five Years of the Magazine and the Feminist Movement* (New York: Henry Holt, 1997), 18, 41.

76. "The Hippies," *Time* 7 July 1967: 18.

77. Ibid.

78. Ibid., 19.

79. Alice Echols, *Scars of Sweet Paradise: The Life and Times of Janis Joplin* (New York: Metropolitan Books, 1999), 97.

80. "Aiming at the Hip," *Time,* 2 June 1967: 33; "Youth, It's Beautiful," *Newsweek,* 11 Oct. 1967: 60.

81. Robert Draper, *Rolling Stone Magazine: The Uncensored History* (New York: Doubleday, 1990), 56.

82. "Soulin' at Monterey," *Time,* 30 June 1967: 48.

83. "Pop Powwow," *Newsweek,* 3 July 1967: 80. The Beach Boys cancelled because Carl Wilson was contesting his draft status. Several of the Rolling Stones were unable to travel to America due to drug arrests. The Lovin' Spoonful also bowed out because of legal problems brought on by drug arrests. The Beatles and Bob Dylan had both retired from touring by 1967.

84. "Soulin' at Monterey," *Time* 30 June 1967: 48.

85. Steve Chapple and Reebee Garofalo, *Rock'n'Roll Is Here to Pay* (Chicago: Nelson-Hall, 1977), 73.

86. Ibid., 76–77.

87. Ibid., 76.

88. Ibid., 77–78.

89. Ibid., 78.

90. For a good discussion of the development of FM radio and the politics

surrounding the primacy of AM radio in America, see Thomas Lewis, *Empire of the Air: The Men Who Made Radio* (New York: Burlingame Books, 1991); also the portions on the history of radio in Erik Barnouw, *Tube of Plenty: The Evolution of American Television* (New York: Oxford University Press, 1990).

91. Chapple and Garofalo, *Rock'n'Roll*, 108–109.

92. Ibid., 109.

93. Ibid., 110.

94. Ibid.

95. The figures for this paragraph are taken from Chart 5.2, "Gold Albums by Repertoire 1968–72," in Chapple and Garofalo, *Rock'n'Roll Is Here To Pay*, 185. These figures are based on CBS Market Research. The contemporary category includes rock, teen, and folk/folk rock albums. The easy listening category is made up of albums released by pop vocalists and pop instrumentalists. All other types includes the following categories: country, original cast/soundtrack, soul, jazz, classical, humor, and all others.

96. Chapple and Garofalo, *Rock'n'Roll Is Here To Pay*, 171.

97. John D'Emilio, *Sexual Politics, Sexual Communities: The Making of a Homosexual Minority in America, 1940–1970* (Chicago: University of Chicago Press, 1983), 231.

98. Lucian Truscott IV, "Gay Power Comes to Sheridan Square," *Village Voice*, 3 July 1969: 18. Truscott was an eyewitness to the riot.

99. In addition to the Truscott article cited above, the *New York Times* and the *New York Daily News* both covered the raid. However, it is instructive to note that the latter paper took a humorous and homophobic approach to the event. The article's title, "Homo Nest Raided, Queen Bees Are Stinging Mad," gives one a sense of the article's tone.

100. Susan Stryker, "Christopher Street Gay Liberation Day: 1970" www.planetout.com/news/history/archive/christopher.html (accessed 21 Jan. 2003).

101. Ibid.

102. I will discuss this theme in more detail in later sections of this work, especially in my discussion of the groupies in the 1970s and Ellen Willis's articles on the New York Dolls.

103. Barry D. Adam, *The Rise of a Gay and Lesbian Movement* (Boston: Twayne, 1987), 79.

104. Ibid.

105. Peter Braunstein, "The Last Days of Gay Disco." *Village Voice*, 30 June 1998: 54–55+.

106. John-Manuel Andriote, *Hot Stuff: A Brief History of Disco* (New York: Harper Entertainment, 2001), 20.

107. Ibid., 28.

108. Ibid., 29.

109. Ibid.

110. Ibid.

111. Ibid., 29–30.

112. Jaime Diaz, *How Drugs Influence Behavior: A Neuro-Behavioral Approach* (Upper Saddle River, N.J.: Prentice Hall, 1997), 58–59.

113. Ibid., 59.

114. Ibid.

115. Ibid., 179.

116. Lucian K. Truscott IV, "Remember the Fillmore?" *Village Voice,* 6 May 1971: 5.

117. Bill Graham, "Advertising," *Village Voice,* 6 May 1971: 45.

118. Jonnes chronicles this addiction in her book *Hep-Cats, Narcs, and Pipe Dreams: A History of America's Romance with Illegal Drugs* (New York: Scribner, 1996).

119. Ibid., 306.

120. These cycles are the first wave of addiction beginning in the 1880s, the one under discussion in the 1970s, and the crack epidemic of the 1980s.

121. One of the best discussion of women musicians during this era is Gillian Gaar's *She's a Rebel: The History of Women in Rock Music.* (Seattle: Seal Press, 1992).

122. Although there were many mixed sex singing groups existed during the 1930s, 1940s, and 1950s, to keep my discussion to a manageable size, and because I believe the reality of the groups with male members were quite different due to this fact, I am focusing on the all-female singing groups during these years.

123. One notable exception to this generalization is The Chantels. In the initial version of the cover for their first album, *We Are the Chantels* (End Records, 1958), the group appeared dressed in matching Southern belle hoop skirts. In the highly charged racial atmosphere of the late 1950s, this was a daring decision, evidenced by the cover used on the records sent to Southern stores: it pictured two white teenagers standing in front of a jukebox (Michael Ochs, *Classic Rock Covers* [Cologne: Taschen, 2001], 44–45).

124. All chart information is taken from two sources, both by Joel Whitburn: *Top Pop Singles, 1955–1999* (Menomonee Falls, Wis.: Record Research, 2000), and *The Billboard Book of Top 40 Hits* (New York: Billboard Publications, 1985).

125. "The Shirelles," http://www.history-of-rock.com/shirelles.htm (accessed 31 Jan. 2003).

126. The Brill Building, located at 1619 Broadway in New York City, was a hotbed of musical activity. In 1962, 165 music businesses rented space in the building. Songwriters like Carole King and Gerry Goffin, Cynthia Mann and Barry Weil, and Neil Sedaka, as well as producers such as Don Kirshner, Phil Spector, and Shadow Morton, were closely associated with it. For more information on the subject see "The Brill Building Sound," http://www.history-of-rock.com/brill_building.htm.

127. Jon Pareles, and Patricia Romanowski, eds., *The* Rolling Stone *Encyclopedia of Rock & Roll* (New York: Rolling Stone Press/Summit Books, 1983), 516–517, 379–380. Unless otherwise noted, my material on Spector and Morton is taken from this source.

128. Morton and Spector, along with Brill Building luminaries Jerry Leiber and Mike Stoller, formed Red Bird Records in 1964.

129. The Shangri-Las, *The Best of the Shangri-Las,* Polygram Records, 1996.

130. After the breakup of the Shangri-Las and the gradual lessening of the Brill Building group's influence on pop music in 1966–1967, Morton expanded his repertoire to include protest music (Janis Ian's "Society's Child) and heavier rock music (Vanilla Fudge's "You Keep Me Hanging On"), although the latter certainly bore more than a trace of the dramatic touches found in the songs of the Shangri-Las.

131. Whitburn, *Top Pop Singles, 1955–1999.*

132. I am aware that some of this sartorial change was due to the influence of the British Invasion, Carnaby Street, and Swingin' London. However, the American emphasis of this project does not allow me to explore those influences in any depth.

133. The duo changed their style in the early 1970s to a more adult-oriented,

middle-of-the-road approach, largely coinciding with their shift to a more Vegas-style audience and then a prime-time variety show. They continued to have hits and be enormously successful.

134. Anomalous female instrumentalists had always been in the music business. A couple of the more notable who played in the years before 1965 were "Lady Bo," also known as Peggy Jones, who played lead guitar with Bo Diddley (http://www.topblacks. com/entertainment/peggy-jones-aka-lady-bo.asp), and Goldie and the Gingerbreads, the first all-woman band to have any success in the pop world. The latter was the first all-woman band to have a song on the British pop charts ("Can't You Hear My Heart Beat," Atlantic, 1965) and opened for the Rolling Stones, the Kinks, and the Yardbirds in England in 1965 (http://www.aurealm.com/goldie.htm).

135. I discuss this aspect of Joplin's career in more detail in Chapter 2.

136. As disco is discussed above, I will not elaborate upon it further here.

137. Originally the band had been a quartet; however, Cindy Birdsong left the group in 1967 to replace Florence Ballard in the Supremes.

138. Gaar, *She's a Rebel*, 200.

139. For a discussion of this matter and Carpenter's drumming, see Ray Coleman, *The Carpenters: The Untold Story* (New York: HarperCollins, 1994).

140. Carol Kaye, personal interview, email, 12 May 2003. All of the information in this section comes from either this source or Kaye's web page, "The Official Carol Kaye Web Site," http://www.carolkaye.com/ (accessed 2 Feb. 2003).

141. June Millington, personal interview, 4 Oct. 1999. All of the information in this section comes from this source.

Chapter 2. Women Rockers on the Printed Page

1. Terri Sutton, "Janis Joplin," in *Trouble Girls: The Rolling Stone Book of Women in Rock*, ed. Barbara O'Dair (New York: Random House, 1997), 157–65.

2. Stanley Booth, "The Memphis Debut of the Janis Joplin Review," *Rolling Stone*, 1 Feb. 1969: 1, 4. Booth was born in 1942, and between 1969 and 1984, wrote four articles, one book review, two record reviews, and one letter to the editor for *Rolling Stone*. Three of the articles are about music in Memphis and the last is a retrospective on the Rolling Stones' 1969 concert at Altamont. The source for Booth's publication history in *Rolling Stone* is Jeffrey N. Gatten, compiler, *The Rolling Stone Index: Twenty-Five Years of Popular Culture, 1967–1991* (Ann Arbor, Mich.: Popular Culture, Ink, 1993). Unless otherwise noted, this book is the source for all of the information on articles published in *Rolling Stone* by the authors referred to in this chapter.

3. Booth, "The Memphis Debut," 4.

4. Steve Chapple and Reebee Garofalo, *Rock'n'Roll Is Here to Pay: The History and Politics of the Music Industry* (Chicago: Nelson-Hall, 1977), 156.

5. Ellen Sander, "The Journalism of Rock," Saturday Review, 3 July 1971, 47, 49. I quote and discuss her work in Chapter 5.

6. Conflicting accounts exist of exactly when Williams began publishing *Crawdaddy*. *Newsweek* says 1965, Chapple and Garofalo say spring 1966, and Draper says February

1966. I discussed the matter with Williams during a personal interview and he confirmed Draper's date of February 1966. Paul Williams, personal interview, 2 Feb. 2001; and "Crawdaddy," *Newsweek*, 11 Dec. 1967: 114.

7. Draper, *Rolling Stone*, 58.

8. Chapple and Garofalo, *Rock'n'Roll*, 157.

9. Chapple and Garofalo, *Rock'n'Roll*, 157; Draper, *Rolling Stone*, 58.

10. Draper, *Rolling Stone*, 58.

11. Robert Anson, *Gone Crazy and Back Again* (New York: Doubleday, 1981), 62.

12. Draper: 59.

13. John Tebbel, "Magazines—New, Changing, Growing," *Saturday Review*, 8 Feb. 1969: 56.

14. "Youth, It's Beautiful," *Newsweek*, 11 Oct. 1967: 60.

15. Ibid. Siegel later worked at *Playboy* and wrote an essay, "Who Is Thomas Pynchon and Why Did He Run Off with My Wife?" for *Esquire*. I am grateful to Jeff Meikle for this information.

16. Chapple and Garofalo, *Rock'n'Roll*, 157.

17. "Youth, It's Beautiful," 60.

18. Ibid.

19. Ibid.

20. Tebbel. "Magazines," 56.

21. Ibid.

22. Ibid.

23. Chapple and Garofalo, *Rock'n'Roll*, 158. See Abe Peck, *Uncovering the Sixties: The Life and Times of the Underground Press* (New York: Pantheon, 1985), for a good discussion of this genre.

24. Draper, *Rolling Stone*, 46.

25. Anson, *Gone Crazy*, 43.

26. "Ralph J. Gleason, Jazz Critic, Dead," *New York Times*, 4 June 1973: 42.

27. "Regrets," *Rolling Stone*, 12 Oct. 1968: 6. In the beginning *Downbeat* covered swing and popular music as well as jazz; however, after World War II its emphasis shifted to just jazz. "*Downbeat* is a music magazine with an international circulation which contains news, feature articles, and reviews. One of the longest-established journals, it is also one of the most influential and reliable magazines in the jazz field," Donald Kennington and Danny L. Read, *The Literature of Jazz: A Critical Guide*, 2nd ed. (Chicago: American Library Association, 1980), 195–96.

28. Draper, *Rolling Stone*, 60.

29. "Ralph J. Gleason, Jazz Critic," 42.

30. Anson, *Gone Crazy*, 43.

31. "Regrets," 6.

32. "Ralph J. Gleason, Jazz Critic," 420. He also twice won ASCAP's Deems Taylor Award for writing on music, in 1967 for his article "Jazz: Black Art, Black Music," and in 1973 for a tribute to Louis Armstrong.

33. Anson, *Gone Crazy*, 43.

34. Draper, *Rolling Stone*, 46–47.

35. Gleason came to the rescue. He was on the editorial board of a San Francisco–based magazine, *Ramparts*. The magazine began in 1962 as a liberal Catholic news journal. In 1964 Warren Hinckle III, a San Francisco *Chronicle* reporter and failed publicist,

took editorial control of the magazine and changed its approach. Hinckle's new slant was to turn *Ramparts* into a bully pulpit for his own left-leaning political views backed by "slick and splashy" art. As such, *Ramparts* strongly reflected the ideas and personality of Hinckle. Advertisers pointedly avoided the magazine, but Hinckle kept it afloat through a combination of subscriptions and the largesse of wealthy patrons.

In 1966, Hinckle was launching, as an offshoot of *Ramparts*, a new magazine called *Sunday Ramparts*. Gleason put in a recommendation for Wenner, and he was hired as entertainment editor. In early 1967 Hinckle wrote and published a scathing attack on the hippies and their philosophy in which he quoted Gleason, who was enamored with the movement, to particularly "unflattering effect," and Gleason resigned "in a fury" from *Ramparts'* editorial board. In May 1967, *Sunday Ramparts* folded and Wenner was once again looking for work (Draper, *Rolling Stone*, 50–52; Anson, *Gone Crazy*, 54, 60).

36. Draper, *Rolling Stone*, 59.

37. Ibid.

38. Ibid., 61.

39. Ibid.

40. Ibid., 67. According to Draper, today Wenner claims that *Straight Arrow* had already folded before these events took place.

41. Anson, *Gone Crazy*, 62; Draper, *Rolling Stone*, 62.

42. Draper, *Rolling Stone*, 63–64.

43. Ibid., 65.

44. Schindelheim was a dentist's daughter from New York whom he met when they both worked at *Ramparts*. Though she had been an artist before coming to the magazine, she had been hired to open mail sent to the magazine for Eldridge Cleaver's defense fund. Draper, *Rolling Stone*, 51.

45. Ibid., 66.

46. Susan Lydon was born in 1943 in New York City and graduated from Vassar College. In addition to her work at *Rolling Stone*, she worked on the staff at *Ramparts* and wrote for *Ms.* and the *New York Times*. Lydon also authored a noted feminist essay, "The Politics of Orgasm." However, drug addiction and abuse interfered with her writing career. After entering a treatment program in the early 1990s to treat her long-time heroin addiction, she wrote an autobiography, *Take the Long Way Home: Memoirs of a Survivor* (San Francisco: HarperSanFrancisco, 1993). The source for the information on Lydon is *Contemporary Authors* (Detroit: Gale Research Company), vol. 152: 284–85.

47. Draper, *Rolling Stone*, 71.

48. Ibid., 70.

49. Anson, *Gone Crazy*, 62.

50. Ibid., 63.

51. Draper, *Rolling Stone*, 73–74.

52. "Regrets," 6; Anson, *Gone Crazy*, 43; Draper, *Rolling Stone*, 61.

53. Draper, *Rolling Stone*, 74.

54. Draper discusses several financial crises *Rolling Stone* experienced in the first few years of its existence; see 99–100, 133–34, 139–40.

55. "Statement of Ownership, Management and Circulation," *Rolling Stone*, 15 Nov. 1969: 38.

56. Draper, *Rolling Stone*, 94.

57. Ibid.

58. Ibid. All the information in this paragraph was taken from this source.

59. Anson, *Gone Crazy*, 63.

60. In order to understand the methods the journalists at *Rolling Stone* employed in their coverage of women musicians, it is useful to turn to the realm of critical theory, specifically film theory. In her article "Film Body: An Implantation of Perversion," Linda Williams described one process by which media producers reduce women to the status of eroticized objects by ascribing a surplus of erotic meaning to the female body through unnecessary detail about any aspect of a woman's physical appearance—clothing styles, weight, or degree of probable sexual attractiveness to men—in *Narrative Apparatus and Ideology: A Film Theory Reader,* ed. Philip Rosen [New York: Columbia University Press, 1987], 507–534. These surplus details trivialize women by concentrating on how they appear, while this emphasis serves both to objectify them and portray their physicality as the most important thing about them. By this method, men exert mastery over women because as objects women are denied independent agency and are, instead, acted upon.

61. On Jimi Hendrix, untitled article, *Rolling Stone*, 15 Oct. 1970: 2, 6–9, on Janis Joplin, untitled article, *Rolling Stone*, 29 Oct. 1970: 2, 6–16.

62. "Hendrix Inquest Inconclusive," *Rolling Stone*, 29 Oct. 1970: 20.

63. Untitled article, *Rolling Stone*, 29 Oct. 1970: 2.

64. "Of Apollo and Dionysus," *Christian Century*, 4 Nov. 1970: 1308–9.

65. Ibid., 1309.

66. Ibid.

67. Fong-Torres's involvement with *Rolling Stone* was much more extensive than Booth's. Jan Wenner hired Fong-Torres to work at *Rolling Stone* as a senior editor and writer in 1968. Described by *Rolling Stone* historian Robert Draper as "a versatile in-house writer," Fong-Torres became bureau chief of the San Francisco office when Wenner and most of the staff moved to New York City in 1977; he left the magazine in 1980. During his years at *Rolling Stone*, Fong-Torres wrote 202 articles, two book reviews, three concert reviews, and two movie reviews. Sources for this information are Draper, *Rolling Stone* and *Contemporary Authors* vols. 93–96: 155.

68. Ben Fong-Torres, "John: 'It Sounded Like the Mamas and the Papas,'" *Rolling Stone*, 10 June 1971: 2–8.

69. Ibid., 6.

70. See "Random Notes," *Rolling Stone*, 1 Mar. 1969: 4.

71. Fong-Torres, "'It Sounded Like the Mamas and the Papas,'" 8.

72. "Aretha Cooks Up Some Pigs' Feet," *Rolling Stone*, 2 April 1970: 14.

73. On Grover Lewis, Draper, *Rolling Stone*, and *Contemporary Authors*, vol. 148: 262–63.

74. Grover Lewis, "The Jeaning of Barbara Streisand," *Rolling Stone*, 24 June 1971: 16.

75. Ralph J. Gleason, "Laura's Got Them Writhing," *Rolling Stone*, 16 April 1970: 20.

76. "The Goose That Laid the Golden Rock," *Rolling Stone*, 23 Nov. 1968: 30; Chet Flippo, "Janis Reunes at Jefferson High," *Rolling Stone*, 17 Sept. 1970: 8. Flippo is one of the best known of the *Rolling Stone* writers. After his discharge from the Navy in 1969, Flippo went to work for *Rolling Stone* as an editor. When the magazine relocated its offices to New York City in 1977, he became bureau chief of that office. Sources: for this information are Draper, *Rolling Stone* and *Contemporary Authors*, vols. 89–92: 212.

77. Patrick Thomas, "Mother Earth Presents Tracy Nelson Country," *Rolling Stone*, 1 Nov. 1969: 42. Thomas began his association with *Rolling Stone* in 1969 and last published in its pages in 1975. During that time he published one concert review, two record reviews, and seven articles. Six of the seven articles were about events in or musicians playing out of Nashville, Tennessee. Additionally, his one concert review was about a show in Nashville. The Mother Earth album referred to in the text was also recorded in Nashville. It most probable then, but not certain, that he was a local "stringer" who wrote about music in Nashville for *Rolling Stone*.

78. Vince Aletti, "Laura Nyro: Every Number an Encore," *Rolling Stone*, 21 Jan. 1970: 14. Born in Philadelphia in 1945, Aletti began his career in journalism as a rock critic for the New York underground paper *Rat*, a position he held until 1969. The concert review referred to above marked Aletti's publication debut in *Rolling Stone*; it is notable that for his first article he was assigned to review a female artist's concert. Aletti would go on to write nine more concert reviews, with his last being published in August 1975. He also wrote one movie review in August 1972. Primarily Aletti was a record reviewer who specialized in soul, rhythm and blues and disco music. From 1974 to 1979 he was also the disco columnist for New York's *Record World*. From 1985 to the present he has been a senior editor at the *Village Voice*. Aletti had more than one hundred record reviews published in *Rolling Stone*, beginning in June 1970 and ending in 1989. The source for this information is *Who's Who in the East*, 27th ed., 1999–2000 (New Providence, N.J.: Marquis Who's Who), 13.

79. Paul Gambaccini, "Singles," *Rolling Stone*, 8 July 1971: 47. Gambaccini published his first record review in *Rolling Stone* in September 1969; his last was in September 1975. During the space of those six years he reviewed hundreds of records, most of them singles, specializing in the pop and soul genres. Gambaccini also had three concert reviews published in *Rolling Stone*. Between 1971 and 1981, he published seventy-three articles in the magazine. He wrote primarily about British bands and American bands touring in England. Three of the concert reviews were of shows performed in English venues, which leads me to surmise that Gambaccini was a writer who lived in England. I am unable to confirm this using the primary sources, as they only list Andrew Bailey the managing editor of the London office on the masthead until mid-1972. At that point Jerry Hopkins is listed as an associate editor. Gambaccini's name does not appear on the *Rolling Stone* masthead during the years covered in this study.

80. Barbara O'Dair, ed., *Trouble Girls: The Rolling Stone Book of Women in Rock* (New York: Random House, 1997), 87.

81. Ben Fong-Torres, "Folk and Soul and Gospel, and Yet," *Rolling Stone*, 15 Oct. 1970: 20.

82. O'Dair, *Trouble Girls*, 243.

83. Lester Bangs, "The Carpenters and the Creeps," *Rolling Stone*, 4 Mar. 1971: 23. Bangs was one of the most passionate and innovative of the writers at *Rolling Stone* during the years of this study, establishing his reputation as a record reviewer of the first rank at *Rolling Stone*. Born in 1949, Bangs responded to one of the help wanted ads printed in the early issues of *Rolling Stone* that asked people to send in their reviews and articles. Draper wrote that Bangs sent in a "sputtering, scathing, condemnation of the debut record of the MC5" (87). After this review was printed in April 1969, Bangs began to send in ten to fifteen reviews a week to *Rolling Stone*. Many of them were among the hundreds published between April 1969 and July 1973. In 1973, Wenner banned him

from writing reviews for *Rolling Stone* after a bad review of a Canned Heat album in June 1973 brought a nasty reply from the group's manager. Before his exile, in addition to the record reviews, Bangs also wrote six book reviews. The article cited above was Bangs's only concert review. His banishment was rescinded in June 1978 when he once again published a record review. His last review was published in *Rolling Stone* in June 1980. Bangs died on April 30, 1982. Sources for this information are Draper *Rolling Stone*; and *Contemporary Authors* (Detroit, Mich.: Gale Research Co., 1995), vol. 106: 35.

84. Michael Lydon, "Soul Kaleidoscope: Aretha at the Fillmore," *Ramparts*, Oct. 1971: 30–39. In August 1967, Jann Wenner hired Lydon to be the first managing editor for *Rolling Stone*. However, Wenner listed Herb Williamson, a former *Sunday Ramparts* editor, on the masthead instead of Lydon. By early 1968, Lydon left *Rolling Stone* to pursue a freelance career. He contributed articles to the *New York Times*, *Rolling Stone*, and *Ramparts*. Sources for this information are *Contemporary Authors*, vols. 85–88: 363; and Draper, *Rolling Stone*.

85. Stu Werbin, "Fanny," *Rolling Stone*, 1 April 1971: 50. This record review was Werbin's second piece published in *Rolling Stone*. Many of Werbin's concert reviews, and the subjects of his articles, were of East Coast derivation. As noted above, at the beginning of his career at the magazine he wrote primarily concert and record reviews. Werbin had three concert reviews published in *Rolling Stone* between January 1971 and August 1973. He also had eight record reviews published between April and November 1971. The record review to which I refer in this quotation, his first, was a review of the eponymous first album by the all-woman band Fanny. This piece seems to be another example of a relatively inexperienced writer being assigned to cover women musicians. However, it is not as egregious an example as the Booth article discussed in note 2. Fanny was, after all, a new band. In February 1972, Werbin had his first article published in *Rolling Stone*. He would go on to publish thirty more through January 1974 when he ceased to be published in its pages. Twelve of the thirty-one articles have East Coast, particularly New York, themes.

86. "Get Behind Fanny on Reprise Records," advertisement, *Rolling Stone*, 2 Sept. 1971: 23.

87. June Millington, personal interview, 4 Oct. 1999.

88. A notable exception to this generalization is Greil Marcus's review of Dusty Springfield's album *Dusty in Memphis*, in the November 1, 1968, issue on page 42. I did not include a discussion of this article here as it concerns a British, rather than American, female artist and as such is outside the scope of this work.

89. The reason for Booth's assignment could have been monetary; flying a correspondent to Memphis may have been beyond the magazine's means. However, his being assigned to write the Franklin review cannot be so easily written off. Consider the fact that between 1969 and 1984, Booth only wrote four articles, one book review, two record reviews, and one letter to the editor for *Rolling Stone*. Booth's career with *Rolling Stone* adds credence to my assertion that the magazine typically did not assign it most seasoned and well-known writers to write pieces on women musicians during this era. The source for Booth's publication history in *Rolling Stone* is Gatten, *The Rolling Stone Index*, 954.

90. In order to make this comparison I selected six periodicals, *Time*, *Newsweek*, *New Yorker*, *Saturday Review*, *Ramparts*, and *Christian Century*. The criteria for inclusion were as follows. First, the magazines must have been nationally distributed, either

by subscription or on newsstands. Second, they must not have been aimed at any specific segment of society based on either race or gender. For these reasons I excluded *Ebony, Esquire, Playboy, McCall's,* and *Ladies Home Journal.* Although it could be argued that both *Time* and *Newsweek* were aimed at white audiences, this is not a specifically stated aim of the publication. Third, they had to be article- (not photograph-) driven. For this reason, I did not include either *Life* or *Look* magazines. Fourth, they must have been general-interest magazines; for this reason I did not include *Hi-Fidelity.* And finally, they must have published in uninterrupted sequence from January 1, 1965, to January 1, 1975. For this reason I excluded *Saturday Evening Post,* which ceased publication in January 1969. However, I decided to include *Saturday Review* because, although it split into four separate parts in January 1973, it continued to publish music reviews and reconstituted itself in 1975.

I looked under the following entry headings in *The Reader's Guide to Periodical Literature* to locate the articles in these magazines: Joan Baez, Judy Collins, Jackie DeShannon, Aretha Franklin, Janis Joplin, Carole King, Melanie, Joni Mitchell, Laura Nyro, Grace Slick, the Supremes, the Mamas and the Papas, Carly Simon, Bonnie Raitt, Linda Ronstadt, Patti Smith, Chaka Khan, Gladys Knight, Patti LaBelle/LaBelle, Karen Carpenter, Cher, Singers, Negro Singers, Celebrities, Music—Popular, Music Festivals, Musicians, Rock and Roll, Groupies, Woman—Occupations, Woman—Entertainers, Women—Famous, Negro Celebrities, Negro Entertainers, Roberta Flack, Tina Turner, Diana Ross, Benefit Performances, Rock Music, Rock Groups, and Bette Midler. Not all entry headings are valid for every year of this study.

91. Hammond was a tremendously influential figure in American jazz music. He also played a large role in helping many African American artists receive the credit that they were due. For a good discussion on Hammond and his work see: John Hammond and Irving Townsend, *John Hammond On Record: An Autobiography* (New York: Ridge Press, 1977).

92. Burt Korall, "The ABC's of Aretha," *Saturday Review,* 16 Mar. 1968: 54–55.

93. "Lady Soul: Singing It Like It Is," *Time,* 28 June 1968: 63; Ann Powers, "Aretha Franklin," in *Trouble Girls: The Rolling Stone Book of Women in Rock,* ed. Barbara O'Dair (New York: Random House, 1997), 96–97.

94. "Bringing It All Together," *Time,* 5 Jan. 1968: 48.

95. Korall, "The ABC's of Aretha," 54–55. I am grateful to Jeff Meikle for pointing out Korall's implications of race essentialism.

96. "Over the Rainbow," *Newsweek,* 21 Aug. 1967: 70.

97. "Garden Gathering," *New Yorker,* 23 Aug. 1969: 23.

98. Six articles in my sample contained comments that reflected this type of authorial approach. The number of these articles by magazine is *Time,* three; *Newsweek,* two; and *Saturday Review,* one.

99. "The Nitty-Gritty Sound," *Newsweek,* 19 Dec 1966: 102.

100. I am indebted to a "Deadhead" friend, Kristin Jones, for this information.

101. "Baby, Baby, Where Did Diana Go?" *Time,* 17 Aug. 1970: 30–31.

102. Ibid., 31.

103. "From Rags to Riches," *Look,* 3 May 1966: 72.

104. Ibid.

105. Not to be confused with the Monterey International Pop Festival that had taken place in June of that same year.

106. Willis Conover, "Music at Monterey," *Saturday Review*, 14 Oct. 1967: 109 and 113.

107. Ibid.

108. I will not discuss all of the instances of extraneous detail found in mainstream articles that were about or included women. However, it was the most common type of sexist writing found in the articles in my sample. In several cases more than one instance of unnecessary detail occurs in the same article. In all, 23 articles contained elements that reflected this type of authorial approach. The number of articles by magazine is as follows: *Time*, five; *Newsweek*, fifteen; *Saturday Review*, two; *New Yorker*, one; *Ramparts*, one. In two notable examples the writers mentioned a female artist's height. While this may seem like a rather trivial detail, printing someone's height is not the same as writing salacious things about them. The point here is that drawing attention to a woman's physicality may objectify her and, due to the sexual double standard so prevalent during this period, diminish her power and position. Also, the male writers who used this method in their articles on women musicians often combined the women's heights with other superfluous details.

109. Charles Michener, "The Pop and Op Sisters," *Newsweek*, 13 Mar. 1972: 90. Michener became a staff writer at *Seattle* magazine from 1965 to 1967 and worked as its managing editor from 1967 to 1970. Michener joined the staff of *Newsweek* in 1970 as an associate editor. He was a general editor there from 1972 to 1975 and in 1975 he became senior editor of *Cultural Affairs*. Source: *Contemporary Authors*. Vol. 104: 315.

110. "Lady Soul," 62.

111. Korall, "The ABC's of Aretha," 54–55.

112. Lydon, "Soul Kaleidoscope," 37.

113. "The Queen Bees," *Newsweek*, 15 Jan. 1968: 77–78.

114. "Family Reunion," *Newsweek*, 15 Nov. 1971: 77, 79.

115. Hubert Saal, "Good-Time Musicians," *Newsweek*, 23 Feb. 1970: 90. He joined *Newsweek* in 1964 and served as that magazine's music and dance critic until he retired in 1984. See: Eric Pace, "Hubert Saal, 72, a Newsweek Critic of Music and Dance," *New York Times* Biographical Service, May 1996: 803; *Who Was Who in America* (Chicago: Marquis-Who's Who, 1997), 241.

116. "The Non-Violent Soldier," *New Yorker*, 7 Oct. 1967: 44–46.

117. "Into the Pain of the Heart," *Time*, 4 April 1969: 78 and 80.

118. Saal, "The Girls," 68 and 71.

119. "Satin, Silky, Sexy," *Time*, 18 April 1969: 72–73.

120. Charles Michener, "The Divine Miss M," *Newsweek*, 22 May 1972: 76.

121. "Pop Powwow," *Newsweek*, 3 July 1967: 80.

122. "Soulin' at Monterey," *Time*, 30 June 1967: 48.

123. Michael Thomas, "Janis Joplin: The Voodoo-Lady of Rock," *Ramparts*, 10 Aug. 1968: 74–77.

124. Ibid., 75.

125. Information on Capp and his politics comes from *100 Years of American Newspaper Comics* (New York: Gramercy Books, 1996), 176–77.

126. "Which One Is the Phoanie?" *Time*, 20 Jan. 1967: 47.

127. Charles E. Fager, "Baez on Film," *Christian Century*, 10 Feb. 1971: 206. A Quaker, Fager was a conscientious objector during the Vietnam War. Source: *Contemporary Authors*, Vol. 85–88: 275.

128. Saal, "The Girls," 68 and 71.

129. "Open Up, Tune In, Turn On," *Time*, 23 June 1967: 53.

130. Saal, "Good-Time Musicians," 90.

131. The article did not profile Tracy Nelson, Mary Nance or Tina Meltzer.

132. "The Queen Bees," *Newsweek*, 15 Jan. 1968: 77–78.

133. Barbara Cowsill sang mostly in ensemble arrangements. Although I do recall in the Cowsills' version of "Hair" hearing a soprano female voice that sounded too mature to have been the young daughter singing.

134. Paul Williams had started *Crawdaddy* in February 1966. However, as it was still at the stage of being mimeographed on yellow paper, it is doubtful that it had much influence in the larger world of journalism at this time. As such, I argue for "Pop Eye" as the first because it had a wide dissemination and was tremendously influential on the genre of rock writing. *Crawdaddy* and the *Mojo Navigator News* of San Francisco, though important, were more underground publications at this time and had relatively few readers when compared with the *Village Voice*.

135. Richard Goldstein, "Pop Eye: Electric Minotaur," *Village Voice*, 24 Oct. 1968: 33.

136. Richard Goldstein, "Pop Eye: The Pop Poll," *Village Voice*, 11 Jan. 1968: 31.

137. Richard Goldstein, "Pop Eye: Aretha Arouses," *Village Voice*, 12 Oct. 1967: 22.

138. Richard Goldstein, "Pop Eye: Phillers," *Village Voice*, 23 Feb. 1967: 14.

139. Richard Goldstein, "Pop Eye: Good Morning Van Dyke Parks," *Village Voice*, 10 Aug. 1967: 22.

140. Richard Goldstein, "Pop Eye: Bobby Gentry Meets the Press," *Village Voice*, 17 Aug. 1967: 13.

141. Richard Goldstein, "Pop Eye: Notes From Underfoot," *Village Voice*, 30 June 1968: 32.

142. Richard Goldstein, "Pop Eye: Homecoming," *Village Voice*, 26 Sept. 1968: 36.

143. Richard Goldstein, "Pop Eye: The Hip Homunculus," *Village Voice*, 29 June 1967: 18.

144. Richard Fannan, "Da Doo Ron Ron," *Rolling Stone*, 11 May 1968: 19.

145. Richard Goldstein, "Pop Eye: "The Soul Sound from Sheepshead Bay," *Village Voice*, 23 June 1966: 8.

146. Robert Christgau, "Rock & Roll: Gap Again," *Village Voice*, 27 March 1969: 33. Robert Christgau, "Rock & Roll: Consumer Guide (1)," 10 July 1969: 29.

147. Robert Christgau, "Rock & Roll: Being," *Village Voice*, 3 July 1969: 28.

148. Robert Christgau, "Rock & Roll: In Memory of Dave Clark Five," *Village Voice*, 4 Dec. 1969: 65.

149. Robert Christgau, "Rock & Roll: We Should Be Together," *Village Voice*, 14 May 1970: 33.

150. Ibid.

151. Robert Christgau, "Rock & Roll: Look at That Stupid Girl," *Village Voice*, 11 June 1970: 35, 38–39, 41.

152. Ibid. He also mentions the groupies on page 38 of the article and intimated that he believed their media treatment had been sexist.

153. It is useful to compare this article with one on the same subject by Ellen Willis that I discuss in Chapter 3.

154. Patricia Horan, "Letters to the Editor: A Critic with Balls," *Village Voice*, 18 June 1970: 57, and Barbara Rhodes, "Letters to the Editor: Guess Who's Coming to Bed," *Village Voice*, 25 June 1970: 4.

155. Robert Christgau, "Rock & Roll: The Joy of Joy," *Village Voice*, 15 April 1971: 45–46.

156. Ibid. 45.

157. Robert Christgau, "Rock & Roll: Consumer Guide (18)," *Village Voice*, 10 June 1971: 40.

158. Robert Christgau, "Rock & Roll: Consumer Guide (20)," *Village Voice*, 14 Oct. 1971: 54.

159. Robert Christgau, "Rock & Roll: Consumer Guide (48)," *Village Voice*, 12 Sept. 1974: 61.

160. Robert Christgau, "Rock & Roll: Consumer Guide (50)," *Village Voice*, 21 Nov. 1974: 92.

161. Annie Fisher, "Riffs: Be Grateful You're Dead," *Village Voice*, 16 May 1968: 31.

162. Annie Fisher, "Riffs: Did You Get a Buzz?" *Village Voice*, 10 Oct. 1968: 42.

163. Lucian Truscott IV, "Riffs: Blind. Faith," *Village Voice*, 17 July 1969: 26.

164. Don Heckman, "Riffs: Untitled," *Village Voice*, 4 Dec. 1969: 47. I designated this as "Untitled" because with the advent of more writers making contributions to the column, the title part of the each "Riffs" column came to refer only to that written by the first author and not the entire column. The rest of the writer's work was, effectively, untitled.

165. Heckman used prose similarly imbued with superfluous details in his description of Judy Collins. Don Heckman, "Riffs: A Christmas Valentine," *Village Voice*, 25 Dec. 1969: 42.

166. Ira Mayer, "Riffs: Untitled," *Village Voice*, 11 May 1972: 63.

167. See Ira Mayer, "Riffs: Untitled," *Village Voice*, 1 Jan. 1973: 45, and Ira Mayer, "Riffs: Untitled," *Village Voice*, 13 Dec. 1973: 72.

168. Frank Rose, "Riffs: Mighty Ochs," *Village Voice*, 3 Jan. 1974: 36.

169. Tom McCarthy, "Riffs: As Bad as Any Boy," *Village Voice*, 21 Mar. 1974: 48.

170. Vince Aletti, "Riffs: Labelle: Overflowing the Met," *Village Voice*, 17 Oct. 1974: 59.

171. Ibid.

172. Howard Smith, "Scenes," *Village Voice*, 22 Feb. 1968: 19.

173. Richard Goldstein, "Pop Eye: Janis: Next Year in San Francisco," *Village Voice*, 18 April 1968: 32.

174. Stephanie Harrington and Blair Sabol, "Outside Fashion: Janis Joplin and Dean Flemming," *Village Voice*, 18 April 1968: 34.

175. Annie Fisher, "Riffs: Rally the Blues," *Village Voice*, 8 Aug. 1968: 18. Fisher also wrote in very laudatory terms of *Cheap Thrills* and wished her well with her new band in "Riffs: NE Winds, Force 8," *Village Voice*, 19 Sept. 1968: 44.

176. Johanna Schier, "Riffs: One of a Kind," *Village Voice*, 2 Oct. 1969: 30–31.

177. Robert Christgau, "Rock & Roll: Consumer Guide (6)," *Village Voice*, 15 Jan. 1970: 35.

178. Don Heckman, "Riffs: The Vigoro Queen vs. the Aristocracy," *Village Voice*, 1 Jan. 1970: 33.

179. Charles Wright, "Riffs: Champagne for Pearl," *Village Voice*, 4 Feb. 1971: 29.

180. "Jimi Hendrix," *Village Voice*, 24 Sept. 1970: 35–36, 38.

181. Smith, "Scenes," *Village Voice*, 8 Oct. 1970: 12. Christgau was in California at

the time and did mention Joplin's death with an opaque comment in his column. See Robert Christgau. "Rock and Roll: A Musical Weekend," *Village Voice*, 15 Oct. 1970: 36.

One of the most interesting series of articles that dealt with Joplin occurred after her death in 1970 and related to her sexual experience with women. In 1971, lesbian writer Jill Johnston, in her rambling, paragraph-less column called "Dance Journal," made an off-handed assertion in one sentence of her column that Joplin was a lesbian. This began a flurry of letters and columns on the subject. The furor that followed is instructive on both the subjects of how Joplin was regarded by elements of the culture and the level of controversy surrounding lesbian behavior at this time. The columns and letters died down for two years, only to resurface in 1973 with the publication of a "tell-all" book by one of Joplin's lesbian lovers, Peggy Caserta. Johnston had the last word on the subject by writing a column about Caserta, and lesbianism in general, called "Going Down with Peggy & Janis," 5 July 1973: 23. It is clear that even years after her death, Joplin exerted a powerful interest in the periodical press. For more information on this controversy, see the following documents in the *Village Voice*. Johnston, "Dance Journal," 14 Oct. 1971: 23; Diane Hyatt, "Letters to the Editor" 21 Oct. 1971: 4; Johnston Johnston, "Dance Journal," 28 Oct. 1971: 54; Lillian Roxon, "Letters to the Editor," 4 Nov. 1971: 4; Lyndall Erb, "Letters to the Editor," 11 Nov. 1971: 4; Johnston, "Dance Journal," 2 Dec. 1971: 39; Leslie Dale "Letters to the Editor," 9 Dec. 1971: 4.

Chapter 3. Rock Women Who Wrote

1. Ellen Willis, "Records: Rock, Etc. Two Soul Albums," *New Yorker*, 23 Nov. 1968: 134–136.

2. A wonderful biography of Lillian Roxon was published in 2002: Robert Milliken, *Lillian Roxon: Mother of Rock* (Melbourne: Black, 2000). I would also like to thank the author for graciously allowing me to reprint a picture of Roxon from his book and for putting me in contact with the Roxon family.

3. *Contemporary Authors*. (Detroit: Gale Research Company, 1981), vol. 106: 523. Unless otherwise noted, the information in this paragraph comes from this source.

4. Ellen Willis, personal interview, 3 Mar. 2003.

5. Ibid.

6. Robert Christgau, personal interview, 13 June 2003.

7. Willis and Christgau had slightly different views of the Free University. In our interview, Christgau characterized it as "a front for the P.L. [Popular Labor] Party." Willis had a different view of the place: "I think it's a stretch to call the Free University a 'front' for PL, a bit like calling the mass peace marches a front for Answer and the Workers World Party. The place was very freewheeling politically and culturally and PL politics were no more in evidence than anything else that was going on; the great majority of people who taught or took courses there had nothing to do with PL one way or another." Ellen Willis, email to the author, 17 June 2003. When informed that Christgau had used the word "front," Willis wrote: "It's really a matter of interpretation. Bob was writing an article about the place, so if PL was running and/or funding it, he ought to know; but 'front' implies that the real function of the place was to covertly

push some version of PL's politics. Whatever PL might have had in mind, that was not how I or most of the people there experienced it, so 'front' strikes me as misleading. There were PL people teaching courses, but also anarchists, cultural radicals, SDSers, even a free-market libertarian—there was no particular political line being pushed, so far as I could tell. (If indeed this was a PL project, it was certainly the best thing they ever did!)." Ellen Willis, email to the author, 17 June 2003.

I asked Christgau for some amplification on this issue and he wrote: "I only found out about this years later, and no longer have any memory of what the source was. Ellen is certainly right in her characterization of how the place felt, although any list of participants should certainly include Lyn Marcus, who later became Lyndon La Rouche, with whom both of us were briefly involved. And it was also clear that the PL was part of it—Len Ragozin, who was very close to Ellen, was completely out-front about his party membership. But my understanding is that it went well beyond participation. The Free U was either conceived or very quickly grasped by PL as a way of infiltrating the student/libertarian left, and sent in many principals who did not identify themselves as PL but meant to take the place and its constituency over." Robert Christgau, email to the author, 18 June 2003.

8. They had actually first met in junior high school. Ellen Willis, personal interview. 3 Mar. 2003.

9. Ellen Willis, personal interview, 3 Mar. 2003.

10. Ibid.

11. Robert Christgau, personal interview, 13 June 2003.

12. Ibid.

13. All articles in this citation were written by Ellen Willis. "Books," *Cheetah*; "At Home," *Cheetah*, February: 19–20; "Bettina Aptheker Is Alive and Well in Berkeley," February: 30, 67–70; "In-Person: A Tribute to Woody Guthrie," *Cheetah*, March 1968: 19; "Books," *Cheetah*. April: 11–12; "Books: Vanity of Duluoz, Why the Draft? The Dissenting Academy," May: 9–11; "At Home," *Cheetah*, May: 23. Since copies of *Cheetah* are difficult to find, I asked Willis if she would send me copies of her articles from the magazine; she graciously agreed.

14. Ellen Willis, "Books," *Cheetah*, April 1968: 11.

15. Ellen Willis, "In-Person: A Tribute to Woody Guthrie," *Cheetah*, March 1968: 19.

16. Ellen Willis, personal interview, 3 Mar. 2003.

17. Ellen Willis, email to the author, 13 June 2003

18. Ellen Willis, personal interview, 3 Mar. 2003.

19. Ibid.

20. Mary Thom, *Inside Ms.: Twenty-Five Years of the Magazine and the Feminist Movement.* (New York: Henry Holt, 1997), 71.

21. Alice Echols, *Daring to Be Bad: Radical Feminism in America, 1967–75* (Minneapolis: University of Minnesota Press, 1989), 72.

22. Thom, *Inside Ms.*, 81.

23. Ellen Willis, "Rape on Trial," *Rolling Stone*, 28 Aug. 1975: 38–39, 79–81.

24. Ellen Willis, "Memoirs of a Non-Prom Queen," *Rolling Stone*, 26 Aug. 1976: 25.

25. This information comes from the NYU web page, Ellen Willis, NYU Department of Journalism Faculty, http:// www.nyu.edu/gsas/dept/journal/faculty/bios/willis (accessed 22 Sept. 2000).

26. Ellen Willis, personal interview, 3 Mar. 2003.

27. For a good discussion of the influence of the New Left and civil rights movements on Second wave feminism, see Sara Evans, *Personal Politics: The Roots of Women's Liberation in the Civil Rights Movement and the New Left* (New York: Vintage Books, 1979).

28. Ellen Willis, email to the author, 18 April 2001.

29. Echol, *Daring to Be Bad*, 77.

30. Echols, *Daring to Be Bad*, 80.

31. For more detail on this protest, see my discussion of it in Chapter 1.

32. Echols, *Daring to Be Bad*, 119. Echols has an in-depth history of Redstockings on 139–55.

33. Ibid., 152, 199.

34. Ibid., 152.

35. Ellen Willis, personal interview, 3 Mar. 2003.

36. Ellen Willis, email to the author, 13 June 2003

37. Ellen Willis, personal interview, 3 Mar. 2003.

38. Thom, *Inside Ms.*, 71–72.

39. Ellen Willis, "Records: Rock, Etc.," *New Yorker*, 6 July 1968: 56–58.

40. Ibid., 57.

41. Ellen Willis, "Concerts: Rock, Etc.: The Scene, 1968," *New Yorker*, 2 Nov. 1968: 160+.

42. Grace Slick, *Grace Slick: Somebody to Love?* (New York: Warner Books, 1998), 53–54.

43. Ellen Willis, "Concerts: Rock, Etc.,"164.

44. Ellen Willis, "Rock, Etc.: Changes," *New Yorker*, 15 Mar. 1969: 173.

45. Ibid.

46. This review was echoed by *Village Voice* writer Annie Fisher in a review of one of Joplin's concerts, which is discussed in Chapter 2.

47. Willis, "Rock, Etc.: Changes," 173.

48. Ellen Willis, "Rock, Etc.," *New Yorker*, 14 Aug. 1971: 81–82.

49. Ibid.

50. Ibid., 82.

51. Ibid., 168–175.

52. An exception to this generalization is Robert Christgau, a writer for the *Village Voice* who also wrote about women in rock. In Chapter 2, I discuss a 1969 column he wrote commenting on the lack of discussion about women in rock in the rock press, "Look at that Stupid Girl." It is important to note that Christgau and Willis had been intimately involved for three years, although they were not involved at the time of the article's composition. Robert Christgau, personal interview, 13 June 2003.

53. Ellen Willis, "But Now I'm Gonna Move," *New Yorker*, 23 Oct. 1971: 168–169.

54. Ibid., 170, 173.

55. Ibid., 173.

56. Ibid., 174.

57. Ellen Willis, "Rock, Etc: My Grand Funk Problem—And Ours," *New Yorker*, 26 Feb. 1972: 80.

58. Ellen Willis, "Rock, Etc.," *New Yorker*, 12 Aug. 1972: 57.

59. Ellen Willis, "Rock, Etc: Into the Seventies, for Real," *New Yorker*, 9 Dec. 1972: 169–170.

60. Ellen Willis, "Rock, Etc: The Return of the Dolls," *New Yorker*, 13 Jan. 1973: 65.

61. Ellen Willis, "The Best of '74," *New Yorker*, 10 Mar. 1974: 109–110.

62. Ibid., 110.

63. Echols, *Daring to Be Bad*, xiv–xv.

64. In the case of unattributed pieces, it is safe to assume that the journalists responsible for them were male due to the paucity of women on the staffs of these magazines.

65. All information in this paragraph comes from Milliken, *Lillian Roxon*, 162–163.

66. Lillian Roxon, "Will Success Spoil Lillian Roxon?" *Quadrant* Jan.–Feb. 1971, reprinted in Milliken, *Lillian Roxon*, 331.

67. Milliken, *Lillian Roxon*, 163–164.

68. Lillian Roxon, *Lillian Roxon's Rock Encyclopedia* (New York: Grosset & Dunlap, 1969).

69. Linda Greenhouse, "Lillian Roxon, 40, Chronicler of Rock Culture, Music, Dies," *New York Times*. 11 Aug. 1973: B22.

70. Howard Smith, "Scenes," *Village Voice*, 16 Oct. 1969: 10.

71. S. K. Oberbeck, "Roxon's Rock," *Newsweek*, 10 Nov. 1969: 127.

72. Roxon, "Will Success Spoil Lillian Roxon?" 332–333.

73. Robert Christgau, "Rock & Roll," *Village Voice*, 15 Jan. 1970: 36.

74. Ellen Sander, "Pop: The Journalists of Rock," *Saturday Review*, 31 July 1971: 47.

75. Milliken, *Lillian Roxon*, 165–166.

76. Ibid., 189.

77. Ibid., 205–6.

78. Here I am referring to the gossip theory of Max Gluckman.

79. Milliken, *Lillian Roxon*, 9. Unless otherwise noted, the majority of the biographical information on Roxon is derived from this source. Not yet available in the United States, this book is the most definitive biography of Roxon up to this point. Milliken concentrates much of his efforts on a discussion of Roxon's roots in Australia. However, he also gives a good accounting of her years in New York City and reprints several of her articles, some from the Australian press, and excerpts from her *Rock Encyclopedia*.

80. Ibid., 16.

81. Ibid., 87

82. Ibid., 106.

83. Lillian Roxon, letter to Rose Roxon, 1961, quoted in Milliken. *Lillian Roxon*, 109.

84. Ibid.

85. This story is related in Milliken, *Lillian Roxon*, 131.

86. Ibid.,132.

87. Ellen Willis, personal interview, 3 Mar. 2003.

88. Milliken. *Lillian Roxon*, 135–136.

89. Roxon, "Will Success Spoil Lillian Roxon?" 328.

90. Lillian Roxon, "The Top of Pop: Rock's Alive, If Not Too Well," *Sunday Daily News*, 23 May 1971: S11. This column consisted of a short essay on some rock artist or subject in the field, followed by a section called "Amplification" that was a classic tabloid-style gossip. Her last column ran on 12 August 1973 (page 9), two days after Roxon's death.

91. Milliken, *Lillian Roxon*, 207.

92. Ibid., 204.

93. Ibid., 205.

94. Ibid., 217–218.

95. Ibid., 220.

96. Paul Gorman, *In Their Own Write: Adventures in the Music Press* (London: Sanctuary Publishing, 2001), 99.

97. Blair Sabol, "Lillian Died Last Week," *Village Voice,* 16 Aug. 1973: 21.

98. Tracy Young, "Lillian Died Last Week," *Village Voice,* 16 Aug. 1973: 21.

99. Greenhouse, "Lillian Roxon, 40, Chronicler of Rock Culture, Music, Dies" *New York Times,* 11 Aug. 1973: B22.

100. Loraine Alterman, "Lillian Roxon, Journalist-Author of 'Rock Encyclopedia,' Dies at 41," *Rolling Stone,* 13 Sept. 1973: 16.

101. Ibid.

102. In gossip theory, all roads lead to Max Gluckman. A professor of social anthropology from the late 1930s, he taught at the University of Manchester from 1949 until his death in 1975 (http://www.comma2000.com/max-gluckman/) (accessed 19 June 2003). His 1963 article "Gossip and Scandal" provided the most cogent and useful theoretical framework for my analysis of Roxon's use of gossip in the rock community (*Current Anthropology*) 4, no. 3 [June 1963]: 307–316). Far from arguing that gossip was useless or destructive to community cohesion, Gluckman argued that it was what preserved "the unity, morals and values of social groups." He also asserted that gossip "is one of the chief weapons which those who consider themselves higher in status use to put those whom they consider lower in their proper place." Gluckman believed that gossip was the clearest arbiter of group membership, "There is no easier way of putting a stranger in his place than by beginning to gossip: this shows him conclusively that he does not belong." He also posited that "the more exclusive a social group is, the more will its members indulge in gossip and scandal about one another." These insights enabled me to address the positive aspects of a column like Roxon's as well as identifying its community building functions within the rock community.

One statement toward the end of the article explained one of the functions, and the popularity, of mass-media gossip columns such as "Top of Pop." Gluckman wrote, "I think we can say that men and women do wish to talk about personal matters, for reasons on which I am not clear, and in the great conurbations the discussion of, for example, stars of film and sport, produces a basis on which people transitorily associated can find something personal to talk about" ("Gossip and Scandal," 315). Here he was commenting on the fact that media gossip can ameliorate the social isolation and anomie that were byproducts of urban living in the twentieth century.

103. Melanie Tebbutt, *Women's Talk? A Social History of "Gossip" in Working-Class Neighbourhoods, 1880–1960* (Hants, England: Scolar Press, 1995), 19–22.

104. Ibid., 9–10.

105. Lillan Roxon, "Top of Pop: Don't Knock Cradle Rock," *Sunday Daily News,* 2 Dec. 1971: S7.

106. Lillian Roxon, "Top of Pop: Jackson 5: Black and Talented," *Sunday Daily News,* 9 July 1972: 9.

107. Lillian Roxon, "Top of Pop: There Must Be a Place, Somewhere, for a Rock Museum," *Sunday Daily News,* 15 April 1973: 9, and Lillian Roxon, "Top of Pop: Yes, All You Rock Fans, Your Idols Love Letters," *Sunday Daily News,* 20 May 1973: 9.

108. Lillian Roxon, "Top of Pop: Rock Stars on Film? It's Mind-Blowing!" *Sunday Daily News*, 27 May 1973: 9.

109. Lillian Roxon, "Top of Pop: The 'Fun City Sound' Is What's Happening in Rock," *Sunday Daily News*, 5 Aug. 1973: 9.

110. Lillian Roxon, "Top of Pop: Rock's Alive if Not Too Well," *Sunday Daily News*, 23 May 1971: S11.

111. Lillian Roxon, "Top of Pop," *Sunday Daily News*, 30 May 1971: S12.

112. A couple of examples will suffice, including an account of the Jefferson Airplane's launch of their new record label, Grunt, in 1971: Lillian Roxon, "Top of Pop: Satyricon West," *Sunday Daily News*, 3 Oct. 1971: S9. Another good example is a column dedicated to record-launch parties for Alice Cooper and the Kinks: Lillian Roxon, "Top of Pop: The New Rock Party Syndrome," *Sunday Daily News*, 21 May 1972: 11LS.

113. Lillian Roxon, "Top of Pop: The Story of the Stones in Words & New Pictures," *Sunday Daily News*, 14 May 1972: 11LS.

114. Lillian Roxon, "Top of Pop: Rock for All Ages," *Sunday Daily News*, 25 July 1971: 2S.

115. Lillian Roxon, "Top of Pop: The Dylan Revival, *Sunday Daily News*, 16 Sept. 1971: S9.

116. Lillian Roxon, "Top of Pop: A New Role for Women in Rock?" *Sunday Daily News*, 5 Nov. 1972: 9L.

117. Lillian Roxon, "Top of Pop: Satyricon West," *Sunday Daily News*, 3 Oct. 1971: S9.

118. Lillian Roxon, "Top of Pop: The '50s Nostalgia," *Sunday Daily News*, 27 Feb. 1972: S11.

119. Lillian Roxon, "Top of Pop: Nona Hendryx of Liberated Labelle," *Sunday Daily News*, 2 July 1972: 9. Another example of this type of item can be found in Lillian Roxon, "Top of Pop: Jackson 5: Black and Talented," *Sunday Daily News*, 9 July 1972: 9L.

120. Lillian Roxon, "Top of Pop: A Kinky Sound," *Sunday Daily News*, 28 Nov. 1971: S7, and Lillian Roxon, "Top of Pop: Let's Hear a Scream for the Jackson Five," *Sunday Daily News*, 17 June 1973: 9.

121. Lillian Roxon, "Top of Pop: Edgar Winters Discovers Music to Have Fun With," *Sunday Daily News*, 22 Oct. 1972: 9L.

122. Lillian Roxon, "Top of Pop: The Graceful Kinks," *Sunday Daily News*, 12 Mar. 1972: S11.

123. Lillian Roxon, "Top of Pop: A Rock Critic's Rough and Reddy Life," *Sunday Daily News*, 26 April 1973: 9L.

124. Lillian Roxon, "Top of Pop: Rock Scene '72," *Sunday Daily News*, 2 Jan. 1972: S7.

125. Lillian Roxon, "Top of Pop: A New Role for Women in Rock?" *Sunday Daily News*, 5 Nov. 1972: 9L.

126. Lillian Roxon, "Top of Pop: Marc Him Well," *Sunday Daily News*, 5 Mar. 1972: S11, and Lillian Roxon, "Top of Pop: Max Serves Rock & Roll with Finesse," *Sunday Daily News*, 7 May 1972: 9LS. Roxon's approach here is obliquely similar to the male writers' use of superfluous details discussed in Chapter 2. However, since she was a woman writing about men, and therefore not in the same position in terms of status and power as either the male writers or her subjects, her comments do not reduce the men to objects in the same way. That is, their status is enhanced rather than reduced by attention being drawn to their physicality.

127. Lillian Roxon, "Top of Pop: The Early Sound of 'Now' Music," *Sunday Daily News*, 29 July 1973: 9L.

128. Lillian Roxon, "Top of Pop: David Bowie: The Elvis of the Seventies," *Sunday Daily News*, 18 June 1972: 9E.

129. Lillian Roxon, "Top of Pop: Banishing the Bad Vibes at Rock Fests," *Sunday Daily News*, 6 Aug. 1972: 9L.

130. Lillian Roxon, "Top of Pop: Alice to Groove in Sponsorland," *Sunday Daily News*, 19 Nov. 1972: 9L.

131. Lillian Roxon, "Top of Pop: There Must be a Place, Somewhere, for a Rock Museum," *Sunday Daily News*, 15 April 1973: 9L.

132. Lillian Roxon, "Top of Pop: Recalling the '60s with Mama Michelle," *Sunday Daily News*, 8 July 1973: 9L.

Chapter 4. The Birth of the Groupie

1. This article, along with many of his others previously printed there and in *Confidential* magazine, was published in 1965 as a collection of essays, *The Kandy-Kolored Tangerine-Flake Streamline Baby*. Thomas Kennerly Wolfe, Jr., was born on March 2, 1931, in Richmond, Virginia. He received a B.A. (cum laude) from Washington and Lee University in 1951. He then earned a Ph.D. in American Studies from Yale University in 1957. In late 1956, Wolfe began working at the *Springfield* (Massachusetts) *Union* as a reporter. He continued to work in newspaper journalism for the next ten years, mostly as a general-assignment reporter. A professional highpoint of this portion of his career came in 1960 when he was awarded the Washington Newspaper Guild's foreign news prize for his coverage on Cuba, written for the *Washington Post*. In 1962, he began working for the *New York Herald Tribune*. He and Jimmy Breslin also wrote for the *Herald Tribune*'s Sunday magazine, *New York*. While in these positions he completed *The Kandy-Kolored Tangerine-Flake Streamline Baby*, his first book. Many influential and best-selling books would follow. A few of these are *The Electric Kool-Aid Acid Test* (1968), *The Painted Word* (1975), *The Right Stuff* (1979), *The Bonfire of the Vanities* (1987), *A Man in Full* (1998). Wolfe was awarded the National Book Award for *The Right Stuff* in 1980. http://www.tomwolfe.com/authobio.html (accessed 10 Mar. 2003), 206.

2. Lillian Roxon, *Lillian Roxon's Rock Encyclopedia* (New York: Grosset & Dunlap), 212.

3. Wolfe, "The Girl of the Year," 210.

4. Ibid.

5. Wolfe, Introduction to *The Kandy-Kolored Tangerine-Flake Streamline Baby*, xv.

6. Gary Comenas, "Baby Jane Holzer," www.warholstars.org/stars.jane.html (accessed10 Mar. 2003). Wolfe, "The Girl of the Year," 215.

7. See the description of Finch College offered by Grace Slick in her autobiography, *Grace Slick: Somebody to Love?* (New York: Warner Books, 1998), 53-54.

8. Comenas, "Baby Jane Holzer," "Baby Jane Holzer, Actor," MSN Entertainment http://entertainment.msn.com/celebs/celeb.aspx?c=358232 (accessed 10 Mar. 2003).

9. "1965," www.warholstars.og/chron/1965.html (accessed10 March 2003). Holzer

stayed away from, in her words, "Edie's [Sedgwick, a well-known Warhol model and actor] arrival and when Andy got shot." Comenas, "Baby Jane Holzer."

10. "1963," www.warholstars.og/chron/1963.html (accessed10 Mar. 2003).

11. Wolfe, "The Girl of the Year," 216.

12. Ibid., 205.

13. Ibid.

14. Ibid., 212–213.

15. In "Daughters of the Revolution, Mothers of the Counterculture: Rock and Roll Groupies in the 1960s and 1970s" (Ph.D. diss., Duke University, 2001), Kathryn Kerr Fenn argues that the earliest documented use of the term "groupie" is as the name of a rock band in New York City in 1965. While technically that is correct, further research on this assertion reveals that this use of the word has little to do with the term as it relates to fan culture and as it would come to be used. I spoke with Norman "Cooker" Derosiers, the band's lead singer, about how the band came to be called by that name and what it meant. He explained that at the time female fans were colloquially known as "groupie chasers." To capitalize on that phrase, the band's manager Steve Venet decided that the band should be called the Groupies. He even had pins and bumper stickers made up that read, "I'm a Groupie Chaser." An example of one of the bumper stickers is available on the website "The Great Hollywood Hangover," which was compiled by Derrosiers's ex-wife Nancy (www.hollywoodhangover.com/groupieb.JPG). Due to the fact that Venet's choice of the name "groupie" had little to do with the fans that followed the bands and was more of a marketing gimmick to play upon the name "groupie chasers," I believe that this instance of the use of the term should not be considered the first. If one were to assert that this usage is the first of the word groupie, due to its meaning one could just as easily argue that the usage of the word by the RAF in World War II, cited in the Oxford English Dictionary, would be a much better candidate. Norman Derosiers, personal interview, 20 Feb. 2003.

16. Paul Williams had started *Crawdaddy* in February 1966 (see note 6 in Chapter 2). However, as it was still at the stage of being mimeographed on yellow paper, it is doubtful that it had much influence in the larger world of journalism at this time. I argue for "Pop Eye" as the first because it had a wide dissemination and was tremendously influential on the genre of rock writing. *Cheetah, Crawdaddy,* and the *Mojo Navigator News* of San Francisco, though important, were more underground publications at this time and had relatively few readers.

17. Richard Goldstein, "Pop Eye: Soundblast '66," *Village Voice,* 16 June 1966: 16.

18. The Druids of Stonehenge was a band formed by New York college students in 1965. A complete list of their discography and personnel as well as their history can be found at the website, "Fuzz, Acid, and Flowers," http://www.borderlinebooks.com/us6070s/fuzz.html.

19. Richard Goldstein, "Pop Eye: The Druids of Stonehenge," *Village Voice,* 17 Nov. 1966: 18.

20. Ibid., 24.

21. Richard Goldstein, "Pop Eye: So Who Believes in Magic," *Village Voice,* 15 Dec. 1966: 11.

22. Ibid., 42.

23. Ibid.

24. In chronological order of their appearance, these columns are "Pop Eye: In

Search of George Metesky," *Village Voice*, 16 Mar. 1967: 5; "Pop Eye: The Billy James Underground," *Village Voice*, 3 Aug. 1967: 13; "Pop Eye: The Insulated Hippie Awakens," *Village Voice*, 21 Sept. 1967: 9; "Pop Eye: Cream: They Play Blues Not Superstars," *Village Voice*, 5 Oct. 1967: 20.

25. Richard Goldstein, "Pop Eye: Rock'n'Wreck," *Village Voice*, 6 Apr. 1967: 23.

26. Ibid.

27. Ibid.

28. Richard Goldstein, personal interview, 23 July 2003.

29. Richard Goldstein, "Pop Eye: C. J. Fish on Saturday," *Village Voice*, 3 Oct. 1968: 30; Richard Goldstein, "Pop Eye: Guerrilla Rock," 14 Nov. 1968: 33+.

30. Goldstein, "Pop Eye: Guerrilla Rock," 36.

31. I will refer to Cynthia Plaster Caster as "Cynthia" due to the fact that Plaster Caster is not her real name.

32. I gained information about Cynthia's life from two main sources: an address she gave in 1997 and interviews with her that I conducted in 2003. Cynthia Plaster Caster, "Visiting Artists' Series: Sculpture," Art Institute of Chicago, Chicago, 1 Dec. 1997.

33. Cynthia Plaster Caster, "Visiting Artists' Series: Sculpture."

34. Ibid.

35. Ibid.

36. Ibid. Cynthia and her then-partner decided that it would be funny to cloak their casting activities in a semi-official aura. "We thought it would be totally ridiculous and absurd and hilarious and make us more comfortable in the exalted presence of our heroes, if we showed up at the hotel with a very business-like demeanor" (Cynthia Plaster Caster, "Visiting Artists' Series: Sculpture). This process involved bringing along a suitcase and a lab coat and having cards made up that read, "Plaster Casters of Chicago. Lifelike models of Hampton wicks."

37. Ibid.

38. Some musicians, as discussed later in an article on the Plaster Casters, did not want to take part in either her sexual favors or her casting. "It really was fashionable back then in society to have orgies and fuck many different people. But there were some musicians who didn't want to be known as group members that pulled [had sex with] groupies" (Cynthia Plaster Caster, personal interview, 11 Feb. 2003).

39. Ibid.

40. Frank Zappa, "The Oracle Has It All Psyched Out," *Life*, 28 June 1968: 84.

41. This name was a pseudonym and Nolan could not remember her real name.

42. The article would appear in *Cheetah* in December 1967.

43. Although this article originally ran in *Cheetah*, I located the article in an anthology from the period and citations in this chapter are to that version. The date publication of the original article was December 1967. Tom Nolan, "Groupies: A Story of Our Time," in *The Age of Rock: Sounds of the American Cultural Revolution*, ed. Jonathan Eisen (New York: Vintage Books, 1969), 77.

44. Nolan, "Groupies," 80.

45. Ibid., 81.

46. Ibid., 78.

47. Cynthia Plaster Caster, personal interview, 11 Feb. 2003.

48. Nolan, "Groupies," 88.

49. Ibid., 83.

50. Ibid., 84.

51. Ibid., 85.

52. Ibid.

53. Ibid., 87.

54. The *Realist* was started in 1958 by stand-up comedian Paul Krassner and continued until 1974. He acted as editor for the magazine. Krassner also edited an anthology of articles from that magazine (*The Best of the Realist*, ed. Paul Krassner [Philadelphia: Running Press, 1984]), which contains articles by Lenny Bruce, Mort Sahl, and Ellen Sander. For more detail on the magazine and Krassner, see Paul Krassner, *How a Satirical Editor Became a Yippie Conspirator in Ten Easy Years* (New York: Putnam, 1971).

55. Two versions of "The Case of the Cock-Sure Groupies" exist: the original version that ran in the *Realist* and a shortened version included in a later anthology of articles from that magazine. In this work I refer to the original version, which had a masthead date of November 1968. However, Ellen Sander, who sent me a copy of the original article, disputes this date. In her cover letter that accompanied the article, she wrote, "The pub[lishing] date on the masthead is 'a lie.'" In an interview with her, she puts its actual date of publication "a few days before" that of the *Rolling Stone* groupie issue. Sources for this information are: Ellen Sander, "The Case of the Cock-Sure Groupies," *The Realist*, 84, Nov. 1968: 1, 14-19; *The Best of The Realist*, 206-209; Ellen Sander, personal interview, 2 Feb. 2001.

56. Initially, Sander had used pseudonyms for the Plaster Casters in the article, but before the article was published the editor included a photograph of the women along with their real names. Sander explained the reason for this change: "Originally, the groupies asked me to use pseudonyms. They then changed their minds due to fact that other groupies were claiming to be The Plaster Casters and they wanted to put a stop to it. There wasn't time to change their names in the text" (Ellen Sander, personal interview, 2 Feb. 2001). The editor's note corroborates Sander's explanation: "Originally, pseudonyms were to be used in this article. Now, however, the girls want not only their correct names published, but also their photo, because of the increasing imposter problem" (Sander, "The Case of the Cock-Sure Groupies,"15). In the article, Cynthia was referred to as "Rennie" and Diane as "Lisa." A Polaroid photograph of the two women accompanied this explanation as well as their real names.

57. Sander, "The Case of the Cock-Sure Groupies," 15.

58. Ibid.

59. Ibid., 14.

60. Ibid., 17.

61. John Burks, Jerry Hopkins, and Paul Nelson, "The Groupies and Other Girls," *Rolling Stone*, 15 Feb. 1969: 20.

62. Sander, "The Case of the Cock-Sure Groupies," 19.

63. Ellen Sander, personal interview, 2 Feb. 2001.

64. Burks, Hopkins and Nelson. "The Groupies and Other Girls," 22.

65. Sander, "The Case of the Cock-Sure Groupies," 18.

66. Ibid., 19.

67. Ibid.

68. Ibid.

69. Sally Kempton, "Zappa and the Mothers: Ugly Can Be Beautiful," *Village Voice*, 11 Jan. 1968: 1, 10.

70. Stephanie Harrington and Blair Sabol, "Outside Fashion: Fillmore East," *Village Voice*, 16 May 1968: 28.

71. Annie Fisher, "Riffs: Live, In Person," *Village Voice*, 25 July 1968: 26.

72. Annie Fisher, "Riffs: Hookered," *Village Voice*, 26 Sept. 1968: 35.

73. Howard Smith, "Scenes," *Village Voice*, 22 Aug. 1968: 10.

Chapter 5. Groupies Take the National Stage

1. "When we tell you what a Groupie is, will you really understand?" advertisement. *New York Times*, 12 Feb. 1969: 80.

2. "When we tell you what a Groupie is, will you really understand?" advertisement.

3. Robert Draper, *Rolling Stone Magazine: The Uncensored History* (New York: Doubleday, 1990), 99.

4. Ibid., 102.

5. Ibid., 100.

6. Ibid.

7. Ibid, 102.

8. John Burks, Jerry Hopkins, and Paul Nelson, "Groupies and Other Girls," *Rolling Stone*, 15 Feb. 1969: 11–26. In 1968, Hopkins responded to the first help-wanted ad published in *Rolling Stone* and was made a feature writer. From 1968 to 1969, he was also editor of *Majority Report*, a marketing newsletter. He was *Rolling Stone*'s Los Angeles correspondent from 1968 to 1970 and its European and African correspondent in 1972. Hopkins has written well-received biographies of Jim Morrison, Elvis Presley, David Bowie, and Jimi Hendrix.

In 1968, Ralph Gleason suggested to Jann Wenner that he hire Burks, who became managing editor that year. In the wake of the Kent State shooting in 1970, Burks decided to "detrivialize" *Rolling Stone*. Wenner's decision to concentrate more on music and cultural events caused Burks to resign that same summer. He is currently chair of the journalism department at San Francisco State University.

Paul Nelson had his first article published in *Rolling Stone* on February 1, 1969, just two weeks before the groupie issue was published. From 1969 to 1991, Nelson wrote nineteen articles, nine book reviews, six movie reviews, and seventy-four record reviews for *Rolling Stone*.

Draper states that it was Wolman's idea to do the groupie article in the first place (99). Baron Wolman provided the illustrations for the article. Described by Draper as "a professional voyeur" by Draper, Wolman was initially hired in 1967 as chief photographer of *Rolling Stone*, in, because he would work for stock instead of a salary (64). After disagreeing with Wenner's editorial style, Wolman left in 1970 to start his own style magazine, *Rags*. Burks and another former *Rolling Stone* writer Jon Carroll joined him there. The sources for this information are: Draper, *Rolling Stone* and Gatten, *The Rolling Stone Index*.

9. Gillian G. Gaar, *She's a Rebel: The History of Women in Rock & Roll* (Seattle: Seal Press, 1992), 128; Gatten, *The Rolling Stone Index*, 419. In addition to those listed below in the text, the other women on the cover before the groupie issue were Yoko Ono (with her husband, John Lennon) and some unidentified models in an issue devoted to fashion.

In fact, 1969 was the first year the *Readers' Guide to Periodical Literature* listed "groupies" as a subject heading. The *Oxford English Dictionary* (OED) cites 1969 as the year in which the word came into common parlance. The first usage of the word as we understand it today was purported by them to have been in the *San Francisco Examiner*, 29 Jan. 1969. However, this citation is incorrect, as no usage of the word appears in that paper on that day. The correct instance of the word's first usage is documented in Chapter 4. The *OED* relies heavily on volunteers and, unfortunately this particular citation serves to establish little except the truth in the old adage "that you get what you pay for." I am deeply indebted to my friend and colleague John Joyner for this fine bit of archival sleuthing.

10. I am indebted to two works by Michael Holquist for my understanding of "contested representation": Michael Holquist, "The Politics of Representation," *Quarterly Newsletter of the Laboratory of Comparative Human Cognition*, 5, no. 1 (Jan. 1983): 2–9; Michael Holquist, *Dialogism: Bakhtin and His World* (London: Routledge, 1990).

11. To better puzzle out the meaning(s) of that article, I turned to an approach by Harold Lasswell's work on communication. Briefly, Lasswell asserts that who speaks, to what audience, and for what reason defines a communication's meaning. In the *Rolling Stone* groupie issue, the women always speak through the filter of the male writers and editors, and therefore their voices are not as clear as the men's, although they do break through on some occasions. My understanding of Lasswell's idea comes from James Gilbert's *Cycle of Outrage: America's Reaction to the Juvenile Delinquent in the 1950s* (New York: Oxford University Press, 1986). I am indebted to Janet Staiger for bringing this work to my attention.

12. As this was a collaborative effort, it is impossible to attribute discrete sections of the article's text to specific writers. Therefore, for the remainder of the article, I refer to Burks, Hopkins, and Nelson as "the authors."

13. Burks, Hopkins, and Nelson, "Groupies,"11; The differences between the definitions offered by the women and those of the men is striking. The exception was the last definition given by a self-described groupie named Anna. However, her reliability as a member of groupie subculture was questioned by others, aspects of which I will discuss in the section of this chapter devoted to reader's letters about the groupie issue written in to *Rolling Stone*.

14. Ibid., 12.

15. Ibid., 13.

16. Ibid.

17. In an interview, Cynthia Plaster Caster stated, "I'm very proud to say the only two male groupies that I know of are both from Chicago. It wasn't too common to find male rock stars who were gay or who would admit they were gay," Cynthia believes that one of these two is deceased, due to the fact that he was HIV-positive several years ago, but could not say definitively. She gave me the address of the other male groupie, who declined to be interviewed. Cynthia Plaster Caster, personal interview, 11 Feb. 2003.

18. Burks, Hopkins, and Nelson, "Groupies," 24.

19. Ibid., 22.

20. Ibid.,

21. Ibid., 13.

22. Burks, Hopkins, and Nelson, "Groupies," 24.

23. Ibid., 15.

24. I briefly discuss Donahue and KMPX in Chapter 1. For a more detailed discussion of Donahue and the station se: Ralph J. Gleason, *The Jefferson Airplane and the San Francisco Sound* (New York: Ballantine, 1969), 45–48.

25. Ibid., 46.

26. Burks, Hopkins, and Nelson, "Groupies," 15.

27. Ibid.

28. Ibid., 15.

29. Des Barres, *I'm with the Band*, 122.

30. Burks, Hopkins, and Nelson, "Groupies," 17.

31. Des Barres, *I'm with the Band*, 122.

32. Zappa also served as The Plaster Casters' unofficial "guardian." Burks, Hopkins, and Nelson, "Groupies," 20.

33. Burks, Hopkins, and Nelson, "Groupies," 15.

34. Ibid. Although I have found references to *The Groupie Papers* in several sources, I found no evidence that they were ever published.

35. Penny Stallings, *Rock'n'Roll Confidential* (Boston: Little, Brown, 1984), 21. Undercover officers of the Ontario, California, vice squad arrested Zappa after he had agreed to make a pornographic tape for one of them. The article stated that Sergeant Jim Willis, a vice investigator for the San Bernardino County sheriff's office, went to Zappa's recording studio and asked if he would rent him a "stag" movie." Zappa then offered to film a movie for $300 instead. By way of demonstrating the type of merchandise he could expect, Zappa played the detective an audio tape that featured Zappa and his female companion Belcher in a sexual dialogue. At that point Willis arrested them both. They were booked on "suspicion of conspiracy to manufacture pornographic materials and suspicion of sex perversions." Both charges during this era were felonies. The article, which was reprinted in Stallings's book from the *Ontario Daily Report*, has no date on it. In the newspaper article, written by Ted Harp, Zappa's age was given as twenty-four. He was born in 1940, so that would put the arrest in either 1964 or 1965. Due to the fact that the newspaper no longer exists and the sheriff's department destroys its records after five years, I have been unable to find a more definitive date for the arrest.

Zappa was convicted of a felony and sentenced to "ten days in jail and three years on probation—during which time he could not be with an unmarried girl under twenty-one except in the presence of a competent adult." Regardless of the fact that it appears Zappa was set up and merely engaged in the manufacture of sexually explicit materials for money on this one occasion, he knew that sex sold from hard experience. It is also notable that just a few years later, the manufacture of pornography wouldn't even be criminalized. Zappa characterized his experience with the police as "harrowing." Despite the circumstances of his arrest, he was a felon convicted of a sex-related crime. Clearly Zappa was no stranger to the legal system and his apprehensions about the underage girls might have stemmed from something other than "ethical" considerations. David Walley, *No Commercial Potential: The Saga of Frank Zappa and the Mothers of Invention* (New York: Outerbridge & Lazard, 1972), 37–41.

36. Burks, Hopkins and Nelson, "Groupies," 19.

37. Ibid., 21.

38. Ibid., 18.

39. Ibid.

40. Ibid., 22. It is informative to compare Miller's account of the encounter with the Plaster Casters to Ellen Sander's chronicle of their meeting in her article, "The Case of the Cock-Sure Groupies," see Chapter 4.

41. Ibid., 24.

42. Ibid., 12.

43. Ibid., 22.

44. Ibid., 24.

45. Ibid., 26.

46. Ibid., 24.

47. I do not know whether this increase in number was due to the number of responses received or the editor's wish to further hype the groupie issue.

48. Gatten, *The Rolling Stone Index*, 414; *Rolling Stone*, 15 Mar. 1969: cover.

49. The sex of the letter authors of the letters breaks down as follows: men, 17; women, 9; indeterminate, 5. The indeterminate authors include a writer who only used initials, a person named Marion, one named Lee, and the members of a band, the Anonymous Artists of America. I realize that Marion is traditionally the "male" spelling of the name; however, it was also my mother's name and she spelled it the same way. Also it is unwise to take these writer's representations of themselves at face value. I am grateful to Janet Staiger for pointing this out to me.

50. I have divided the letters into five categories: condemnatory letters, 9; congratulatory letters, 5; letters written by groupies, 8; anti-Plaster Casters letters, 3; anti-Anna (one of the groupies given special coverage in the article) letters, 2; and anti-Frank Zappa letters, 2.

51. Marion Nicholas, "Correspondence, Love Letters & Advice," *Rolling Stone*, 15 Mar. 1969: 2.

52. Ibid. Paul M. Cormany, "Correspondence, Love Letters & Advice," *Rolling Stone*, 15 Mar. 1969: 2.

53. Ibid. Irwin Beer, "Correspondence, Love Letters & Advice," *Rolling Stone*, 15 Mar. 1969: 4.

54. Ibid. Bruce Borgerson, "Correspondence, Love Letters & Advice," *Rolling Stone*, 15 Mar. 1969: 2.

55. Ibid. Stan Miklose, "Correspondence, Love Letters & Advice," *Rolling Stone*, 15 Mar. 1969: 4.

56. Ibid. Beer, "Correspondence, Love Letters & Advice," *Rolling Stone*, 15 Mar. 1969: 4.

57. Ibid. Rich Szathmary, "Correspondence, Love Letters & Advice," *Rolling Stone*, 15 Mar. 1969: 30.

58. I would like to have included the lyrics to these songs but must have permission from Zappa's estate to reprint them. They are located in the original text on pages 12 and 15.

59. Tony Fleming. "Correspondence, Love Letters & Advice," *Rolling Stone*, 15 Mar. 1969: 30.

60. Ibid. Doris Wilkes, "Correspondence, Love Letters & Advice," *Rolling Stone*, 15 Mar. 1969: 4.

61. Ibid. Richard Lee, "Correspondence, Love Letters & Advice," *Rolling Stone*, 15 Mar. 1969: 30.

62. Ibid. Doris Wilkes, "Correspondence, Love Letters & Advice," *Rolling Stone*, 15 Mar. 1969: 4.

63. Ibid. Alice Stewart, "Correspondence, Love Letters & Advice," *Rolling Stone*, 15 Mar. 1969: 2.

64. Ibid. Steve Carey, "Correspondence, Love Letters & Advice," *Rolling Stone*, 15 Mar. 1969: 4.

65. Lee Tanner, "Correspondence, Love Letters & Advice," *Rolling Stone*, 15 Mar. 1969: 4. The spelling of the name to which he refers in the letter is a typo of indeterminate origin. The Harvard professor at the time who was interested in contemporary adolescent psychology was George W. Goethals. He, along with Dennis S. Klos, published a book on youth the next year: *Experiencing Youth: First-Person Accounts* (Boston: Little, Brown, 1970). Thanks to Jeff Meikle for pointing out this typo to me.

66. Wexler is one of the most successful record producers in American popular music. Closely aligned with Atlantic Records, his list of artists and hits reads like a "Who's Who" of popular music, especially those from the 1960s. It was Wexler who, in 1967, signed Aretha Franklin to Atlantic after she had been dropped by Columbia Records the previous year. He was responsible for taking her to Muscle Shoals studio, which resulted in "I Never Loved a Man (The Way I Love You)." Wexler also produced Dusty Springfield's masterpiece *Dusty in Memphis* in 1968. For more information on Wexler and his career, see Justine Picardie and Dorothy Wade, *Music Man: Ahmet Ertegun, Atlantic Records and the Triumph of Rock and Roll* (New York: W. W. Norton, 1990).

67. Gerald Wexler, "Correspondence, Love Letters & Advice," *Rolling Stone,* 15 Mar. 1969: 4. However, it is unclear if this praise was the main reason Wexler wrote to the magazine. The majority of the letter was addressed to an unnamed record reviewer who had reviewed musician John Hammond's new album in the groupie issue. In his review, the reviewer expresses fears that Atlantic would drop Hammond's contract when it expired. Wexler wrote to reassure the reviewer that there was no danger of that happening. The praise for the groupie issue comes off more as an afterthought, or a canny bit of flattery, than the primary reason for the letter.

68. Ibid. Geoffrey Link, "Correspondence, Love Letters & Advice," *Rolling Stone*, 15 Mar. 1969: 4.

69. Ibid. Isis, "Correspondence, Love Letters & Advice," *Rolling Stone*, 15 Mar. 1969: 2.

70. Draper, *Rolling Stone*, 71.

71. Henri Napier, "Correspondence, Love Letters & Advice," *Rolling Stone* 15 Mar. 1969: 4.

72. Burks, Hopkins, and Nelson, "Groupies,"13.

73. Genie (the Tailor) Franklin, "Correspondence, Love Letters & Advice," *Rolling Stone* 15 Mar. 1969: 30.

74. Ibid. Isabel, "Correspondence, Love Letters & Advice," *Rolling Stone*, 15 Mar. 1969: 30.

75. Burks, Hopkins, and Paul Nelson, "Groupies," 11–26. The frequency of the groupies' quotations breaks down as follows: Anna, 15; Sunshine, 6; Lacy, 5; Sally, 4; Henri, 4; Karen, 2. Sunshine, the groupie most cited after Anna, had only six quotations included. It is noteworthy that of all the groupies quoted, only Sunshine and Henri did

not receive feature coverage. The reason perhaps lies in the fact that Sunshine was both heavier and older than all the other groupies and Henri was African American and pregnant at the time the issue was written and the photographs for it were taken.

76. Burks, Hopkins, and Nelson, "Groupies," 26.

77. Ibid.

78. The Silver Flower, "Correspondence, Love Letters & Advice," *Rolling Stone* 15 Mar. 1969: 30: 4.

79. Ibid. Rose Sweetly, "Correspondence, Love Letters & Advice," *Rolling Stone*, 15 Mar. 1969: 4.

80. Ibid. Clark Thomas, "Correspondence, Love Letters & Advice," *Rolling Stone*, 15 Mar. 1969: 4.

81. Ibid. A Young Girl, "Correspondence, Love Letters & Advice," *Rolling Stone*, 15 Mar. 1969: 4.

82. Ibid. In her confessional autobiography *I'm with the Band*, Pamela Des Barres does admit to having been attracted to one of her female friends to the point of staging a mock wedding with her (Des Barres was the "bride"). However, she also states that they never "consummated" their "marriage," 55–57.

83. Don Hiemforth, "Correspondence, Love Letters & Advice," *Rolling Stone*, 15 Mar. 1969: 30.

84. Ibid.

85. "Correspondence, Love Letters & Advice," *Rolling Stone*, 15 Mar. 1969: 30.

86. "The Groupies," *Time*, 28 Feb. 1969: 48.

87. Ibid. The *Time* author continued to use both informants and quotations from the *Rolling Stone* article without attributing his sources, and in one instance, he even neglected to include their name. In a manner similar to the plagiarized quotation above, he also cited Bob Hite, Canned Heat's lead singer, who was fairly ubiquitous in the groupie issue. However, the *Time* author referred to him by his nickname "the Bear," and even though he did list him as the leader of Canned Heat never identified him by name.

88. "The Groupies," 48.

89. The Revelles were a rock band based in Chicago for whom Pichinson played drums from 1968 to 1970. They were on the Gemco record label and had two moderately successful singles, "Something Good About Living" and "Little Girl." I interviewed Pichinson by phone and questioned him about the statements. He did confirm that he had made the comments but had no idea why the *Time* writer (whose name he couldn't remember) had contacted him. I am grateful to Jeff Meikle for tracking him down for me. Marty Pichinson, personal interview, 2 Jan. 2001.

90. In 1962, Harlan Ellison moved to Southern California where he gained a reputation, according to biographer Michael Zuzel, as "one of the more daring and talented science fiction writers." His books *Paingod and Other Delusions* (1965) and *I Have No Mouth and I Must Scream* (1967) are representative of his science-fiction work during this period. Ellison is also a talented essayist. During the 1960s his work in this area concentrated on politics, current events, and popular culture. He wrote of his involvement in the civil rights movement in his collection of essays, *Gentleman Junkie: Other Stories of the Hung-Up Generation* (1961). He was also opposed to the Vietnam War and wrote many essays on this subject in a regular column that he wrote for the *LA Free*

Press, an underground newspaper. Zuzel's biography of Ellison is published on the web at http://www.islets.net/islets.html (accessed 5 Jan. 2001).

91. "The Groupies," 48.

92. The author quoted a woman purported by him to be a "super groupie," Her name was Cleo, an eighteen-year-old New Yorker who was "a look-alike for Jane Fonda." I am assuming that he was referring to Cleo Odzer; in our interview, Ellen Sander referred to her. Ellen Sander, personal interview, 2 Feb. 2001. Also, there is an interview with Odzer in Kathryn Kerr Fenn, "Daughters of the Revolution, Mothers of the Counterculture: Rock and Roll Groupies in the 1960s and 1970s" (Ph.D. diss., Duke University, 2001).

93. "The Groupies," 48.

94. The *Time* article ends with a report that I have never seen mentioned anywhere else, on an anti-groupie movement, "the Super Fans." The writer described them as a fast-rising and "formidable counterforce" that was "evangelically dedicated to keeping rock musicians out of the groupies passionate clutches." He recounted the actions of the Super Fans, which included storming performers' hotel rooms to forcibly remove groupies. The author offered no information about the number of those who made up this group but he did quote one member: "'It's a vocation,' explains one, 'like being a nun.'" He then ends the article, "the problem is that her protective efforts on behalf of her heroes do not often seem to be appreciated," Due to the author's use of the word "evangelical" and the Super Fan's comparison of her behavior to that of a nun, it appears this movement may have had some sort of religious basis or affiliation. However, because this one paragraph is the only data that I have on this "movement," my speculations on it must end here.

95. For a good discussion of the moral panics of the 1950s, see Gilbert, *A Cycle of Outrage.*

96. Jenny Fabian and Johnny Byrne, *Groupie* (London: Omnibus Press, 1997), iv.

97. Jonathan Green, preface to the 1997 edition of *Groupie,* v.

98. Ibid.

99. Fabian and Byrne, *Groupie,* 14.

100. Ibid., 38.

101. Ibid., 87.

102. Ibid., 142.

103. Ibid., 91.

104. Ibid., 121–22.

105. Ibid., 154.

106. Ibid., 185.

107. *Groupie's* success in England proceeded and efforts were made to bring it to the big screen. Fabian and Byrne sold the novel's film rights. In June 1970, *Rolling Stone* reported on the progress of the project in its "Random Notes" section, a sort of music and industry gossip portion of the magazine. If the report was accurate, some of the people involved in this project were quite impressive: "*The Groupie* [*sic*], a big-selling knee-high view of the pop world, will be shot as a movie this spring in London. According to Joe Lustig, an American who is co-producer, shooting will begin in early March. Tony Palmer, creator of some of England's top TV documentaries including the pop-oriented *All My Loving,* will direct. 'Top British pop names' are supposed to be featured

in the film, but none have yet been signed. Jennie Fabian, author of the book, is currently working on a second draft of the film script with another writer. *The Groupie* [*sic*] will be financed by Claude Giroux, who made *A Man and Woman* and *Belle Du* Jou" (*Rolling Stone*, 11 June 1970: 4). I have not been able to find any evidence that the film described above was ever made, nor able to locate any evidence that a movie fitting this general description was ever produced or released.

Presumably due to the stir being caused by the film's production, *Rolling Stone* decided to review *Groupie* in the issue that contained the Random Notes blurb above. Writer Ed Ward's one-paragraph review makes you wonder why they bothered. He began by stating that the book was apparently Jenny Fabian's autobiography as "told to a tape recorder and written down with all of its sloppy grammar intact by Johnny Byrne" (*Rolling Stone*, 11 June 1970: 41). Though hardly a work of stunning prose, the grammar in *Groupie* was superior to much of that in *Rolling Stone*'s groupie issue. Ward then characterizes the musicians in the book as "second rate British rock stars," Jonathan Green, in his preface to the 1997 edition of *Groupie,* lists the real names of some of the bands whose names and personnel had been fictionalized in the novel. These bands included Pink Floyd, the Animals, and the Jimi Hendrix Experience, to name but a few. Some of the bands fictionalized in the novel certainly weren't members of the top tier of rock groups, but these three could hardly have been characterized as "second rate."

I suspect that due to the impending film version of the novel and the caliber of people involved in that project, they did not dare to ignore it. If the movie turned out to be a hit and *Rolling Stone* hadn't run a review, their claims to having their finger on the pulse of America's youth culture might have been viewed with some skepticism. However, as I discuss below, another reason *Rolling Stone* might have been loathe to acknowledge or publicize *Groupie* in any form was its own forthcoming book on the topic.

108. In the article, cited below, Smith writes that Lorber was "an arranger and producer who has been responsible for over $1 million worth of Neil Sedaka, Shirelles, Connie Francis, and Anthony Newly records." Although all these artists were credible players in the music business, they would have been considered more middle-of-the-road type artists, especially in 1969.

109. Howard. Smith, "Scenes," *Village Voice*, 22 May 1969: 56, as found on *The Groupies*, Earth Records, 1969. I do not have the exact date of the album's release; however, the article stated that it would be released "in a month," An advertisement for the album appears in *Rolling Stone* on July 22, 1969, so I assume that it was released in late June or early July 1969. "The Groupies" advertisement, *Rolling Stone*, 22 July 1969: 33. I am indebted to Jeff Meikle for sending me a taped copy of this album and its liner notes.

110. Ibid.

111. Ibid.

112. Cynthia Plaster Caster, "Visiting Artists' Series: Sculpture," Art Institute of Chicago, 1 Dec. 1997.

113. Smith, "Scenes," 56.

114. Ibid.

115. All of the comments printed in this section are from *The Groupies*. Earth Records, 1969.

116. Aside from *Rolling Stone*' groupie issue, *Groupie* remained the only in-depth

work on the subject available in 1969 and 1970, though it was occasionally overshadowed by promises of other impending works on the subject. In the groupie issue, Frank Zappa suggests that his work on the subject would soon be forthcoming; *Time* and the *New York Times* reiterate that in late 1969 and early 1970. In October 31, 1969, *Time's* article "Mephisto in Hollywood" covers Zappa's dissolution of his group the Mothers of Invention and catalogues his new pursuits in the entertainment world. Included in his endeavors is a reference to one of his new companies, "a book division that will start off with *The Groupie Papers*, a look at life among the female camp followers of rock" (46–47). The *New York Times Book Review*, in a collection of reviews called "Rock and Its Culture" from its February 15, 1970, issue, chimes in on the subject, but it also includes a mention of *Groupie*. Encompassing a wide variety of books about rock music and the subculture attached to it, the collection includes *Groupie* and Zappa's promised work in a section that covers "the culture of rock, which means not the performers but their audiences," It lumps the two together as the only two books on the subject: "The queens of the latter [the rock audiences]—or maybe just the jesters—are soon to be memorialized in Frank Zappa's promised "The Groupie Papers" and Johnny Byre [*sic*] and Jenny Fabian's slick novel *Groupie*, Despite all the advance press *The Groupie Papers* received I have been unable to locate any record of its publication.

However, in July 1970, Bantam Books, the American publisher of *Groupie*, finally published the book promised by *Rolling Stone* at the end of the letters to the editor about the groupie issue. Referred to as "A *Rolling Stone* Special Report," its title echoes the magazine article. The book's authors, John Burks and Jerry Hopkins, are two of the three writers responsible for the groupie issue article, and the photographer, Baron Wolman, also provided the illustrations for the magazine article. In one notable difference, the book lists Jann Wenner as editor. The cover featured the same photo used in the *New York Times* ad the year before and announces that the book is "a frank and freaky speak-in with the daughters of the rock revolution," Thus *Rolling Stone* went on record as putting forward the groupies rather than female rock musicians as "the daughters of the rock revolution."

Much of the material was a rehash or an expansion of the magazine article; however, there were many different images of the groupies that had not appeared in the groupie issue. There were also three notable differences in the text. For one, many of the musicians who had been identified by name in the magazine article became anonymous in the book. Second, there was no mention of Anna, the suspect groupie from the magazine article, and all but one of her quotations was omitted. Finally, a description of a homosexual male groupie appears in the book version.

 117. Smith, "Scenes," 12.

 118. "Groupies," advertisement, *Village Voice*, 5 Nov. 1970: 55.

 119. Groupies, dir. Ron Dorfman and Peter Nevard, Maran, 1970.

 120. "Groupies," advertisement, *Village Voice*, 5 Nov. 1970: 55.

 121. Andrew Sarris, "Films in Focus," *Village Voice*, 12 Nov. 1970: 70.

 122. Alex Kenyon, "Group Therapy," *Newsweek*, 16 Nov. 1970: 102–3.

 123. Jonathan Cott, "A Rock and Roll 'Mondo Cane,'" *Rolling Stone*, 2 Dec. 1970: 8.

 124. The "Mondo Cane" he refers to is the Gualtiero Jacopetti film of that name, described as "the original shockumentary," which is a visual exploration of the weird customs and bizarre rituals of many cultures. "Mondo Cane: 1962," *Losman's Mondo Mania*, 31 July 2000, http://losman.com/.

125. Stanley Kauffmann, *New Republic,* 5 Dec. 1970: 22 and 35.

126. Pauline Kael, "The Current Cinema: World's Apart," *New Yorker,* 5 Dec. 1970: 167–68.

127. Henry S. Resnik, "The Rock Pile," *Saturday Review,* 30 Jan. 1971: 48–50.

128. Cynthia Plaster Caster, personal interview. 11 Feb. 2003.

129. See note 138 for a discussion of her dissatisfaction with the film.

130. Lillian Roxon, "Who Are the Real Groupies?" *Village Voice,* 26 Nov. 1970: 42–45.

131. Of course, I cannot be 100 percent sure that is the groupie to whom she was referring. However, Roxon and Eastman had a close friendship before Eastman's marriage to McCartney. For a good account of this friendship, see Robert Milliken, *Lillian Roxon: Mother of Rock* (Melbourne: Black, 2002), esp. chap 13.

132. Roxon, "Who Are the Real Groupies?" 42.

133. Cott, "A Rock and Roll 'Mondo Cane,'" 8.

134. Roxon, "Who Are the Real Groupies?"44.

135. Ibid., 45.

136. Ruth Herschberger, Letter to *Village Voice,* 10 Dec. 1970: 81.

137. William Kloman, Letter to *Village Voice,* 10 Dec. 1970: 81.

138. In the *Village Voice* following *Rolling Stone*'s groupie issue, many articles appeared that used the term groupie. Almost all of them were one-time usages of the word in articles about music. Their numbers are as follows: post-groupie issue 1969, 11 uses; 1970, 7 uses; 1971, 5 uses; 1972, 7 uses; 1973, 3 uses; 1974, 3 uses. These figures exclude those usages of the word associated with the film *Groupies.*

Six articles used the term in connection with the movie *Groupies,* and all but one has been cited above in my discussion of that film. The one not mentioned was a blurb in Howard Smith's column about a suit that Cynthia Plaster Caster brought against the filmmakers. Smith. "Scenes," 8. I originally believed that this suit exhibited the level of dissatisfaction, at least on the part of one groupie, of the women in the film. However, after speaking with Cynthia, she made it clear that it was not the film that she was unhappy with but rather how she looked. "It wasn't the way I was portrayed. It was just because I was overweight, again. It was happily a temporary state and I didn't want to be filmed but I went along with it anyway just because I had a hard time saying no. But being a wuss, I waited until the end and told them I didn't want to be in the film but they portrayed me very, very well. I always thought it was a brilliant film and I feel like I gave those people a hard time and I really feel bad about it now." Cynthia Plaster Caster, personal interview, 11 Feb. 2003.

There were also two rather prominent articles relating to the discussion of the groupie in the post-groupie issue/pre-glam era that I have chosen to omit: "Sex and the Super-Groupie," *Time.* 12 Apr. 1971: 75, and Robert Greenfield's "A Groupie In Women's Lib," *Rolling Stone.* 7 Jan. 1971: 17. In both articles, feminist author Germaine Greer is called a groupie. Greer and her own philosophy of sex are highly complex and I do not believe that I have been able to gain a sufficient understanding of them to address them in any meaningful way.

139. The timing of Fabian and Byrne's novel—it was released close on the heels of the groupie issue—and the fact that it was primarily British in its focus account for much of the differences between its approach and that of *Rolling Stone*'s. It is also noteworthy

that Roxon and Fabian are the only two women who created any of the works to which I am referring and both are from members of the Commonwealth of Nations.

140. I discuss the radical feminists in Chapter 1.

141. Bobbie Goldstone, "Culture Vulture: Groupies, et. al.," *Off Our Backs*, 31 July 1970: 15. An online version of this article, which is a facsimile of the original version, is available at http://www.softlineweb.com/softlin.

142. Goldstone, "Culture Vulture," 15.

143. Ibid.

144. Its editor, Charles Clayton Morrison, clearly stated that he believed that America's involvement in the war was a result of its own unnecessary and unjust actions. Charles H. Lippy, ed., *Religious Periodicals of the United States* (New York: Greenwood Press, 1986), 109–14; Mark P. Fackler and Charles H. Lippy, eds., *Popular Religious Magazines of the United States* (New York: Greenwood Press, 1995), 111.

145. "Citizens or Subjects," *Christian Century*, 17 Dec. 1942: 1307.

146. Lippy, *Religious Periodicals*, 109–14; Fackler and Lippy, *Popular Religious Magazines*, 112.

147. This album was also advertised in *Rolling Stone*, 26 July 1969: 33.

148. Charles E. Fager, "Prey to Charisma," *Christian Century*, 17 Mar. 1971: 356–57.

149. Ibid., 357.

150. Though first published in 1969, I am referring to the 1971 edition. Roxon's encyclopedia was the first encyclopedia of rock-and-roll music and culture published. Lillian Roxon, *Lillian Roxon's Rock Encyclopedia* (New York: Grosset & Dunlap, 1971).

151. Roxon, *Rock Encyclopedia*, 212.

152. Ibid.

153. Ibid., 212–213.

154. Ibid.

155. Grace Slick, *Grace Slick: Somebody To Love?* In the course of her involvement with the Jefferson Airplane, Slick at one time formed love/sexual alliances with every member of the band with the exception of Marty Balin. At band meetings, Slick never spoke but preferred to have her opinions voiced by her partner. Due to the voting block that she and her partner formed, her opinion usually prevailed. It is a savvy approach to adopt in a male-dominated group and industry.

156. Susan Hiwatt, "Cock Rock," *Twenty-Minute Fandango and Forever Changes*, ed. Jonathan Eisen (New York: Random House, 1971), 141–47. The article originally appeared in a slightly different version in the New York underground newspaper *Rat* under the title, "Cock Rock: Men Always Seem to End Up on Top" (Oct.–Nov. 1970: 8–9, 26). I have been unable to locate any more information on Hiwatt other than that which can be gleaned from the article itself. I know she was a feminist, and from the phrasing she uses in the article I believe that she was a lesbian or bisexual. For example, she writes, "for a couple of years, when I was with a man," which leads me to believe that she might have been involved with a woman at the time she wrote this article.

157. Ibid., 145.

158. Ibid., 146.

159. Ibid.

160. Another work containing dissenting voices that I feel compelled to mention does not fall within the scope of this work's timeline. It is in Steve Chapple, and Reebee

Garofalo's *Rock'n' Roll Is Here to Pay: The History and Politics of the Music Industry* (Chicago: Nelson-Hall, 1977). This work is the best, most thoroughly researched book on the rock-and-roll music industry of the 1960s and 1970s I have encountered in my own research on the subject. Chapter 8 "Long Hard Climb: Women in Rock," is an amazingly evenhanded and sympathetic discussion of women in rock music and includes two insightful pages on the groupie phenomenon. These author's conclusions closely mirror those of Roxon and Hiwatt.

Chapter 6. Second-Generation Groupies

1. Peter Osnos, "Singer Peter Yarrow Convicted of Morals Charge With Girl, 14," *Washington Post.* 27 Mar. 1970: A1 and A11; "Yarrow, Folk Singer, Pleads Guilty to a Morals Offense," *New York Times*, 27 Mar. 1970: 21:1; "Peter Yarrow Took 'Immoral Liberties,'" *Rolling Stone*, 30 Apr. 1970: 16.

2. Osnos, "Singer Peter Yarrow Convicted," A11; Peter Osnos, "Folk Singer Gets Jail Term," *Washington Post*, 15 May 1970: A2, A15; Osnos, "Singer Peter Yarrow Convicted," A11; Osnos, "Folk Singer Gets Jail Term," A15.

3. Osnos, "Singer Peter Yarrow Convicted," A1, A11.

4. Ibid., A11. After the incident, Yarrow had married Mary Beth McCarthy, the niece of Senator Eugene McCarthy, on October 18, 1969.

5. William F. Buckley, Jr., "Edward Bennett Williams, RIP," *National Review*, 16 Sept. 1988: 17.

6. *The Complete Marquis Who's Who*, 1999 edition. Citations of this information are from its online version available at htttp://galenet.com. Another good source for background information on Williams is Robert Pack, *Edward Bennett Williams for the Defense* (New York: Harper & Row, 1983).

7. Osnos, "Singer Peter Yarrow Convicted," A11.

8. Evan Thomas, *Edward Bennett Williams: Ultimate Insider, Legendary Trial Lawyer* (New York: Simon and Schuster, 1991), 256.

9. Osnos, "Folk Singer Gets Jail Term," A15.

10. Ibid. To explain Yarrow's mental state, Williams brought in the singer's psychiatrist, Dr. Silvano Arieti, who had been treating Yarrow on a weekly basis since 1964. He explained that his patient's "deep-seated inferiority feelings" about women had improved dramatically since his recent marriage. Arieti also said that before Yarrow's marriage, he had never thought he would be able to experience "the love of a woman," but that his marriage had given him "tremendous reassurance, [and] he has flourished in many ways." The doctor then stated that the singer had experienced one "relapse," which had occurred on March 26, when Yarrow had been jailed for four hours by Judge Curran following the hearing at which he pled guilty. Arieti stated that during that incident he feared Yarrow was near collapse, testifying that the singer had given up touring in order to stay in New York and receive treatment (Osnos, "Folk Singer Gets Jail Term," A15; all information in this paragraph about the doctor's testimony comes from this source). Williams also commented on Yarrow's psychiatric problems, characterizing his client's psychoses as "deep-seated" and describing them as "inferiority feelings" that caused him to suffer "sexual problems" as a result (Thomas, *Edward Bennett Williams,*

256). After the medical testimony, Williams extolled Yarrow's efforts on behalf of worthwhile causes: "No one in the entertainment world . . . had identified himself with more charitable purposes" (Thomas, *Edward Bennett Williams*, 256). Williams then added that Yarrow's legal woes had brought about his "professional destruction."

11. Thomas, *Edward Bennett Williams*, 256.

12. Osnos, "Folk Singer Gets Jail Term," A15. I do not believe that his use of the word "liberated" was unintentional. Women's liberation was a tremendously controversial and ubiquitous topic in America at this point and I believe that Williams was trying to appeal to Curran's conservatism by using it. Williams's biographer Evan Thomas also drew the same conclusion about this maneuver. "He [Williams] played to Judge Curran's disapproval of modern mores by portraying the groupie as 'the end product of an upbringing in jungle morality,' and noted that her parents were divorced" (256). He also mentioned that the girls' parents were embroiled in a "nine-year custody battle over her [the victim] and her sister" (Osnos, "Folk Singer Gets Jail Term," A15). I'm not sure why Williams mentioned this fact, as it hardly seems the actions of parents who don't care about their children. My assumption is that this "battle" was supposed to be another example of the harmful effects of divorce on families with children.

13. I am indebted to attorney Linda Perine for this information.

14. The third part of Williams's defense strategy involved pending law. He mentioned that under a revision of the federal criminal code that had been recently completed but not yet enacted into law, Yarrow could have offered two defenses for his actions (Osnos, "Folk Singer Gets Jail Term," A15). "The first defense would be the prior sexual promiscuity of the girl. The second defense would be that she lied about her age. In any event, the proposed law would provide that the maximum penalty be 30 days in jail." Here, Williams was stating that while his client could offer no defense under existing laws, as soon as the law changed, he would have two defenses for his actions. Williams then closed his remarks with a request that the judge "postpone sentencing for six months to allow Yarrow more time for psychiatric treatment."

15. Government sources said that the probation officer who had prepared a pre-sentencing report on Yarrow had recommended probation rather than a jail term (Osnos, "Folk Singer Gets Jail Term," A15).

16. Osnos, "Folk Singer Gets Jail Term," A15.

17. Thomas, *Edward Bennett Williams*, 256.

18. Osnos, "Folk Singer Gets Jail Term," A15.

19. Ibid.

20. "Yarrow, Folk Singer, Pleads Guilty to a Morals Offense," 21:1.

21. "Peter Yarrow, Folk Singer, Gets 3-Month Jail Sentence," *New York Times*, 15 May 1970: 53:2.

22. "Singer's Offence Against Girl," *London Times*, 15 May 1970: 5: 3.

23. The magazine noted, ironically, that Peter, Paul, and Mary had won the Grammy award that year for Best Recording for Children for the album *Peter, Paul, and Mommy*. It is curious that it took *Rolling Stone* that long to include a story on this incident. The plea hearing took place on March 26, 1970, but *Rolling Stone*'s story was published a full month later. The magazine was a bi-monthly at this point and there would have been plenty of time to include it in their April 15 issue ("Peter Yarrow Took 'Immoral Liberties,'" *Rolling Stone*, 30 Apr. 1970: 16).

24. "Peter, Paul, and Mary: Time Out," *Rolling Stone*, 29 Oct.1970: 22.

25. Ibid.

26. Ibid.

27. "It Happened in 1970," *Rolling Stone*, 4 Feb. 1971: 44.

28. "Random Notes," *Rolling Stone*,15 Apr. 1971: 4.

29. Ibid.

30. "Random Notes," *Rolling Stone*, 30 Mar. 1972: 4.

31. Osnos, "Folk Singer Gets Jail Term," A15.

32. "New York Rallies: Newman Bugs Out," *Rolling Stone*, 20 Jul. 1972: 20.

33. Ibid. Newman's presence caused an immediate "jam of people" and necessitated his being removed by six security guards. Thus, the "Newman Bugs Out" in the article's title.

34. Ibid.

35. Chet Flippo, "Peter Yarrow, Singer-Organizer," *Rolling Stone*, 2 Aug. 1972: 16.

36. Ibid.

37. "Social Notes," *Rolling Stone*, 22 Nov. 1973: 33.

38. That Peter, Paul, and Mary are still active performers is demonstrated by the fact that from July to November 2001 the group has seventeen scheduled shows. Yarrow also remains active as a solo performer, with ten of his own dates scheduled from June to November 2001. That Yarrow's reputation has not suffered irreparable harm due to his conviction is also evidenced by the fact that in 1982, he was awarded the Allard K. Lowenstein Award for his "remarkable efforts in advancing the cause of human rights, peace and freedom." The source for this information is "Aviv Productions, Inc," http://www.aviv2.com/yarrow/ (Accessed 9 July 2001).

39. Greer Litton Fox, "'Nice Girl': Social Control of Women Through a Value Construct," *Signs: A Journal of Women in Culture and Society*, Vol. 2 No. 41 1977: 805-817.

40. Ibid., 809.

41. Ibid., 817.

42. Osnos, "Singer Peter Yarrow Convicted," A11.

43. James S. Kunen, "They Change Hair and Clothes but Not Their Minds," *Washington Post*, 31 Aug. 1969: D5.

44. Zappa's involvement with the GTOs and the Plaster Casters as well as the impending publication of *The Groupie Papers*, is discussed in detail in the *Rolling Stone* groupie issue (John Burks, Jerry Hopkins, and Paul Nelson, "The Groupies and Other Girls," *Rolling Stone*, 15 Feb. 1969: 11-26). I discuss Zappa's involvement with the groupie subculture in Chapters 4 and 5.

45. Kunen. "They Change Hair and Clothes."

46. Burks, Hopkins, and Nelson, "Groupies and Other Girls," 13.

47. The lyrics of the song, which was written by the GTOs, can be found at "FZ Lyrics & Else," The song. http://globalia.net/donlope/fz/related/Permanent_Damage.html#Rodney (accessed 7 May 2003). The first time I had heard of Bingenheimer was in relation to his promotion on his radio show of a single record by the Austin band D-Day. The song was called "Too Young to Date" and had a picture of a small female child made up to look like an adult on its cover. The band and its management related to me that Bingenheimer liked little girls and that was why he had initially added the record to his playlist.

48. Lina Lecaro, "Have You Ever Been Teen?" *LA Weekly*. 6-12 Nov. 1998, http://www.laweekly.com/ink/printme.php?eid=1575 (accessed 6 May 2003).

49. "Sex and Violence," *Rolling Stone*, 3 Feb. 1972: 38.

50. Barney Hoskyns, *Waiting for the Sun: Strange Days, Weird Scenes and the Sound of Los Angeles* (New York: St. Martin's Press, 1996), 260.

51. Ibid.

52. Ibid., 262. A picture of Phillips in front of the club appears on page 261 of Hoskyns's book. Phillips also discussed her time there in the *E* Television Network show, "True Hollywood Stories: Mackenzie Phillips," which told her life's story.

53. Hoskyns also makes an intriguing reference to a "groupie band called Backstage Pass, the missing link between the GTOs and the Runaways" (262). However, I have no additional information on this group. Phillips had a band at that time and played at the Troubador, but she did not mention its name so I don't know if they were the same band.

54. "Rodney Bingenheimer: It's All Happening," http://www.rodney-b.com/biography_1.htm (accessed 6 May 2003).

55. "The LA Musical History Tour: Rodney Bingenheimer's English Disco," http://www.oversight.com/soFein/tourBook/ppBookR.html (accessed 6 May 2003).

56. Hoskyns, *Waiting for the Sun*, 262.

57. Ibid.

58. Ibid., 263. For a good history of the Biba girl, see "The History of Biba," http://www.bibacollection.com/history.htm (accessed 7 May 2003).

59. Howard Smith and Tracy Young, "Scenes," *Village Voice*, 15 Mar. 1973: 26, As the column was jointly credited, it is impossible to ascertain whether Smith or Young, or both writers, were the author of this piece.

60. Smith and Young, "Scenes," 58.

61. Carole Pickel, "Sunset Strip Groupies: Who, What, When & How (Wow!)," *Star Magazine*. June 1973. I refer to a version I found online at http://www.groupiecentral.com/articlessable.html (accessed 4 April 2002). However, as of May 2003, this site is no longer functional.

62. Ibid.

63. Pamela Des Barres, *I'm With the Band*, (New York: Beech Tree Books, 1987), 262.

64. Pennie Lane, personal interview, 19 Feb. 2003.

65. Cynthia Plaster Caster, personal interview, 11 Feb. 2003.

66. Pickel, "Sunset Strip Groupies."

67. "Random Notes," *Rolling Stone*, 11 Oct. 1973: 24. The guitarist's last name is actually "Thunders." The complete story on Thunders' and Starr's tempestuous romance can be found in Nina Antonia's *Johnny Thunders: In Cold Blood*, (London: Cherry Red Books, 2000). In it, Antonia reports that Starr gave up the groupie lifestyle, moved to New York City, and dedicated herself to Thunders (31-46). She was later linked with rocker Richard Hell, a proto-punk musician from New York (http://www.ukairguitar.com/meme.htm). My thanks to Antonia and her publishers for sending me a copy of her book and sharing her memories with me.

68. Terry Atkinson, "Teen Deco-Disco: Striking a Pose on Sunset Strip," *Rolling Stone*, 22 Nov. 1973: 24.

69. Ibid.

70. Ibid.

71. "Pennie Lane" is not the former groupie's real name. She prefers that her real name not be used. For this reason, I have also not been able to corroborate all of her statements.

72. Pennie Lane, personal interview, 19 Feb. 2003.

73. Ibid.

74. Ibid.

75. Pennie Lane, email to the author, 21 Feb. 2003.

76. Pennie Lane, personal interview, 19 Feb. 2003.

77. Ibid.

78. Pennie Lane, email to the author, 21 Feb. 2003.

79. Pennie Lane, personal interview, 19 Feb. 2003.

80. Ibid.

81. Ibid.

82. Margaret Moser, email to the author, 18 Apr. 2003.

83. Margaret Moser, "Lust for Life: Memoirs of an Unrepentant Ex-Groupie," *Austin Chronicle*, 11 Aug. 2000, http://www.austinchronicle.com/mnogosearch/search.php?q=lust+for+life (accessed 3 Nov. 2002).

84. Margaret Moser, personal interview, 10 Oct. 2002.

85. Ibid.

86. Ibid.

87. Ibid.

88. Cynthia Plaster Caster, "Visiting Artists' Series: Sculpture," Art Institute of Chicago, 1 Dec. 1997.

89. Margaret Moser, personal interview, 10 Oct. 2002.

90. Margaret Moser, "Lust for Life."

91. Margaret Moser, personal interview, 10 Oct. 2002.

92. Pennie Lane, personal interview, 19 Feb. 2003.

93. Margaret Moser, personal interview, 10 Oct. 2002.

94. Ibid.

95. Pennie Lane, personal interview, 19 Feb. 2003.

96. Pennie Lane, email to the author, 4 May 2003.

97. Margaret Moser, personal interview, 10 Oct. 2002.

98. "Pennie Lane," http://www.pennielane.com/mmarketing.html (accessed 3 Mar. 2003).

99. Margaret Moser, personal interview, 10 Oct. 2002.

100. Ibid.

101. Pennie Lane, personal interview, 19 Feb. 2003.

102. Ibid.

103. Margaret Moser, personal interview, 10 Oct. 2002.

104. Pennie Lane, email to the author, 21 Feb. 2003.

105. Pennie Lane, email to the author, 4 May 2003.

106. Margaret Moser, personal interview, 10 Oct. 2002.

107. Pennie Lane, personal interview, 19 Feb. 2003.

Conclusion

1. Robert Draper, *Rolling Stone Magazine: The Uncensored History* (New York: Doubleday, 1990), 216.

2. Ibid., 217.

3. Partridge had previously worked at the *New York Times* and *The Saturday Evening Post* before her stint at *Forbes*. The source for this information is Draper, *Rolling Stone Magazine*, 218.

4. Draper, *Rolling Stone Magazine*, 218.

5. Ibid., 240.

6. Ibid., 296.

7. As quoted in Draper, *Rolling Stone Magazine*, 297.

8. Ellen Willis, "Rape on Trial," *Rolling Stone*, 28 Aug. 1975: 38-39 and 79-81; Ellen Willis, "Is Lina Wertmuller Just One of the Boys?" *Rolling Stone*, 25 Mar. 1976: 31, 70-72.

9. Between August 1976 and April 1978, Willis wrote seventeen columns for *Rolling Stone* that were published under the title "Alternating Currents." She also wrote three feature length-articles for *Rolling Stone* during these years. They are "Janis Joplin," *Rolling Stone*, 18 Nov. 1976: 60-63; "A Personal Account: Next Year in Jerusalem," *Rolling Stone*, 21 Apr. 1977: 64-76, which is an article about her brother's conversion to Orthodox Judaism and her reactions to this event; "One Small Step for Womankind," *Rolling Stone*, 12 Jan. 1978: 33, 35, which is an article about her participation as a delegate from the State of New York in the 1978 National Women's Conference in Houston, Texas.

10. Ellen Willis, personal interview. 5 Mar. 2001.

11. Ellen Willis, "Memoirs of a Non-Prom Queen," *Rolling Stone*, 26 Aug. 1976: 25.

12. *Almost Famous*, dir. Cameron Crowe, WGA. 2000.

13. Pennie Lane, personal interview, 19 Feb. 2003.

14. Margaret Moser, email to the author, 9 July 2003.

15. *The Banger Sisters*, dir. Bob Dolman, FoxSearchlight, 2002.

16. "Bob Dolman," *The Banger Sisters* official website, http://www2.foxsearchlight.com/thebangersisters/index_flash html (accessed 7 July 2003).

17. Pennie Lane, personal interview, 19 Feb. 2003.

18. Ibid.

19. Ibid.

20. Margaret Moser, personal interview. 10 Oct. 2002.

21. These included well-known stars such as the Everly Brothers, Jackie Wilson, Ray Charles, Gary U.S. Bonds and the Four Seasons. However, lesser known stars such as Bill Black's Combo, Mike Clifford (twice), and Cliff Richard (three times) were also featured on the show. Alan Betrock, *Girl Groups: The Story of a Sound* (New York: Delilah Books, 1982), 83.

22. Ibid.

23. These include Elvis Presley, Fabian, Frankie Avalon, Chubby Checker, Duane Eddy, Bobbie Rydell, and Paul Anka. Betrock, *Girl Groups*, 83.

24. Ibid., 83.

Index

Page references to illustrations appear in italics.

Acknowledgments

I would like to acknowledge a few of the people who were instrumental in my being able to bring this book to the page. Neil Nehring, whose writing on music is always an inspiration; Bill Stott, who (as usual) makes my writing much more elegant through his masterful editing; and Jeff Meikle, whose enthusiasm for the project was a much needed tonic to my spirits on more than one occasion. Desley Deacon and Janet Staiger were relentless in their demand for excellence. Their rigor has made me not only a better writer and scholar, but also a more confident one. Their encouragement and belief in the project has been one of its saving graces. They have been inspirational mentors and I owe them more than I can say. I owe these scholars a great debt of gratitude that I hope to repay through my own students.

The musicians, journalists, and groupies who agreed to be interviewed also deserve my thanks. Cynthia Plaster Caster, Robert Christgau, Roberta Cruger, Richard Goldstein, Carole Kaye, Pennie Lane, Sarah Lazin, June Millington, Margaret Moser, Tom Nolan, Marty Pinchinson, Ellen Sander, Paul Williams, and Ellen Willis. All were very generous with their memories and I hope they like the book.

Several scholars and journalists were also kind enough to send me materials and correspond with me about facets of this book. They are Nina Antonia, Norma Coates, Donna Gaines, Gillian Garr, Nadine Hubbs, John Joyner, Kim Powell, and Holly George Warren. I also received a lot of invaluable suggestions for research sources and citations from the members of the Popular Culture Association's threaded newsgroup. Lillian Roxon biographer Robert Milliken has been especially generous with his time, in interceding on my behalf with the Roxon family, and in allowing me to reprint a photograph from his book. A special thanks to Beth Boyd, who has been a wonderful friend and colleague throughout this project.

Two reference librarians at National University in La Jolla, California, who provided me with countless rolls of microfilm and arcane books. Betty Kellogg and Patrick Pemberton, my thanks don't say enough for all your help.

Baron Wolman's generosity and support were also essential to the photography section of this book, and his interest in the project was also very important to me personally.

Robert Lockhart at the University of Pennsylvania Press both helped to ensure that the book would be published and shepherded it home.

I also would like to thank my family, including my big brother Fred, for having the good sense to play bass in a band that practiced in our garage and starting this whole rock-and-roll thing for me; my sister Kathleen, for sharing her 45s and supporting my musical career; and to my dad, George Fred, for having musical talent and giving me his guitar on which to learn. Also thanks to my aunt and uncle, John and Joanna Athey, for their love and support.

A special thanks must go to Mike Horowitz and his bookstore, Flashback Books. By finding everything from groupie porn to a mint copy of *Rolling Stone*'s groupie issue, he gave me the grist for the mill. His enthusiasm for the project at an early point in its conception helped inspire me to finish it and shored up my own belief in the importance of work on this subject.

My most profound thanks I reserve for Samantha Foster, my editor at the University of Pennsylvania Press. She believed in this project from the outset. Her timely and thoughtful editing, as well as her warm personal touches, helped to make our work together nothing but one big pleasure. I wish for all writers an editor like Sam.

Finally, to Trisha Ryan for putting up with my crankiness, fear, and exhaustion, my feelings go way beyond thanks. For listening to all my arcane babbling about the popular culture from this era and for making me smile when I most needed to, you have my eternal gratitude. Your love and support made the whole thing worthwhile.